Experimenting the Human

Experimenting the Human

Art, Music, and the Contemporary Posthuman

G DOUGLAS BARRETT

The University of Chicago Press
Chicago and London

The University of Chicago Press, Chicago 60637
The University of Chicago Press, Ltd., London
© 2023 by The University of Chicago
All rights reserved. No part of this book may be used or reproduced in any
manner whatsoever without written permission, except in the case of brief
quotations in critical articles and reviews. For more information, contact
the University of Chicago Press, 1427 E. 60th St., Chicago, IL 60637.
Published 2023
Printed in the United States of America

32 31 30 29 28 27 26 25 24 23 1 2 3 4 5

ISBN-13: 978-0-226-82335-5 (cloth)
ISBN-13: 978-0-226-82340-9 (paper)
ISBN-13: 978-0-226-82339-3 (e-book)
DOI: https://doi.org/10.7208/chicago/9780226823393.001.0001

Library of Congress Cataloging-in-Publication Data

Names: Barrett, G. Douglas, author.
Title: Experimenting the human : art, music, and the contemporary posthuman /
 G. Douglas Barrett.
Description: Chicago : University of Chicago Press, 2023. | Includes bibliographical
 references and index.
Identifiers: LCCN 2022020205 | ISBN 9780226823355 (cloth) | ISBN 9780226823409
 (paperback) | ISBN 9780226823393 (ebook)
Subjects: LCSH: Lucier, Alvin—Criticism and interpretation. | Z, Pamela, 1956—
 Criticism and interpretation. | Paik, Nam June, 1932–2006—Criticism and
 interpretation. | Sonami, Laetitia de Compiègne—Criticism and interpretation. |
 Avant-garde (Music) | Music and technology. | Art and music. | Music—Social
 aspects. | Posthumanism. | BISAC: MUSIC / Philosophy & Social Aspects |
 ART / History / Contemporary (1945–)
Classification: LCC ML3877 .B37 2023 | DDC 781.1/7—dc23/eng/20220428
LC record available at https://lccn.loc.gov/2022020205

Contents

Introduction: Music in a Wired Brain 1

1 The Brain at Work: Cognitive Labor, the Posthuman Brain, and Alvin Lucier's *Music for Solo Performer* 21

2 "How We Were Never Posthuman": Techniques of the Posthuman Body in Pamela Z's *Voci* 38

3 "The Catastrophe of Technology": Posthuman Automata and Nam June Paik's *Robot K-456* 58

4 Deep (Space) Listening: SETI, Moonbounce, and Pauline Oliveros's *Echoes from the Moon* 77

5 Engendering the Digital: Digitality and the Posthuman Hand in Laetitia Sonami's Lady's Glove 99

6 The Last Invention: Recursion, Recordings, and Yasunao Tone's *AI Deviation* 124

Conclusion: Music after Extinction 145

Acknowledgments 155
Notes 159
Index 207

INTRODUCTION

Music in a Wired Brain

If the ambitions of one tech corporation come to fruition, listeners may soon be able to stream music directly to their brains. During an employee recruiting event held in summer 2020, the tech entrepreneur Elon Musk confirmed that the ability to listen to music silently in the absence of headphones or earbuds is a feature planned for the neural implant chip the Neuralink company is currently developing. More than an audio device, to be sure, the chip promises to function as a multipurpose brain-machine interface that allows bidirectional communication with a phone. With precedents in therapeutic neural implants as well as non-invasive electroencephalography (EEG) techniques in use now for over a century, the Neuralink chip physically replaces a small piece of skull and comprises a series of fine electrode threads stitched into the brain by a neurosurgical robot. So far, the device has been restricted to animal brain output in which neural activity controls various computer functions. The input capability required to stream music remains an aspiration, as are a host of therapeutic uses along with direct, brain-to-brain communication. Beyond these abilities, Musk's goal is to augment cognitive functioning to meet the "existential threat" of artificial intelligence by allowing humans to merge with it.[1]

What can such a vision tell us about the status of the human in a moment marked by its purported technological decentering? What role has music played—particularly, experimental music since the second world war—in developing and challenging the concept of the posthuman? This concept ranges in function between fantasy, engineering program, and critical diagnosis and refers to the human's relativization—even its potential supersession—amid technoscientific, biological, medical, and economic networks. Posthumanism refers to philosophical and analytical approaches that take this variously

demoted, dematerialized, and de-autonomized human as a point of departure. This book will explore and put into dialogue some of the most compelling views from this expansive, multifarious theoretical literature. Yet rather than surveying posthumanism, I want to ask how the temporality of the postwar era complicates a progressive sequence already implied in the term's use of "post." What happens to the supposed moving beyond the human during a time when time itself moves forward for some and seems to stand still—or indeed move backward—for others? How has art music composed the subject of this time?

This book examines postwar experimental music that shapes and reflects on what I will define as the *contemporary posthuman*, a concept describing the temporal interpenetration of the posthuman and its ideological predecessors in the human and prehuman. I argue that experimental music addresses this condition not by adhering to the formal strictures of musical modernism but by producing extra-formal meaning through its immanent transdisciplinary involvements with postwar science, technology, and art movements. In 1965, Alvin Lucier composed *Music for Solo Performer*, a work that calls for electrodes to be attached to the scalp of a musician who sits motionless as their EEG signals activate a battery of percussion instruments. Roughly a year later, Lucier anticipated a form of brain-to-brain communication not unlike the one Neuralink later envisioned: "I also would love to be able to hook my brain up with the audience's brains so that I can tell them how I hear and think without having to go through the air."[2] In 2004, Pauline Oliveros ruminated on the musical possibilities of the neural implants that the futurist Ray Kurzweil discusses: "What if my ears could detach and fly around the space [and] merge with any other ears in the audience?"[3] Beyond the formal or structural dimensions of musical sound (yet still invested in them), Oliveros was interested in how such a technology might affect "future human values."[4] And Lucier alludes to cognitive labor, and even political economy, when he refers to his process as "doing work."[5] This book considers how these artists both construct and respond to the contemporary posthuman.

Science and technology play their parts as well. Neural implants can be seen as one step toward transcending the "external" boundaries of the human, while they accompany a deepening of its various "internal" divisions. This dynamic recalls perhaps the boundary breakdowns between humans, animals, and machines that Donna Haraway elaborated roughly thirty-five years ago in her critical notion of the cybernetic organism, or cyborg.[6] Such eroding exterior boundaries doubtless appear alongside interior differentiations based on race, ethnicity, gender, sexuality, ability, and class. Both types of division, I'll argue, are central to the contemporary posthuman. In this instance, the

billionaire-led Neuralink corporation showcased chip-implanted animal test subjects in a spectacle Musk referred to as his "three little pigs demo." As the number of deaths due to the coronavirus pandemic surpassed one million worldwide—alongside a global financial crisis, increases in unemployment and wealth inequality, and protests following the murder of George Floyd in the US—a suited Musk addressed a socially distanced crowd of mostly masked attendees seated around cocktail tables. In front of a large theatrical curtain, three pigpens appeared beside the large surgical robot responsible for implanting the device in one of the pigs' brains. Whenever the snout of this pig, "Gertrude," encountered food or a piece of hay, a computer monitor displayed a series of vertical bars whose respective heights tracked the density of neural firings over time. Using a form of what new and experimental music composers refer to as "sonification," the system also emitted a series of computer-synthesized tones that correlated the pitches of a pentatonic scale to this neural activity.[7] The process was engineered to demonstrate continuity between human and animal neurobiology (if it works on Gertrude . . .). At the same time, the sounds indexed the corporation's (gendered) exploitation of nonhuman animals against a backdrop of racial and economic *dis*continuity between humans.

A related dynamic appeared regarding the human's relationship to machines, and music returned as an illustrating device. In a question-and-answer session, a Neuralink engineer described how the chip implant detects spikes of neural activity using a figure comparable to Lucier's neural transduction. "If you think of [the 1,024 electrodes] as microphones sending audio information, we're basically filtering all of that in real time and looking for these characteristic shapes."[8] Each of the shapes refers to the firing of a single neuron. In this way, the system relies on a model of the brain traceable to the 1943 work of the neurophysiologist Warren McCulloch and the logician Walter Pitts, who understood cognition as "information flowing through ranks of neurons."[9] Neural networks process such data—whether abstract thought, physical sensations, or numerical calculations—using a system of binary electrical pulses. One or zero—that is, a neuron either fires or it does not. Likewise, the Neuralink chip filters the seemingly smooth space of neurobiology into striated binary data that pass through a technological system ultimately impartial to its human or animal origins. Rendered as a form of *information*, cognition appears epistemologically equivalent to the operations of a computer.

To chart experimental music's interfaces with the posthuman, we must first look to the latter's ideological and technoscientific origins. The biotechnological relativization of the human amid systems of control and communication

seen in Neuralink has roots in cybernetics, the transdisciplinary science and technology movement that grew in part out of military science near the end of the second world war. In his watershed 1948 text, *Cybernetics; or, Control and Communication in the Animal and the Machine*, the mathematician Norbert Wiener understands biological and mechanical systems alike as feedback networks that, like the self-governing mechanism of a thermostat, seek a homeostatic equilibrium with their environment.[10] The consequences of cybernetics have been far-reaching as it has applied similar systems-based regulatory models to a panoply of biological, technological, economic, social, psychological, governmental, mathematical, and engineering fields. Experimental music itself has shaped and has been shaped by cybernetics. During the 1940s, for instance, Claude Shannon used his then-burgeoning information theory in collaboration with the composer John R. Pierce to invent Pulse Code Modulation (PCM), a standard that continues to underpin telecommunications networks as well as digital audio (see chapters 5 and 6). Cybernetics' genealogical relevance is difficult to overstate; it was, according to the literary theorist Bruce Clarke, "the technoscientific forethought of the contemporary posthuman."[11] Yet if cybernetics challenges the centrality of the human, what is this concept of the human in the first place?

Ideologically, the posthuman springs from the racializing, gendered, and political-economic construction of the human of humanism. Since the Enlightenment, philosophers have reckoned with the crisis initiated in René Descartes's dualist split between the mind and the body. If the human can be identified as a mind that owns a body, liberal political theorists figured, then such a cognitive subject can effectively lease out the body's productive capacities and conscript it into the labor relations of market liberal capitalism. In a notorious passage (to which we'll return in chapters 1 and 2), the liberal political theorist John Locke writes, "every man has a property in his own person."[12] Rather than being identical to a body, the human—rendered not accidentally as "man"—possesses one. This concept of the human can already be seen to dematerialize the body—with its attendant markers of gendered, racial, ethnic, and sexual difference—and set the stage for the posthuman.[13] In a different yet related path to the posthuman, the eighteenth-century post-Cartesian materialist Julien Offray de La Mettrie expanded Descartes's contention that the human body is, essentially, an automaton. If the mind is truly separate from the body, then the body could, at least in theory, be replaced by prosthetic organs, body parts, and (potentially) a full mechanical body: a *Machine Man*.[14] Responding to this idea, the artist/composer Nam June Paik's *Robot K-456* connects eighteenth-century musical automata to contemporary robots while underlining the radical self-negating potential of human labor

(see chapter 3). Apart from labor and political economy, though, how are we to approach the racializing and gendered aspects of "man"?

Given its apparent shortcomings, some wonder why we don't simply throw out humanism's vexed concept of the human. Others see the only way out as *through* it—the human of humanism, that is, may provide the very conditions of possibility for its overcoming.[15] Posthumanism protracts a profound skepticism of the human already found in post-Enlightenment antihumanists like Michel Foucault, Louis Althusser, and Jacques Derrida.[16] More recently, theorists such as Alexander G. Weheliye have focused on the historical effects of the restriction of "man," in Locke's formulation, to the "heteromasculine, white, propertied, and liberal subject," which historically rendered others as exploitable nonhumans subject to the dehumanizing oppression of colonialism and slavery.[17] While posthumanism gestures beyond the human, many continue to endure the extended effects of having never been considered human in the first place. Such gestures, according to Zakiyyah Iman Jackson, "effectively ignore praxes of humanity and critiques produced by black people, particularly those praxes which are irreverent to the normative production of 'the human' or illegible from within the terms of its logic."[18] The Black feminist theorist Sylvia Wynter, a key reference for Weheliye, draws on cybernetics to argue not simply for abolishing the human of humanism, but for reinventing it through a kind of cultural-biological "feedback loop."[19] Chapter 2 locates a version of this reimagining of the human in composer/performer Pamela Z's work with technologies of the embodied voice.

As a virtualized extension of the body, the voice subtends humanism's human as a function of sociality and the political. In one of his last texts, the Enlightenment humanist Immanuel Kant was ultimately unable to define the human without reference to a hypothetical society of extraterrestrials who, unlike us, lack the ability to lie. In contrast to such aliens, according to Kant, humans live in a "cosmopolitical" society of creatures whose thoughts may differ from their speech—a state that requires us to unite against deception and other such evils.[20] More recently, in addition to imagining and even realizing extraplanetary vocal music, Oliveros was interested in the social effects of technology on interpersonal communication: "What if we could share our thoughts instantly over a network as computers now do?"[21] Could the posthuman upend the kind of interiority Kant deems essential to our humanness? In his recent monograph on Neuralink and a different German idealist, *Hegel in a Wired Brain* (2020), Slavoj Žižek understands such technologies as threatening our basic ability to engage in private thought and, indeed, to lie.[22] What would happen to such a capacity if we were to realize Musk's fantasy of "merging" with AI, if we were to achieve Kurzweil's technological

singularity?[23] How would we understand ourselves in the absence of a boundary between interior and exterior subjective space?[24] How would we experience music in a wired brain? Moreover, how might such an invention affect an understanding of ourselves as (cosmo)political, social creatures? How to think the posthuman together with the social?

Posthumanism, Experimental Music, and the Social

In her recent analysis of music *from* a wired brain, the musicologist and anthropologist Georgina Born argues for the value of posthumanism in considering digital and experimental music, while she cautions against relegating the social when using such a framework. Born examines *Thought Conductor #2* (2000), a work by the interdisciplinary artist Bruce Gilchrist that, like Lucier's *Music for Solo Performer*, uses real-time brain waves to produce unpredictable musical results. In this case, a computer analyzes a participant's EEG output, which it uses to generate musical notation displayed for the members of a live string quartet. To determine the musical output, the system compares the participant's real-time EEG activity to a database of neural streams captured from twelve composers who had previously been invited to write string quartet music while their brain activity was captured in a lab. When the system finds a close match between the participant's live EEG and a moment in one of the twelve composers' brain data, it displays to the live string quartet the fragment of music that composer had been writing at the time.[25] During a performance, a feedback loop emerges in which the participant's brain waves affect the music, which inflects their affective state, which in turn alters the notation displayed for the string quartet. For Born, this comprises "a fluid circuit of unending translation—or of the mutual negotiation of difference—between subjects and objects, humans and technologies, a circuit in which human subject becomes object becomes musical sound becomes subject . . . *ad infinitum*."[26] Such a reading suggests both an ontological flattening and an expansion of the subject–object relation which is paradigmatic of posthumanism. At the same time, Born insists that if analysts adopt such an approach, it must accompany a rich social phenomenology of music. This includes an apprehension of music's institutional support and legitimation structures; the divisions of labor involved in performance; the social production of listener communities; large-scale economic and historical processes; and structures of race, class, nation, gender, sexuality, and ability.[27] Elsewhere, Born underscores this tension between post-anthropocentric thought and the social by asking if music and music studies can learn from posthumanism

while retaining a concern for subjectivity.[28] How to account, then, for this kind of contemporaneity of the human and posthuman?

Experimental music can be seen as prefiguring the posthuman in the ways indeterminacy seeks to remove the human from the creative process. Years before her landmark 1999 text, *How We Became Posthuman*, the literary theorist N. Katherine Hayles spoke at one of John Cage's last public appearances and offered an analysis of the experimental composer's work prior to his death in 1992.[29] Hayles considered the indeterminate techniques Cage called "chance operations" in which, beginning in the mid-1940s, he measured the imperfections of blank sheets of paper; used the ancient Chinese *I Ching* text together with flipping coins and rolling dice; and, in his monumental 1969 multimedia collaboration with the composer and scientist Lejaren Hiller, *HPSCHD*, employed computer algorithms to derive musical structures.[30] Expanding this use of computers during the 1980s, Cage worked with the programmers Andrew Culver and Jim Rosenberg to create twenty-six applications variously written in C, PAL, and ZIM that automated mesostic writing and generated various chance operations.[31] Hayles focuses on a tension between the open-ended aspects of "chance" and the implications of control inherent to "operations." When framed in relation to contemporary science, according to Hayles, Cage's chance operations speak to a paradoxical attempt to "grasp through our intentions a world that always exceeds and outruns those intentions."[32] In this way, Cagean indeterminacy confronts the posthuman—even prior to the latter concept's widespread circulation—by homologizing its challenge to human agency.[33] "By giving up an anthropomorphic viewpoint based on control," Hayles contends, Cage reveals "a more capacious view of connection that engages us in the world rather than isolates us from it."[34] For Cage, as we'll see, some forms of connection and engagement were more acceptable than others.

A tension arises between indeterminacy's programmatic withdrawal of control and forms of technological control that give way to the posthuman. In his 1955 article, "Experimental Music," Cage defines experimentalism "not as descriptive of an act to be later judged in terms of success or failure" but rather as "an act the outcome of which is unknown."[35] Cage's statement contains a scientistic valence comparable to that of the European musical avant-garde. Indeterminacy was central to the encounter between the American and British experimentalists (Cage, Christian Wolff, Earle Brown, and, at the time, Cornelius Cardew)[36] and the European avant-garde composers (Pierre Boulez, Karlheinz Stockhausen, György Ligeti, and Henri Pousseur) during the 1957–1959 Darmstadt Summer Courses. Many think of experimentalism as the principal

if not sole proprietor of indeterminacy. In fact, both sides of the somewhat mythologized Darmstadt rift used graphic scores, open and mobile forms, and statistical structures—compositional devices that result in various degrees of unpredictability.[37] For instance, Stockhausen's *Klavierstück XI* (1956), a work dedicated to the American pianist David Tudor, consists of a set of nineteen piano fragments that are freely configurable in performance. Indicative of indeterminacy's level of controversy, however, Cage criticized *Klavierstück XI*'s limitation to large-scale formal variability along with its conventionally notated pitches and rhythms as ultimately unable to bring about an unforeseen musical situation; hence, for Cage, it remained determinate.[38] As opposed to what Born describes, at an extreme, as post-serialist musical modernism's "hypercontrol of all parameters of sound," experimental music has pursued strategies of *noncontrol* (which among other attributes distinguish it, for Born, as postmodern).[39] During his tenure at Bell Laboratories in New Jersey during the 1960s, for example, James Tenney suggested while composing his algorithmic computer music work, *Ergodos I (for John Cage)* (1964), that his "last vestiges of external 'shaping' ha[d] disappeared."[40] No longer beholden to the sole will of the human, in this sense, Tenney cedes agency to the algorithm.

Cage similarly understands indeterminacy as an attempt to excavate human agency and intention from the artistic process. He describes his 1951 piano composition, *Music of Changes*, for instance, as "an object more inhuman than human, since chance operations brought it into being."[41] It is not simply that the results of this artistic process appear unfamiliar to its creator (a tendency Freud often observed with patients); it's as though, for Cage, music becomes consequently less human as indeterminacy takes over the poietic process. Written a year after *Music of Changes*, Cage's notorious silent composition, *4'33"*, was perhaps his most radically indeterminate work; it opens a musical performance up to the contingent sounds of its environment by instructing an instrumentalist to refrain from producing intentional sounds. Premiered by Tudor in Woodstock, New York, in 1952, *4'33"* came into being through the same kind of *I Ching* chance operations Cage used to compose *Music of Changes*. In this instance, the indeterminate process produced the respective durations of its three parts—33", 2'40", 1'20"—which, in the text-only version of the score, Cage notes can be replaced with any durations.[42] *4'33"* is not typically understood technologically, yet these open windows of time, according to Liz Kotz, structurally resemble the temporal affordances of the tape recorder, a technology Cage used during this period to compose his similarly chance-derived *Williams Mix* (1951–1953).[43]

Of course, Cage's silence never truly becomes inhuman. *4'33"* does not eliminate the role of the performer, for example, so much as it shifts our focus

to the observation of sounds and phenomena beyond those an instrumentalist typically produces. Highlighting performance if only by reducing it to a bare minimum, *4'33"* draws attention to the process of listening. Nevertheless, Cage composed the work following his notorious visit to the Harvard anechoic chamber, where instead of silence he heard his nervous system and his blood circulating. This demonstrated, to Cage, that even anthropomorphic listening was non-integral to his vision of music: "Until I die there will be sounds. And they will continue following my death."[44] Death, a subject to which we'll return in this book's conclusion, is perhaps one form of noncontrol. In the wake of intentionality, then, Cage pursued sounds "themselves" rather than as vehicles for "man-made theories or expressions of human sentiments."[45] This stance led to Douglas Kahn's incisive criticism that Cage effectively "silence[s] the social" in favor of the natural—or, in the case of the anechoic chamber, the technoscientific—by attempting to excise music from its broader sociopolitical situation.[46] Despite his later interest in Maoism, Cage aligned himself with anarchism and often claimed to be apolitical. Disavowing overtly political interpretations of his work, furthermore, Cage was openly hostile to Julius Eastman's 1975 queer realization of his *Song Books* (1970)—a work that includes a version of Cage's *o'oo"*, otherwise known as *4'33" No. 2* (1962).[47]

If we follow Born's imperative to think posthumanism together with the social, indeterminacy not only points to a world beyond intentionality but also appears as a gesture imbued with human meanings—including those beyond Cage's own purported intentions. Cage describes his turn to indeterminacy during the 1940s and 1950s as in part a result of his dissatisfaction with psychoanalysis in dealing with a series of personal "disturbances." "I was not only in a troubled state personally," he reports, "but I was concerned about why one would write music at this time in this society."[48] Cage's "troubled state" likely refers to the composer's coming to terms with his sexuality amid the lack of support and, indeed, the homophobia present in psychology; the American Psychological Association considered homosexuality pathological until 1973. Cage's questioning of writing "music at this time in this society" suggests multiple meanings. It's hard to ignore, for instance, the phrase's similarity to Adorno's famous quip about writing poetry after Auschwitz. Yet, rather than the horrors of the second world war, according to the queer theorist Jonathan Katz, Cage refers to its aftermath in the Cold War and McCarthyism, and specifically America's infamous Red and Lavender Scares, which respectively targeted communists and homosexuals. Cage's indeterminacy, far from an apolitical gesture of indifference, figures in this view as a historically specific form of queer resistance.[49] Cage composed *4'33"*, that is, as

a semi-closeted, bisexual man during one of the most violently homophobic eras in history; he turned to silence and indeterminacy as forms of artistic negation because open political protest was often met with worse forms of violence. The musicologist Philip Gentry and the art historian Caroline A. Jones have offered similar interpretations of Cage's indeterminacy that cut, to an extent, against his own discourse which relegated the social in pursuit of a radically "inhuman" music.[50]

To this end, indeterminacy has been seen as reflecting other large-scale cultural, political, and technological processes of the postwar era. During the 1960s, which Branden W. Joseph describes as a high point of Cage's "techno-optimism," the artist used chance procedures to author "Diary: How to Improve the World (You Will Only Make Matters Worse) (1965)" (1966), a text containing various quotations of Marshall McLuhan and Buckminster Fuller, among others, along with original aphorisms. Complicating and augmenting the subtitle's parenthetical warning of the inefficacy and even danger of the individual will are quasi-utopian, futurist-inflected statements like "Conflict won't be between people and people but between people and things."[51] Cage was likely aware of the Cold War's integral, although of course not exclusive, conflict between people and things found in the nuclear deterrence strategy of mutually assured destruction (MAD), which on both sides employed automation and artificial intelligence for decision making.[52] The possibility of a nuclear weapons accident or a preemptive strike loomed, while conflict was also a matter of the military-cybernetic *thing* of AI. The computer and the atom bomb were born together.[53] Cage's indeterminacy arrived shortly thereafter, gestating first in the chance techniques of the historical artistic avant-garde (Surrealism, Dada, abstract expressionism) and maturing in opposition to the total serialism of the European musical avant-garde. This is not somehow to suggest a causal link, yet Andreas Huyssen similarly understands indeterminacy not only as Cage's musical response to serialist rationality but also as an artistic reflection of the "dialectical closeness of chance and determination" expressed in the nuclear attack drills starting in the 1950s. Demonstrating the danger of technological progress and the absurdity of the politics of deterrence, he recalls that schoolchildren lined up and covered their heads to brace for the possibility of a devastating "silence beyond art and life."[54]

Like other cultural and technological developments of the time, such a dynamic implicates questions of human and nonhuman agency that have long haunted music. In 1943, in order to execute calculations required for the Manhattan Project's hydrogen bomb, the mathematician John von Neumann programmed one of the world's first electronic computers, known as the ENIAC; his subsequent designs for the EDVAC led cyberneticians and laypeople

alike to wonder whether such machines could think.[55] The following decade, Hiller and Leonard Isaacson used the ILLIAC, a similar mainframe based on what became known as the von Neumann architecture, to ask whether computers could compose. The results were a string quartet titled the *Illiac Suite* (1957) and a text, *Experimental Music: Composition with an Electronic Computer* (1959). The latter detailed how their various algorithms produced music following historical music theory texts, traditional part-writing techniques, and other, less conventional rule sets. For example, "Experiment One" deploys the Renaissance polyphony rules codified by Austrian music theorist Johann Joseph Fux, while "Experiment Two" includes a passage of "random white note music" and other sections that progressively incorporate common practice–period tonal conventions such as cadential structures and the avoidance of parallel octaves and fifths.[56] Hiller co-wrote *Experimental Music* around the same time as Cage's 1955 article of the same name. And although, as noted, the two composers would come together in 1969 to collaborate on *HPSCHD*, Hiller proceeds with a rather different conception of the musical experiment. Whereas Cage understood it as the *observation* of "an act the outcome of which is unknown," Hiller approached the musical experiment as a kind of *test* capable of delivering a determinate answer: can a computer produce music based on a set of rules or norms?[57] While Cage attempts to expel human intentionality and expression from music, Hiller encodes their machinic equivalent.[58] Neither understood the social as a fundamental part of the artistic process.

Other experimental music *begins* with the social. For example, the French American composer, performer, and artist Laetitia Sonami describes her work as a "social commentary on technology."[59] Specifically, Sonami understands the wearable electronic instrument she created in 1991 known as the Lady's Glove as an alternative to the military aesthetics of other electronic music devices of the late 1980s.[60] As opposed to what the composer and cybernetician Herbert Brün criticized during the 1960s as a desire to "make music with the weapons of death,"[61] Sonami makes music with devices of social reproduction and care. She wittily refers to her Lady's Glove invention, which began as a pair of rubber kitchen gloves that she modified with sensors and electronics, as the "perfect housewife's tool."[62] Sonami construes her work, furthermore, as a feminist response to computer music's institutional underrepresentation of women and minorities along with what she identifies as its tendency toward technological disembodiment. If computer music "cut[s] everybody's body off," as Sonami suggests, her glove seeks to re-suture it by considering the embodied registers of reproductive and domestic care labor—registers that, she suggests, ultimately undergird computer music's

cerebral pursuits.[63] If computers do the thinking and composing, who does the cooking and cleaning? Sonami thus points to the hand as a surface for the human inscription of gender and gendered labor, while I argue in chapter 5 that her glove–computer interface also links the appendage that gave rise to counting to an inchoate digitality found at the heart of the posthuman. How, then, to conceive this kind of contemporaneity of the human and posthuman in experimental music? How to recompose posthumanism?

The Contemporary Posthuman

In order to account for experimental music that holds in tension the posthuman and the social, we must first look more closely and more theoretically at posthumanism. Posthumanism represents a variegated and conceptually rich discourse due, in part, to the complexity of the concept of the human upon which it is based. First, posthumanism stands for the instability, or mutability, of the "external" difference between the human of humanism and its various others in the pre- or nonhuman (machines, animals, aliens, and so on). Second, posthumanism inherits antihumanism's critique of the Enlightenment subject, which includes the historical remainders of humanism's racializing and gendered "internal" differentiations of the human. In a third sense, posthumanism refers to a historical moment that, for Cary Wolfe, marks "the decentering of the human by its imbrication in technical, medical, informatic, and economic networks."[64] Wolfe contends that, paraphrasing Jean-François Lyotard's rendering of the postmodern, the posthuman occurs, paradoxically, both before and after the human of humanism: prior to the historically specific humanist human, and after it in the human's technological de-autonomization.[65] This decentering effect can be compared to the negation of agency seen much earlier in such philosophical determinists of the Enlightenment as La Mettrie who, unlike many *liberal* humanists, rejected the notion of free will said to distinguish humans from animals and machines.[66] In this case, it refers to the posthuman as a diagnostic concept related to cybernetics, the postwar technoscientific discourse that produced a theoretical model of information, biology, and communication that removed the human from its privileged role in the production of meaning.

Here I want to propose a conception of posthumanism based on the overlapping contemporaneity of the pre-/nonhuman, human, and posthuman. Rather than the postmodern, however, I suggest that "the contemporary," a critical alternative to postmodernism that emerged in art theory during the 1980s and 1990s, better captures the temporality of the posthuman. The concept refers to the uneven historical time of postwar global capitalism—according

to Peter Osborne, its "totalizing but immanently fractured constellation of temporal relations."[67] There are other possibilities; for instance, Gilles Deleuze links "control societies" to the postwar rise of the corporation along with "cybernetic machines and computers."[68] Yet Deleuze's concept is premised, to an extent, on historical discontinuity even though it derives from Foucault's power regimes, which overlap and intersect.[69] Rather than signaling a rupture with the past, the contemporary represents a kind of non-stagist stage that is partially contiguous—or "conjunctively disjunctive"—with the modern.[70] The contemporary posthuman, in this sense, can be understood as a function of temporality and sequence: some suggest that we're already posthuman; others emphasize the extended consequences of people of color, women, and other subaltern subjects having never been considered human in the first place. Along with the before and after, the contemporary underscores the complex, inconsistent persistence of the during. Postmodernism connotes comparable forms of nonlinear temporality including Lyotard's figure of the "future anterior."[71] Wolfe uses Lyotard's postmodernism to describe a kind of temporal "loop" in which posthumanism helps to facilitate the conditions for a critical retrospective analysis of humanism's human.[72] Yet, unlike postmodernism, the contemporary does not arrive in anticipation of capital's beyond, as implied in Fredric Jameson's use of the term *late* capitalism, but rather marks its fractured global unity following the Cold War.[73]

This difference is key, I think, to situating the de-autonomizing effects of cybernetics following the second world war that Wolfe and Hayles associate with the posthuman. Despite short-lived experiments with cybernetics in the Soviet Union in the 1960s and in Salvador Allende's Chile during the 1970s, cybernetics was pivotal to the development of the contemporary deregulated financial system understood as a pillar of the posthuman's agential decentering.[74] While others were asking whether computers could think and compose, indeed, the ardent anti-communist von Neumann was asking if they could buy and sell. His influential work in economics and his later logical theory of automata would ultimately converge in the cybernetician's radical vision of a *computational economics*.[75] To this end, the historian Philip Mirowski hails von Neumann as possibly "the single most important figure in the development of economics in the twentieth century."[76] Through the eventual establishment of a global deregulated economy, which some report experiencing as "beyond human control," we arrive at the contemporary's own decentering of human action, which distinctly parallels Wolfe's posthuman. Along these lines, Suhail Malik borrows from Hannah Arendt to characterize the contemporary as historically *post-anthropogenic*: history is no longer strictly the product of modernity's human-directed action but

is rather driven by a complex arrangement of sub- and potentially supra-agential forces—algorithms, automation, analytics, informatics, climate and ecological systems, autonomous weapons, and AI agents.[77] Recall Cage's conflict between "people and things."[78] If the modern stands for the time of the human production of *the new*—evident in the German portmanteau of "new time," *Neuzeit*, or modernity[79]—then the contemporary marks its fractured coincidence with emergent forms of non-anthropogenic production which, among other things, obscure distinctions between novelty and sameness. If the modern is the time of the humanist human, then the contemporary is the temporality of the posthuman. To connote the resulting fractured simultaneity of the pre-/nonhuman, human, and posthuman, I propose the phrase *contemporary posthuman*.

Experimenting the Human

This book argues that postwar experimental music composes the contemporary posthuman. Picture Pamela Z sculpting the sound of her voice using her system of wearable sensors known as the BodySynth. Imagine Oliveros and others sending their voices to the moon and back using radio signals. Hear the evolving electroacoustic textures Sonami creates with her Lady's Glove. Or consider Paik's walking, talking musical sculpture, *Robot K-456*. What these musical artworks have in common is an engagement with the notion that the privileged position of the human has found itself increasingly challenged through cultural, biological, medical, economic, and technoscientific means. Yet rather than the postmodern, the temporality proper to this posthuman subject, I argue, is the contemporary, while the art form that most rigorously and imaginatively responds to it is experimental music. Through a series of six case studies respectively on Lucier, Z, Paik, Oliveros, Sonami, and Yasunao Tone, *Experimenting the Human* shows how these artists both produce and reflect on the contemporary posthuman. This book articulates relationships between experimental music and cybernetics since the second world war, beginning mainly in the 1960s, while linking these interfacings to theories of posthumanism for which cybernetics is a central point of departure. How, then, does the work of these artists, musicians, and composers speak to the contemporary posthuman? If not by mirroring Cage, how do these artists approach experimental music?

To explain what I will define as these artists' interdisciplinary postformalist approach to experimentalism, we'll need to revisit the European musical avant-garde and briefly consider contemporary art. In her 1995 ethnography of the French state-funded computer music research and production institute

known as IRCAM (*Institut de Recherche et Coordination Acoustique/Musique*), Born makes a critical distinction between experimental music and the post-serialist tradition the institute has largely represented since its founding in the late 1970s. In short, the European musical avant-garde preserves a form of aesthetic modernism, whereas experimentalism exemplifies musical postmodernism.[80] In addition to indeterminacy, the areas of difference she outlines include their respective approaches to popular culture, technology, and the social.[81] Regarding popular culture, the European musical avant-garde—also known as modern or new music—generally refrains from reference or even acknowledgment, whereas experimentalism at times transforms or appropriates popular material; think of Tenney's 1961 *Collage #1 ("Blue Suede")* tape composition based on Elvis Presley's 1956 hit record. Technologically, new music composers tend to privilege state-of-the-art institutions like IRCAM (although note that Cage was a composer-in-residence there in 1981), whereas experimental musicians whether by choice or by circumstance often employ DIY or low-tech approaches; think of Tudor's later electronic music.[82] Altogether exemplary of these experimental approaches to indeterminacy, popular culture, and technology is perhaps Tone's 1986 *Music for 2 CD Players*, in which the composer applies pieces of Scotch tape poked with small pinholes to the surfaces of popular and classical music recordings that he plays back on consumer audio devices.[83]

This is not to suggest that the European musical avant-garde is incapable of exhibiting postmodern features, nor is it to contend that experimental music by default eschews artistic modernism; it is, though, to recognize certain tendencies as evidence of a deeper ideological disparity. By far, the most interesting distinction Born makes between experimentalism and new music is the latter's purported lack of a "supraformalist concern with the social."[84] Rather than an interest in the kind of sociality that *exceeds the form* of music—seen, for example, in Sonami's understanding of her work as a "social commentary on technology"[85]—new music restricts its focus to nondiscursive sound. New music inherits this concept from the early nineteenth-century discourse of absolute music—which replaced the polyvalent premodern concept of music (harmony, rhythm, and language) with instrumental sound—and, as Born notes, through aesthetic modernism. Throughout the twentieth century, aesthetic modernism's paradigmatic search for the new pushes art music beyond *instrumental* sound to incorporate electronics, tape work, analog and digital synthesis, interactive components, and so on. Nevertheless, sound (understood as a nonconceptual sensory/aesthetic stratum) remains musical modernism's privileged form. Note Born's use of "supraformal*ist*," a term whose suffix implies not simply a material distinction but an ideological orientation.

This orientation does not exclude the extra-musical, but rather trivializes it. As seen in the traditions of program music, art song, and opera, musical modernism of course does not forbid extra-musical reference, language, or multimedia. Yet, as an instance of aesthetic modernism, new music's evaluative, and even ontological, criteria remain limited to the sensory and aesthetic qualities of sound supplemented by their technical-formal execution in individual musical works. Extra-artistic meaning is non-integral. Institutions like IRCAM, Born argues, reinforce this ideology through cultural policies and corresponding material practices.

Experimental music marks the possibility of a significant mutation beyond aesthetic modernism that allows it to speak to the social—and likewise, I contend, address the contemporary posthuman. Unlike Cage, other experimental composers such as Frederic Rzewski, Wolff, and Cardew (have) embraced overt political expression. Born, like others during the debates around postmodernism in the 1990s, identifies these and other tendencies, as noted, as embodying a form of musical postmodernism. Yet unlike many music studies analyses of the time, she goes a step further to contextualize experimentalism as a form of *artistic* postmodernism. She notes, for example, the important "two-way influence" between experimental music and postwar art movements, while, in addition to musicology and anthropology, she grounds her analysis with relevant background in art theory and art history.[86] Also around this time, as critics increasingly challenged the political and theoretical merits of postmodernism, many modern art institutions began to rebrand themselves as contemporary.[87] With this, "contemporary art" came to refer to what had been understood as *postformalist art*: art that takes its formal constitution *as* art as a problem while privileging social process and the generation of extra-artistic meaning. Although music and music studies have not, broadly speaking, settled on a concept of music after postmodernism that parallels contemporary art's postformalist (or postconceptual) condition, we can nonetheless sketch the contours of one here.[88] *Postformalist music* will define music that is formally reflexive—it challenges the formal boundaries of music—while producing discursive meaning that exceeds those boundaries to impinge on social life, institutions, and any number of nonmusical fields. As formally reflexive, postformalist music is not only capable of producing extra-musical meaning—it is also involved in ongoing boundary negotiations between itself and the other arts.

As such, artistic interdisciplinarity is integral to postformalist experimental music. Several of the composers and artists examined in this book move between contemporary art and art music institutions, and overall they use a variety of media: performance, texts, scores, images, objects, instruments,

clothing, costume, video, installation, movement, interactivity, and sound. Such a list should warrant an explanation, since this book is a study of music. Historically, though, music has included a variety of non-sonic media; think of opera. Chapter 2 considers Z's watershed experimental opera, *Voci* (2003), which layers live and recorded voice with video, digital audio, movement, and gesture. Broadly, music is distinct from sound, yet modernism equates them; recall Edgard Varèse's notion of music as "organized sound."[89] As a departure from aesthetic modernism, however, postformalist experimental music opens the possibility of approaches that operate, at an extreme, even beyond the auditory (which ultimately distinguishes it from sound art).[90] What makes postformalist experimental music music, then, is not sound, strictly speaking, but rather its reflexive artistic use of or reference to musical materials—by which I mean, loosely, the cultural and technological "stuff" of musical reproduction: instruments, scores, concerts, records, musical automata, etcetera (this ultimately distinguishes it from nonmusical multimedia). Consider, for instance, George Brecht's *Piano Piece No. 1* (1962), which consists of an "event score" that simply reads, "a vase of flowers on(to) a piano." Rather than calling for sounds, Brecht draws attention to the architectural dimensions of an arrangement that playfully transforms a musical instrument into furniture (as the title's "piece" also slips in meaning from "musical work" to "furnishing"). Nonetheless, the piano—like the score—figures as a kind of musical material; sound is not required, at this extreme, to create a situation in which music operates meaningfully, or even to constitute a musical work. But is Brecht's event score an instruction or an observation? Or is it a text? Does the piece require an actual piano or merely the thought of one? To this end, Julia Robinson understands Brecht's event scores as important precursors to the conceptual art of the late 1960s.[91] Cage's *4′33″*, according to Kotz, served a similar function.[92]

Although Cage did not ultimately pursue postformalist concerns for the social, he was nevertheless pivotal to interdisciplinary exchanges between experimental music and postwar art. His notion of experimentalism as observation leads, for him, to a kind of medial and perceptual opening. In his 1955 "Experimental Music" article, Cage contrasts serialism as a "thing upon the boundaries, structure, and expression of which attention is focused" with the "observation and audition of many things at once, including those that are environmental."[93] If Cage's experiment disavows the notion of a single point of attention—exemplified by the twelve-tone row and its transformations—then not only any sonic attribute but, potentially, any sensory aspect of a musical event can invite focus. During a performance of *4′33″*, in this sense, one's attention may drift from the hum of the air conditioner to its appearance to

the flow of air passing over one's skin. One becomes, in Cage's terms, a perceptual "tourist."[94] Of course, Cage never abandoned sound, and even *4'33"* can be argued to foreground the aural if only through its absence. Yet this kind of decentering of sound and, by extension, of medium was influential for postwar art. This was especially the case for Fluxus, the transnational neo-avant-garde movement that included Brecht, Paik, and Tone along with Yoko Ono, Dick Higgins, Ben Patterson, Alison Knowles, Shiomi Chieko, and George Maciunas. While moving freely between mediums and materials, Fluxus has used event scores, like Brecht's *Piano Piece No. 1*, to stage collective encounters between art and life. Along with conceptual art, Fluxus participated in contemporary art's broader shift away from the centrality of medium and toward transdisciplinarity as a prevailing methodology.[95] Emblematic of this shift was Higgins's notion of "intermedia," which signified the porous borders between postwar art, experimental music, and a variety of non-artistic fields.[96]

It is through such an interdisciplinary postformalist approach to experimental music that, I contend, experimentalism is capable of producing and speaking to the contemporary posthuman. Such artwork challenges music's various formal and artistic boundaries, while it uses indeterminacy and cybernetics—along with an expanded palette of musical and nonmusical materials—to create extra-artistic meaning that implicates the shifting borders between the pre-/nonhuman, human, and posthuman. In this sense, Lucier's music not only uses an intricate biofeedback system of EEG electrodes and amplifiers to create unpredictable percussion textures, but also speaks to cognitive labor and the crisis of the posthuman brain. Pamela Z not only combines digital audio, video, and movement in her posthuman opera, but also challenges the racializing and gendered logic of the humanism on which the posthuman is built. Sonami's Lady's Glove not only applies wearable electronics and gestural performance to issues of social reproduction and care labor but also reflects on what I describe as the posthuman hand. The composers, artists, and musicians examined in this book not only use music technology in ways that range from state-of-the-art to DIY; they also thematize the human–technology relationship that has been integral to studies of posthumanism. Not only do they use cybernetics; their work is *about* cybernetics and its decentering effects on the human. Moreover, they respond to the legacy of humanism's human and its fractured simultaneity with the techno-scientific, biological, medical, economic, artistic, and musical networks that together compose the contemporary posthuman.

Experimenting the Human analyzes these experimental music practices alongside theories of posthumanism and related cultural and artistic objects.

Note that this study is partial; it is not intended as a survey of music and cybernetics or a history of music technology. Rather, I consider experimental music that addresses the contemporary posthuman, a criterion that has pragmatically guided my selection of case studies. This has resulted in a focus on American artists supported at least in part by art music institutions, although consideration could just as well be extended to other regions and even beyond art music. At the same time, this selection speaks, to some degree, to the transnational character of postwar experimental music networks, as three of the six case study artists are or were émigrés (Sonami, Tone, and Paik), and all (have) sustained extensive international careers. While I consider these artists' respective uses of technology, animals have been another major subject of posthumanism.[97] In this book, animality appears in Z's use of birdsong and in Sonami's collaborative musical text setting of the architectural historian Sigfried Giedion's *Mechanization Takes Command* (1948), which includes an account of automated pig slaughtering. Like animal studies more broadly, animal musicality has garnered dedicated treatment in a number of recent edited volumes and monographs, while various composers and performers have specialized in this area.[98] This field overlaps with cybernetics and posthumanism, yet here it remains secondary to my interest in the latter's technological side. This book thus shares some theoretical territory with David Cecchetto's important *Humanesis: Sound and Technological Posthumanism* (2013), although the experimental music in this book, as noted, emphasizes sound as one medium among others.[99] Black feminist thought has significantly influenced popular music studies' treatment of posthumanism, including Justin Adams Burton's visionary *Posthuman Rap* (2017).[100] The present study shares theoretical terrain with this work as well, yet pursues a different object of study: as noted, I focus on art music rather than popular music even though both domains have to an extent challenged that distinction. There have also been notable recent studies of cybernetics and experimental music (Kahn, Hannah Higgins, You Nakai, and Jennifer Iverson stand out), which my study complements and extends through posthumanism.[101] Finally, I conceive this project as equally an intervention into music studies and a dialogue with art history—including the work of Robinson, Joseph, Kotz, Natilee Harren, and others focusing on postwar interdisciplinary movements—and contemporary art theory; it also contributes to ongoing exchanges between these fields and media theory.[102]

The following chapters consider postwar experimental music that composes and complicates the contemporary posthuman. Chapter 1 analyzes Lucier's use of neurofeedback as a response to cognitive labor and the posthuman brain. From the brain to the body, in chapter 2, Z's technologies of the

embodied voice speak to the continued racializing and gendered effects of the posthuman's ideological preconditions in liberal humanism. In chapter 3, Paik expands our encounter with the Enlightenment through *Robot K-456*'s simultaneous references to the proto-robotics of the eighteenth century and the potential uniqueness of human labor. We then lift off, in chapter 4, with Oliveros's *Echoes from the Moon* and her musical experiments with so-called Earth–Moon–Earth communication. Chapter 5 takes us from the extraplanetary to the close-at-hand as Sonami's Lady's Glove wields references to reproductive labor and the corporeal origins of digitality. Chapter 6 examines the concept of recursion in Tone's uses of AI and recording technology while considering the problems of newness and invention in a contemporary posthuman era. *Experimenting the Human* concludes with death and extinction. We'll follow Cage to the silent ends of the universe after listening to the life and work of the Texas-born experimentalist Jerry Hunt. First, however, let us attune to Lucier's wired brain at work.

1

The Brain at Work: Cognitive Labor, the Posthuman Brain, and Alvin Lucier's *Music for Solo Performer*

Introduction

When asked about his compositional process, John Cage often explained that he could not hear music in his head.[1] As the story goes, Cage radicalized this supposed shortcoming by using chance and indeterminacy to remove his musical tastes from the artistic process. In a seemingly converse gesture, Alvin Lucier began in 1965 to use the literal contents of his head, specifically brainwaves, to perform experimental music. Following a conversation with Cage, Lucier premiered *Music for Solo Performer*, a work in which electrodes are attached to the scalp of a musician who sits motionless as EEG signals are routed to speakers affixed to percussion instruments distributed throughout the performance space. When the musician produces alpha waves, a process referred to as a "skill" and even "work," the speakers activate the instruments, which pulsate at frequencies analogous to the performer's brainwaves.[2] This chapter interprets Lucier's composition as staging the brain at work in response to the cybernetic project of reverse engineering the brain in order to offload its labor onto machines—a project I'll refer to as the posthuman brain.[3] Yet rather than opposing this drive toward cognitive mechanization with musical expressiveness, Lucier's own use of indeterminacy disrupts a different drive by frustrating the artistic desire for creative control. Indeterminacy, I suggest, contrasts with an automaticity not inherent to technology, but rather found in the heads of its users and creators.

Music for Solo Performer can be viewed as an attempt to relocate musical performance to the site where Cage's interlocutors had expected to find his composing: the brain. In the score to *Music for Solo Performer*, Lucier asks the soloist to produce alpha waves by inducing a psychological state typically obtained by closing one's eyes and refraining from visualizing—a task the composer says requires specific training and endurance.[4] "Working long

hours alone in the Brandeis University Electronic Music Studio," Lucier recalls, "I learned to produce alpha fairly consistently," given "the right physical and psychological conditions."[5] Lucier describes his composition further as an effort to bypass the body altogether and, using only the performer's alpha waves, link the brain to musical instruments directly.[6] The composer construes his soloist, then, less as an embodied actor than as a kind of cognitive performer. Musical performance, including *Music for Solo Performer*, doubtless requires coordination between mind and body, just as even factory labor demands intellectual input. But considered alongside economic and technological changes of the era, Lucier's gesture resonates—consonantly, yet also critically—with historical shifts in the conception of labor that foreground mental over physical activity. These industrial transformations, largely associated with post-Fordism, reconceive the worker as a kind of processor of information: a brain worker.

This chapter analyzes *Music for Solo Performer* as an artistic response to cognitive labor and the posthuman brain. Lucier's composition, a work indebted to Cage's notions of indeterminacy and experimentalism, appears alongside the expansion of the military-industrial complex and the large-scale labor transformations of postwar global capitalism. When read as staging the performer's brain at work, Lucier's project reflects post-Fordist notions of cognitive labor in which mental rather than manual work had become prioritized. Contemporary realizations of *Music for Solo Performer* often use brain–computer interfaces, tools considered integral to the development of computational neuroscience and artificial intelligence.[7] *Music for Solo Performer* was a collaboration between Lucier and Edmond M. Dewan, a physicist and associate of Norbert Wiener's who as early as 1957 had linked brainwave analysis to AI. Through my interpretation of Lucier's work, I want to speculate on the artistic and economic possibilities of neuroscience research that seeks to create AI through functional replicas of the human brain, also known as brain emulations. Inaugurating what one can call without exaggeration a "neuromusical turn" in the experimental music of the 1960s, Lucier anticipates the kinds of neuroscience research central to brain emulations and other contemporary visions of the posthuman brain.[8] I suggest, then, that indeterminacy not only appears as a formal feature of experimental music but can be imagined as a response to capitalism's apparent gravitational pull toward this project of reverse engineering the brain. By impeding the libidinal gratification of the creative process, that is, indeterminacy prototypes a disruption of our seemingly automatic responses to capitalist subjectivity. Lucier's experimental music thus speaks to the contemporary posthuman by addressing its technological and political–economic conditions of possibility.

Posthuman Political Economies—Biofeedback, Liberal Humanism, and the Posthuman Brain

In order to frame *Music for Solo Performer* as a response to cognitive labor and the posthuman brain, we must first chart its roots in biofeedback and its extension to the critique of political economy. This trajectory will, consequently, trace the production of information from the cognitive subject of liberal humanism to the discourse of cognitive labor to the crisis of the posthuman brain. *Music for Solo Performer* uses a form of feedback known as biofeedback. The performer's brainwaves affect the system's output, which in turn influences the cognitive state of the performer, thus producing a biologically based feedback loop. Broadly, feedback was responsible for the technological and economic features of post-Fordism, including large-scale machine automation.[9] Once machines could use sensors that adjust for output and autocorrect for errors in performance, the formerly indispensable role of the human could be reduced to the point of obsolescence.[10] Feedback thus imparted to machines qualities once thought of as unique to living labor, including adaptability, flexibility, and even learning.[11] Cyberneticians ultimately saw no difference between machines, organic life, and even the human brain: all could be placed within or could constitute a feedback loop. Biofeedback inserts specifically biological entities, including the human subject, into the cybernetic circuit, thereby calling into question the boundary between the human and its others.

If biofeedback thus challenges the human's boundaries, then cybernetics provokes our basic condition of autonomy. "From Norbert Wiener on," writes N. Katherine Hayles in *How We Became Posthuman*, "the flow of information through feedback loops has been associated with the deconstruction of the liberal humanist subject."[12] Like free will, autonomy is central to liberal humanism. As opposed to mechanistic determinists such as La Mettrie, liberal humanists understood the human as a site of freedom and liberty. But while biofeedback may challenge such a state—the image of Lucier strapped into his chair, in this sense, conjuring perhaps the carceral restraints of an electric chair—liberal market humanism already produces political-economic conditions that sustain yet threaten to overturn human freedom through exploitation, unemployment, and immiseration.[13] Through feedback, automation, and AI, cybernetics only amplifies this internally contradictory state of liberal humanism. Hayles periodizes cybernetics in three phases: the first, *homeostasis* (1945–1960), is based on information and feedback; the second, *reflexivity* (1960–1980), is based on autopoiesis; and the third, *virtuality* (1980–present), involves brain emulation and AI. Lucier's *Music for Solo Performer* relates directly to the first phase, while it anticipates the third through its engagements

with neuroscience. Hayles opens her study with a reference to the third phase, describing the sense of terror and amusement she experienced upon reading the MIT robotics expert Hans Moravec's 1988 prediction that it would soon be possible to "upload" human consciousness to a computer.[14]

There's no mind-uploading in Lucier, but a similar fantasy is at play in *Music for Solo Performer*'s basic premise of "offloading" cognition through biofeedback. For Hayles, the fantasy of disembodied cognition represents nothing new and in fact parallels a key feature of liberal humanism. Namely, the Cartesian subject's identification with a rational mind that *possesses* a body (rather than *being* a body) was, paradoxically, both a product of and a condition for market liberalism in the first place. Liberal political theorists from Locke to Thomas Hobbes to James Mill similarly argued that the liberal subject is effectively constructed through a kind of internal split with the body. If, according to Locke, "every man has a property in his own person," then such a cognitive subject, as suggested, can effectively lease out the body's productive capacities and conscript it into the labor relations of capitalism.[15] The Marxist political scientist C. B. Macpherson refers to this condition, which he finds at the heart of liberal humanism, as *possessive individualism*.[16] The body does not disappear but is rather desubstantiated, rendered as a kind of Cartesian prosthesis that belongs to the possessive cognitive subject of liberal humanism. Cybernetics and the posthuman brain have sought to concretize, technologically, this ideological separation of the body which both facilitates the market and produces this humanist cognitive subject. Both liberal humanism and the posthuman brain, in this sense, dematerialize the body.

We arrive, then, at a critique of political economy that turns from the body to the cognitive production of information.[17] Hayles and others have argued that the denial of bodily materiality has been key to preserving the liberal subject's supposed universality through an erasure of sexual, racial, and ethnic markers of difference.[18] This, along with the "dematerialized" character of digital media, is one sense in which Hayles argues that through the figure of the posthuman, "information lost its body."[19] Political-economic theorists would corroborate such a contention, for instance in Mirowski's claim that the "economic agent" represented by neoclassical economics is ultimately nothing more than a "processor of information."[20] Already in cybernetics, as Mirowski notes, one finds an ambition to apply the same kinds of control and communications paradigms to financial exchange, and from an early stage Wiener acknowledged such an interest.[21] As noted, Mirowski hails the anticommunist John von Neumann, coauthor with Oskar Morgenstern of *Theory of Games and Economic Behavior* (1944), as possibly the "single most important figure in the development of economics in the twentieth century."[22]

Information may have lost its body, but it requires the work of both minds and bodies for its creation and transmission. Not until 1961 would cybernetics receive what theorists cite as its first Marxist analysis in the work of Italian *operaist* (workerist) Romano Alquati. Here, as in Hayles's account, information is primary: "Information is the most important thing about labor-power: it is what the worker, by the means of constant capital, transmits to the means of production upon the basis of evaluations, measurements, elaborations in order to operate on the object of work all those modifications of its form that give it the requested use value."[23] Information thus forms both the medium of transmission and the object upon which labor works, marking a qualitative alteration in the means of production. What characterizes this shift, and necessitates the term "cognitive labor," is a change in work of a certain quality, not the fundamental (yet historically specific) status of the system in which it operates. That is, both physical and cognitive labor are subject to value generation as a function of time under capitalism. As Moishe Postone explains in his reinterpretation of Marx, *Time, Labor, and Social Domination*, "Value is a social form that expresses, and is based on, the expenditure of direct labor time."[24] Whether writing computer code or working in a steel factory, labor as a category is united by the commodification of the worker's time. Cognitive labor, in particular, is a useful analytical category for apprehending labor's shifting valences brought about through changes in industry and technology, here particularly via automation and cybernetics. It is through the advent of the latter that the worker, in Matteo Pasquinelli's analysis, is no longer a "thermodynamic animal steaming in front of a machine but is already a brain worker," hence the brain at work.[25]

Posthumanism complicates a politics of this brain at work. A critical distinction is to be made, for instance, between the posthumanist *critique* of market liberalism and its posthumanist *amplification*. Characteristic of the latter is a desire to expand the category of the human to encompass "multiple forms of life and machines."[26] If adhering to such a position, which is often reflected in popular science fiction, involves extending property rights to companion species or paying wages to chatbots, we could be in trouble. Indeed, not all posthumanists (or would-be posthumanists) begin with a radical critique of liberal democratic capitalism (at least not from the left), but a recent sampling of technoculture across the political spectrum reveals a variety of implications about AI and the posthuman brain. The right-wing Deleuzian and self-proclaimed "neoreactionary" philosopher Nick Land, for instance, claims that the one premise guiding his work for the past twenty years has been "the teleological identity of capitalism and artificial intelligence."[27] Roughly twenty years earlier, Land conjectured: "what appears to humanity

as the history of capitalism is an invasion from the future by an artificial intelligent space that must assemble itself entirely from its enemy's resources."[28] A strong claim, even from someone who thinks it's a good thing. Yet considering the billions of dollars invested annually in artificial intelligence, institutions like Oxford's Future of Humanity Institute and the Cambridge Centre for the Study of Existential Risk could be justified in corroborating warnings from popular figures such as Elon Musk and the late Stephen Hawking that developing full artificial general intelligence could be disastrous for humanity.[29] Debates have ensued about whether such human-level AI will ultimately be the result of hard-coded expert systems, artificial neural networks, or computer simulations of the brain.[30]

If the human brain labors, what about these computer emulations? Could (and should) what they do ever be understood as work? The right-leaning Moravec is not the only thinker involved in projections (and constructions) of the posthuman brain.[31] Take the libertarian economist Robin Hanson's recent prediction: "[S]ometime in roughly the next century it will be possible to scan a human brain at a fine enough spatial and chemical resolution, and to combine that scan with good enough models of how individual brain cells achieve their signal-processing functions, to create a cell-by-cell dynamically-executable model of the full brain in artificial hardware, a model whose signal input-output behavior is usefully close to that of the original brain."[32] It will be, purportedly, through such a process that we will create the first operational artificial minds, what Hanson calls brain emulations or ems. "A *good enough* em has roughly the same input-output signal behavior as the original human." Hanson, an investor in such technologies, explains: "One might talk with it, and convince it to do useful jobs."[33] Another reason Hanson gives for the looming ascendancy of brain emulation technology is the ability to cheaply copy and run any number of emulations—potentially trillions—limited only by hardware costs. This promises a virtually infinitely reproducible source of labor power ultimately irresistible for investors. Wages for ems, then, become Malthusian (which turns out to be more efficient than enslaving them), reduced to an amount just above subsistence levels (the cost to run their hardware), while (non-investor) humans ultimately die off.

Much of the work is already underway to attempt to realize comparable visions of the posthuman brain. The European Union's Blue Brain Project and the Human Brain Project, along with the American BRAIN Initiative which began under Barack Obama, collectively command billions in their efforts to map and emulate the human brain.[34] Research conducted by the Human Brain Project and the BRAIN Initiative promises important benefits to brain disorder treatments, along with a better understanding of neurological

THE BRAIN AT WORK 27

diseases and brain injury trauma. But significant work remains to achieve complete brain emulations: computers must become considerably faster, microscopy scanning techniques must improve, and functional models of the brain need to become more robust. The BRAIN Initiative and the Human Brain Project have only begun to work toward the modest goal of mapping the brains of mice and rats. Moravec's *Mind Children* have yet to even crawl.[35] Such an approach to engineering virtual life forms nevertheless represents a key goal of computational neuroscience, a relatively new field based on the intersection between cybernetics, informatics, and neuroscience. This discipline draws significantly upon the kinds of early neurofeedback used in *Music for Solo Performer* but represents neuroscience's radical shift "from a life science approach (biology and medicine) to a computer science approach in order to perpetuate a techno-rationality that concentrates on engineering [rather than] representing nature."[36] The object of computational neuroscience is, as already with neurofeedback, the posthuman brain.

The posthuman brain thus emerges as the result of a process beginning with the biofeedback loops of first-phase cybernetics—which finds artistic expression in musical works like *Music for Solo Performer*—and seems to culminate in one of various eschatological scenarios. Through his reflexive use of cybernetics and indeterminacy, Lucier's work can be seen as an incipient response to this crisis of the posthuman brain. Thinkers like Hayles have criticized the fantasy at play in both biofeedback and brain emulation, and doubtless the topic invokes myriad philosophical questions about consciousness, identity, and the self.[37] Yet contemporary technoculture suggests that runaway posthuman processes might emerge through capitalist economic interests alone, irrespective of questions of embodiment, the uniqueness of the biological human, and so on. Furthermore, Moraveckian predictions like Hanson's point to capitalism's properly speculative and "experimental" nature: capitalism simultaneously *forecasts a future*—dynamically, yet with a kind of infallible automatism—and *experiments*, relentlessly tries out programs up to and including various "sci-fi scenarios" to achieve such results.[38] This structure, I suggest, finds an unlikely correlate in experimental music: according to Cage, "It doesn't matter if it doesn't work."[39] (Only, perhaps, that it is good enough.)

Music for Solo Performer and Cognitive Labor

Those were Cage's words to Lucier on the eve of the latter's 1965 premiere of *Music for Solo Performer for Enormously Amplified Brain Waves and Percussion*.[40] As noted, the score calls for EEG electrodes to be placed on the performer's scalp which, during a performance, activate a battery of percussion

instruments arranged throughout the concert hall.[41] Lucier's work attempts to transduce the performer's alpha waves, the relatively faint pulsations of electrical activity of the brain historically associated with states of cognitive idleness, into electrical signals that an amplifier increases significantly in strength. These pulsations, as Lucier's score notes, oscillate between eight and twelve cycles per second, or Hertz, well below the range of human hearing. Yet when amplified "enormously" such vibrations readily appear as rhythms. Exploring this feature of alpha waves, Lucier's score calls for the performer's brainwaves to be routed to an array of speakers which are affixed to various percussion instruments: "large gongs, cymbals, tympani, metal ashcans, cardboard boxes, bass and snare drums (small loudspeakers face down on them)," along with switches that trigger a set of pre-arranged, sped-up brainwave recordings. When the soloist produces alpha waves, which can be achieved by closing one's eyes and refraining from visualizing, the speakers sympathetically resonate the various instruments to which they are attached at a frequency analogous to the amplified brainwaves. The soloist, now embedded in a feedback loop, is exposed to the resulting percussion sounds, which may end up halting the alpha wave production.

Music for Solo Performer is part of a broader turn to the use of EEG in postwar experimental music. As noted, Lucier was not the only composer to use neurofeedback, as he helped to inaugurate no less than a neuromusical turn beginning in the experimental music of the 1960s: Cage, James Tenney, Nam June Paik, Manford L. Eaton, David Rosenboom, and Petr Kotik had all worked with brainwaves in some capacity. Importantly, such a musical incorporation of neuroscience began in parallel with the expansion of the military-industrial complex and on the cusp of labor transformations associated with post-Fordism. As Douglas Kahn explains, "it becomes impossible to talk about American experimentalism in any comprehensive way distinct from the knowledge and technologies flowing from the militarized science of the cold war, more specifically, cybernetics."[42] Experimental music not only appropriates the rhetoric of scientific experimentation but here also reflexively incorporates the tools and methodologies of Cold War technoscience. *Music for Solo Performer* stands out and further resonates with post-Fordism in requiring a cognitive "skill" that involves "work."[43]

Beyond an analysis of "sonification," or an exploration of electromagnetic waves, I want to read Lucier's composition as an attempt to index cognitive labor through Lucier's neuromusical biofeedback network. Although the composition seems to require only a soloist sitting still for an extended duration with electrodes attached to their head, Lucier's score asks the performer to produce alpha waves by manipulating specific mental and psychological

states—a job that, as noted, demands special preparation and training. "This is a specially developed skill which the soloist learns with practice," Gordon Mumma contends, "and, no matter how experienced the soloist has become, various conditions of performance intrude upon that skill."[44] Lucier's manipulation of psychological states differs from actions that might be more readily identified with cognitive labor—performing numerical calculations, entering data, typing, or answering phones—since it requires the performer to enter a relaxed, meditative state not typically associated with work. Yet the notion of cognitive labor—as with the concept of reproductive labor we'll consider in chapter 5—expands labor's purview to include many psychological activities not typically understood, even by their own performers, as labor. Therefore, when Lucier suggests that in performances of *Music for Solo Performer* "The harder you try, the less likely you are to succeed," he seems, paradoxically, to affirm the work involved in the cultivation and execution of this novel cognitive ability.[45] Patience, as we'll see in the work's premiere, is key.

Lucier first staged *Music for Solo Performer* on May 5, 1965 at Brandeis University's Rose Art Museum. For nearly forty minutes, the composer sat virtually motionless as he periodically drifted in and out of alpha states. Following Cage's opening performance of *o'oo" (4'33" No. 2)* (1962), which consisted of performing an amplified "disciplined action" (in this case, typing out correspondence letters using an onstage typewriter), Lucier sat down as electrodes were affixed to his head. At first nothing happened. But then, as he closed his eyes and settled into place, the various percussion instruments and objects distributed around the room began to rumble. After a while, the sounds stopped, and a similar process continued throughout the performance. Overall, the event seemed to test not only Lucier's endurance but the audience's patience as well—so much so that one of his Brandeis colleagues reacted by giving another faculty member, who had been pretending to sleep, a "hotfoot": an adolescent practical joke in which one inserts a match into an adversary's shoe and lights it.[46] In order to produce alpha waves consistently, Lucier worked to avoid such distractions while remaining unperturbed by the recurring percussion sounds. Video documentation of a performance staged roughly a decade later shows Lucier on multiple occasions raising his right arm to cover both eyes with his thumb and middle finger to induce concentration (fig. 1).[47]

Lucier renders musical performance as a cognitive activity that resembles a form of labor. While it can be argued that in Lucier's composition the "performer performs by not performing," in such a view performance figures as a primarily bodily process.[48] *Music for Solo Performer*, seemingly in response to theories that mark capitalism's shift to cognitive labor, displaces the site

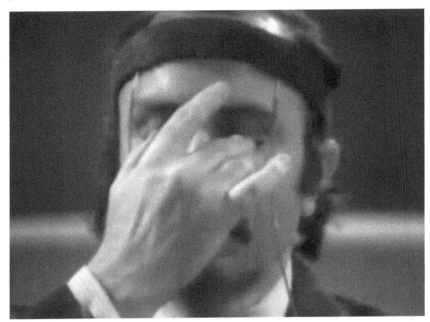

FIGURE 1. Alvin Lucier performing *Music for Solo Performer* (1965). Still from Robert Ashley's video *Music with Roots in the Aether* (1976).

of artistic labor from the body more generally to the brain in particular. As though realizing the fantasy of a technological interface between mind and music, according to Lucier, his composition attempts to link "the brain to the instruments, bypassing the body entirely."[49] Lucier went further, as noted in this book's introduction, in his 1966 "dream" to link the brain of the performer with audience members in order to exchange thoughts and aural sensations directly[50]—a proposal that anticipates the more recent ambitions of Neuralink and others to achieve direct, brain-to-brain communication. Such processes may involve intersubjective as well as subjective consequences. Regarding the latter, Lucier's soloist becomes perhaps what Fernando Vidal has critically identified as the "cerebral subject" of neuroscience, the realization of an equality between the modern "self" and the brain—designated by the phrase "You are your brain"—that began in the mid-twentieth century and strengthened with the introduction of fMRI scanning in the 1990s.[51]

Cognitive labor discourse was, to be sure, still in its infancy when Lucier premiered *Music for Solo Performer* in 1965. The conceptual groundwork for cognitive labor can be traced to the Italian Marxist feminist movement of the late 1970s and 1980s, which developed the related concepts of reproductive,

immaterial, and affective labor, especially in the work of Leopoldina Fortunati and Silvia Federici, to which we'll return in chapter 5. Similar engagements have arisen from those associated with the Italian autonomia movement (Antonio Negri, Mario Tronti, Paolo Virno, Maurizio Lazzarato, and Christian Marazzi); more recently, this discourse has expanded into digital labor studies and analyses of what Jodi Dean has called "communicative capital."[52] As early as 1961, Alquati published his unique study of the Italian Olivetti factory, which Pasquinelli considers both the first Marxist study of cybernetics and a founding inquiry into the notion of cognitive labor. In this paradigm, Alquati argues, "Productive labor is defined by the quality of information elaborated and transmitted by the worker."[53] As such, these theories of cognitive labor mark capitalism's shift from the energy-producing body to the information-producing brain. According to Pasquinelli, "At the beginning of the industrial age, capitalism was exploiting human bodies for their mechanical energy, but soon it became clear that the most important value was coming from the series of creative acts, measurements, and decisions that workers constantly have to make."[54] Along these lines, the soloist in *Music for Solo Performer*, when restricted to the task of producing alpha waves, is *not* being asked to make these kinds of creative decisions. The focus is rather on achieving and manipulating specific mental or psychological states.

But here it is important to consider the formal differences, especially as they relate to musical divisions of labor, between Lucier's indeterminate score and the hyper-specificity associated with post-serialist musical modernism. "The score specifies a task to be accomplished, not a composer's idea of a fixed object," Lucier explains.[55] Typical of Lucier's compositions of this period, the composer leaves a variety of musical parameters open to the creative discretion of the performer. This includes, as we've seen, the number and types of percussion instruments. The score also invites the soloist "to activate radios, television sets, lights, alarms, and other audio-visual devices," and suggests that the performer "experiment with electrodes on other parts of the head" in order to pick up alternate frequencies that may produce stereo effects. Finally, Lucier's score allows the performance to be of any duration. Such a delegation of the "creative acts, measurements, and decisions" to the performer/worker (as with other experimental music scores of this era) accords with the post-Fordist *redefinition of the worker*, which required workers to be more than "obedient hands" and to participate actively in production.[56]

Lucier discusses labor, often in seemingly anthropomorphic terms, in connection with *Music for Solo Performer*. The composer explains, "Most of the time my sounds do some kind of work."[57] At times Lucier seems to acknowledge less the artist's labor than the equipment involved, relegating the

human component to the work's technological processes. Referring to the ways the speakers physically activate the percussion instruments, Lucier suggests, "The speaker is a performer. . . . It's doing something. It's doing work."[58] Recall, though, the cybernetic tendency in the context of biofeedback to flatten operative distinctions between humans and machines. Lucier's comment suggests, in this sense, that the speaker becomes a kind of prosthesis, rendering the soloist a kind of musical cyborg.[59] Such a conception of musical labor, moreover, appears in line with the cybernetic transformations of post-Fordism: "The first step was redefining the worker as part of a feedback loop," Nick Dyer-Witheford contends, "a sensor component in a goal-oriented process which was adjusted until the biological and machine components of the total system were in balance. The machine is not over and against the worker—because the worker is part of the machine."[60] Lucier's soloist similarly appears to be subjected to this machinic structure of cognitive capitalism.

Relatedly, *Music for Solo Performer* contributes to discussions of the movement from industrial to cognitive labor that occurred alongside art's concomitant shift toward conceptual and "dematerialized" practices.[61] *Music for Solo Performer* marks a similar movement from the sensorial and aesthetic to the cognitive and conceptual—domains typically seen as more relevant to contemporary art than music. Lucier's 1965 composition predates some of the foundational works of conceptual art—for instance, Sol LeWitt's 1969 *Sentences on Conceptual Art*—yet Volker Straebel and Wilm Thoben argue for a consideration of the work as a form of "conceptual music."[62] Even though they focus on technological sonification practices, Straebel and Thoben consider Lucier's work as music that exists "beyond the audible" which reveals "much more than sound"[63]—a characterization that accords with what I've discussed as an interdisciplinary postformalist approach to experimental music. Further corroborating this claim, Lucier insists that *Music for Solo Performer* "isn't a sound idea, it's a control or energy idea,"[64] a statement that resonates with first-phase cybernetics as a control paradigm. In addition to cognitive labor, Lucier exemplifies experimentalism's twined inheritance of cybernetics and indeterminacy.

Cybernetic Indeterminacy

Music for Solo Performer was Lucier's first work of experimental music and represents his foray into indeterminacy.[65] Experimentalism borrows the iterative testing and verification procedures found in both capitalism and technoscience while deracinating such procedures from their ordinarily correlated

systems of value and knowledge production. Broadly, indeterminacy departs from the prescriptive form of the musical score and can involve introducing unpredictable musical variables in composition or performance. Indeterminacy was foundational, as noted, for Cage's conception of experimentalism as a process whose results are unknown.[66] *Music for Solo Performer*, with its open-ended text score instructions, posits a musical unknown in the form of the indeterminate outcome of the composer's neurofeedback network. The results fall, in Cage's terms, outside the rubric of "success or failure"—it doesn't matter if it doesn't work.[67] Cybernetics and information theory influenced Cage's notion of indeterminacy particularly regarding the registers of predictability and unpredictability. Shannon's 1948 "A Mathematical Theory of Communication" described this relationship by interpreting the information encoded in signals that may also contain noise.[68]

Some of Cage's formative statements on indeterminacy, moreover, exhibit a desire to subvert desire itself—or, in Cage's terms, to remove the "dictates of [the] ego" from the artistic process.[69] On this account, indeterminacy contains an incipient link to the libidinal, which Lucier further attaches to labor and, by extension, to political economy. In terms of the libidinal, Cage construes indeterminacy as an attempt to undermine the goal-directed gratification associated with the creative process, and more specifically with composing music. In addition to what Katz describes as a historically specific form of queer resistance, recall that Cage turned to indeterminacy as an alternative to psychoanalysis and the ego fulfillment otherwise associated with composition.[70] In Cage's elaboration, indeterminacy figured as an artistic intervention intended to undermine artistic desire. Ultimately, I want to understand Lucier's use of indeterminacy as a subtle kind of inhibitor of the conditioned responses people have to capitalist subjectivity that are ordinarily governed by what Catherine Malabou defines as *automaticity*. Automaticity is a term Foucault borrows from psychology to describe an individual's conditioned reactions to stimuli. Malabou extends the concept in her political and philosophical critique of the posthuman brain.[71]

Music for Solo Performer straddles indeterminacy—understood as a controlled undermining of artistic control—and cybernetics' first-phase program of technoscientific control. The work is the result of a collaboration between Lucier and the physicist and brainwave researcher Edmond M. Dewan, who as noted was a close friend and colleague of Wiener's. Dewan worked for the US Air Force and was an adjunct professor at Brandeis University, where he had initially met Lucier, who taught in the music department. In the score to *Music for Solo Performer*, Lucier lists Dewan as "Technical Consultant" even though he introduced Dewan as the composer of the work following its

1965 premiere. Dewan was important enough to Lucier's development that Kahn devoted an entire chapter of his 2013 book to their relationship.[72] Complementing Dewan and Lucier, Cage and Wiener rounded out this network of relations. *Music for Solo Performer* was, according to Kahn, "a manifestation of cybernetics within music, a meeting of Wiener and Cage, one step removed."[73]

Here I want to extend Lucier's neurofeedback, especially considering this relationship with Dewan, to a discussion of the contemporary impasses of the posthuman brain. Brainwaves were central to Dewan's understanding of consciousness, and consciousness was integral to his conclusions about artificial intelligence. "Let us start by loosely defining consciousness as 'awareness,'" he proposes in a 1957 paper. "Recent investigations with the electroencephalogram [EEG] reveal interesting correlations between certain forms of electrical activity in the cerebral cortex and certain states of awareness." Neurofeedback provides a marker of such an "awareness," which in turn Dewan thinks lies at the root of consciousness. Dewan then discusses the possibility of artificial intelligence. As though presaging the transformations that would later be associated with computational neuroscience, he concludes that, "in order to decide whether or not a machine thinks, one would have to know all the physical correlates of consciousness; for only then could we know whether or not there is a structural isomorphism between the machine and that property of the brain which is associated with consciousness."[74] Once one fully knows the brain, one possesses the tools to ascertain, and even to create, its machinic equivalent.

What Should We Do with Our Brain Music?

Efforts to engineer the posthuman brain along similar lines are already underway. Malabou, upon learning of the Blue Brain Project's competitive goal of simulating the neocortical column of a rat—alongside the release of IBM's "neurosynaptic" CPU chip, which promises the equivalent of neuroplasticity in silicon—suggested revising the title of her widely influential 2008 essay, *What Should We Do with Our Brain?* as "Rat Race; or What Can We Do with Our Blue Brain?"[75] This is because neuroplasticity, which the philosopher defines as the brain's radical ability to both give and receive form, had fortified the human brain, for her, against its potential capture via machinic duplication or emulation. According to Malabou, "The 'plasticity' of the brain refers to the capacity of synapses to modify their transmission effectiveness. Synapses are not in fact frozen; to this degree, they are not mere transmitters of nerve information but, in a certain sense, they have the power to *form* or

THE BRAIN AT WORK 35

reform information."[76] If IBM's new chip could, in fact, simulate such plasticity in silicon, as the company had claimed, this capacity would challenge the conception of plasticity as a privileged feature of biological human brains.

For Malabou, plasticity creates the conditions for a genuine *historicity*—and hence, politics—of the brain. Drawing on Marx's notorious statement about history, she proclaims, "Humans make their own brain, but they do not know they are doing so."[77] This had led her to posit a "critique of neuronal ideology," which insists on plasticity against the kind of neoliberal "flexibility" that coincides with what Žižek paraphrases in his discussion of Malabou as a resonance "between cognitivism and 'postmodern' capitalism."[78] Such a formulation of "neuronal politics" further gives way to Malabou's critique of the cybernetic conception of the brain as a computation machine. In a section of *What Should We Do with Our Brain?* titled "End of the 'Machine Brain,'" she criticizes "technological metaphors" of the brain such as Henri Bergson's "central telephone exchange" and, of course, the computer brain. She argues, "Opposed to the rigidity, the fixity, the anonymity of the control center is the model of a suppleness that implies a certain margin of improvisation, of creation, of the aleatory."[79] Note Malabou's use of not only musical but specifically experimentalist metaphors.

Yet, as Hanson's Moraveckian scenario suggests, such an attempt to differentiate the biological from the machinic may simply not matter. Recently, Malabou has acknowledged a conceptual impasse preventing assertions of the biologically essential, concluding that a "strategy of opposition" has become untenable. She continues,

> Critiques of technoscience and biopower, deconstructions of sovereignty, denunciations of instrumentalization of life in particular produced by biopolitical and cybernetic modes of control lack actuality as long as they rely on the strict separation between the symbolic and the biological and think of critique as a possible outside, whatever its form, of the system. I now realize that the strategy developed in my book, *What Should We Do with Our Brain?*, was itself participating, in its own way, in this confidence in the outside. Because, again, I believed that neural plasticity, which I discovered and studied with such curiosity, such excitement—passion even—was the undeniable proof of the irreducibility of the brain to a machine and, consequently, also of intelligence to a flexible software program.[80]

Such overconfidence in an outside had inhibited Malabou from apprehending the overlapping non-identity between the human and the machinic, their mutual forms of co-constitution. The problem then becomes not one of ascertaining the uniqueness of the biological human over the machine's

supposed determinism but rather one of disrupting "conditioned responses" to capitalist subjectivity: our own automaticity. So, how can we break with the teleological identity of AI and capitalism when the latter appears simultaneously so erratic, dynamic, and, indeed, experimental? The kind of indeterminacy articulated by Cage and expanded in Lucier, I suggest, can already be seen as an artistic model for diverting capital's libidinal pull toward the posthuman—indeterminacy as an obstruction to the conditioned responses of capitalist subjectivity.

Malabou notes that Foucault had similarly asked how we might be capable of interrupting our own automaticity. She answers, in fact, with a call for an experimentalism carried out through the "neurohumanities"—a category in which we might also include neuro*music*. "The historical-critical attitude must be an experimental one," Malabou insists. "Neurohumanities should then be the site for experimental theory, opening the path for diverse thoughts and techniques of self-transformation, inventions of the transcendental, and, again, interruptions of automaticity."[81] If Cage's indeterminacy stages a potential challenge to technoscientific automaticity, then Lucier can be seen to extend this gesture through an experimental neuromusic.

A politics of the posthuman brain might take precisely the kind of speculative, experimental attitude found in Lucier's neuromusic as a point of departure. Through its use of cybernetic indeterminacy, in this regard, *Music for Solo Performer* imagines an impediment to the kinds of conditioned responses to capitalist subjectivity that may eventually give rise to contemporary posthuman scenarios of catastrophic proportions. One could, conversely, seek a more directed approach to technological crisis, attempting to calculate and anticipate such catastrophes in advance. Hanson admits that his "ems" scenario can occur only in the absence of a large-scale "global effort" of resistance.[82] As suggested in this chapter's introduction, *Music for Solo Performer* can be said to playfully invert the common trope of hearing music "in one's head"—instead, Lucier renders the contents of the brain *as* music. In the end, the rise of the posthuman brain may similarly turn out to be entirely in our heads. As David Golumbia has argued, we may simply never become capable of achieving genuinely human-level artificial intelligence through brain emulations or by any other method.[83] Nevertheless, the fervor around such fantasies remains acutely real, as the billions of dollars presently invested in AI and brain emulation make clear. It doesn't need to work in order to impact the present or indeed to shape the future.

Returning to the past—and in summation—Lucier's experimental neuromusic, exemplified in *Music for Solo Performer*, responds to the posthuman brain through its reflexive use of biofeedback and in its musical display of cog-

nitive labor. When read through the political and technological impasses of the postwar era, Lucier's indeterminacy presents an incipient challenge to cybernetic control and, by extension, to our automatic responses to capitalist subjectivity. Beyond a formal feature of experimental music, indeterminacy models an interruption of this automaticity by interfering with the libidinal gratification ordinarily associated with the creative act. This is not to argue that indeterminacy is somehow inherently anti-capitalist or even that Lucier was personally concerned with contemporary debates around AI or neuroscience. But, ultimately, what are we to make of the suggestion that Lucier's 1965 foray into indeterminacy and EEG was "doing work"?[84] Rather than writing note-to-note or through-composed percussion music, Lucier pursued something else. I think this something else says something important about its technological and political-economic circumstances. Beyond saying, indeterminacy experiments with doing. In this instance, Lucier built and challenged, he *composed*, what I'm calling the contemporary posthuman. Lucier experimented the human by staging the brain at work.

2

"How We Were Never Posthuman": Techniques of the Posthuman Body in Pamela Z's *Voci*

Introduction

Poised on stage in front of a microphone and alongside an array of technological and musical devices set up in San Francisco's black box ODC Theatre, composer and multidisciplinary performer Pamela Z premieres *Voci* (2003), an eighty-minute multimedia work the artist describes as a "polyphonic mono-opera."[1] Through a series of eighteen scenes, Z layers live vocal performance with video projections, audio samples, digital delay, and other audio effects. She manipulates the audio effects and triggers samples using the BodySynth, an electronic device that converts bodily movements into expressive musical control signals. In an eponymous section of the work, Z creates a pointillistic rhythmic texture consisting of looped vocal clicks and clacks, along with pulsating and sustained tones over which she speaks matter-of-factly: "announcer voice / anxious voice / Asian voice / authoritative voice / bashful voice / black-sounding voice." Z's encyclopedic listing continues as she outlines a variety of affective, vocational, geographical, gendered, national, and ethno-racial markers of difference ascribed to the voice.

Z's *Voci* intervenes into the relationships between voice, body, race, and gender especially as mediated through technologies that contribute to a posthuman imaginary. Already Z's use of digital delay loops recapitulates in miniature the process of capturing, storing, and replaying sound endemic to audio recording—a technology whose discourse since the phonograph has been haunted by representations of its disembodied sources as otherworldly or nonhuman ghosts. *Voci* addresses this dynamic directly. Z concretizes the concept of *acousmatics*—or a sound whose source is unknown or disembodied—in "La Voce nella Doccia," a scene in which she exits the stage to sing *bel canto* while leaving the audience with the sounds and a faint image of a shower.[2] Through the litany of vocal identities listed above, Z points to the

simultaneous disembodiment and hypercorporealization that applies especially to recordings of nonwhite subjects. As Alexander G. Weheliye argues, "Paradoxically, black voices are materially disembodied by the phonograph and other sound technologies, while black subjects are inscribed as the epitome of embodiment through a multitude of U.S. cultural discourses."[3] Such an instance of what N. Katherine Hayles has called "embodied virtuality,"[4] here ascribed to recording technology and its relationship to the Black voice, is central to Z's encounters with the contemporary posthuman.

Z uses the BodySynth as a form of cybernetic musical control. Initially conceived as a dance technology, the BodySynth is understood as an "alternate controller," a tool that allows a performer to manipulate various musical parameters in real time.[5] Construed as alternatives to electronic keyboard controllers, alternate controllers communicate using MIDI (Musical Instrument Digital Interface), a protocol standardized in 1983 for audiovisual devices and instruments. Emphasizing the dynamic regulation of musical parameters, alternate controllers inherit cybernetics' paradigm of the command and control of complex systems. Many controller interfaces use forms of biofeedback, not unlike Alvin Lucier's *Music for Solo Performer*, which were integral to first-order cybernetics. "Transform your body into a musical instrument. Become a multi-media [*sic*] controller." "Biofeedback!" offer BodySynth creators Chris van Raalte and Ed Severinghaus.[6] Such a transparent notion of control of course remains under threat from idiosyncrasies ranging from latency (unwanted lag introduced by digital signal processing) up to full technological failure (e.g., computer crashes)—or, as we've seen, from indeterminacy.[7] The BodySynth invites comparisons to systems such as Oliveros's Expanded Instrument System, which the composer created in 1965 (incidentally, the same year Lucier composed his neurofeedback music), in a similar attempt to technologically interface the body with sound production. Such systems ultimately conceive of musical control as a somatic process tethered to bodily functioning.

In addition to music technology, a number of postwar cultural, political, philosophical, and artistic sites have produced claims about the body, especially since the 1960s: civil rights, feminism, the gay and lesbian movements, HIV/AIDS; poststructuralism, antihumanism, minority discourse; and performance and body art. Posthumanism emerged, in a sense, at the height of these developments. In 1995, Jack Halberstam and Ira Livingston proposed: "The posthuman body is a technology, a screen, a projected image; it is a body under the sign of AIDS, a contaminated body, a deadly body, a techno-body; it is, as we shall see, a queer body."[8] In addition to the emergence of queer theory, which since the 1990s has pursued a conceptual framework for

such nonnormative bodies, this era also saw the creation of several academic disciplines based on the bodily senses, including visual studies, touch studies, olfactory studies, food studies, and sound studies. The turn of the millennium further witnessed the maturation of new media scholarship, which among other subjects has theorized technology's relationship to the body.[9] Meanwhile, personal computers, laptops, personal digital assistants (PDAs), cell phones, and the emergence of big tech out of the dot-com era have all contributed to miniaturization processes that intensify the convergence between bodies and technology.[10]

This chapter shifts from the brain to the body, including its virtualized extension as the voice, to analyze Z's *Voci* in light of responses to posthumanism found in Black studies. The conditional dyad that terminates "An Encyclopedia of Voices, Human and Otherwise," the title of the *New York Times* review of Z's performance of *Voci* in 2004 at The Kitchen, ostensibly refers to her work's incorporation of the voices of answering machines, bird songs, and other nonhuman sources/bodies.[11] Yet another association of the nonhuman voice concerns precisely the extended effects of those bodies expressly excluded from the dominant category of the human during its inception as the Western masculine liberal subject. Z's work has been variously considered through cyborgian, Afrofuturist, and posthumanist discourses.[12] But rather than affirm her practice as fully consonant with technological visions of the posthuman, I argue that she challenges the very liberal humanism upon which the posthuman is built. For a key tenet of liberal humanism, as Weheliye observes, was the racial and gendered apportionment of humanity into full humans, not-quite-humans, and nonhumans. We have never been completely human, he suggests, let alone posthuman.

Z uses technologies of the embodied voice to confront both the posthuman and the continued effects of its ideological preconditions in raciocolonial liberal humanism. In another *Voci* scene, "Voice Studies," Z engages the problem of "linguistic profiling" as it applies to housing discrimination, citing the work of the Stanford linguistics researcher John Baugh. Against a backdrop of percussive vocalizations, Z explains, "Studies reveal that people can often infer the race of an individual based on the sound of their voice," subsequently playing back recordings of housing applicants with vocal signifiers of racial difference.[13] The chapter then contrasts the "aural dimension of race" found in Jennifer Lynn Stoever's notion of the "sonic color line" with composer Pierre Schaeffer's attempt to separate sound from the social—as well as from bodies and identities—in his practice of acousmatic reduction.[14] With this in mind, I show how Z construes the voice as an acous(ma)tic technology of embodiment while reframing opera's humanist legacy through

Voci's polyvocal narration of the prehuman, human, and posthuman. Poly-vocality stands for Z's shifts in register, her shuttling between the vocal codes of opera, experimental music, popular music, punk rock, jingles, and the objective voice of scientific rationality.[15] Moving with and against a posthuman imaginary, Z's *Voci* ultimately attests to how we never became posthuman.

"How We Were Never Posthuman": Posthumanism and the Body

Some of the most interesting and radical challenges to posthumanism have come from Black studies and Black feminist theories of the human. Zakiyyah Iman Jackson argues, as noted, that "gestures toward the 'post' or the 'beyond' effectively ignore praxes of humanity and critiques produced by black people, particularly those praxes which are irreverent to the normative production of 'the human' or illegible from within the terms of its logic." Such gestures beyond the human, she contends, inevitably appear as attempts to move beyond race. Rather than a "post" that points to the future, Jackson advocates a refractory understanding of the human in the historically informed present through a kind of anamorphic queering of perspective that "mutates the racialized terms of Man's praxis of humanism."[16] Meanwhile, Weheliye insists that "the posthuman frequently appears as little more than the white liberal subject in techno-informational disguise," seeking instead an alternative vision of technology and the Black voice.[17] Analyzing this confluence through Black feminist theories of the human, Weheliye pursues alternatives to the human by seeking to dislodge it from "man."[18]

Whereas the previous chapter considered the critique of political economy, we turn here to a different critique of liberal humanism and, by extension, of the posthuman. There is of course some overlap. Weheliye responds to Hayles's argument in *How We Became Posthuman* and discusses its premises in C. B. Macpherson's *A Theory of Possessive Individualism*, which again locates the foundations of liberal humanism in the identification of a Cartesian subject as a mind that *possesses* a body rather than *being* a body. Through this logic we arrive at the conditions for—and, paradoxically, the results of—the legal property relations that define liberal market humanism. For Weheliye, the "man" in John Locke's statement, "every man has a property in his own person," further represents "the human as synonymous with the heteromasculine, white, propertied, and liberal subject which renders all who do not conform to these characteristics as exploitable nonhumans, literal legal no-bodies": hence liberal humanism's apportionment of humanity into full humans, not-quite-humans, and nonhumans.[19] This does not simply correlate liberal humanism with racism, nor is it to discount the work of modern

liberal antiracists or, historically, the work of antebellum abolitionist humanists such as Frederick Douglass, Henry David Thoreau, and Walt Whitman.[20] But a critical engagement with posthumanism must contend with liberal humanism's legacy in the radical oppression of those human bodies it deemed somehow less-than or not-at-all human.

It is pertinent to consider, then, Black feminist theories of the human that foreground the body. For Hortense J. Spillers, the sociopolitical order of the New World represents not only a scene of "mutilation, dismemberment, and exile," but also a "theft of the body—a willful and violent (and unimaginable from this distance) severing of the captive body from its motive will, its active desire." Even after being granted the illusion of possessing a body, the flesh continues to be oppressed through the instruments of what Spillers calls "hieroglyphics of the flesh."[21] For Sylvia Wynter, the body appears as the outcome of an interface between biology and language: the very construction of the human is at once a linguistic one—what she calls *genres of the human*: we "performatively enact ourselves as being human in the genre-specific terms of an *I* and its referent *We*"—and a result of the kind of autopoietic "languaging living system" advanced by second-order cyberneticians Humberto Maturana and Francisco Varela.[22] Standing at the nexus of social systems, the biological sciences, and the humanities, Maturana and Varela's "realization of the living," the subtitle of their 1992 *Autopoiesis and Cognition*, informs Wynter's analysis of how, in Katherine McKittrick's words, "our present analytic categories—race, class, gender, sexuality, margins and centers, insides and outsides—tell a partial story, wherein humanness continues to be understood in hierarchical terms."[23] Neither settling for an unreconstructed humanism nor advocating for its complete (uncritical) abolition due to its racio-colonial baggage, Wynter calls for its strategic reinvention through a kind of cultural-biological "feedback loop."[24]

Z similarly reimagines the human through musical biofeedback loops and technologies of the embodied voice. At the same time, her work suggests an engagement with race and gender not only in music technology but also across a broader cultural and historical field that sutures problems of the voice and embodiment onto the contemporary posthuman. Delays are feedback loops. The delay effect described earlier, a mainstay for Z since she bought an Ibanez DM1000 Digital Delay unit, works by subjecting an input signal to a recursive feedback circuit. With this technology, Z was able to, in her words, "find a new voice."[25] In *Voci*, Z uses this voice to sing and speak a kind of meta-commentary on the voice's cultural, historical, and political dimensions. Originally using hardware devices, Z later recreated these delay

effects using the interactive music programming language Max/MSP (see chapter 5). This configuration allowed her to control her delays and other parameters with physical gestures in real time using the BodySynth.[26]

Z uses the BodySynth to extend the voice musically while complicating technological notions of control. Alternate controllers such as the BodySynth have recently been considered in light of what the composer Atau Tanaka calls "embodied musical interaction": instances of human–computer interaction (HCI) that shift from concerns with performance optimization to a focus on "experience and meaning-making."[27] Considered alongside Black feminist theories of the human, Z's meaning-making reaches beyond the notion of expression found in music technology contexts and, furthermore, speaks to the legacy of liberal humanism.[28] In light of Z's 2004 sound installation for Dak'Art (the Biennale of Contemporary African Art held on Gorée Island), which consisted of cries and whispers evocative of the island's massive deportations of slaves, her use of the BodySynth may even suggest a link between cybernetic control and the radical notion of control inherent to slavery and colonialism.[29] Norbert Wiener, in fact, compares slavery to the possibility of full machine automation, which although sharing "most of [its] economic properties," avoids in his view slavery's "direct demoralizing effects of human cruelty."[30] Far from an attempt to move beyond race, Z stitches it into the very fabric of her work using technologies of the embodied voice.[31]

Rather than supplemental, the voice and its relationship to the body are central to Weheliye's critical notion of Black posthumanism, which Z, I think, productively protracts in her polyvocal performances. Whereas for Jackson the very notion of "beyond the human" invokes an explicitly white and fully colonial metaphysics, Weheliye leaves open the possibility of, and ultimately argues *for*, a Black posthumanism.[32] Such a vision, while speaking to the notion of technological control, rejects the fully disembodied virtuality at play in Hayles by arguing for the voice as a strategic technique of embodiment. At the same time, Weheliye provides an alternative to the influential work of Kodwo Eshun, who envisions an Afrofuturist–inflected Black posthumanism that, in addition to privileging Black *instrumental* music, accords with an alien otherworldliness. Instead, Weheliye's posthumanism turns on the voice and its relationship to the body via recording technology. He cites the work of Lindon Barrett, who argues in his *Blackness and Value: Seeing Double* (1999) that the Black voice has served as a unique form of value within African American culture not only as an instrument of survival but also as a mode of (extra-)discursive expression that contrasts with and subverts the white economy of literacy from which Black subjects were historically barred.

44 CHAPTER TWO

Here I want to look closer at this reference to Lindon Barrett as it allows for an important point regarding the deliberate kind of inauthenticity heard in Z's acousmatic techniques of embodiment.

Specifically, Barrett differentiates between *the signing voice* and *the singing voice*: the former represents, synecdochically, the white humanist subject through the "sleight of hand" of the Enlightenment thinkers Hobbes, Locke, and Kant wherein human subjectivity became equated with the ability to read and write, while the latter stands for an undoing of the former through the kind of "sly alterity" heard in the Black voice from spirituals to Billie Holiday.[33] Furthermore, the Black *singing voice*, according to Weheliye, suggests "a rather different access to the Enlightenment category of humanity from the *signing voice*, and in the process undermines the validity of the liberal subject as the quintessence of the human, instead providing a fully embodied version thereof." He continues, "Black subjectivity appears as the antithesis to the Enlightenment subject by virtue of not only *having* a body but by *being* a body."[34] Recording technology plays against the hyperembodiment ascribed to Blackness since Enlightenment discourse by disembodying the Black singing voice through technological virtuality. Z speaks to this dynamic with her delay loops and the acousmatic voice, but she also creates distance between the body and the voice, calling into question their uncomplicated fusion. Opposed to a transparent technological authenticity in which the recorded Black voice requisitely *belongs* to a body—and this is his critical intervention into Barrett's study—Weheliye views the tension therein as a tactic of embodiment, or a "technique of corporeality," inherent to his Black posthumanism.[35]

Z mobilizes such posthuman techniques of corporeality while revoicing tensions pertaining to the Black voice and its historical phono-linguistic-musical status. This is not to essentialize the Black voice, or to insist upon an authenticity ascribed to, for instance, the use of African American Vernacular English (or AAVE), but rather to suggest that Z reflects as an artist on the construction of these categories and listeners' attendant expectations. Along these lines, George E. Lewis cautions: "At first blush, Z's classically trained vocal identity seems to defy easy identification with the set of vocal timbres most routinely identified as 'African' or 'Afro-American,' and consequently the association here may seem indirect for listeners and critics unfamiliar with the long history of engagement of Africans on both sides of the Atlantic with pan-European vocal tropes."[36] Beyond such easily identified tropes, Z deploys a range of polyvocalities that productively interrogate such associations. For instance, in *Voci*'s "Qwerty Voice," the title of which refers to the Latin-script keyboard design used in typewriters since 1873, Z uses a form of *Sprechgesang* that gestures toward Barrett's signing/singing problematic. The scene begins

with her sitting at a desk on stage while typing on a manual typewriter. After a series of key strikes, she rolls back the platen and reads/sings from the page: "DTK! R-JVV, Wo-HAH! FV-JAAY . . . NNNGuo, Wahl ee-WE! Nng, G-k, k-k, k-k, k-K. . . ."[37] Given its staging within a multidisciplinary performing arts venue, such a scene could be contextualized in light of canonical sound poetry ranging from Filippo Tommaso Marinetti to Kurt Schwitters to Cage's *Sixty-Two Mesostics Re Merce Cunningham* (1971).[38] These artists and their works are said to emphasize the materiality of language often at the expense of its signifying properties, however latent or explicit the latter may be.

But given her interfacings with technology's cultural registers, Z's use of the typewriter here connotes on the one hand the historically gendered status of typing as an early form of "digital" labor: as Friedrich Kittler notes, by 1930 the profession was so suffused with women that the very term "typewriter" referred interchangeably to the machine and to its female operator (a cyborg assemblage if there ever was one!).[39] On the other, Z's vocalizations point to the New World reception of the Black voice as an incomprehensible "disturbance"[40]—a reception whose effects continue to be felt in the marginalization of composers and performers of color including Black women and transgender subjects in today's new and experimental music circles. Such a reading of "Qwerty Voice," moreover, emphasizes the role of language as a technology, not only in recent anthropological species-differentiating understandings of the human (discussed by thinkers ranging from Bernard Stiegler to Gary Tomlinson) but also in their precursors in Enlightenment thinkers' construction of the human as an oppressive racializing category tied to literacy. If the subaltern can speak, what are their phono-linguistic-musical conditions of possibility?

In her movement from typo-grapheme to vocal-phoneme, Z underlines the instability between the written word and its vocalization—an indeterminacy of the signifier long considered the stuff of poststructuralism—in shifting between the signing and singing voice. Here, as with the aforementioned "La Voce nella Doccia," Z employs the kind of subversive perceptual play that turns as much on what is presented as on what is not. Unable to verifiably "match" sight to sound, that is, audiences cannot read her typewritten page, just as Z is acousmatically hidden from view, and hence "disembodied," when she sings her offstage *bel canto* alongside the shower image. A similar phenomenon becomes the subject of her discussion of vocal profiling in "Voice Studies," where housing discrimination is achieved by "matching" race to voice. Altogether Z's gestures play against a sense of the strict authenticity Weheliye criticizes in Barrett's argument while resonating with the techniques of corporeality central to the former's notion of Black posthumanism.

Through such uses of the polyvocal voice, furthermore, Z interrogates the hierarchical division between "whiteness" and "Blackness" marshaled through an invisible yet vocalized echo of the *color line* said to have defined the twentieth century.

(Un)hearing the Acousmatic Color-Line

Z's techniques of vocal embodiment not only function as cultural and artistic metaphors that intervene into a history of raced and gendered hierarchies but also refer to social processes with material effects in the present. In Z's "Voice Studies" scene, she discusses the work of John Baugh, a Stanford University linguist who has devoted his career to the study of linguistic profiling following an incident in which he was discriminated against when applying for housing upon relocating to Palo Alto, California, in 1988. Tests conducted by the National Fair Housing Alliance, he notes, have routinely revealed evidence of similar forms of discrimination based on the sound of a caller's voice. Baugh points further to a paradox in which perpetrators of such profiling, when queried, claim to have no knowledge of linguistic markers of perceived racial difference, while in practice they not only claim to recognize the race of callers but also use this information to deny service to callers of color. Meanwhile, in courtrooms, layperson witnesses often claim to possess enough phonolinguistic knowledge to reliably identify the race of a speaker in the absence of visual cues.[41] How, then, are we to understand this kind of double bind in which the Black voice is simultaneously overdetermined and undervalued—especially as mediated through audio technologies? How do disparate sense modalities and their technological mediation combine to contribute to such a problem? How can they work against it?

Z's acous(ma)tic performances speak to the voice's inter- and extrasensorial dimensions—its constitution across language and the senses—while intervening into constructions of race and gender. As a way to contextualize such techniques of the embodied voice, I want to turn here to recent studies of the Black voice and its historical sites of technological mediation. The "sonic color line" is Stoever's inventive term for the "aural dimension of race," which she locates primarily but not exclusively in the voice.[42] Stoever develops the concept as an extension of W. E. B. Du Bois's 1903 color line, itself already an imbrication of optical and geometric metaphors that, taken together, describe the racializing discourse and practices of the era writ large. In his watershed autoethnography, *The Souls of Black Folk*, Du Bois prophesies that "The problem of the Twentieth Century is the problem of the color-line."[43] Du Bois supports this thesis through a variety of scopic metaphors

including blindness/sight, his theory of double-consciousness, and the veil.[44] The veil is an analog to the color line. It points to Black subjects' simultaneous invisibility and hypervisibility while providing a "second sight" capable of viewing the truths of white hegemony despite the latter's enforcement of Black self-understanding through its own normative lens. As a way of hearing Du Bois's veil, Stoever locates a range of acous(ma)tic figurations in Du Bois. In addition to the transcriptions of spirituals that Du Bois uses as epigraphs for each of *Souls'* chapters, the book includes accounts of opera, screams, wails, silences, and the noises of industry, along with the author's resolute championing of Black music. For Stoever, this makes Du Bois "the 'articulate' Pythagorean figure whose voice traverses the sonic color-line between Black and white audiences as well as aural and written epistemologies."[45]

The veil, which has remained an important figure throughout African American literature since Du Bois's *Souls*, has occupied a privileged position in theories of sound and recording technology, especially from across the Atlantic since the 1950s. The French *musique concrète* composer, radio engineer, and theorist Pierre Schaeffer invokes the Pythagorean veil in his version of acousmatics, which refers to the philosopher's practice of lecturing behind a curtain so as to prevent disciples from being distracted by his bodily gesticulations.[46] Intended to separate the causes of sounds from the sensorial effects for a listener, this practice, which Schaeffer terms *entendre* or "reduced listening," figures as a form of phenomenological reduction modeled after the philosophy of Edmund Husserl. Theorists have roundly criticized Schaeffer's thinking as promoting an essentializing form of technologically mediated listening ultimately unable to account for the social. Patrick Valiquet refers to Schaeffer's evacuation of "bodies, desires, and identities," while Brian Kane contends that Schaeffer's "ahistorical view of technology, sound, and listening" is premised on an "anti-natural" separation of the senses that "bars direct access to visible, tactile, and physically quantifiable assessments" of phenomena.[47] In this sense, Schaeffer's acousmatics not only deracinates sounds from the network of causal relations that produces them, but also restricts the polyvalent experience of music—seen especially in opera—to sound. If the sonic color line stands for the aural dimension of race, Schaeffer's acousmatics sought to exclude race as well as politics and the social from the listening experience.

Radio was central to Schaeffer's development—as it was for Du Bois and for Z—although it resulted in a markedly different attitude toward race.[48] During the early 1950s, alongside his *musique concrète* composing, Schaeffer was sent by the French government to consult for and repair the infrastructure of the Société de radiodiffusion de la France d'outre-mer (SORAFOM), a

network of radio stations connecting the French colonies in Africa. He served as the director of SORAFOM from 1956 to 1957. This endeavor was, according to Noé Cornago, the first serious effort to provide the French African colonies with the technical means to produce their own radio broadcasts, which helped set the stage for decolonization. Indicative of a sedimented Western humanism, however, Schaeffer's sincere yet "somewhat paternalistic" commitment to improve critical African infrastructure was marked by a profound ambivalence: "SORAFOM was an expression of poetic neo-colonialism," he writes, "and at the very same time a rather prosaic form of decolonization."[49] Writing of the role of the SORAFOM stations in the independence processes of the French African colonies, Schaeffer went so far as to insist, "The history of radio-diffusion and political history have been absolutely coincidental."[50] Nonetheless, following this experience, Schaeffer proffered his acousmatics theory, which tacitly separated such a political history from a listener's experience.[51]

Z's work in radio led not to a restriction to phenomenological listening but to an artistic approach that operates across the senses. Z explains that while working as a public radio programmer at Boulder, Colorado's KGNU, she led a free-form music program called "The Tuesday Afternoon Sound Alternative," which included such a variety of music that it required, as she saw it, inventive connections between selections. Her way of smoothing out the otherwise irregular shifts between Edgard Varèse, Laurie Anderson, the Residents, and the Ramones was to create short audio loops that she could mix in between tracks. When combined with other media, this segue technique would later become an important device in her compositions. "I had all of these little pieces, ideas that I had come up with," she notes. "I had to work out: how do I make that all hang together as a show? So, I did a lot with visuals, and projected images, and segues where I would make loops out of something—and that loop keeps going—and then it segues right into some other thing."[52]

Beyond purely formal devices, Z's delay loops figure in her commentary on the voice as a cultural and political object. In addition to outlining the political stakes of Baugh's linguistic profiling, Z poses the acousmatic problem of identifying a sound's source in cultural-geographical terms. In another section of *Voci*'s "Voice Studies," Z builds up a texture consisting of looped clicks and clacks as she puts on a blazer, complementing her "objective voice" with a visible sense of authority. "Linguists have observed some correlations between geographical regions," she explains. "In European languages, isolated click sounds, for example are only used as meaningful noises, such as the English 'tut tut' or 'tsk tsk' click often used to express disapproval[, w]hile

in many African languages these sounds are included in the normal system of vowels and consonants."[53] The loop, which began as a seemingly abstract texture providing cover for her wardrobe change, is recoded, ex post facto, as an illustration of the geolinguistic phenomenon she describes. As an extension of the acousmatic, here the vocal sounds' "unknown" source is not their physical site of production—we clearly saw Z make the clicks and clacks herself—but rather their cultural-geographical source of reference, which only later becomes evident through Z's discursive explanation.

Such segues between language, sound, and non-sonic media in Z's work form a kind of polyvocal circuit. The voice, even when isolated, can be understood as a technology that creates a feedback loop with the ear due to the inevitability of hearing oneself speak. As a site of vocal production and reception, the body both facilitates and constrains this feedback loop.[54] Radio and recording technologies externalize it, expanding the circuit spatially while extending it in time and inserting it into history. If Schaeffer's acousmatics suffers from an ahistorical barring of the body and social meaning, thinkers such as Du Bois, Weheliye, and Stoever suggest a historically situated and embodied listening dependent upon yet irreducible to the interconnected circuits of technology, race, and gender. Z routes these polyvocal nodes across the eighteen scenes of her posthuman opera, *Voci*.

Voci as Posthuman Opera: Re-narrating the Human

Opera has always used technology. The technologies discussed previously—radio, sound recording, costume, and even the telephone—have been integral to its development, and many have played roles in opera's constructions of race and gender. The philosopher Lydia Goehr discusses the telephone services offered between the 1880s and the 1920s in which subscribers listened to entire operas via an earpiece.[55] Stoever, Nina Sun Eidsheim, and Rosalyn Story consider white critics' often disparaging coverage of the pre-technological performances of some of the first African American women opera singers such as Elizabeth Taylor Greenfield along with the impact of recording technology, radio, and other broadcast media on the reception of performers such as Marian Anderson.[56] Technologies of the *Gesamtkunstwerk* of course have not been limited to the audible and include scenography, architecture, lighting, and makeup. The musicologist Naomi André describes being made aware of the continued use of blackface until as recently as 2012 in the Metropolitan Opera's production of Verdi's *Otello* (1877) via the Met's digital televisual *Live in HD* series.[57] Since the 1803 invention of the limelight, directors have been able to accentuate any body on stage.[58] Often highlighting

the existing marginalization and typecasting of Black opera performers, these technologies, while not universally negative in their effects, have cast the kind of penumbra that André has critically termed Black opera's "shadow culture."[59]

Prior to opera's use of digital media, its technological history extends back to the Italian Camerata's invention of the art form in the context of Florentine humanism at the turn of the seventeenth century. The Camerata, a society of Florentine musicians, poets, philosophers, and scholarly members of the nobility, sought to recreate ancient Greek drama based on the presumption that Greek drama was sung throughout.[60] This program arose from the Camerata's deployment of the humanistic principle of *imitatio* or the imitation of classical art.[61] They simply *copied* ancient Greek culture—but an inaccurate version of it. In addition to the primary borrowed musical device of singing speech, or *recitativo* or *parlar cantando*, the Camerata also relied upon the architectural technology of the Greek proscenium stage, the writing technology of musical notation already in circulation across Europe, and the libretto, which it adopted from preexisting literary and dramatic theatrical forms. The Camerata not only created opera in the technological image of a Renaissance revival of ancient music drama; they also used the new art form to promote a Florentine humanism that ultimately set the stage for the Enlightenment's own humanist vision of "man."

Considering this coterminous development of opera and humanism, *Voci*'s operatic status, rather than being incidental, provides an important frame for considering the contemporary posthuman. Throughout *Voci*, Z uses a range of opera technologies from the past, present, and future which she combines and interweaves while examining the ways they contribute to both human and posthuman imaginaries. Shifting forward and backward in imagined time, this dynamic recalls Wolfe's understanding of the posthuman which, following Lyotard's postmodernism, occurs both "before and after" the human of humanism.[62] As an alternative to the postmodern, however, the contemporary refactors this before and after into a complex, multilayered *during*. Thus when framed through the contemporary, *Voci* underscores the temporal interpenetration of humanism's human—with its exclusions of the not-quite-human and not-at-all-human—and its extended reflection in the posthuman. Z reimagines these states by re-narrating the human.

If there is a formal correspondence between *Voci* and opera's general narrative structure, then it inheres less in the succession of acts occurring over the course of its eighty minutes and more in the work's allegorical layering of the prehuman, human, and posthuman. The *New York Times* review focuses on *Voci*'s synchronic "encyclopedic" aspect, whereas the *Washington Post* concludes, to *Voci*'s supposed fault, that "there's no dramatic structure."[63]

However, I think *Voci* has more in common, formally, with operatic narrative than these characterizations let on. There are of course narratives within many of the acts themselves; for instance, in "Voices in Your Head," Z tells the story of her mother, who suffered from schizophrenia. Yet, more significantly, a narrative structure of *Voci* emerges through the imbrication of its techno-cultural pasts, presents, and futures, which Z expands and contracts through the polyvalent temporality of the contemporary posthuman. This structure parallels perhaps Clarke's notion of narrative as "the mode of deliberate allegory" that "leap[s] from one level of signification to another."[64] In this sense, Z's opera *leaps* from the level of self-contained story to an allegorical staging of the prehuman, human, and posthuman.

In *Voci*, these categories unite under the signifier of the voice. The opera begins with "The Larynx," a multimedia scene that focuses on the human voice's anatomical production. The scene starts with a series of prerecorded technical descriptions of the voice, which Z triggers and manipulates with the BodySynth and over which she intones "oo," "ah," and "oh" sounds.[65] Next, we hear "It Is the Voice," an aria that begins with "Your Voice has a pungent smell" and then attributes to the voice other synaesthetic qualities including texture, taste, color, and size. *Voci* contains eighteen of these individual scenes, as noted, each lasting between ninety seconds and ten minutes and using one of various configurations of sung and spoken voice (with delay and reverb effects), instruments and/or objects (water cooler bottle, typewriter, telephone, mobile phones), media (prerecorded and/or triggered audio, projected video, monitor panel video), lighting, costumes, and audience participation. Z uses the BodySynth to alter digital signal-processing effects, trigger various audio samples, and play an "air cello" in "Cellovoice." Other scenes focus on relationships between the singing voice and instrumental sound. In "Metal/Vox/Water," Z sings into three hanging sheets of metal with attached piezo microphones, and with a pitch-to-MIDI conversion process, she uses her voice to trigger various speech samples. "Bone Music" consists of a non-texted vocal melody sung over a subtle percussion loop created by striking an empty water cooler bottle. "Voice Lesson" collages multiple traditions of vocal pedagogy as Z responds to the recorded voices of three different teachers: bel canto opera, Balkan, and Tuvan throat singing. Finally, the work ends with the previously discussed eponymous scene "Voices." Here is a full list of scenes:

The Larynx
It Is the Voice
Voice Activated
That Tone

Bone Music
Metal/Vox/Water
La Voce nella Doccia
Voices in Your Head
Divas
Qwerty Voice
Lost Voice
Cellovoice
Voice Lesson
Birdvoice
Keitai (Cell Phone Voice)
Ebben, n'andrò lontana
Voice Studies
Voices[66]

For the remainder of this analysis, I want to focus on *Voci*'s contemporaneous stagings of the prehuman, human, and posthuman through Z's uses of communications technologies and her techniques of the embodied voice. In addition to representations of such technologies from the past, present, and future (e.g., typewriters, cell phones, and artificial intelligence), Z also refers to the voices of nonhuman animals. In "Birdvoice," Z draws attention to an imagined continuum between human, animal, and machine—a constellation already at work in Wiener's *Cybernetics; or, Control and Communication in the Animal and the Machine* and, as noted, extended in the work of Haraway, Wolfe, and others. The scene begins with Z triggering birdsong samples using the BodySynth. She then uses an onstage keyboard MIDI controller to transpose one of the birdsongs (with duration linked to pitch) several times to land roughly two octaves lower in pitch and four times the original duration. At that point she uses her voice to imitate the bird melody, as it is then within her range.[67] Numerous writers have discussed the relationship between the human and nonhuman animal at play in art music's extensive historical references to birdsong, which include imitation, transcription, and field recordings.[68] What follows, however, focuses on Z's references to communications technologies, cybernetics, and opera.

An exemplary meeting between cybernetics and opera, *Voci*'s "Ebben n'andrò lontana" channels music-technological representations of desire by juxtaposing a late nineteenth-century Italian aria with artifacts of natural language processing and computational linguistics. The scene begins with a text-to-speech voice reciting, with poor pronunciation, the Italian libretto of the first aria of Catalani's *La Wally* (1892), with each line followed by an

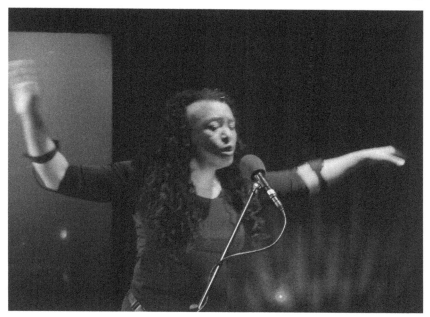

FIGURE 2. Pamela Z performing *Voci* (2003).

English translation created using the online translation tool BabelFish. The output volume of this computer-generated voice is reflected visually in a pulsating Macintosh speaker icon projected via video, over which the libretto appears when Z takes the stage and begins singing the aria. An obvious disparity inheres between the awkward rigidity of the "Victoria" Macintosh system voice and Z's languid rendering of "Ebben n'andrò lontana." At the same time, both systems—opera and computational linguistics—embody distinct shortcomings of communication and language. On the one hand, the operatic voice, with its rigorous stylization, often loses intelligibility across translations (hence Z's use of supertitles). As Mladen Dolar succinctly observes, "singing is bad communication"[69]—a characterization in tension with first-order cybernetics' control and communication program. On the other hand, as the ungainliness of the text-to-speech voice suggests, the history of computational linguistics has been riddled with failure. Golumbia argues, for instance, that the goal to show that language is computational or to produce a "'speaking computer' and/or 'universal translator'" will likely never succeed.[70] Still, each form relates to desire: the "La Wally" aria stages the tragic libidinal excesses of a peasant heroine, while the speech synthesis points to

54 CHAPTER TWO

natural language processing's origins in psychotherapy including Joseph Weizenbaum's famous 1960s ELIZA program.[71]

Z addresses these historical touchstones not only in the context of opera and experimental music but also as they relate to a posthuman imaginary. Another scene from *Voci*, which links AI to the acousmatic voice, consists of prerecorded offstage sound and a video projected as Z segues between two other sections. "Voice Activated" shows the image of a cassette tape–style answering machine—described in the libretto as possessing a "Hal [9000]-like blinking red light"—as Z's colleague, Dan, attempts to leave a message on an answering machine that appears to become increasingly self-aware:

CALLER: What? You're there! I thought I was talking to your message machine!
MACHINE: This IS the message machine.
CALLER: But you're responding to me![72]

"Voice Activated" thus re-genders (and re-races) the HAL 9000, while it domesticates the cinematic voice of space-age AI through the fantasy of an advanced AI agent, seemingly a disembodied (acousmatic) version of Z relegated to home office work. Given *Voci*'s San Francisco premiere and Z's physical proximity to Silicon Valley as a Bay Area resident, there is reason perhaps to compare such a scene to the cultural impact of big tech in recent decades. In this regard, "Voice Activated" appears somewhat prophetic in its anticipation of the proliferation of feminized virtual assistants beginning in the early twenty-teens. Apple's Siri, for instance, handles a range of office work and initially spoke only through phones.[73] Z thus uses techniques of the acousmatic voice to address the automation of historically gendered office work and its extension in contemporary fantasies of AI.

Along with AI, phones figure throughout *Voci*. In "That Tone," Z stages a duet with a physical answering machine, which she uses to sample and loop her voice. "That Tone" figures as a kind of embodied answer to the disembodied, acousmatic call placed in "Voice Activated." Both scenes use language and the voice to illuminate gendered aspects of communications technologies. Here Z envisions the family perhaps as a kind of "imagined *comm*-unity,"[74] a phrase that refers to the ways communications technologies provide it with both functional conditions and sources of interruption. The notion of "tone" in this case suggests a short circuit between music (as in vocal tone), technology (as in a "beep"), and the maternal: addressing the small answering machine device, which she cradles in one hand, Z struggles to sing a full melodic phrasing of "Don't use that tone with me." She starts with only the beginning of the phrase, uttering the single word, "Don't"—only to be repeatedly

interrupted by an impatient child–device, which indicates, following a beep, "you have no messages."[75]

The phone is premised upon notions of sender/receiver and signal/noise, key concepts in information theory.[76] In "Lost Voice," Z dials an onstage rotary phone to contact the offstage prerecorded voice of a medical doctor to whom she indicates, with a harsh vocal timbre, "I've been really resting my voice," and "I've been doing everything you said but still. . . ." As the vignette progresses, her voice deteriorates further into a series of noisy squeals and squeaks to which the doctor repeatedly responds, simply, "Mm hm. Yeah."[77] Here "signal" mirrors the healthy, able-bodied voice, while "noise" stands for its loss of fidelity, its anatomical precarity. In a moment of fiction-turned-reality, Z describes how she lost her voice on the second night of the New York premiere of *Voci* at The Kitchen. Although her voice did not fully recover in time—during the second night's performance her middle range was impaired—she visited a vocal specialist in Manhattan who prescribed steroids to treat her inflamed vocal cords.[78] Overall, the scene pairs the fleshy contingency of the human voice—and its dependence upon the body's precarious status as sick/well—with the cybernetic paradigm of signal/noise.

In "Keitai (Cell Phone Voice)," Z extends this metaphor of signal/noise by manipulating musical, social, and technological conventions. The scene uses a set of participatory mobile phone activities to playfully invert the expectation that audiences should remain seated in silence—a convention that first arose in nineteenth-century Europe, and, though widely adopted, is not universal. During Keitai's first movement, a prerecorded spoken message, which is also displayed via projected video, instructs a set of audience members to call other audience members whose phone numbers they have been given in advance. Upon receiving a call, each audience member is asked to say in their "loudest Cellphone [sic] voice": "I'm sorry I can't talk right now. I'm attending a performance!"[79] In the second movement, the audience members swap positions, and senders and receivers exchange roles. Central to Weheliye's notion of Black posthumanism, cell phone references figure prominently in Black popular music and, as an acousmatic technology of the embodied voice, the devices point for him to a "mechanized desire at the cusp of the human and posthuman."[80] Z was inspired by the ubiquity of cell phones in 1999 during an art residency in Tokyo. There she had decided to rework Western music's proscenium structure in favor of a diffuse ensemble of mobile phones composed for her own "listening pleasure"—all while she remained acousmatically hidden from the audience's view.[81]

"Divas" returns to Z's meditation on technologically mediated operatic desire. The scene consists of the simultaneous presentation of three different

arias—"Per pieta" from Mozart's *Così fan tutte*, "Quando m'en vo'" from Puccini's *La bohème*, and "Vissi d'arte" from Puccini's *Tosca*—sung, respectively, by three performers: Julie Queen, Amy X Neuburg, and Z. Two of these arias ("Per pieta" and "Quando m'en vo'") are prerecorded, and the performers (Queen and Neuburg) are shown as life-size video projections, each framed from head to foot, which taken together bookend the stage. Meanwhile, Z sings her aria, "Vissi d'arte," live on stage. Although spatially separated and differentiated in terms of live and prerecorded statuses, the characters portrayed in all three arias are the objects of male desire—a status heightened by Z's reference to the diva, which since the 1820s has invoked the otherworldly power implied in its earliest meaning as "goddess."[82] Focusing on the commonalities between the three singing parts, Lewis contends that in "Divas" Z stages a set of "sonic multiplicities," suggesting that one of the two accompanying videos figures as Z's "Doppelgänger."[83] Rather than focusing on similarities between the performances, however, I want to suggest that Z uses disparities between her performance and the performances of her video counterparts in order to reflect on technologies of the embodied voice. Distinct from her digital counterparts, Z sings center stage, a significant arrangement in light of a history of the peripheralization of Black voices in opera. Z is the only performer among the three who is given physical embodiment, and it is this very lack of technological mediation that figures here as an exemplary technique of corporeality.[84] Along with an expression of the power of the feminine voice, "Divas" enacts a form of what André refers to as "downstaging," which "brings black perspectives and experiences downstage in our narrative of how the story is told and who is telling and interpreting the story."[85] In "Divas"—and indeed throughout *Voci*—Z reclaims the centrality of this story by *re*-narrating the human.[86]

Overall, Z uses technologies from the past, present, and future to mark the multilayered time of the contemporary posthuman. In the process, she underscores this condition as the temporal interpenetration of the posthuman and its ideological predecessors in the human and prehuman. From gendered office work to social reproduction and maternal labor, that is, Z illustrates how liberal humanism's core racializing and gendered functions extend through technoculture from cybernetics to big tech. At the same time, *Voci* reframes opera's inheritances from Florentine humanism through natural language processing and AI along with audio recording, telephony, and other technologies based on disembodied sound. Rather than tools for pure abstraction, Z uses these acousmatic devices equally for musical expression and as vehicles for meaning-making. Z construes acousmatics, in this way, as a technique of embodiment that contrasts with Schaeffer's phenomenological reduction and its evacuation of bodies, desires, and extra-musical meaning.

Through her use of the BodySynth and these technologies of the embodied voice, ultimately, Z gestures toward alternatives to humanism's human and its technological imbrication in the posthuman. Pointing further to the complex registers across which gender and race are constructed, she suggests that although we've never been completely human or posthuman, we may nevertheless narrate new versions of each.

3

"The Catastrophe of Technology": Posthuman Automata and Nam June Paik's *Robot K-456*

Introduction

Robots are at once emblems of the posthuman and often designated as technological replacements for an activity—labor—that is said to mark humans as unique. In this chapter, I argue that, rather than any positive distinguishing feature, the difference between human labor and its robotic simulation lies in the human capacity to refuse it. To make this argument, I examine Korean American artist and composer Nam June Paik's *Robot K-456* (1964), an anthropomorphic robot sculpture he used to perform—and refuse to perform—experimental music, in light of cybernetic robots since the second world war. In addition to these robots, Paik's work relates to their precedents in eighteenth-century musical automata, which, as incipient posthumans, had already challenged boundaries between humans and machines. Ultimately, the chapter contends that Paik's robot affirms a capacity for self-negation as uniquely human by failing at radical refusal—by failing at its own self-destruction during a fateful event Paik staged in 1982. Before analyzing *K-456*'s final public appearance, however, let us begin with its first.

K-456 first appeared before an audience at the Second Annual New York Avant Garde Festival at Judson Hall on August 30, 1964. Before he arrived in New York earlier that year, Paik had assembled the life-size robot with one of his brothers, along with the help of the Japanese electrical engineer Shuya Abe, while in Tokyo. In transit and in transition, *K-456* had both foam breasts that could rotate and a penis made of sandpaper and flint, which Paik had removed before the two traveled to New York. The robot's exposed "skeleton" stands at about six feet and consists of aluminum-frame profiles of various lengths that are bolted together and, in the case of the arms, head, and torso, attached to servo motors that allow for a limited range of motion when engaged via Paik's twenty-channel radio controller (fig. 3). During the robot's various public

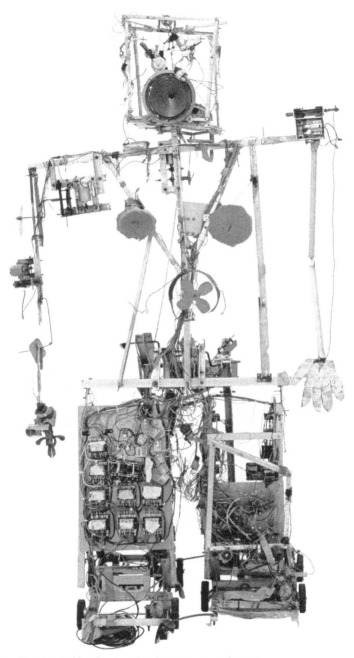

FIGURE 3. Nam June Paik's *Robot K-456* (1964). © Nam June Paik Estate.

60 CHAPTER THREE

appearances, which continued, intermittently, for almost twenty years, Paik used between one and four small control boxes adapted from model airplane remotes. Each control box has an antenna and several individual knobs and switches for executing a variety of actions from a distance, including a slow, walking motion using a set of four wheels attached to the bottom of each of its legs. Footage of Paik in Berlin in 1965 shows him crouched on the street carefully alternating between two of the remotes to produce the robot's measured stride—robots appear to replace some forms of labor and generate others.[1]

Nevertheless, it was with this shambling pace that *Robot K-456* first greeted its audience at Judson Hall for the premiere of Paik's *Robot Opera* (1964), a title used to refer to the robot's solo act as well as a number of subsequent collaborative performances with the cellist and performance artist Charlotte Moorman. Moorman, who had organized the festival, invited Paik to participate after learning that he was integral to Karlheinz Stockhausen's *Originale* (1964), which they, along with several other artists and musicians, performed on the latter five of the festival's ten days. *Robot Opera* was programmed on the first five days, starting off each concert after James Tenney's magnetic tape realization of the initial half of George Brecht's *Entrance Music/Exit Music* (1964), which consisted of a three-minute crossfade between white noise and a pure sine tone. The lights gradually dimmed as *K-456*, controlled by Paik in the wings, took the stage.[2] It walked around, moved its limbs, bowed, and twirled its breasts.[3] It also played John F. Kennedy's inaugural "ask not" speech using a small tape recorder held in the robot's left foot wired to a four-inch speaker in its head.[4] Afterward, *K-456* greeted visitors and passersby in front of Judson Hall; it then took to the streets and squares of New York (57th Street, Park Avenue, Washington Square), where, in an homage to the French inventor Jacques de Vaucanson's digesting duck automaton of 1739, it left trails of defecation in the form of dried beans.

An artistic commentary conceived during the Cold War cybernetic era, *K-456* also refers to musical, cultural, and technological developments dating back to the eighteenth century which played a significant role in humanism's construction of the human. In addition to Vaucanson's defecating duck automaton, Paik's title, *Robot K-456*, is a play on the *Köchelverzeichnis*, or "K-system" of naming used to catalog the works of Mozart; in this case "K. 456" refers to Mozart's Piano Concerto No. 18 in B-flat major of 1784. Such music, and its technological mediation in the form of self-playing musical automata, was integral to the early modern negotiation of the boundary between humans and machines. Just as materialist philosophers began to conceive of humans and animals in mechanical terms—and hence to imagine their ability to be simulated in automata—musical pedagogy insisted that performers,

"THE CATASTROPHE OF TECHNOLOGY" 61

through the use of expressivity in realizing works like Mozart's *Piano Concerto*, avoid appearing too rigid or machine-like. Despite being remembered mostly for his video work, Paik's formal music training (he wrote a thesis on Arnold Schoenberg at the University of Tokyo and studied music history at the University of Munich) suggests that his use of such references was self-conscious. Along similar lines, *Robot Opera*'s deflationary humor resonates with experimental music practices of the 1960s, especially those emerging from or influenced by Fluxus (which Paik joined at the invitation of George Maciunas in 1960), but it also derives from *opera buffa*, the eighteenth-century genre that made use of comedy and gag.[5]

Such references that simultaneously straddle eighteenth- and twentieth-century musical, cultural, and technological discourses are as important to an analysis of *K-456*, I think, as are the specifics of its performances. Although its use of recorded speech draws on a technology in existence since the nineteenth century, the issuers of those speeches, including the (at that time) recently assassinated JFK and then-mayor elect of New York John Lindsay, were of contemporary relevance. And while *Robot Opera* made reference to the prominence (and duration) of high nineteenth-century opera—"Wagner is too long. Money is too short," read a flyer for the work—it also compared *opera buffa* to contemporary soap opera, a genre Paik refers to as "cheap."[6] Concerning its physical construction, *K-456* was not cheap, but it wasn't exactly state-of-the-art either.[7] Paik didn't, for instance, provide his robot with the kind of photoelectric sensors that would allow it to roam semi-autonomously, like those included in the British cybernetician W. Grey Walter's famous tortoises of the 1940s.[8] In this sense, despite Paik's references to contemporary cybernetics, his robot resembles more the automata of the late eighteenth century, which did *not* simulate sensory processes, than those of the twentieth.[9] What to make of *K-456*'s spinning breasts, then, a feature of *Robot Opera* that invites comparisons perhaps as much to the history of Pygmalionism as to more recent discussions of sex robots? The gesture was conspicuous enough to appear in virtually all of the festival reviews at the time. Crossing Fluxus and experimentalism with the genre of burlesque, the *New York Times* compared *K-456*'s display to the striptease performer Carrie Finnell, whose act had also featured breast spinning.[10]

If sex work seems like an unlikely context for analyzing *Robot Opera*, then perhaps that is due to the contradictory view of robots as both embodiments of and ostensible replacements for labor more broadly. Paik's work from the 1960s exhibits a sustained interest in erotics and sexuality, including for instance his musical striptease *Sonata for Adults Only* (1965). That work consists of a marked-up copy of the prelude to Bach's third cello suite in

C Major that asks the musician to pause every three measures and remove an article of clothing; Paik proposed the performance to Moorman during their first meeting in New York as part of what would become an ongoing artistic partnership, and they toured with it together in 1965.[11] A consideration of these performances as forms of sexualized labor is complicated, not only by the multiple, and at times ambiguous, musical/artistic roles Paik and Moorman inhabited (performer, composer, collaborator, concert organizer), but also by the questionable and at times sexist attitude Paik expressed toward Moorman and toward women in general (alongside Moorman's reciprocal racialization and objectification of Paik as an Asian diasporic subject).[12] In an undated letter to Gordon Mumma (likely written around 1966), for instance, Paik attempts to describe Moorman's uniqueness: "Pretty girl, who is ready to strip, cannot play cello. [A]nd young and pretty cellist will never strip."[13] *Robot Opera* nevertheless transposes these performances' sexualized spectacle into robotics. The systems art theorist Jack Burnham compares Paik's robot to Marcel Duchamp's *The Bride Stripped Bare by Her Bachelors, Even (The Large Glass)* (1915–1923), writing that the robot is "'stripped bare' of everything but her skeletal and aluminum components."[14] Whether in the context of collaborating with humans or with machines, a question of agency appears: who (or what) is being exploited (or exposed), and who/what is doing the exploiting?[15]

In this sense, robotics discourse complicates the thing/human distinction, which *K-456* extends to the figure of the artist. As Paik would have it, the robot's bean defecation action represented the technological recuperation of his own artistic labor. His 1962 work *Simple* also called for excreting beans, for instance, by throwing them into an audience.[16] Through a different conflation between human and mechanical subjects, Paik's *K-456* may have also been playing off of existing racial stereotypes, especially in the West, of Asians as "robotic," or akin to a thing. Moorman recalls her response in conversation with Stockhausen to his insisting that Paik was central to a performance of *Originale*: "You have to have Paik," pleaded Stockhausen. To which Moorman responded, "What's a paik? . . . [I]t turns out it's a human being. Nam June Paik." Reflecting further on their first conversation, Moorman refers to Paik as an "Oriental man," a phrase that similarly conflates thing and human.[17] Paik apparently saw robots as a technological extension of slavery's original conflation of thing and human, an idea already imbricated in the etymological origins of "robot" as the Czech *rabota*, or forced labor, found as early as Karel Čapek's 1920 play *Rossum's Universal Robots (R.U.R.)*.[18] In Paik's utopian vision, the robotic overtaking of human labor would lead to lives of pure leisure.[19] Short of such a fantasy, though, robotics often heralds a *dys*topian

counterpart, seen in Čapek's fictional imaginary but also in real economic inequality and unemployment. Robotics discourse is posthuman, then, in its technological marginalization of the human but also through its continuation of the machine–human boundary refiguring that emerged as early as the musical and nonmusical automata of the eighteenth century.

This chapter analyzes Paik's *Robot K-456* in the context of postwar cybernetics, while it grounds Paik's robotics work in a longer history of musical automata, or the kinds of self-playing musical robots that emerged in the late eighteenth century. These "Enlightenment androids" established a link between music, machines, and humanism's original construction of the human. Paik's *K-456* points to these eighteenth-century automata, and related musical artifacts, through specific signifiers as well as through the robot's construction: Paik's reluctance to model sensory organs, *K-456*'s lack of sensors or feedback mechanisms, and its consequent reliance on human assistance make the robot, functionally speaking, closer to its Enlightenment-era ancestors than to its cybernetic contemporaries. What *K-456* shares with cybernetic robotics is an interest in *simulating* the human, loosely in terms of its skeletal anatomy or its ability to "speak" certain phrases but more importantly in its capacity to perform and, apparently, to resist performance. Simulation, in N. Katherine Hayles's periodization, belongs to the final phase of cybernetics, "virtuality."[20] In the historian Jessica Riskin's analysis, simulation refers to an experimental process set in motion in order to discover the properties of a natural subject. Such simulation appears as early as Vaucanson's eighteenth-century musical automata, which played a significant role in negotiating the boundaries between humans, animals, and machines.[21] The Enlightenment had given birth to the human alongside its posthuman twin: the musical automaton.

As much as historical musical automata are central to *K-456* and its meanings, Paik used his robot to engage with cultural and technological themes of his day including cybernetics. Paik conceived of cybernetics, in his reading of Norbert Wiener, as a kind of "inter-science" comparable to Dick Higgins's intermedia and the boundary crossings of the postwar arts, of which *K-456* was exemplary.[22] Paik links Wiener's cybernetics, which itself challenged human, animal, and machine boundaries, to McLuhan's understanding of media and machines as human "extensions."[23] Paik's robot also extended the artist's own cultural and technological speculations: in addition to his vision of a fully automated robot economy, Paik considered "cybernated art" as a kind of homeopathic treatment for "cybernated life," a state that reciprocally called for moments of shock and catharsis.[24] Paik's robotics work therefore thematizes not only the posthuman birth of the human but also its technological crisis, even its imminent death. Following an exhibition of *K-456* in 1982 at

the Whitney Museum in New York, and Paik's staged collision between the robot and a car on Madison Avenue, the artist prophesied that *K-456* represented the "catastrophe of technology in the twenty-first century."[25] Challenging the modernist investment in technological mastery—in addition to "human[izing] technology," Paik also sought to make it "ridiculous"[26]—his eschatological vision turns on the figures of disaster and failure. *K-456*'s ultimate failure to self-destruct then serves in this chapter as an affirmation of the uniquely human capacity to refuse labor.

In addition to an analysis of *K-456*, this chapter considers Paik's project in light of a contemporary posthuman era of global economic crisis catalyzed by automation and robotics. How are we to understand robots in cultural and economic terms? In order to analyze Paik's *K-456* and its simultaneous resonances with cybernetics and historical musical automata, we must first articulate the contemporary figure of the robot, particularly as it relates to political economy and labor.

What Is a Robot? Toward a Robot Labor Theory of Value

Paik suggests that *K-456* speaks to the common understanding of robots as technological replacements for human labor. "[G]enerally people say that robots are created to decrease people's work," he explains, "but my robot is there to increase the work for people because we need five people to make it move for ten minutes."[27] Strictly speaking, robots do not actually labor, nor do they produce value. Yet one way to understand them is through the observation that they simulate labor processes, which they appear to replace and to embody. Such an apparent replacement of labor does not necessarily produce gains for the human worker, but rather results under capitalism in the generation of surplus-value.[28] Like any other kind of machine, robots rearrange the labor time of an already stratified population of human workers, whose labor, once relieved from roboticized tasks, is assigned—in typically unequal distributions of race, ethnicity, gender, sexuality, ability, and class—to other, yet-to-be-automated processes. How, then, do robots embody labor?

First, the robot literally takes the form of a biomorphic body, as in its resemblance to an animal or, in specifically anthropomorphic variants, a human. For many critics of political economy, Karl Marx included, animals are excluded from the category of value-producing labor, since virtually all productive uses of animals, not unlike machines, require some form of human input or control. In resembling nonhuman animals, such devices might be described then as "biomorphically regressive"—think of how the popular domestic cleaning robot Roomba resembles, not unlike one of Walter's tortoises,

a shell-covered reptile.[29] Nevertheless, an understanding of such machines as robots captures their value as the transformation of labor (the work it takes to design, execute, and manufacture the device) into labor-saving machinery: domestic cleaning robots apparently require less work than vacuuming. In this second sense, the robot also embodies labor in that it *stores* it as the objectified or "dead" labor that went into their production in the first place— whether that consists of research, development, manufacturing, or the programming of other robots. We can understand robots, then, as *biomorphic simulation as objectified labor in the form of machinery*.[30] Since we understand labor as social, in that it requires and creates human relations, we can add, following Matteo Pasquinelli, that roboticization is *sociomorphic*.[31]

Robots thus simulate the *form* of labor while they remain, as non-laboring machinery, strictly external to it. Robots often execute work-like tasks that might otherwise be assigned to or taken up by humans, including historically non-waged forms—such as the housework or reproductive labor we'll consider in chapter 5. Paik's *Family of Robot* series, which consists of TV and radio sets arranged to resemble members of an extended family, alludes, for instance, to the way telecommunications devices are sometimes used to supplement or even replace care labor.[32] The contention that robots do not labor and thus don't produce value may nevertheless seem provocative in the context of cybernetics, whose principal theorists (including Wiener and John von Neumann) saw the potential for feedback and self-replicating systems to radically undermine the notion that machines produce value only at the hands of humans. Furthermore, as we've seen in chapter 1, technologies such as AI and brain emulation may eventually not only challenge the human-machine distinction but also suggest that software versions of us might be capable of "experiencing" exploitation not unlike their fleshy counterparts. Prior to such a future scenario, the ability to mathematically model virtually any finite decision procedure—and hence any determinate work process— was proven as early as the 1930s in Alan Turing's universal Turing machine. If every labor process can, at least in theory, be simulated computationally and executed by robots, then what is it that makes human labor unique? For one cannot point to any positively unique feature of labor since, as we saw with Catherine Malabou, even the brain's supposed "plasticity," its potential for creative adaptation and malleability, can be modeled in silicon.[33]

Although there may be no positive distinction between robotic and human labor, there is perhaps a *negative* one, in the historically specific ability for humans to refuse it. Indeed, this formal freedom to opt out of work constitutes one of the basic conditions of liberal market humanism: the ability to sell one's labor on the free market—or not. Such a freedom is fundamental,

under liberal humanism, to the very way we understand ourselves *as* humans. On the one hand, its absence would reduce everyone, including what Alexander G. Weheliye describes as the "heteromasculine, white, propertied, and liberal subject,"[34] to nonhuman slaves. This "freedom" of the free labor market is of course only formal in that, as liberal subjects, there is no actual choice, if one expects to survive in a capitalist society, but to sell one's labor. Its transformation into concrete freedom, on the other hand, may eventually be the result of a radical political formation beyond capitalism, or indeed it could accompany a significant mutation of the biotechnological coordinates of the human beyond its current frame of reference: the posthuman. What gives human labor its value, then, is not its inability to be simulated in the form of robotics, on which there seems to be no actual limit, but rather its constitutive negativity. Such a capacity can already be seen in Descartes's conception of the human soul as capable of intervening upon and interrupting our otherwise mechanical bodies.[35] Yet what makes human labor human, as George Caffentzis argues, is not its "nonmechanizability" but rather its "self-negating capacity": its very ability to refuse to be.[36] Doubtless, capitalism distributes the consequences of and stakes for labor's refusal unequally across divisions of race, ethnicity, gender, sexuality, ability, and class. At the same time, labor's political negation in the form of strikes, revolts, and revolutions—and, perhaps by extension, of failure, catastrophe, and disaster—has been integral to the history of capital.

This speaks, conversely, to the paradox of a robot strike, an implausibility seemingly not beyond the imagination of cyberneticians and, at least programmatically, within the scope of Paik's project of making technology "ridiculous."[37] Consider *K-456*'s frequent malfunctions. Following its appearance in *Robot Opera* during the Second Annual New York Avant Garde Festival, for instance, *K-456* was supposed to play percussion alongside Moorman in Stockhausen's *Plus-Minus* (1963). But it broke down at the last minute. The reasons reviewers gave were a "nervous short circuit" and "stage fright":[38] facetious, of course, yet revealing perhaps in their hyperbolic rendering of an all too human alibi for the robot's apparent refusal to perform. This chapter concludes with a reading of *K-456*'s final performance, *First Accident of the Twenty-first Century* (1982), in which Paik staged its collision with a car on Madison Avenue. Such an event has precedents in cybernetics. For instance, Claude Shannon's own foray into artistic production suggests a similar aporia of the labor-refusing robot. Conceived together with Shannon's colleague, the AI engineer Marvin Minsky, the *Ultimate Machine* (1952) consisted of a small wooden casket with a single switch on it. When a viewer flips the switch, the casket lid rises, and out of it comes a hand that turns the switch back off.[39]

"THE CATASTROPHE OF TECHNOLOGY" 67

Is Shannon's robot committing suicide or going on strike? In her wonderful book, *The Freudian Robot: Digital Media and the Future of the Unconscious* (2010), the media theorist Lydia H. Liu interprets Shannon's gesture as a kind of robot manifestation of the Freudian death drive, particularly given the relationship between cybernetics and psychoanalysis since as early as Joseph Weizenbaum's AI therapist of 1964, ELIZA (and considering applications of Freud's notion of the uncanny to robotics studies, including interpretations of Masahiro Mori's highly popularized "uncanny valley").[40] But such a project can also be read, despite Shannon's own hesitations around the application of his information theory to fields outside of communications, in light of the intimate connection between cybernetics and economics (to which Shannon himself nonetheless contributed), alongside shifting relationships between machines and labor.[41]

In this complex historical negotiation between humans and robots, automation and cybernetics exert similar forces on labor's composition; yet labor as negation plays a role as well. For instance, the first industrial robot arm, known as the Unimate and developed in the late 1950s (just a few years before Paik created *K-456*), did not result in automobile workers losing their jobs immediately. In the decades following its introduction, strikes, absenteeism, and sabotage led to the arm's slow adoption by auto manufacturers. But robotics would eventually lead to the wholesale transformation of the auto industry, and indeed to the larger changes in labor that we now associate with post-Fordism. This included mass layoffs and a significant reduction in the workforce in favor of small groups operating several machines at once—an average of five, initially, at Toyota (incidentally, the same number Paik notes were required to operate *K-456*).[42] But it also included, as discussed in chapter 1, the redefinition of the worker: rather than simply an obedient hand operating on an assembly line, the exemplary post-Fordist worker became an "active participant" in more open-ended production processes. An ambivalence is already at play: on the one hand, this new, "flexible" worker of the just-in-time auto plant gives up the job security of the previous generation.[43] And, in the process, many traditional forms of labor would consequently become degraded or "deskilled" in favor of service and clerical work.[44] On the other, through the introduction of industrial robots like the Unimate, each worker's tasks came to demand more unscripted "creativity" and to point toward a cognitive laborer expected to be, in some sense, less robotic.

Rather than participating directly in such processes, *K-456* engages with cybernetic robots through fantasy by creating a series of connections and disconnections with what Jennifer Rhee calls a "robotic imaginary."[45] Paik did not use just-in-time work processes, for instance, nor did he create *K-456* in

a robot factory (although starting in the 1980s he produced his work in a factory in Cincinnati).[46] *K-456* contained servomotors not unlike those found in the Unimate arm, yet rather than a single appendage, Paik's robot simulated all four. The Unimate's functional hand is versatile enough to pick up objects such as auto parts and to operate welding guns.[47] *K-456*'s arms move at the shoulders and wrists, but its hands appear to be mostly for show: the left hand consists of a large, cartoonish cloth glove; on the right is what appears to be a retooled pair of wire clippers, at times covered with a similar glove. The Unimate can be programmed and reprogrammed on the fly, allowing for changes in performance; for auto plants this represented a paradigm shift away from single-purpose machines and toward meeting the demand for rapid adjustments to new car models and variants.[48] Similarly, Paik reused *K-456* in multiple performances, including his work and that of other composers.

Yet Paik's robot relates to its cybernetic contemporaries more through hyperbole than through homology. *K-456* contained a 10-channel data recorder that could, at least in theory, be used to capture the robot's movements sent via its remotes and then replay them at a later time. Although there are no references to the data recorder's use in performance, it appeared in the work's official title, *Robot K-456 with 20-Channel Radio Control and 10-Channel Data Recorder*.[49] Like the Unimate arm, *K-456* was apparently capable of storing a series of maneuvers that could allow Paik to command a performance in his absence. Yet unlike the Unimate, *K-456*'s data recorder appears to have offered no practical benefits to the robot's actual performances. *K-456* departs further from self-governing cybernetic robots in its lack of feedback mechanisms, including sensors and limit switches that would allow it to operate autonomously or even semi-autonomously. Moreover, *K-456*'s reliance on the remote control compounds the robot's necessity for multiple assistants; rather than decreasing labor, his robot counterproductively increases it. By contrast, the Unimate sought to minimize certain forms of labor by maximizing automation—an aspiration evident perhaps in the name of its parent company, Unimation: a portmanteau that combines "universal" and "automation."

It would not be for a few decades, yet still during Paik's lifetime (he died in 2006), that the cybernetic dream of a fully automated robot factory would, to some extent, be realized. Apparently Fanuc, a Japanese company that rather than creating cars builds the robots that create them, has been running an automated factory supposedly without any on-site human presence for over twenty years.[50] Such a facility is referred to as a "lights out" factory because they have no need to supply human occupants with the means to view their surroundings. "Not only is it lights-out," claims Fanuc vice president Gary Zywiol, "we turn off the air conditioning and heat too."[51] By 1948, Wiener had

already imagined the "automatic factory and the assembly line without human agents." And, not unlike Čapek, as noted in chapter 2, Wiener compares such a scenario to slavery in a formulation that, despite its progressive appearance, risks catachresis if we accept the incommensurability between human labor and its machinic equivalent: "Such mechanical labor has most of the economic properties of slave labor, although unlike slave labor, it does not involve the direct demoralizing effects of human cruelty."[52] In his 1965 poem "Pensée" (which contains a reference to Wiener's "control and communication"), Paik expresses a similar interest, though he lacks Wiener's inhibitions: "leisure for the leisure's [sic] sake / not as vacation for more work . . . / cultured idleness à la slave owner / of Greece, but with robot-slave. . . ."[53] As with robots, lights out factories have yet to eliminate the need for workers. Fanuc employs nearly 5,500 across the US, Japan, and Europe.

The point isn't to find the human component of robotics and automation but rather to refine our distinctions between robotics, automation, and labor. Human labor can be defined, again, not through any positive difference with its roboticized or automated equivalent but rather through its self-negating capacity, its ability to choose not to be. What distinguishes robotics from automation is that robots are based on biomorphic simulation, which is further differentiated from the mere representation of life in whatever form or medium. At a minimum, a robot models some part of the *functionality* of a biological organism, from individual organs up to body parts or even a complete humanoid. Paik takes some liberties with the human form in *K-456*. Its gangly, exaggerated appearance is perceived as comic by most viewers. As noted, the robot's legs are capable of producing bipedal motion yet use abnormally large "feet," each fitted with four wheels. Such a design derives from Paik's interest in radio-controlled airplanes and remote-controlled cars, which he discovered while in Cologne before he left for Japan in 1963; once in Japan, he adapted the remote controllers in constructing *K-456* with Abe.[54]

Through this wheeled solution to ambulatory motion, *K-456* invites other comparisons to robots of the era. The Cart was a four-wheeled "robot car," for instance, created in the computer scientist John McCarthy's Stanford Artificial Intelligence Laboratory (SAIL) around the same time Paik erected his robot.[55] Described as a precursor to today's self-driving cars, the Stanford Cart was similar to Paik's robot in that it incorporated a radio controller, yet different in that it roamed autonomously.[56] While a cart with four wheels seems an unlikely source of anthropomorphism, the thinking was that it simulated the way animals navigate their surroundings using sensory data. *K-456* again had no sensors, but according to one viewer it could "simulate most human actions,"[57] and as noted could, theoretically, be preprogrammed to move

without continuous human control. The Cart's breakthrough was its shift away from a computer vision-based approach—which was slow and computationally expensive but provided a complete map of its surroundings—and toward a more "embodied" design capable of "sensing" what was in front of the Cart. This was not altogether unlike Walter's use of photoelectric sensors in his tortoises. The Polish artist Edward Ihnatowicz's *The Senster* (1969–1970) uses sensors and microphones to detect quiet sounds, toward which it then cranes its long neck-like appendage, as though listening. Paik's robot "spoke" but did not listen.

Receptive sense modeling was novel for cybernetic robots, yet the broader paradigm of biomorphic simulation stretches back to the eighteenth century. The robotics expert Rodney Brooks describes the shift to sensory simulation, for instance, in the Cart and in Walter's tortoises, as producing a "situated" robot that "does not deal with abstract descriptions, but through its sensors with the here and now of the world, which directly influences the behavior of the creature."[58] Rather than the AI-based approaches of his colleagues that used a virtual software model of the world—imagine a primitive version of Google maps running on a 1960s mainframe—Brooks equipped his robots with "senses" that respond spontaneously to their surroundings. Such responsive behavior, as opposed to being processed through a "computational homunculus," emerges out of an interaction between the machine's body and its environment. Beyond a machine used merely to execute tasks, such an embodied robot "experiences the world," Brooks contends, "directly through the influence of the world on that body."[59]

But how can "experience" be attributed to robots if we understand them as machinery? What kind of metaphysics would support such a view? To answer that, we have to trace a longer history of robotics that accounts for biomorphic simulation and its supporting ideologies as early as the eighteenth century. For the origins of artificial life and AI can be found not only in these various proto-robots, or automata, of which Vaucanson's defecating duck was exemplary; we should also consider materialist philosophies contending that life itself is mechanical. It is in this nexus that we find, for instance, in one of the earliest French materialists of the Enlightenment, Julien Offray de La Mettrie, humanism's own *Machine Man*: a posthuman avant la lettre.

Already Posthuman? Posthuman Automata and the Robot Origins of the Human

More than two centuries before the contemporary posthuman, a similar figure had already taken shape in the philosophy and artisanal practices of

eighteenth-century Europe. This figure, elaborated through musical and nonmusical automata and accompanying materialist philosophies, was "posthuman" because it contributed to a complex renegotiation of the boundary between humans, animals, and machines. Doubtless this version of the posthuman is far removed from the later instantiation of it that Hayles locates in the Macy Cybernetics conferences of the 1940s and 1950s, but it nevertheless foreshadows the posthuman conceived as the human's technological decentering. As such, these *posthuman automata*, rather than simply rendering inanimate objects as living, embodied the contradictory belief that animal life was reducible to mechanism while mechanism remained unable to explain the basis of human consciousness.[60] I call these posthuman automata in order to expand the historical purview of the contemporary posthuman—underscoring its temporal interpenetration with the human of humanism—while also relativizing the posthuman's claims to novelty. Indeed, posthuman automata like Vaucanson's defecating duck can be understood as important precursors to contemporary robots and AI. Riskin goes as far as to claim that, despite significant changes in technology and science between the eighteenth century and the present, we still live in the "age of Vaucanson."[61] Since the emergence of humanism's human, we've lived alongside its robotic doubling in posthuman automata.

In addition to the duck automaton to which Paik's *K-456* alludes, Vaucanson created two other automata that were similar yet anthropomorphic in appearance and musical in their actions: a flautist and a pipe and tabor drum player. Rather than a music box whose outward appearance only represented a musician, remarkably, each of these androids actually played its instrument—a first in the case of the flautist. Automata date back to antiquity, yet this principle of biomorphic simulation represented a novel invention for the automata of the eighteenth century. These musical automata further represented a shift in music-technological mediation from the score's prescriptive function to physically simulating the *causes* of musical sound. With the advent of recording technology, this paradigm would shift again to include the capture, storage, and replaying of acoustic *effects*. In this sense, *K-456* joins together, anachronistically, all three phases of musical mediation (scores, automata, and recordings) in a robot that, like Vaucanson's pipe and tabor player, was a percussionist, but in Paik's case "read" from scores (for instance, in its planned but failed 1964 performance of Stockhausen's *Plus-Minus*) and played speech recordings in the place of a voice.

K-456 signals the broader legacy of Vaucanson, while Paik further references music technologies of the era. Few commentators have interpreted the name Paik gave *K-456*—aside from the general reference to Mozart—despite

the historical relevance such music has to the human–machine boundary that Paik engages. Mozart's K. 456 may have been written for Maria Theresa von Paradis, a renowned Austrian pianist and composer who was blind and used one of Wolfgang von Kempelen's printing machines for the visually impaired to write letters and typeset her scores.[62] This, coupled with the fact that Mozart himself went temporarily blind from smallpox as a child, may have been a reason Paik refrained from using cameras or light sensors in *K-456*; in the place of eyes, Paik attached two small motorized propellers. Further related to robotics, Mozart also composed works for mechanical instruments. The composer describes, for instance, his F Minor Fantasie, K. 608 (1791), as "an organ piece for a clock," a work commissioned by the Austrian Count Franz Deym to play on the hour, every hour via an automatic musical clock on display in a Viennese *Kunstkabinett*. According to Annette Richards, such works demonstrated for audiences that it was possible for the "mechanical to supersede the human."[63]

Such a musical fascination with mechanism also anticipates advents in computer music to which Paik was an early contributor. In 1967 and 1968, Paik was a resident artist at Bell Laboratories working with the programmer and artist A. Michael Noll and under the invitation of the computer music pioneer Max Mathews. During this time, Paik created a handful of works using computer code as their source or means, including the concrete poem *Confused Rain*; a film consisting of rotating numbers and flashing dots, *Digital Experiment at Bell Labs* (both 1967); and *Etude 1* (1967–68), likely a result of his attempt to compose the first "computer-opera in music history."[64] Shortly after his stay at Bell Labs, Paik described his use of permutation sets (i.e., ordered combinations of a certain number of elements) in a manner that resembles some of the earliest automatic compositions. Paik explained that a computer program he created can write all of the haikus possible in Japanese, a finite number given the language's 111 syllables and the seventeen allowed in the poetic form: "When I let the computer write out all these possibilities, which is pretty easy, thereafter no one *can* write any more Haiku poems."[65] Like Mozart's *Musikalisches Würfelspiel* (Musical Dice Games), K. 516f (1787 [1792]), which allow "the composition of as many waltzes as one desires with two dice, without understanding anything about music or composition," such work *deskills* composition.

In addition to political-economic implications, posthuman automata had a profound influence on philosophical conceptions of the human. All three of Vaucanson's automata were precursors to the inventor's automatic loom of 1747, which led to the wholesale deskilling of weaving.[66] Although it did not simulate animal biology, the automatic loom was similar to automata in that

"THE CATASTROPHE OF TECHNOLOGY" 73

it illustrated that tasks once thought of as uniquely human—whether playing music or weaving fabrics—could be done by a machine. As such, posthuman automata tested the hypothesis that life itself was mechanical, ultimately reducible to a complex system of clockwork: a machine man. "The human body," La Mettrie writes along these lines, "is a machine that winds itself up, a living picture of perpetual motion."[67] Descartes is known for contending that the human body is an automaton, and La Mettrie's title, *Machine Man*, is a reference to this hypothesis.[68] Yet distinct from his interpretation in La Mettrie, Descartes offers a concept of the human that breaks with pure mechanism.

In addition to his references to eighteenth-century automata, Paik's robots also refer to Enlightenment philosophy (including that of the seventeenth century). His work *Descartes in Easter Island* (1993), for instance, consists of a robot head composed of laser discs, circuit boards, video screens, and speakers.[69] The notion of the Cartesian mind-body split, as discussed in this book's introduction, is already robotic. If the mind is truly separate from the body, then the body is simply incidental; it can be replaced by any number of prostheses corresponding to organs, body parts, and potentially up to a full mechanical body. Cyberneticians Wiener, Shannon, and McCarthy acknowledged Descartes as an early theorist of automata. Yet despite his conception of the human *body* as mechanical, Descartes identifies the soul as ultimately unsimulatable, irrecuperable in automata.[70] For Descartes, "The soul intervenes on behalf of the organism," according to historian David Bates, "by forcing the automaton to act against its own automaticity."[71] Is it possible, then, that Paik's *K-456* stages a similar kind of interruption of its own automaticity? We've considered how *K-456*'s various performative refusals, its breakdowns and bouts of "stage fright,"[72] parallel the human capacity for self-negation in the form of strikes, sabotage, staged accidents, and even suicide. In light of this intersection, we turn now to Paik's staged collision between *K-456* and an automobile, which the artist likened to technological catastrophe.

Robot K-456 and the Catastrophe of Technology

Robot K-456's final performance, *First Accident of the Twenty-first Century*, occurred as part of Paik's retrospective at the Whitney Museum of American Art, organized in 1982 by the curator John G. Hanhardt. On June 22 at 11 a.m., Paik removed the robot from its display on the fourth floor of the museum, which at the time was located on Madison Avenue, on the Upper East Side of Manhattan. Paik placed *K-456* on the sidewalk, and stood behind the electronic creature while operating his radio controller. As spectators and a TV crew looked on, *K-456* began to move with the same shambling stride of its

first appearance nearly twenty years prior. The robot moved north on Madison, stopping first in front of the Whitney to "eat" a hot dog purchased from a stand, then continued until it reached the crosswalk at 75th Street. *K-456* waited for the light and, as impatient commuters honked, crossed the busy intersection. The robot then traversed Madison but roughly halfway across was struck from behind by a white Volkswagen turning from 75th Street.[73] The robot's initial encounter with the car, which was driven by the artist William Anastasi, left the figure standing. But then the robot's metallic frame jolted forward again, and after further thrusts of the automobile's bumper, *K-456* fell on its face, its backside lodged underneath the vehicle's front end.[74] A group of onlookers approached Paik's life-size creature, dragging it back onto the sidewalk and, later, hoisting it onto a "stretcher."[75] During an interview with a TV reporter on the scene following the incident, Paik prophesied that the event represented the "catastrophe of technology in the twenty-first century. And we are learning how to cope with it."[76]

Paik's *First Accident of the Twenty-first Century* expresses two antithetical conjectures—that the robot is autonomous and that it is unfree—which both challenge and affirm distinctions between the human and its machinic equivalent. As anthropomorphic simulation, Paik's robot *takes the form* of the human's capacity for self-negation, its radical potential for refusal. *K-456*'s accident might be thought of as the result of carelessness or neglect. As suggested, it can also be read as rendering the paradoxical gesture of a robot suicide not unlike the "robot strike" found in Shannon's *Ultimate Machine.* Through its display of vulnerability during the collision, *K-456* simulates the human susceptibility to harm and, in perhaps the robot's only foray into sense modeling, a sensitivity to touch. In addition to its appetite, Paik attributes other features to the robot that "humanize technology."[77] As the recipient of faux medical attention, *K-456* functions, according to Jennifer Rhee, as a kind of technological "surrogate" for care labor.[78] Speaking to an on-site TV reporter, Paik suggested in his typical deadpan manner that *K-456* had health issues commonly associated with aging, which may have contributed to its impeded movement: "This robot is almost twenty years old, and [it's] got arthritis." Robots apparently age more quickly than humans, although Paik noted that *K-456* "has not yet [had a] bar mitzvah."[79] Even religious ceremony is not beyond the robot's refusal—which speaks to ways, beyond labor, that robotic simulation can be understood as *sociomorphic.*

At the same time, *First Accident* stages the robot's attempt to escape from captivity. Such a reading is complicated by the fact that Paik's robot, while in some ways lifelike, seems far from autonomous. *K-456*'s autonomy is undermined, that is, by the knowledge that the robot acts not on its own volition

"THE CATASTROPHE OF TECHNOLOGY"

but according to the will of another. *K-456* is both "humanized" and tethered to Paik's control, rendered in this sense as subhuman. As the news anchor noted following the event, "On Madison Avenue today, a speeding car struck a pedestrian stepping off the curb. But [it] was no normal pedestrian. It was a remote-controlled robot."[80] Recalling Čapek's *R.U.R.*, but also Wiener's fully automated factory and Paik's poem "Pensée," *K-456* appears as no more than a slave under Paik's control. As noted, in "Pensée" Paik compares robotics to slavery ("slave owner / of Greece, but with robot-slave"), and he goes further to comment on artistic medium and property ("Painting is the private property . . . / Music is the public common good . . ."); and race, global economics, and class. Paik continues, tentatively foreshadowing perhaps *K-456*'s attempted suicide: "Kill Paik's Art?" "Kill The Robot Opera?"[81]

Paik's staged collision between robot and automobile invites, as suggested, a longer view of such intersections between humans and robots. According to Wulf Herzogenrath, Paik became interested in constructing an anthropomorphic robot after learning that the brain began to grow after early humans ceased moving around on all fours and, as a result, had to operate two newly freed hands.[82] The biotechnological legacy of this story of human ambulation returns in the postwar automobile industry through the Unimate arm. That invention not only transformed the manufacturing of cars but brought about a major change in the structure of labor. Paik's *K-456*, as noted, shares features with the post-Fordist factory automation the arm helped to bring about, while another origin of the robot is remote-controlled toy cars.[83] Following his performance in front of the Whitney, Paik's interest in cars appeared as a leitmotif in *Electronic Superhighway* (1995) and, in a work that recapitulates *K-456*'s links between eighteenth-century music and twentieth-century technoculture, *32 Cars for the 20th Century Play Mozart's Requiem Quietly* (1997). *First Accident* uses these technological themes of the twentieth century as a basis to speculate about their catastrophic development in the twenty-first.

What is the catastrophe of technology in the twenty-first century? Paik prophesies that "in the next century New York will be filled with robots, so we have to teach robots how to avoid cars."[84] There's of course no way to know what the remainder of the twenty-first century will bring. Data suggest that automation and robotics have already contributed to unemployment in the transportation industry. Paik's literal collision between automobile and robotics in the late twentieth century anticipates perhaps the figurative one in the twenty-first. Specifically, autonomous vehicles are projected to significantly transform the US economy in the coming decades. Paik of course had no knowledge of the emergence of contemporary self-driving vehicles, let alone any anticipated political-economic consequences. But he was likely aware of

McCarthy and SAIL's attempts to create a "robot car" around the same time the artist created *K-456*. And Paik did not speculate on the consequences of autonomous vehicles, yet he expressed a professional interest in economics and computing, writing of his potential for a "Copernic[an] discovery" in line with Marx or Keynes.[85] Weary of catastrophe, Paik also saw in technology utopian potential. In an undated letter to Cage written following Paik's stay at the art and technology commune Pulsa, he attempted to describe a life that "would be more relevant in the decentralized, post-industrial, jobless-oriented future [of] communal living."[86] One can only speculate whether robotics and automation will lead to such a future or to its dystopian reflection.

The catastrophe of technology, in this sense, is not limited to the twentieth or twenty-first century but applies to a longer history of robotics and automation. This history is underpinned by ideological supporters and artistic and philosophical detractors alike. From La Mettrie's machine man of the Enlightenment to Brooks's robotic "experience," such mechanistic views of the human encounter our capacity for self-interruption articulated as early as Descartes. Music, from Vaucanson and Mozart to Paik and Moorman, plays a central role in this negotiation not because it announces a romantic core of the human ultimately irrecuperable by technological simulation. Rather, the experiments of eighteenth-century posthuman automata link perhaps unexpectedly to postwar experimental music through Paik's interdisciplinary confrontation with robotics and cybernetics. It is in this context that Paik's robot seems to parody the project of artificial life found in cybernetics but also stretching back to posthuman Enlightenment automata. As opposed to Eduardo Kac's reading of *K-456* as a "caricature of humanity," I interpret Paik's work as a critique of robotics as technological catastrophe.[87] There may be no positive limit to the kinds of things, including various forms of labor, that robotics and automation are capable of doing. But by failing to achieve the human's purely negative difference from the mechanical as radical refusal, Paik's robot demonstrates that such a capacity for self-negation might be the human's last determining attribute.

4

Deep (Space) Listening: SETI, Moonbounce, and Pauline Oliveros's *Echoes from the Moon*

Introduction

Looking up at the night sky, as the old saw goes, one wonders if we're truly alone in the universe. How might the detection of, and even communication with, an extraterrestrial intelligence affect our understanding of ourselves as humans? What would such a discovery say about the contemporary posthuman?

In 1987, the composer, performer, and technologist Pauline Oliveros presented the first realization of *Echoes from the Moon*, a multi-form work that uses radio transmissions to allow performers and audience members to broadcast their voices and other sounds to the moon and, subsequently, hear reflections of those signals received back on Earth. Oliveros traveled to New Lebanon, Maine to work with Dave Olean, an amateur (or "ham") radio operator who during the 1960s had participated in one of the first two-way Earth–Moon–Earth (EME) communications using ham radio. EME communication, also referred to as "moonbounce," was first developed through war efforts to communicate and spy across large geographical distances prior to the development of communication satellites. In addition to other military purposes, moonbounce was formative in the development of radio astronomy and the Search for Extraterrestrial Intelligence (SETI). Ham radio astronomers have used resources like the Arecibo Observatory in Puerto Rico, a facility well known for its long-standing involvement in SETI, for moonbounce experiments not unlike Oliveros's *Echces*.[1] And, in a recent project based on a proposal from the 1970s that we can usefully think of Earth from the perspective of an observing exoplanet (short for "extrasolar planet"), a current SETI researcher has been listening to radio waves reflected from the moon as one of our own technological signs of life.[2] Moonbounce both creates and observes, in this case, one of our own "alien" technosignatures.

Echoes is a far cry from so-called Active SETI, or Messaging Extraterrestrial Intelligence (METI), even though moonbounce may result in broadcasts that reach other stars. In their initial home-studio moonbounce, Oliveros and Olean configured an array of twenty-four large, directional Yagi-Uda antennae, each consisting of a series of thin metal bars arranged in parallel and supported by a perpendicular crossbar rod. These antennae, which had inputs and outputs connected to Olean's audio setup, were together capable of both sending and receiving radio signals. To alternate between these states, Olean had configured a footswitch to change the antennae from radio broadcasting to receiving mode. This allowed Oliveros to transmit a sound to the moon and then tap the switch to hear its Earthbound echo. Since radio waves travel at the speed of light, the roughly half-million-mile trip (768,800 kilometers) to the moon and back takes about 2½ seconds to complete. This, then, was her delay line—an effect that was central to Oliveros's musical practice since the 1960s and to which we'll return below. Here the delayed sound underwent a slight downward pitch-shift due to the Doppler effect—imagine a car horn's descent as the vehicle whizzes past—caused by the moon's movement relative to Earth.[3] In her first "duet" with the moon, Oliveros used a tin whistle, a conch shell, and her primary instrument, the accordion. Yet before these instrumental sounds began their respective round-trip journeys to the moon, Oliveros's role was, in her words, that of a "vocal astronaut." Indeed, the first utterance Oliveros sent to the moon was, simply, "hello."[4] But whom was she greeting?

Echoes and other forms of EME communication involve extraplanetary broadcasts and share SETI's emphasis on listening across space and time. Oliveros notes that she arrived at the idea for *Echoes* after watching Apollo 11's first lunar landing in 1969, one of the most widely viewed media events in history. If extraterrestrials were to intercept radio waves from Earth, such a broadcast—like Hitler's 1936 Summer Olympics speech—would have an increased likelihood of becoming a kind of interstellar beacon due to its strength. While more modest in scale, *Echoes* contains similar implications. One might hear Oliveros's first moonbounce utterance not only as musically performative, but also in J. L. Austin's sense that the signifier "hello" *does* something potentially extralinguistic—namely, the interpellation of an other: in this case, either Oliveros herself 2½ seconds in the future or, indeed, some form of life listening in from elsewhere in the universe.[5] As a form of aural time and space travel, then, *Echoes*' delays isomorphically reflect the historical structure of recording technology which, as we saw with Z in chapter 2, lets us hear earlier, potentially distant events. In fact, Oliveros's opening salutation echoes Thomas Edison's own first utterance into his newly invented phonograph in 1877.[6] Along similar lines, Oliveros conceived

of her Expanded Instrument System (EIS)—a complex and evolving system of delays and signal-processing algorithms she created in 1965 and developed throughout her career—as "both a time machine and space machine."[7] In *Echoes*, the capture and storage phases lack a physical (non-ephemeral) medium and are reduced, as noted, to the speed-of-light time-lag caused by travel to the moon and back. With radio astronomy, such time delays are built into the "lookback time" of cosmic listening: the farther away a source is in light-years, the earlier in time an astronomer effectively listens.

A comparable emphasis on listening spans from Oliveros's early engagements with cybernetics and feedback systems to her later interest in posthumanism. *Echoes* can be traced to Oliveros's first uses of tape delay, including her 1967 composition *Alien Bog*. In that work, she processed sounds from a Buchla Box 100 synthesizer with delays to create textures that resembled the natural yet seemingly otherworldly soundscape of the frog pond seen from her electronic music studio window at Mills College. At this stage, Oliveros used EIS as a kind of feedback circuit that integrated her actions as composer, performer, improviser, and listener. Like Lucier's neurofeedback experiments, Oliveros's cybernetic system contained both human and nonhuman self-regulating components.[8] As a real-time interactive system, EIS suggests a shift from composition as a cognitive activity to an embodied improvisational process. As much as she emphasized listening, the technological interplay in this setup was reciprocal. In *Alien Bog* and *Mnemonics* (1966), Oliveros played with oscillators and tape machines, as Ted Gordon notes, "as much as they were playing with her."[9]

Oliveros's EIS evolved over the decades. She began with tape delays, and subsequently used rack-mounted Lexicon PCM 42 delay units with MIDI foot controllers, then computerized versions using digital signal processing engineered via the Max/MSP programming language. More than simply a tool, EIS would lead her to consider future consequences of artificial intelligence and, influenced by her readings of Kurzweil, its posthuman merger with the biological human. "I fully expect EIS to become more and more intelligent and self-determining," she announces, going on to contend that with the imminent merger between humans and computers, "my music will be a new cry from and for post-humanity."[10] Such a futurist pursuit of artificial intelligence contains important parallels, as cyberneticians have noted, with the spatial search for extraterrestrial intelligence. According to Marvin Minsky and John McCarthy, both paradigms have sought the discovery of a human-*like* intelligence beyond its known biological substrate.[11] Given the size and age of the universe, by this account, our discovery of an ET may turn out to be an encounter with an AI.

80 CHAPTER FOUR

While she embraced the posthuman, Oliveros often criticized the way institutions deal with more human forms of marginality and alienness. Techno-scientifically, she reproaches NASA for marginalizing the "aurally-oriented" by including with their $165 million Mars probe a mere $15 microphone adapted from a hearing aid.[12] Musically, she describes the instrument on which she trained, the accordion, as "a symbol of the outsider," noting its associations with working-class culture and its general exclusion from the canon of Western music.[13] As a composer, moreover, Oliveros perceived the exclusionary effects of the structural sexism, homophobia, and racism at play in music institutions of which she was a vocal critic. She speaks of feeling anxious, for instance, while installing speakers for a 1997 version of *Echoes* in Salzburg, which occurred on the same day as a concert by the Vienna Philharmonic—an organization she had denounced for its exclusion of women and musicians of color in a statement she made earlier that year to the American Federation of Musicians.[14] Her public critique began decades earlier in her article, "And Don't Call them 'Lady' Composers," published in the *New York Times* in 1970.[15] Around this time, Oliveros began to include explicit feminist themes in her compositions, including her 1970 text score, *To Valerie Solanas and Marilyn Monroe in Recognition of Their Desperation----*. According to Oliveros, that work sought to express the "deep structure" of Solanas's 1967 *SCUM Manifesto*.[16] Alluding to the manifesto's "paradoxically utopian" modes of social organization,[17] Oliveros's score provides instructions for creating nonhierarchical modes of sounding and listening—a key premise of the Deep Listening practice she developed starting that year and would go on to define as an active reception of the "whole field of sound."[18] Considered in the context of *Echoes* and SETI, what might such radical forms of listening and human organization say about extraterrestrial life and the posthuman?

Oliveros's Deep Listening, alongside her related work with site-specific performance, figures as another important path to *Echoes*, while it provides an artistic frame for considering technoscientific practices of listening to the cosmos. Altogether, Deep Listening's roots span the spatial, sensorial, political, and technological. The composer recounts how, after she had received an Eico tape recorder as a gift from her mother on her twenty-first birthday—and she realized that the device had picked up sounds outside of her apartment window of which she was not previously aware—she began to "train" herself with the following meditation: "Listen to everything all the time and remind yourself when you are not listening."[19] In 1971, one year after she wrote *To Valerie Solanas*, Oliveros composed *Sonic Meditations*, a series of text scores that describe various participatory listening activities that she developed in a course at the University of California, San Diego; she dedicated the meditations

to the ♀ Ensemble, which she started there in part as an attempt to listen to women who had felt "less visible around the university community."[20] Together these impetuses led her to "Deep Listening," a phrase she first used as the title of a 1989 New Albion CD recording of her site-specific improvisation with Stuart Dempster and Panaiotis held in a large underground cistern in Port Townsend, Washington.[21] Alongside her expansion of Deep Listening to include workshops, compositions such as her *Deep Listening Pieces* (1990), retreats, and a three-year certificate program, Oliveros had also been developing what she calls "telemusical" or "distance" performances that used various telecommunications technologies to improvise with musicians located in different parts of the world. *Echoes* extends such distances to the moon.

This chapter analyzes Oliveros's *Echoes from the Moon* and its multiple executions in light of scientific and artistic experiments that foreground listening in the exploration of space. Following its 1987 premiere in Maine, *Echoes* received several further realizations: a 1996 performance with Scot Gresham-Lancaster during a lunar eclipse at California State University, Hayward, in which approximately four hundred people lined up to "touch the moon" with their voices;[22] the aforementioned 1997 version in Salzburg with the Swiss sound artist Andres Bosshard; a 1999 realization in St. Pölten, Austria, with Bosshard, the Nigerian-French percussionist Guem, and the writer and artist (and long-term partner of Oliveros) Ione; and three recent posthumous versions (2017–2019) that connected the artist Daniela de Paulis, Ione, and members of the US-based nonprofit Astronomers Without Borders with Dutch radio astronomers at the Dwingeloo Radio Observatory in the Netherlands. What these realizations of *Echoes* have in common is their artistic use of radio astronomy to achieve a telemusical interface between the Earth and the moon. *Echoes* extends EME communication through Oliveros's Deep Listening practice, while it uses radio astronomy for the receiving and sending of extraplanetary sounds and messages. An earlier example of the latter can be found in the astrophysicist Frank Drake's Arecibo message of 1974, which used a three-minute radio signal to send into space 1,679 binary digits that describe various mathematical, biological, and chemical numerical constants, bitmap portrayals of the solar system and the Arecibo telescope, and a pictographic image of (a) man.[23] What, then, can such technoscientific and artistic practices of sending and receiving radio signals to and from space tell us about this figure of "man"?

The chapter further considers what an aural confrontation with the radical alterity of extraterrestrial life could mean for the historical category of the human. How might Oliveros's radical listening practice—which, again, brings together the spatial, the sensorial, the technological, and the political—shape our understanding of the possibilities of otherworldly life? The figure

of the alien has not only been a subject of the contemporary popular imagination fueled by science fiction and conspiracy theories; over two centuries ago it was critical for humanism's enduring philosophical construction of the human. During the Enlightenment, that is, when a belief in aliens was ubiquitous among both intellectuals and laypeople, Kant was unable to adequately define humans without recourse to extraterrestrials: if the human is understood as a rational terrestrial being, the philosopher figured in a text of 1772, one can only comprehend it through its comparison with a rational *non*-terrestrial being. Incidentally, Kant speculates that such extraterrestrials might only be capable of thoughts that they voice at the same time—a stream-of-conscious speech seemingly not unlike that of Oliveros's *Echoes* participants. In an earlier text, Kant's aliens formed a strict racial hierarchy, which mirrored racial and colonial attitudes of the time. Two centuries later, some scientists continue to express surprise at the lack of evidence for the extraterrestrial colonization of our galaxy and even Earth. In the words of the Italian American physicist Enrico Fermi, "where is everybody?"[24] Yet why do scientists apply such a contingent world-historical process to life elsewhere in the universe and imagine aliens as inevitable colonizers? In this context, Deep Listening encourages us perhaps to hear space differently. Nevertheless, since Oliveros received her first "hello" reflected back from the moon in 1987, scientists have discovered more than 4,000 exoplanets in our galaxy alone. So, why haven't aliens visited us already? Where is everybody?

Where Is Everybody? Fermi's Question, Deep Listening, and the Great (Radio) Silence

That was the question Fermi posed in conversation with fellow nuclear technology researchers over lunch at the Los Alamos National Laboratory in New Mexico during the summer of 1950. Generally, it refers to the contradiction between the presumed high probability of the existence of life elsewhere in the universe and the apparently lifeless universe that we observe. The physicist's reasoning was that if intelligent extraterrestrial life existed it would with enough time achieve space travel and, eventually, colonize the galaxy and even Earth. That's at least one widely accepted interpretation of Fermi's question.[25] Since he died only four years later, and never codified it in a written account, most knowledge of the question stems from later interpretations or from those who were present at the lunch.[26] According to another colleague, the physicist went further to estimate the probability of Earth-like planets appearing elsewhere in the universe, the emergence of simple life on those planets, and the development of intelligent creatures—a precursor to the equation

the SETI researcher Drake devised a decade later to estimate the amount of life in the galaxy.[27] Drake's equation started with the rate of star formation and added the likelihood of developing interstellar communication technology and the civilizations' longevity. For communication, it's figured that extraterrestrials might use any number of techniques including radio.[28] Regarding colonization, Drake's fellow Los Alamos researcher, John von Neumann, imagined that extraterrestrials could plausibly take over the galaxy using the self-replicating robot probes he envisioned. Nonetheless, "communicate" and "colonize" present considerably different motivations and outcomes, and I think Oliveros's Deep Listening suggests that we consider this disparity further. As Fermi saw it, the galaxy should be teeming with life. Yet when we look up at the sky, we neither see nor hear any evidence for it. This cosmic isolation remains what the Soviet radio astronomer Iosif Shklovsky called the "Great Silence."[29]

In an early instance of what she would later call Deep Listening, Oliveros was interested in the ability to communicate across vast distances, including between Earth and other star systems; later on, she even imagined hearing interstellar music as a "sign of life."[30] In the fourth of her *Sonic Meditations*, Oliveros asks performers to attempt "interstellar telepathic transmission." She instructs musicians to separate physically, a distance that may be "small or great," and perform one of two other meditations involving telepathy. Each performer transmits a series of "sound images" according to meditation III (either performing "Pacific Tell" or "Telepathic Improvisation"), while the other group, upon receiving the sound image, realize it audibly. The groups are to record these performances and, at their conclusion, compare results. Altogether the instruction can be considered as an early instance of her telemusical practice or "distance performance." The interest in telepathy arose from her various experiments with biofeedback—incidentally, around the time Alvin Lucier created *Music for Solo Performer*.[31] Perhaps there are capacities of the human brain that, with or without technological enhancement, might be able to communicate across space. The meditation also anticipates her later interest in posthumanism, which she expressed through various predictions around a potential merger between humans and computers. Published with twenty-four accompanying *Sonic Meditations* just a year after the Apollo 11 mission, meditation IV also invokes the posthuman in that it presages a time when humans, or our post-biological successors, might finally achieve interstellar space travel. Yet would such spacefaring posthumans be visiting far-off worlds or staying for good?

As it turns out, such post-biological entities may simply have no interest in or need to colonize space. According to the Serbian astronomer Milan

Ćirković, advanced extraterrestrial civilizations, particularly those that transition intelligent life to some kind of post-biological substrate, are more likely to develop according to a city-state model than as an expanding imperial one.[32] The reasoning is that, in a civilization that values computation over biological resources, expansion beyond a certain point will undermine efficiency and introduce suboptimal noise and bandwidth issues. Even trips to nearby stars, according to Ćirković, would more likely result in the extraterrestrials returning with resources than in staying to set up a colony. Rather than colonize the outside world, such post-biological societies may turn to virtual space with its endless malleability—although this would by no means equate to a loss of interest in the physical world.[33]

Yet wouldn't such ubiquitous computation require, potentially, vast amounts of energy typically thought of as scarce for any civilization? In chapter 1, we explored Robin Hanson's futurist brain emulation scenario. (Note that Hanson has also developed the "Great Filter" response to the Fermi paradox—there are several stages, or "filters," according to the hypothesis, that fatally prevent alien life from developing interstellar colonies—which Ćirković here opposes.)[34] Recall that the em world not only entailed an aggressive regime of virtually ceaseless digital labor output, but also required significant increases in energy to run trillions or more digital minds and their respective universes. At that rate, wouldn't such a post-biological society eventually burn out its host star and, indeed, feel the need to send out fleets to conquer new worlds? According to Ćirković, not only will the post-biological alien likely avoid colonization for reasons of efficiency and overall cost, but they may never need to leave their dead star in the first place. This is because such stellar remnants (whether a white dwarf, a neutron star, or a black hole) apparently contain an order of magnitude *more* energy even without the additional stellar engineering of which such an advanced civilization would likely be capable. Because this kind of star engineering would likely precede interstellar travel for such a society, exploration would be a choice rather than a necessity for post-biological extraterrestrials. Colonization for such aliens might just be impractical.

But all it would take, one might object, is a single exception to the city-state paradigm for an alien empire to emerge on a galactic scale but with parallels perhaps to our own colonial history here on Earth. Thinkers across various scientific disciplines have proposed numerous "solutions" to Fermi's question. The scientist Stephen Webb recently cataloged a total of seventy-five.[35] In one sense, Ćirković is right when he argues that many proposed Fermi solutions "uncritically apply the usually assumed model of [an] expanding 'colonial empire' from human history."[36] In another sense, though, precisely

the opposite is true since the discovery of "empty" cosmic space starting with the Copernican revolution of the sixteenth century provided the conditions of possibility for colonialism. Europeans had previously landed on other continents, to be sure, but it took a cosmological spatial revolution to bring about the notion of colonial conquest here on Earth. After Copernicus, "Men could henceforth imagine empty space," Carl Schmitt contends, "something that wasn't the case before."[37] As the philosopher Peter Szendy argues in his reading of Schmitt, "The spatial revolution that stems from the discovery of a new continent is only a revolution if placed against the backdrop of the cosmological revolution (the one in Copernicus's *De revolutionibus* [*orbium coelestium*] and of his successors) that preceded it and made it possible." He continues, "The cosmos, a paradigm of empty space, was thus already there; its discovery preceded and conditioned the revolution of earthly space, in other words, the institution of the first truly global or globalized order on Earth. The invention of the void in the cosmos will thus, according to Schmitt, have allowed for the discovery of the free space that, on planet Earth, will have in turn made the institution of a *nomos* possible."[38] Prior to the discovery of the cosmic void, Schmitt argues, the legal and conceptual frameworks for the conquest of new worlds were not possible without the concomitant notion of free space that it heralded. If astronomers are guilty of applying colonial history to the cosmos, then space itself is already imbricated in the origins of colonialism. As with *Echoes*, reflections are everywhere.[39]

Like a feedback circuit, then, our understanding of extraterrestrial space shapes our conceptions of spatiality here on Earth, which we in turn map, epistemologically, back onto the cosmos. Copernicus made his discovery with the naked eye. The introduction of optical instrumentality in the form of the telescope significantly shaped its subsequent refinements in Galileo and then in Johannes Kepler. As one philosopher has explained it, the telescope was an "artificial organ" that extended sight to the heavens and opened a "new visible world."[40] Jumping ahead three centuries, the radio telescope complemented this optical sensorium with hearing. The invention of radio astronomy had the effect of producing a kind of second, "audible" sky superimposed on the known visible one. "It not only created a new sky," the radio astronomer Woodruff T. Sullivan contends, "but necessarily meant that the previously known sky now became an *optical* sky. There were *two* ways to view the heavens."[41] One such "view" would in fact involve listening.

Alongside the introduction of new instrumental techniques and their consequent shifts in available sense modalities, space has continued to reflect its terrestrial conditions of possibility. Radio was pivotal not only for communication and science but also for science fiction. Shortly after Guglielmo

Marconi invented the first radio receiver–transmitters, and just one year before Nikola Tesla claimed to have received an actual radio broadcast from Mars, H. G. Wells's 1897 novel *The War of the Worlds* imagined the Martian colonization of Earth as a symmetrical inversion of the British invasion of indigenous Tasmania.[42] Apparently, Wells wondered what would happen if Martians were to inflict the same kind of genocidal massacre on Britain to which they had recently subjected indigenous Tasmanians.[43] A decidedly humanist text perhaps, based on such a colonial premise, yet also, as Neil Badmington argues, in the unambiguous opposition it sets up between "an 'Us' and a 'Them.'"[44] As is well known, Wells's novel caused public panic when it was broadcast via radio in 1938.[45] Yet years later, Bell Labs engineer Karl Jansky's pioneering talk on his discoveries in radio astronomy, "Electrical Disturbances of Extraterrestrial Origin," fell on deaf ears as neither scientists nor engineers seemed to grasp the new science's potential.[46]

A candidate for our earliest interstellar transmission, the first moonbounce, conducted in 1946 by Janksy's colleague John DeWitt, confirmed that extraplanetary broadcast was possible, although its official ambitions lay in gendered fantasies of military domination. Stationed at Camp Evans in New Jersey, DeWitt led the project, which he dubbed Project Diana in reference to the Roman goddess. DeWitt legitimized the project according to the US government's interest in detecting and controlling guided missiles such as the German V-2.[47] Yet the prospect of bouncing a radio signal off the moon and receiving its reflection had been an elusive challenge up until then; DeWitt's prior attempts to use the technique to study the upper atmosphere of Earth had proved fruitless. According to DeWitt, he chose the reference to the virgin Diana because, like the problem of moonbounce, she had "never been cracked."[48] Comparing DeWitt's feat to Oliveros's *Echoes*, Kahn writes, "The idea of individuals touching the moon with their voices, or making it murmur as one might send waves across an ocean, is in sharp contrast to the masculine aggression involved in the first moon bounce," which DeWitt executed.[49] Although the press hailed the accomplishment as "man finally reach[ing] beyond his own planet," the intention was not to use EME to contact other planets, since DeWitt insisted that it wasn't possible with current technology.[50] One Air Force general nonetheless warned that the radio signals would eventually reach other planets and that their inhabitants might respond in kind.[51]

Yet the idea of listening to the cosmos for signs of life, and even sending out signs of our own, was far from new. Prior to Kant's astrobiological speculations, the seventeenth-century English bishop Frances Godwin imagined in his 1638 novel *Man in the Moon* being carried by geese to the moon to find

aliens who speak in a musical language. Such a story reflects the Renaissance revival of ancient Greek culture in its implicit reference to Plato's "music of the spheres." Oliveros imagined a literal instance of such music in an orbiting satellite with a microphone attached.[52] At the same time, such a fantasy of a lunar music culture anticipates the problem of language in interstellar communication and the significance that music would later have in modern attempts to communicate with extraterrestrials. Accompanying each of the two Voyager missions of 1977, for instance, Carl Sagan's notorious Golden Record contains a range of recorded music.[53] One piece was a computer-generated realization of Kepler's 1619 *Harmonices Mundi* created by Laurie Spiegel, a contemporary experimental music composer and colleague of Oliveros.[54] Sagan's inspiration for the Golden Record apparently derived from the plaques sent aboard the earlier 1972 Pioneer space probe, which contained line drawings of a man and a woman. Reflecting themes of gendered coloniality (already at play perhaps in the Pioneer probe's name), the figures sent to represent humanity appear Caucasian, and the female stands in silence while the male figure's right hand is raised as if to say "hello."

Other artistic and scientific experiments of the postwar era use extraplanetary radio transmissions to intervene in dominant attitudes toward space and its human representations. Just a year before Oliveros sent her first "hello" to the moon, the artist Joe Davis broadcast recordings of the vaginal contractions of dancers to the Epsilon Eridani and Tau Ceti star systems using MIT's Millstone Hill Radar. Davis was responding to the conspicuous plaques sent aboard the Pioneer probe, on which he observed that, in addition to the aforementioned anomalies, the female figure, unlike the male figure, possessed no genitals. The broadcast, which Davis saw as a potential corrective to NASA's "strangely incorrect pictures," lasted only a few minutes before a US Air Force colonel learned of the content and stopped it.[55] Although the subsequent Voyager missions omitted visual depictions of human sexual anatomy, the Golden Record contains aural representations of inner amorous states; as it turns out, Ann Druyan, who served as the project's creative director, agreed to marry Sagan during their conversation held just days before recording her brain waves for inclusion on the golden disc.[56] More recently, de Paulis, the artist who led the 2017–2019 realizations of *Echoes*, has been responsible for an ongoing project that, recalling Lucier's *Music for Solo Performer*, uses the Dutch Dwingeloo radio telescope to send brain waves into space. Another project has transmitted functional cybernetic minds: in 2003, the code for a chatbot named Ella, based in part on Weizenbaum's ELIZA program, was transmitted to a star system located in the Cassiopeia constellation. From the perspective of an extraterrestrial, one can only imagine the vexed impressions

of an eventual recipient. Such signals may seem unrecognizable, even to their originators.

We're already alien, in this sense, to ourselves. Just who *are* these robots, dancers, recording engineers in love, and, in the case of *Echoes*, moonbouncers? As with Drake's androcentric Arecibo message, such examples also point to the seeming impossibility of a universal perspective from which we can adequately represent the human. Instead, we hear a series of gaps, fissures, and incomplete representations mapped onto the cosmos. If there is life out there, it may be incommensurably different from us, but, as Badmington would have it, we already differ from ourselves. Nonetheless, for those of us fortunate enough to travel into low-Earth orbit, space may offer a psychological shift in perspective like the so-called "overview effect," a cognitive vantage point from which one imagines perhaps difference dissolving into a unifying planetary whole.[57] However, as Kant had concluded in his *Anthropology from a Pragmatic Point of View* (1798), it is perhaps only in comparison with an actual extraterrestrial—itself a kind of impossible necessity—that we can adequately understand ourselves as human in the first place. The question *where is everybody?* becomes *who* is "everybody"?

Who Is Everybody? Echoes of *Anthropology* and Posthuman Improvisation

"The idea that *man*, the term, refers to all human beings," Oliveros once quipped, "was too abstract for me."[58] What is this abstraction, then, that we refer to as "man" or "mankind"? What role can space and the cosmos play in answering the question that, notably, also motivated Kant's *Anthropology*: "what is the human being?" On April 15, 2018, de Paulis led a networked performance of *Echoes* that connected Ione, Gresham-Lancaster, various members of Astronomers Without Borders, and the Dutch radio astronomer Jan van Muijlwijk at the Dwingeloo Radio Observatory, where de Paulis was also stationed. Each of these participants logged on from a different geographical location using videoconferencing software, together creating a total of eight independent video sources that alternated in focus depending on who was speaking at the time; the entire performance was broadcast online via social media. After an introduction, they greeted their first caller. The name Stephen Bedingfield appeared on the screen, and a voice described himself as an amateur astronomer and a retiree from Yellowknife, Canada. After a brief welcome, de Paulis asked the caller, "Are you ready to speak to the moon?" The caller's utterance, it was explained to him, would be sent to the moon using the Dwingeloo radio telescope and received roughly 2½ seconds later

upon completing its round trip to the moon. Following de Paulis's countdown, Bedingfield declared, "The Earth is but one country and mankind its citizens." An eager audience awaited, but, alas, there was no echo. Try as we might to avoid it, space exploration is littered with malfunction and, as we'll see, mishearing. After a few further attempts, a mildly distorted and slightly pitch-shifted version of the original message returned.

If the caller's message sounds familiar, it may recall earlier echoes from the moon emitted during the Apollo missions of the 1960s and 1970s. Oliveros was inspired to create *Echoes*, as noted, after watching the Apollo 11 moon landing, an event just decades after the second world war and in the middle of the Cold War that the US had wrapped in a transnational rhetoric of the "unity of mankind."[59] Neil Armstrong's 1969 "giant leap" statement remains, accordingly, one of the most widely recognized recordings of the twentieth century, even though we're still not quite sure what he said. According to Armstrong, he intended to place an "a" before "man," as in "one small step for [a] man, one giant leap for mankind." Due to either phonolinguistic variation (his Ohioan accent) or faulty equipment (a less than adequate vocal microphone), most people over the last fifty years have heard the statement as a strange kind of tautology, instead of the synecdoche connecting the individual ("*a* man") to the universal human ("mankind") that Armstrong had intended.[60] "Why wasn't a poet sent to the moon?" Oliveros wondered in a 1977 talk on art and technology.[61] Another interpretation reads the slip as subsuming the individual token into the abstract type, which points further (despite the "great man" treatment the moon landing would invariably receive) to the human's decentering—a contemporary posthuman loss of agency in an increasingly networked and now nascently extraplanetary society. A comparable message can be found in the commemorative plaque the Apollo 11 crew left, incidentally, just twenty-five miles from the lunar plateau named after Kant—a philosopher who not only studied the moon, but has shaped our understanding of the human in light of extraterrestrials.[62]

The previous chapters explored how the contemporary posthuman remains haunted by echoes of humanism's construction of the human since the Enlightenment, and this chapter is no different. In addition to the "unity of mankind" messaging of the Apollo missions, the caller's moonbounce speech resembles the definition of the human that Kant gives in the final lines of his *Anthropology*. The character of the human species, Kant concludes, is that of a "cosmopolitically united" society: "taken collectively (the human race as one whole), it is a multitude of persons, existing successively and side by side, who cannot do without being together and yet cannot avoid being objectionable to one another."[63] Although constantly under threat of disunion, Kant argues,

the cosmopolitan society generally progresses toward unification. "Mankind" is a collection of social—and cosmopolitical—creatures.

Kant arrives at this description through a comparison between the human and a seemingly unusual hypothetical other: an alien. He reasons that in order to adequately characterize the human, which the philosopher defines as a rational terrestrial being, such an entity must be compared to a rational *non*-terrestrial being. The "being that we know (A)," as he puts it, must be compared to a "being that we do not know (non-A)." He acknowledges that the latter is, paradigmatically—and as if to anticipate Fermi by a century and a half—"missing to us."[64] Nevertheless, he proceeds to imagine an extraterrestrial society whose members would be, essentially, unable to lie. "It could be that on some other planet," he speculates, "there might be rational beings who could not think in any other way but aloud; that is, they could not have any thoughts that they did not at the same time utter, whether awake or dreaming, in the company of others or alone."[65] What's unique about the human, Kant figures, is that we're interested in the thoughts of others yet withhold our own, a tendency that can easily progress from such withholding to deception to lying, or even worse—hence our defining human need for cosmopolitical unity in the face of such evils. Kant's hypothetical extraterrestrials, conversely, seem to revel in a kind of parrhesiastic truth-telling.

As with Kant's aliens, *Echoes* acutely externalizes the voice, which it accomplishes through an open-ended forum for producing speech acts. Other callers during de Paulis's realization echoed the performative/interpellative function of Oliveros's original lunar utterance. The amateur astronomer Hafez Murtza exclaimed, for instance, "Apa khabar bulan dari Malaysia" (Hello, moon from Malaysia), and an ambitious caller from India pronounced, "Hey, moon! I'll come to you one day." In "touching" the moon with their voices, *Echoes* participants can be said to achieve a kind of extraplanetary status as "vocal astronauts." While not subject to Kant's aliens' constraints, participants receive an invitation to "speak to the moon" wherein the content and dissemination are potentially limitless. *Echoes* seems to impose no linguistic barriers. Responding to an Italian participant's inquiry during the St. Pölten performance, Ione noted, "the moon speaks all languages."[66] And while bounded by a 2½-second timespan, transmissions reflect off of the moon and, as astronomers know, travel still farther into deep space. Nothing would prevent participants from lying or deceiving (despite his chosen screen name, the caller from India is clearly not the contemporary politician Saurabh Bhardwaj). Yet, by design, Oliveros's EME system produces a delay that provides a certain measure of *distance* in which one's utterance becomes an object of scrutiny. As a variation on Oliveros's notion of distance performance—and as an aural alternative to

the ocular "overview effect"—we can think of *Echoes* as a variation on Bertolt Brecht's "distancing effect," a theatrical defamiliarization of identity whose German *Verfremdung* also translates as "alienation." Completing a round-trip journey to the moon, one hears one's utterance anew, as estranged. Oliveros's vocal astronauts become alien(s).

If cosmopolitical humans compose rational thoughts, then perhaps extraterrestrials improvise. Oliveros's use of improvisation in *Echoes* invites a comparison to the unfettered speech Kant attributes to aliens.[67] In addition to the voice, Oliveros sent various instrumental sounds to the moon. As with the premiere in New Hampshire, for the 1997 Salzburg realization she played accordion and conch shell. Situated in front of the Salzburg Cathedral, Oliveros began the performance by blowing the conch in the four cardinal directions before improvising a forty-minute accordion "duet" with the moon. "Thick accordion chords, ethereal embellishments, engulfed the magnificent space," writes music critic Mark Swed, "and bent around it with Doppler-like effects in a manner absolutely appropriate to [the cathedral's] Baroque splendor."[68] The performance also included the sound artist Andres Bosshard, who contributed spatialization effects and surround mixing. Oliveros wrote extensively about improvisation and was a proponent of improvised music despite its marginalized status within the academy.[69] Improvisation means responding to the unknown and the unexpected. "The improvising musician," according to Oliveros, "has to let go of each moment and also simultaneously understand the implications of any moment of the music in progress as it emerges into being."[70] It also means working with what's at hand. During her 1996 telephone-networked performance between California, Syracuse, and Seattle, Oliveros complemented the conch shell with a gas pipe whistle, Tibetan cymbals, a wood block, and a temple block. Paradigmatically, she gravitated toward the gas pipe and cymbals because they worked best with the telephone's narrow bandwidth.[71] In *Echoes*, Oliveros responds to the technological setup as much as to its eponymous lunar delay. She plays the moon as much as the moon plays her.

Such a feedback circuit returns us to humanism's construction of the human as it points further to its posthuman beyond. One thing the human and Kant's alien have in common is the ability to externalize conscious thought in the form of language. Yet whereas, according to Kant, the alien enacts a strict stream of consciousness, the human can filter and modulate its output. Oliveros's early use of electronics and tape delays involved a reflective process similar to *Echoes*. Upon listening back to a recording, or indeed when hearing its echo, as she explains, "you listen to what you thought you heard and you begin to perceive what you did not hear consciously when you performed";

importantly, this leads to "interactivity, stimulation of memory, and consciousness."[72] Such a dynamic is present not only in contemporary recording technology but, as Oliveros contends, also already in the origins of language and writing as tools for the externalization of such consciousness.[73]

Writing and literacy were paradigmatic technologies, as we saw in chapter 2, for the Enlightenment's construction of the human: one is only presumed to be human when he (and it was certainly a "he") attained the ability to read and write—a process that notably includes the selection from one's private thoughts of those appropriate for public dissemination. Kant's "public use of reason" has similar yet perhaps loftier goals in mind (even though its antithesis in "private reason" is not personal, or necessarily "withheld," but rather pertains to the state).[74] At the same time, Kant equated literacy and education with the very status of being human, designating the uneducated as prehuman savages or even animals.[75] This was a racializing operation, as Lindon Barrett and Alexander G. Weheliye have argued, which links to Kant's various writings about race, including his early ethnographic speculations on aliens. His "precritical" cosmogony based on Newton's physics applies a strict racial hierarchy to the solar system such that the intelligence of the inhabitants of a planet increases in proportion to its distance from the sun. On Venus and Mercury, a "Greenlander or a Hottentot would be a Newton," for instance, while on the highly intelligent planets in the opposite direction, Isaac Newton himself would compare to an ape.[76] Notwithstanding such racist presuppositions, Kant anticipates the cyberneticians Minsky and McCarthy in imagining extraterrestrial intelligence as correlated to spatial distance.[77] The farther we extend our search into the cosmos, he suggests, the more likely we are to find superintelligence.

Yet the posthuman, Oliveros would warn, poses its own threats to the human and its cosmopolitical unity. As much as she marveled at the possibilities of cybernetics, AI, and even neural implants, Oliveros expressed concerns over the potential merger between humans and machines. Already Kurzweil's vision of a technological singularity, which she cites, notably requires the consolidation of "all biological and nonbiological intelligence"[78]—a process that would seem to exclude the private thinking capacity integral to Kant's human and absent in his (later) alien. In short, such a superintelligent singleton may have no use for individuated private thought or cosmopolitical discourse. Many take for granted the contemporary proliferation of digital telecommunications technologies, yet as early as 2000 Oliveros had wondered about the potential threat such systems might pose to liberal democracy. "What if we could share our thoughts instantly," Oliveros wonders, "over a network as computers now do? Such possibilities and amplified intelligence will present

new challenges to our ethics and future human values."[79] On the one hand, she anticipates today's popular criticism of social media that through various forms of private manipulation and social engineering it is capable of undermining liberal institutions (e.g., national elections). On the other, Oliveros questions the perhaps equally popular futurist vision of a technological singularity. Speaking to the neural implants that Kurzweil promises will "enhance auditory and visual perception and interpretation, memory and reasoning," she asks, "What would be enhanced?" "What's the algorithm," she continues, for "free improvisation?"[80] What about the fleshy contingencies of performance?

Improvisation represents for Oliveros a significant yet not insurmountable challenge to the posthuman while implicating the problem of embodiment. One of improvisation's paths of resistance for Oliveros is its insistence on the body despite music's purported contrary movement since the advent of recording technology toward disembodiment. Recalling her notion of "distance performance," Oliveros describes how through the very development of musical instruments, the body had become "distanced from the process of music-making. Through the millennia, this distance has increased exponentially, until, with the inventions of recording technology and radio broadcasting, music could be completely disembodied."[81] A posthuman technique of embodiment as we've seen with Pamela Z, the technologically mediated voice figures as a virtualized extension of the body. Through distance performance, *Echoes* requires a form of extraplanetary disembodiment, while situating the intimacy of the voice (along with its instrumental counterparts) within a technological network that iteratively returns its signal to the ear. Listening thus figures for Oliveros as an improvisation with the body. As described in this book's introduction, John Cage visited an anechoic chamber at Harvard in 1951 (one year after Fermi's famed lunch), and rather than silence, he heard two sounds: his blood circulating and his nervous system.[82] Oliveros seems to have had a similar idea in the thirteenth of her *Sonic Meditations*: "Listen to the environment as a drone. Establish contact mentally with all of the continuous external sounds and include all of your own continuous internal sounds, such as blood pressure, heart beat [*sic*] and nervous system."[83] In listening to silence, Oliveros and Cage suggest, we invariably hear our (embodied) selves.

As with Lucier and Cage, indeterminacy was integral to Oliveros's work. She describes, for instance, how when performing *Echoes* the distance to the moon constantly fluctuates and requires constant tracking with the antennae, noting that "sometimes the signal going to the moon gets lost in galactic noise."[84] Oliveros contrasts such unpredictable processes and the "nonlinear

carbon chaos" of improvisation with the "silicon linearity of intensive calculation."[85] At the same time, she speculates, "Our life improvisations will soon include the products of accelerated artificial evolution . . . in addition to the life we already lead through the habits of our own natural evolution and traditions."[86] Oliveros ultimately moves both with and against the posthuman, embracing its artistic possibilities while questioning its purported drive to eliminate the "weakness of the flesh," or the finitude of the body.[87] In response, *Echoes* extends the "flesh" of voice as far as the moon.

If the question *who is everybody?* returns us to the body, embodiment is itself for Oliveros a question of distance. Participants become "vocal astronauts," not by setting foot on the moon but instead by "touching" its surface with the voice via radio. By a similar token, space exploration has proven influential for many—paradoxically, due to the distance rather than the proximity it creates between humans and their home planet. Consider, for instance, the influential photographs of Earth taken by the Apollo missions. Some have seen the hovering blue dot shown in *Earthrise* as vulnerable and in need of protection (and hence its significance for the environmental movement), while others view *The Blue Marble*'s isolated sphere as a call for global unity.[88] *Echoes* redirects this kind of gaze both outward and inward (as intimate as the body), while supplementing the ocular focus of the "overview" with the distancing effects of Deep Listening. What happens, though, when the distance becomes greater, as listening grows deeper and extends farther into the cosmos? Oliveros, together with Gresham-Lancaster, had already envisioned extending *Echoes* to other planets in the solar system, even contemplating a "network of bounces."[89] Considering further possibilities, "As telematic technology improves," Oliveros conjectures, "there will be no reason not to make music over any distance"[90]—distances Oliveros imagined extending, as we saw in her *Sonic Meditations*, even beyond our solar system, to other stars.

Echoes from the Moon: A Distancing Effect

Echo is a function of distance. The farther away a reflective surface, the more time must elapse before a listener hears a delayed return of their original sound. For our final echo, then, we travel to the realization site furthest from Oliveros's regular life orbits. In 1999, Oliveros, along with Ione, Bosshard, and Guem, presented a collaborative realization of *Echoes* held in a large courtyard in St. Pölten, Austria. The performance began with audience members speaking to the moon, often saying hello or uttering their names, which altogether proceeded for roughly an hour.[91] Ione recalls wearing a white gown and, prior to the group-improvised performance, assisting with the audience

participation process.[92] The poet also presented an "invocation" titled "Moon, Mond, Luna, Lune," a kind of multilingual, intergenerational personification of the moon that she read through Oliveros's lunar echo. "Remember my name / I am old one, *L'ancienne, L'antepasada, Abuela de tus sueños* / You remember—the old house / and I am calling, calling, but you can't find the path / I return again."[93] Her repetition of "calling" invokes perhaps Oliveros's use of telecommunications technologies in this and other realizations of *Echoes*, while the redoubled "return" recalls the basic feedback mechanism at play in the lunar delay. After audience members spoke to the moon, Oliveros began an hour-long improvisation along with Ione, Guem, and Bosshard, who played a series of cassette decks and operated the surround mix.[94] This spatialization process, according to Bosshard, aimed to mirror the direction of reflection detected from the radio telescope, resulting in a kind of "moon space" that enveloped the audience.[95] As with other realizations, the result created an aural circuit with the moon: the input being the voice and other sounds; the output, after considerable distance, its echo.

Such is an example of an "effect" in the language of contemporary audio signal processing. Imagine a box with an input and an output. An audio signal travels into the box, in this case the voice and other sounds; the box does something to the sound; and a (possibly) different sound emerges from the output. Examples include distortion, pitch-shift, reverb, and delay. This basic structure of the modern audio effect—in use today by everyone from recording engineers to guitar players to children's toy manufacturers—derives in part from early cybernetics research. In particular, the notion of the "black box," which Ross Ashby and Wiener themselves derived from electrical engineering, is a metaphor that refers to the unknowable yet functionally analyzable inner workings of physical systems. One example Ashby gives is a hypothetical extraterrestrial artifact that has fallen from a flying saucer. Due in part to its alien origins, he contends, we may not (be able to) know how it works, but we can nonetheless observe its behavior—its "output," based on certain "inputs," or things an observer can do to the box. (One example of Ashby's inputs is the flipping of a switch that causes the frequency of the object's hum, its "note," to rise an octave.)[96] Yet beyond the example of such a radically alien object, black boxes are, according to Ashby, all around us even when we ostensibly understand how a system works. That is, we may think that we know how, say, a bicycle functions mechanically, while aspects of the interatomic forces that hold the frame's steel together elude the cyclist altogether.

A similar relationship holds between *Echoes* participants and the EME system they activate. They speak into the microphone not knowing perhaps exactly how their voices will respectively "touch the moon," or even whether

such a claim is not fabricated to some extent. In terms of behavior, *Echoes* would then seem to work like Ashby's alien device; or rather, what they have in common for the observer is their very functioning per se. (In this sense, *pace* Cage, it *does* matter if it works.) Both processes illustrate what Andrew Pickering refers to as a "black box ontology," or cybernetics' performative understanding of reality: not a complete knowledge of its inner workings, but an experiential understanding of what it does, how it behaves.[97] For black box ontologists, furthermore, there is no limit to this dynamic, including its applicability to everyday life. Through such a purview, as Ashby puts it, "we have in fact been operating with Black Boxes all our lives."[98] Every object we encounter, in this regard, is a fallen alien artifact.

But we do know how Oliveros's moonbounce system works, so is it not more of a *white* box? Like the interatomic forces of the bicycle, or indeed the potential consequences of EME serving as one of our own technosignatures, there may be elements of the system beyond our immediate grasp. Yet rather than further black-boxing its functionality, Oliveros sought to make the operation of *Echoes* transparent to the public. She was at pains in her *Echoes* realizations, including the one in St. Pölten, to extend the experience of interacting with the EME system to as many participants as possible, despite her use of the setup in her relatively lengthy improvisations.[99] Oliveros embraced the extra-scientific domains of the spiritual and ritualistic, yet their presence doesn't seem to occlude the legibility of the processes in question. The functionality of *Echoes* was to be open and accessible to all who were interested. At the same time, what *Echoes* shares with black box theory, I think, is its insistence on the experimental—its iterative and time-dependent testing of a physical system through an open set of interactions with observers and/or activators. This process produces a kind of reciprocal agential relationship, what Pickering calls a "dance of agency," conducted between the human and objective reality.[100] We begin to feel out the contours of *Echoes*, that is, just as we are respectively interpellated by the moonbounce system we observe.

Given enough distance, we enter the domain of the posthuman. *Echoes*'s use of indeterminacy and its demonstrated fallibility notwithstanding, its behavior is predictable in the short term. A correct technical setup and the unwavering presence of our moon ensure the return of each participant's voice, accompanied as we've heard by somewhat irregular "iridescent crackling," Doppler shifts, and distortion.[101] We've seen that even the moon's positioning is unpredictable and can lead to the signal being lost in "galactic noise."[102] And there could be further consequences of the system beyond its immediate 2½-second echo. As noted, moonbounce experiments could eventually become technosignatures detectable even from other star systems. In this way,

Echoes converges on Cage's notion of experimentalism as a process the results of which are unknown. But is anything about it unknowable? Consider, for instance, Breakthrough Listen's recent detection of radio bursts from a dwarf galaxy three billion light-years away.[103] Although such phenomena were likely naturally occurring, how might we respond if we suspected that they were indeed of an extraterrestrial origin? What would it mean for us to attempt communication across the distance of a six-billion-year echo? What appears to be a white box in the near term becomes asymptotically darkened as we extend the observation window to such posthuman distances and timescales. Due to the expansion of the universe, in fact, there will come a time when even the closest stars will recede beyond our cosmic horizon, and astronomy itself will no longer be possible. The night's sky will eventually become, both luminously and epistemologically, black.

The posthuman appears, then, as a function not only of time but also of space. Programmatically, the posthuman is conceived as a temporal category, with the prefix "post" generally understood to mean following from yet in some ways continuous with the human. Recall again Wolfe's posthuman, which, paralleling Lyotard's notion of the postmodern, comes before and after humanism's human.[104] Various thinkers of postmodernism have engaged space—for instance, Fredric Jameson via his notion of "cognitive mapping."[105] The contemporary extends this dimension further, in Peter Osborne's terms, through the "spatialization of historical temporality," which supplants the progressive historical time of modernity with its planetary expanse.[106] Understanding the posthuman through the contemporary in this way, the temporality of the pre-/nonhuman, human, and posthuman turns on its spatial equivalent as fractured global simultaneity. Accordingly, Oliveros's engagements with distance performance implicate this spatial posthuman as a function of distance—from the subatomic to the intergalactic, and indeed from terrestrial coloniality to its ideological echoes across the cosmos (and vice versa). "I got very interested in the distance between the record head on a tape machine and the playback head. That little distance meant that you had a delay."[107] On the one hand, distances include such small tape machine adjustments that create delays and feedback processes ultimately leading to the posthuman ambitions of her EIS system. On the other, Oliveros imagined the depths of Deep Listening extending not only to the moon, the solar system, and other star systems, but even approaching the ends of the known, and perhaps knowable, universe. "What if we could sound out, hear and perceive the shape of the universe," she wonders, "by bounding sound around the torus?"[108]

Oliveros encourages us not only to hear space differently, but also to listen to the differences we create through and with space.[109] We've seen how

historical conceptions of extraterrestrial space have shaped our understanding of spatiality on Earth, which we in turn map back onto the cosmos. How such a dynamic will play out in the future is doubtless yet to be determined. But we can nonetheless shape its functioning, listen to its foundations. I'm reluctant to concede that *Echoes* fully conceals what it does within a black box, even though we may never know the effects of its lingering broadcast signals as they ripple through deep space. Rather, Oliveros's postformalist experimental work poses extra-musical questions that, while open-ended (and involving the senses), are discursively legible as they open, programmatically, onto unknowns. Specifically, as we project sound beyond the Earth's atmosphere and listen to its return, what happens to our understanding of the human—along with its multifarious reverberations in the posthuman—as we become extraplanetary? As we become "vocal astronauts"? Such questions invariably latch onto those earlier, seemingly insoluble inquiries, namely, *where is everybody?* and *what is the human? Or, who* is "everybody"? We may never receive a definitive answer to the question of extraterrestrial life, and if an unambiguous concept of the human depends on an encounter with aliens, we may never fully answer either inquiry. As we listen to the expanse of cosmological silence—as lifeless as it indeed appears—we're directed back to a perhaps more intimate unknown: the human. Listening even further, beyond human frames of reference, we find a margin not only from the known but also from what is knowable. Rather than collapse such distances, Oliveros plumbed their depths in her lifelong improvisation with listening.

5

Engendering the Digital: Digitality and the Posthuman Hand in Laetitia Sonami's Lady's Glove

Introduction

The hand is intimately human. It is at once an instrument and a surface for the inscription of gender, sexuality, race, class, and ability. At the same time, the appendage that gave rise to counting points to an inchoate digitality found at the heart of the posthuman.

It is the year 2000, and the French American composer, artist, and instrument designer Laetitia Sonami takes the stage at the New York performing arts venue Roulette to present *Why __ dreams like a Loose Engine (autoportrait)* (2000); she dons a form-fitting Lycra glove on her left hand.[1] This wearable controller device, which Sonami has called the Lady's Glove since she introduced the instrument in 1991, is translucent and covers the forearm to just past her elbow. Vein-like wires extend from the backs of the fingers and travel along her arm, feeding into a partially viewable onstage computer after passing through a hip-worn rectangular device that consolidates a number of cables and knobs.[2] Bending slightly at the waist, Sonami reaches outward and warbles the gloved hand back and forth at the wrist, slowly, as though caressing the head of a child. With each undulation, a synthetic pitched percussion sound issues from the onstage loudspeakers, altogether producing a broken, half-step melody over a subtly modulating drone. A vocabulary of gestures ensues, each movement tied to a change in sound: choreography preceding its own accompaniment.[3] Her hands separate gradually like an accordionist's, for instance, yet rather than reeds or bellows, a synthesized voice swells according to her hands' spacing. Smaller, single-digit movements near her mouth trigger granulated speech fragments, and arrhythmic glitches accompany Sonami's frustrated struggle with an invisible gear shift. "You ride," Sonami intones a text by her longtime collaborator, Melody Sumner Carnahan. She continues, "The wrinkles on your hand," pointing to her gloved palm,

"are deeper than the ones around your eyes." As much as it is already a kind of tool, the hand also communicates.

In Sonami's work with the Lady's Glove, the hand mediates between electroacoustic sound and (para)linguistic signification, while it metonymizes the body as an instrument of social reproduction. Part of a body of work Sonami calls "performance novels," *Why __ dreams* describes a train traveler whose thoughts meander from the close-at-hand—including the narrator's own jewelry, perfume, clothing, and reading materials—to observations and fantasies involving other passengers. These impressions range from the color of travelers' facial and pubic hair to descriptions of familial relationships to stories involving reproductive and gestational labor.[4] "The patterns on the old woman's scarf lead you into her thoughts," Sonami chants while gesturing, semicircularly, toward the audience. "She died when her last child was born." Sonami's bodily movements run on a distinct yet parallel track to the travelogue. At one point, the digits of her ungloved hand refer to an emotionally conflicted passenger whose heart is in "three sections"—altogether suturing the hand's simultaneous ties to numericity and corporeality. The hand, as we discovered with the voice in chapter 2, provides an interface between virtuality and embodiment and, by a similar token, between abstraction and physicality. At another point, both hands knead the air to a pulsing noise as a semi-crouched Sonami hovers over an imaginary basin. Despite its associations with the perhaps more ephemeral categories of care and affect, reproductive labor—work associated with caregiving and domestic life—is no less manual than its typically remunerated counterparts. Even beyond the paralinguistic, the hand itself narrates these labors of care, entanglements of desire, and productions of life. Sonami amplifies this metaphor of the speaking hand through her glove's digital circuits. A self-described "wired storyteller,"[5] she uses the Lady's Glove to weave together movement, sound, and text into intimate reflections on the body and its imbrications across contemporary technoculture.

The Lady's Glove expands this music-technological link between the body—replete with gendered and sexualized markings—and a posthuman imaginary premised on fantasies of cybernetic communication and control. Speaking to the origins of her instrument, Sonami suggests a resonance between music technology and the military roots of cybernetics, alluding to the at times uncritical adoption of robotics and combat-inspired joysticks in alternate controller design.[6] "Some of the control[ler]s that came out in the late '80s were these very robotic, masculine, 'let's fight the war' kind of controllers. So, I thought mine would be a French, sexy controller."[7] Such a description resonates with the version of the Lady's Glove Sonami wore in her 2000

performance of *Why __ dreams*, which along with its successor she imagined covering with fabrics comparable to the glovewear of Michael Jackson or Elizabeth Taylor.[8] As a "social commentary on technology," moreover, Sonami's glove speaks to a history of the hypersexualization of women who perform with electronic instruments, especially those who foreground the hands such as Clara Rockmore and her work with the Theremin.[9] At the same time, Sonami underscores latent influences of Cold War cybernetics on music technology. Prior to the paradigm of alternate MIDI controllers that emerged in the 1980s, Norbert Wiener saw a role for the hands not necessarily in sound's creation but in its tactile reception. The "hearing glove," which Wiener didn't invent himself but nonetheless demonstrated to Helen Keller at MIT in 1950, attempted to allow deaf subjects to "hear" through the fingers. Such a foray into "medical cybernetics" has been interpreted as one of Wiener's attempts to remediate damage from the very military weapons he had a hand in creating.[10] Apparently, Sonami wasn't the only one to point to a latent influence of the symbols of war on audio technologies. Roughly a decade after Wiener's demonstration, the composer and cybernetician Herbert Brün (as noted in this book's introduction) located a desire in electronic music to "make music with the weapons of death."[11]

Rather than weapons of death, Sonami envisions the hand and its technological extensions as digital instruments of care. Her first version of the Lady's Glove, which she unveiled in 1991 at the Ars Electronica festival, in fact consisted of a *pair* of rubber kitchen gloves that she wore on both hands. She outfitted these garments with sensors glued onto the left-hand fingertips: five transducers that measure the magnitude of the field generated between them and a magnet affixed to the right hand through a phenomenon known as the Hall effect (allowing, for instance, the accordion-like gesture described earlier).[12] Augmenting the common household garments with a bundle of wires that coalesce from holes punched in the fingertips, she refers to the gloves as "the perfect housewife's tool"[13]—a formulation further complicated by the slippage between an ability to read "perfect" as modifying either "housewife" or "housewife's tool." Sonami nevertheless extends such complex references to domestic work, not only by suggesting that one could "do music while [doing] the dishes," but also by comparing the use of her system to the performing of service labor. Conjuring the image of a subordinated, feminized hand serving up soporific musical commodities, Sonami correlates her role as performer with that of a "glamorous waitress" for an audience on the verge of sleep.[14] The ostensible target of her quip is excessively "academic" new music concerts, yet Sonami also takes issue with contemporary laptop performance, and its supposed lack of physicality, as an outgrowth of computer

music's historical de-emphasis of the body's role in computational processes. According to Sonami, with the arrival of computer music, "you could have cut everybody's body off."[15] Sonami's broader project takes aim, then, at the purportedly dematerialized domain of the digital through the discourse and practices of computer music and its entanglements with experimentalism.

Cybernetics was integral to the notion of digitality at the heart of computer music and its various uses in experimentalism. Since her first version of her Lady's Glove, Sonami has used the instrument to control, in addition to various hardware (and later software) synthesizers, audio playback and digital samplers.[16] The latter is a technology based on the watershed breakthrough in cybernetics that not only laid the foundations for the digital audio paradigm later found in CDs, MP3s, and today's online streaming services, but at the time provided composers and engineers with the ability to represent audio using a time-ordered series of numbers—one of the basic premises of computer music. Pulse Code Modulation, or PCM, is a method for digitally representing an analog signal by sampling its amplitude at a regular time interval (the *sampling rate*) and correlating each sample to a numerical value (rounded up or down, or *quantized*, the precision of which is based on how many numbers are available for the representation, or the *bit depth*).[17] Together with Claude Shannon, the scientist (and SETI researcher) Barney Oliver and the engineer and computer music composer John R. Pierce are credited with the invention of PCM while in residence at Bell Labs during the 1940s and 1950s. Later on, the discovery would underlie, for instance, the complex forms of granular synthesis—a sound generation technique based on splitting a recorded sound into smaller, milliseconds-long "grains" and then recombining them according to various algorithms—heard in Sonami's *Why __ dreams*. At the time, PCM supported a wave of computer music activity at Bell Labs, including the work of James Tenney and Max Mathews. In addition to the alternate MIDI controller precursor known as the Radio-Baton, Mathews developed one of the first languages for computer music composition in 1957, known as MUSIC—an ancestor of Max/MSP, the eponymous language for real-time computer music applications that Sonami uses to this day. Uses of these tools, with perhaps the exception of Tenney's algorithmic music, have often centered around an increased control of sound.

Sonami's metaphor of the hand intervenes into digitality as a mechanism of cybernetic control, while it speaks to experimentalism's artistic attempt at control's negation. Recall from this book's introduction Tenney's characterization of his 1964 Bell Labs computer music work *Ergodos I (for John Cage)*, in which, through an attempt to hand over artistic control to the algorithm, Tenney's "last vestiges of external 'shaping' ha[d] disappeared." Tenney also

shared Cage's interest in avoiding the implications of control found in the serialism and post-serialism of musical modernism. Tenney's use of *ergodicity*—a concept borrowed from probability theory that refers to the use of random variables in stochastic processes that effectively cover a system's entire possibility space—was his way of reformulating Cage's chance procedures using algorithms: a kind of cybernetic formalization of indeterminacy. Tenney further saw his use of such algorithms as a way to undermine the presence of a "guiding hand" whose dramatic expression was ultimately no different from that of Beethoven.[18]

Born in France, Sonami received formative musical training in the US from the experimentalists Robert Ashley and David Behrman at Mills College, along with the late electronic music composer Joel Chadabe in Albany. Sonami was also a student of Éliane Radigue; while she emerged from the tutelage of Pierre Schaeffer and Pierre Henry in Paris, Radigue has achieved as much, if not more, notoriety in the context of North American experimentalism than in France. One result of this background can be seen in Sonami's embrace of a DIY approach to instrument building closer to the electronics work of David Tudor perhaps than the stricter composer–engineer paradigm found at European institutions like IRCAM—even though she has worked with engineers, for instance during her residency with Amsterdam's Studio for Electro-Instrumental Music (STEIM). This is not to essentialize her approach based on training or geography.

Yet an important consequence of Sonami's experimental background is nonetheless apparent in her embrace of indeterminacy. In one of her final appearances with the Lady's Glove (in 2015 she retired the glove to focus on her latest instrument, the Spring Spyre), Sonami describes a shift from an interest in control and power in her early glove performances to a desire for greater "inefficiency and unpredictability." She urges users of wearable interfaces and alternate controllers to "move beyond illusions of control."[19] Control may ultimately be illusory, yet rather than relinquish it, Sonami reroutes it. As opposed to cybernetic "dreams of control," Sonami locates a form of indeterminacy—a kind of anatomical contingency—in the biomechanical functioning of the hands: "the bending of one finger forces other muscles to trigger and contribute to unintentional events which in turn shape the performance."[20] Metonymized by the hand, the body itself becomes a vector of indeterminacy. Indeed, if experimentalism has sought, through indeterminacy and stochastic algorithms, to bypass the composer's hand (detectable in art music all the way from romanticism to post-serialism), then Sonami's work with the Lady's Glove attempts, in her words, to "bypass the brain"[21]—precisely through a critical *return* to the hand. Sonami's formulation can be read, furthermore, as

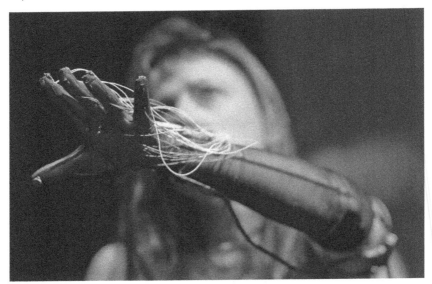

FIGURE 4. Laetitia Sonami performing with her Lady's Glove instrument. Photo by Joker Nies.

an inversion of Alvin Lucier's fantasy of "bypassing the body,"[22] while it situates "control" beyond both computation and neurology. It's important to consider Sonami's work, then, not as a regression to traditional forms of human expression embodied in the hand, but as a reconsideration of embodiment in experimental music especially as it concerns virtuality and the digital. Sonami articulates, in this sense, the posthuman hand (fig. 4).

This chapter shifts from the cosmic to the close-at-hand to consider the subjects of digitality and the posthuman hand in Sonami's performances with the Lady's Glove. For nearly twenty-five years Sonami used different versions of the wearable controller for the real-time manipulation of digital sound. Sonami introduced the first, "kitchen wear" version of the Lady's Glove, as noted, at Ars Electronica in 1991, for a collaborative performance with the American artist and composer Paul DeMarinis based on *Mechanization Takes Command: A Contribution to Anonymous History*, a 1947 text by the Swiss architectural historian Sigfried Giedion.[23] Giedion's text describes among other things the historical effects of automation and mechanization on the human body, even anticipating a posthuman conception of the hand in referring to the organ as a "prehensile tool."[24] In their multimedia text setting, Sonami and DeMarinis refract Giedion's *Mechanization* through manualization and competing forms of digitality. While Sonami dons her "housewife's tool," DeMarinis commands a video game controller designed by Mattel Toy Company in 1989 known as the Power Glove. In addition to her criticism of the aggression

linking video games and alternate controller design, Sonami also describes the Lady's Glove as a response to the "heavy masculine apparel" found in virtual reality systems.[25] In the third version of her glove, she nevertheless incorporated sensors from the Power Glove, a device that brought such VR aesthetics to consumers and used a tracking function based on the reflection of audio signals above the range of human hearing—a technique associated with obstetrics known as ultrasound. The chapter concludes with a consideration of gestation and gesture in *What Happened II*, in which she uses her gestural controller to portray familial reproduction and its disintegration.

Sonami's performances imbue computer music with the analog contingency of the gendered and sexualized body, while her Lady's Glove points to a tacit continuity between the body and number inherent to the concept of digitality. Speaking to her glove's somatic and libidinal dimensions, Sonami contends, "Through gestures, the performance aspect of computer music becomes alive, sounds are 'embodied,' creating a new, seductive approach."[26] While glove controllers may involve novelty, the hand has a history in both music and computation: the medieval mnemonic device known as the Guidonian hand, for instance, tied the task of dividing the musical hexachord to the palm, thumb, and fingers; the early modern musical keyboard was often referred to as an abacus; and early computing used punch cards that mirrored the hand-punched rolls found in Joseph Marie Jacquard's early nineteenth-century update of Vaucanson's automatic loom.[27] More recently, the term "computer"—not unlike "typewriter" as noted in chapter 2—referred to manual work: calculations performed by women prior to their automation—altogether pointing to the significance of embodiment in music and computation. Furthermore, some consider the ability to count—a capacity that underpins modern science as much as it does the emergence of market liberal humanism—as a form of human difference attributable to the biological uniqueness of the hand.[28] Yet while opposable thumbs may distinguish us "externally" from other primates, humans have created various "internal" differentiations based in part on the role assigned to the hands.

Sonami's Lady's Glove suggests an understanding of musical performance that parallels the use of the hands in domestic care and housework. Indeed, if music, markets, and computation can be variously reduced to forms of counting, then such reproductive work—as a form of non-remunerative or "decommodified" labor—is, precisely, work that is *not* counted.[29] In addition to considering Sonami's collaborative performance *Mechanization Takes Command: Verses from Giedion's Bible* (1991) alongside themes of automation and digitality, this chapter analyzes the Lady's Glove in the context of feminized labor and reproductive work. Altogether, in her chiro-choreography

106 CHAPTER FIVE

conjoining virtuality and embodiment, Sonami's posthuman hand rearticu-
lates the digital by accounting for the uncounted.

The Posthuman Hand Takes Command: *Verses from Giedion's Bible*

The hand is, practically speaking, a mechanism. With it we reach, grip, and
grasp. Using our hands we hold, take hold of, and manipulate; we touch,
seize, love, and labor. It is 1991, and Sonami and DeMarinis take the stage in
the large concert hall of the Brucknerhaus festival center in Linz, Austria to
perform their collaborative multimedia work based on Giedion's *Mechaniza-
tion Takes Command*. Sonami wears the first incarnation of her Lady's Glove,
which as noted consists of a pair of rubber kitchen gloves wired with sensors
and magnets. DeMarinis is outfitted with a modified Power Glove, a video
game controller originally designed for use with the Nintendo Entertainment
System; released less than two years prior, the glove was discontinued in 1990
following criticism of its cumbersome controls and imprecise functionality.
The duo stand side by side, semi-formally dressed, facing their onlookers—
American Gothic for the information age, the iconic three-pronged pitchfork
replaced by three five-fingered datagloves. In front of Sonami and DeMarinis
sits a table positioned lengthwise across the stage. Yet rather than cutlery or
plates (to complement Sonami's kitchen garments), the table is set with an
arrangement of electronics and computing equipment. An array of cathode-
ray tube monitors faces Sonami and DeMarinis and illuminates various de-
vices and cables. The wires connect the duo's controller interfaces to Macin-
tosh computers running Max/MSP patches that filter and route MIDI data
streamed from the respective gloves, Lady's and Power. Instead of a home
video game console for the latter, though, another monitor displays custom
speech synthesis software written in C running on an IBM Personal Com-
puter AT (Advanced Technology) machine. This computer, along with exter-
nal hardware synthesizers, takes commands from Sonami and DeMarinis's
hand-worn devices. Mechanization and its technological reflection in the
digital, in effect, take command over the Linz audience throughout the duo's
performance.

 With a focus on the hand and its incipient ties to digitality, Sonami and
DeMarinis extend Giedion's technological history to a confrontation with
the contemporary posthuman. The duo describe the performance as a song
cycle, a text setting of "verses" from *Mechanization* that includes musical ac-
companiment as well as movement. The IBM computer's speech synthesis
program voices three sections of Giedion's text—"The Hand," "Mechanization
and Death: Meat," and "The Mechanization of the Bath"—alongside melodic

material and rhythms derived from a computer analysis of the tonal and temporal features of the text. Synthesizers and samplers give life to these musical textures which, along with the speech synthesis output, receive further manipulation from Sonami's and DeMarinis's glove controllers. The effect is a kind of puppetry—itself an ancient ancestor of robotics—engineered to manually command the digital mechanisms of synthetic speech. Speech synthesis, as noted in chapter 2, emerges from the fields of computational linguistics and natural language processing, fundamental research areas of cybernetics and AI that are also related to automation and robotics.

Here the speech synthesis application written in C uses a technique known as Linear Predictive Coding, or LPC, which simulates the vocal process as a series of excitations, or "buzzes," taking place at the end of a tube: the throat. In addition to mouth-based hissing and popping sounds that correlate to sibilants and plosives, LPC models throat activity by describing changes in loudness and pitch, and variable distributions of spectral energy, or *formants*, that correlate to changes in the vocal tract which produce different vowel sounds. LPC uses a number (or set of numbers, in the case of formants) to describe each of these parameters. At a rate of thirty to fifty digits per second, it can produce intelligible speech patterns. Yet as these frame rates decrease, speech becomes less human-like and more "robotic." Recalling our discussion of robots in chapter 3, Sonami and DeMarinis refer to this biomorphic aspect of LPC—its simulation of human anatomy—as a series of bodily subtractions: "nasals without nose, plosives without lips or tongue," and "chest resonance without chest."[30] Acousmatically puppeteered through this chain of disembodied lack, our synthetic sänger (gendered masculine) takes command from (and at) the hands of Sonami and DeMarinis.[31]

The duo ventriloquize this cybernetic vocalist to enunciate Giedion's encyclopedic cataloging of technological mechanization and its decentering effects on the human. One immediately detects an ambiguity with respect to the meaning of "command" in Giedion's title, *Mechanization Takes Command*. Does mechanization take command *of* or *from* its human operator? The latter reading encapsulates first-order cybernetics understood as a program of control and communication, whereas the former anticipates the posthuman conceived as cybernetics' undoing of human agency through technological, environmental, and informational networks. Although Giedion wrote *Mechanization* while living in the US during the second world war, and his text was published the same year as Wiener's *Cybernetics*, the Swiss architectural historian had only learned of Wiener's work, a project for which he ultimately expressed great sympathy, after the two met at a conference at MIT in 1950.[32] *Mechanization* nonetheless draws upon physical, physiological, and biological

models of homeostasis comparable to Wiener's in which, just as *Cybernetics* illustrates with the operation of a thermostat, opposing forces dynamically counterbalance one another. Each of *Mechanization*'s chapters—which stretch from agriculture to bathing to bread-making to kitchen mechanization to Taylorism to Fordism—attempts to portray how technology has upset the equilibrium between humans and their environment. Such an imbalance Giedion locates, for instance, in the mechanization of livestock production and in various graphic depictions of "meat," which some commentators interpret as a metaphor for the human body and the violence of war.[33] Yet rather than simply arguing "for or against mechanization," Giedion seeks to recover a new balance, an "equipoise" between the human and its technological surroundings, between organic and artificial existence.[34]

Sonami and DeMarinis focus on passages from Giedion's text devoted to human anatomy, bodily care, and the mechanization of (non)human death. In the section titled "The Hand," against a backdrop of dataglove-guided electroacoustic sounds, the synthetic vocalist intones, "The human hand is a prehensile tool, a grasping instrument." An irony arises in that neither Sonami nor DeMarinis grasps anything of physical substance, despite their various digitally choreographed gestures' suggestions to the contrary. At the same time, their hands do function as instruments, both musical and perhaps in the sense implied by Giedion's paradoxical characterization of the reaching organ as a "prehensile tool."[35] On the one hand, such a phrase appears to conflate the thing with its user, since we generally understand tools as objects that, while often functioning as our prosthetic extensions, remain categorically distinguished from the body. Tools are objects the hand typically grips. They are, as Heidegger tells us, ready-*to*-hand, not the hand itself.[36] On the other, the formulation suggests a conception of the body in which the hand provides the biological preconditions for humans as tool-using beings. In this sense, the physician and philosopher Raymond Tallis's description of the hand as a "master-tool, the father of the possibility of tools"[37] might, if not for its patriarchal implications, appear apt. In either case, the question of control comes into contact with unpredictability and, in Sonami's treatment, the notion of indeterminacy. For Giedion, the brain commands the hand regardless of whether the task is artistic, artisanal, or in the service of domestic work; voiced by the LPC robot, the hand passage continues: "The kneading of bread; the folding of a cloth; the moving of brush over canvas: each movement has its root in the mind."[38] Sonami, whose kitchen wear accords to an extent with the historically feminized tasks of bread-kneading and cloth-folding, as noted, would later point to an anatomical contingency beyond conscious manipulation precisely in the biological functioning of the hand: the

movement of one finger may cause the unintended behavior of others. When performed with her Lady's Glove, such an outcome leads to indeterminate musical results. Although Sonami notes that at this point in her development she was positively concerned with control, virtuosity, and even power, she also describes the gloves' inception as stemming from a desire to sever the hands from direct cognition.[39] Nevertheless, the robot voice intones: "Each movement depends on an order that the brain must constantly repeat." Does this mean that the brain is ultimately in command? If the brain orders the hand, what forces operate on consciousness?

Technology, according to Giedion, is a force that commands *us*; mechanization is a process that happens to humans. Notably, each of the manual activities enumerated above (painting, bread-kneading, cloth-folding), while gendered and raced differently throughout history, is likely to be a component of unwaged labor. Such nonremunerated work, as autonomist feminist Marxist thinkers like Silvia Federici and Leopoldina Fortunati have argued, has been integral to the functioning of capital and social reproduction.[40] Yet rather than understanding the hand's behavior as influenced by political-economic forces, or by their collusion with patriarchy in the case of domestic labor, Giedion contends that mechanization lies at the seat of command. This is not to suggest that control and communication operations comparable to those of first-order cybernetics are absent from Giedion's text. Indeed, extending his technological understanding of the hand's physiology, for instance, Giedion underscores the appendage's ocular support in contending that "[t]he eye steers its movement."[41] Recall that the term *cybernetics* derives from the Greek κυβερνήτης, or *kybernētēs*, which refers to a "governor" or the *steerer* of a ship. All hands on deck: synecdoche for the master metaphor that is the hand of the steerer. But as technological navigation gets more and more out of control, Giedion contends, humans stray further out of balance with their surroundings, left in the end without equipoise. Beyond an account of the steersmen of history, however, the Swiss academic rejects the notion of "great men" in his *Contribution to Anonymous History*, the subtitle of his monograph. Rather, mechanization operates in Giedion's account as what Christopher Hight calls an "autonomous life force" that effects historical change and ultimately "molds" human life and shapes consciousness.[42] A form of anthropocentrism is nonetheless present in Giedion's centering of "man" and what he refers to as the "human standpoint."[43] Yet, for all of that, he devotes considerable attention to life typically considered beyond the purview of "man"—namely, women and animals.

In their reflection on nonhuman life, Sonami and DeMarinis bring Giedion's account of the mechanization of death found in livestock industrialization

into contact with their musicalized vision of the contemporary posthuman: nonhuman death and its contemporaneousness with posthuman life. In one of the sections of "Mechanization and Death: Meat," they protract Giedion's technological understanding of the hand—indeed its "machine-like" operation—in their setting of his extended quotation of an architect's visit to a nineteenth-century pork-packing site in Cincinnati. The LPC robot recites Giedion's quotation of Frederick Law Olmsted's account: "we found there a sort of human chopping-machine where the hogs were converted into commercial pork." Accompanying the computer voice (itself perhaps a chopped up "human–machine") is a muted synth pad wielded through the duo's hushed gloved gestures, which results in a series of overlapping tones that dissipate into a single drone. After a few seconds, the synthetic voice returns in a register that matches the low-pitched pedal tone, together producing a subtle robot vocal fry further augmented by upwardly swirling accents of filtered noise: "No iron-cog wheel could work with more regular motion." Upon that texture's brief fade into silence, a quick succession of pitched percussion tones creates an angular figure that melodically mimics the next line of text: "Plump falls the hog upon the table." A similar pattern of mimicry continues with "chop, chop, fall the cleavers," and "chop, chop, sound[s] again," each of which recurs before Sonami's and DeMarinis's meat-worker mimetics widen and crescendo to climax with the repeating two-note motif "chop, chop / chop, chop."[44] A synonym for "motif," "motive" is an appropriate term for this kind of repeated musical figuration; the word also refers to motion and mechanization—as in "motive force"—which hints at the worker's machine-like manual movements. Meat figures for Giedion as a recurring motive for the degradation that technology inflicts upon the human body which ultimately culminates in death. Here the glove-guided slaughtering mirrors the textual dissociations that link the chopping hand to its conscious inscription to its writing to its quotation and, eventually, to its synthetic reconstruction. Hand in glove; corpus into corpse.

Sonami and DeMarinis homologize the dismembered animal carcasses with the disembodied aurality of LPC synthesis, which they further dissect into musical structures. "Here we have excised melodies like bodily organs," the duo contend, "trimmed away fat and gristle to reveal underlying harmonic and rhythmic skeletons."[45] Until this point, Sonami's rubber kitchen gloves read perhaps as stable signifiers for housework or domestic labor despite the technological enhancements necessary for their alternate controller functions. In "Mechanization and Death: Meat," however, Sonami's kitchen gloves become protective coverings for the hands of a butcher.[46] Signifiers associated with a subordinated gender slip into others that signal the carving up of a subordinated

species. Throughout this tacit transition, DeMarinis's Power Glove retains its associations with video games and virtual reality. Together, the technological coupling suggests a variation on the subcultural term "meatspace," which has been used to contrast with VR, cyberspace, and, more recently, the online space of the Internet. The digital, as we'll later discuss, consists of a *carving up*, or making discrete of such analog space. The phrase "in real life" (IRL) here conjures multiple opposites, including (in)authentic death and VR.

Over a faux-harmonica melody pastorally outlining a pentatonic scale, the voice synthesizer returns: "The transition from life to death cannot be mechanized if death is to be brought about quickly and without damage to the meat. What mechanical tools were tried out proved useless. They were either too complex or outright harmful."[47] As the account of mechanized death continues, two projectors bookend the stage and display 35-millimeter slides culled from the more than five hundred black-and-white illustrations that accompany Giedion's text, along with additional color images that further inflect the display. Eadweard Muybridge's motion studies and Marcel Duchamp's cubist reinterpretation of them shift to a photograph of chickens killed by hand and a diagram of a pig-killing apparatus, which transition to an engraving of eighteenth-century handicraft workers and a 1917 vacuum cleaner ad: from motion to the hand to (its) mechanization.[48]

And from death to regeneration, if we take Giedion at his word, then mechanization was born in a bathtub. "The Mechanization of the Bath" is the final section of Sonami and DeMarinis's performance and the penultimate part of Giedion's book. Far from an afterthought, baths are forerunners of Giedion's mechanization: "The present-day type of bath, the tub, is actually the mechanization of the most primitive type." The robotic voice synth chants: "The brilliant Minoan age, the last matriarchy, possessed not only bathtubs, but sewer systems and water closets."[49] Although historians have debated whether the Minoans were matriarchs, Giedion's point is that bathing reveals a culture's attitude toward bodily care. As much a social as a technological problem, bathing since antiquity breaks down for Giedion into two main camps: private ablution and communal regeneration. Whereas the former is mostly functional and exemplified in the modern cell-bath (i.e., the private bath found in most homes today), the latter takes place in bath houses and is valued for its sociality, even used as a "gauge of culture."[50] Not only is the decline of regenerative bathing evidence of modernity's depletion of leisure and free time; the rise of the private bath signals our immersion into full mechanization. "No period before ours has so unquestioningly accepted the bath as an adjunct to the bedroom." The robot voice continues: "Each of its components was the outcome of a slow, tedious mechanization; hence the

bathroom with running water emerged only toward the end of the last century, while not until the time of full mechanization between the two World Wars was it taken for granted."[51] The architectural historian notes further that during the nineteenth century hot water had to be heated in the kitchen and moved by hand to the bathroom in buckets. The advent of plumbing that brought running hot water into the bathroom sink was thus a major labor-saving device.[52] Similar forms of mechanization would later facilitate what Giedion refers to as the "servantless household," the rationalization of which leads to the domestic application of scientific management principles that placed even further demands on women and their labor.[53]

Sonami's Lady's Glove exfoliates this historically raced and gendered division of labor ("servantless household") in reproductive care work, while it points to fantasies of its fully disembodied virtualization. Throughout *Mechanization* Sonami wields her gloves to trigger sounds and, to a varying degree, control the synthesized voice of Giedion. Yet her manual motions, while at times mimicking the work of caregiving (or butchering), do not encounter the kind of resistance or friction found, for instance, in dishwashing or sponge bathing—the latter being a historically feminized task typically associated with infant or elder care and for which special gloves are often worn. Rather than performing such activities, Sonami supplants them with her virtual rendering of computer-synthesized voices and sounds together conceived as a critical response to the problems of digitality and embodiment.

Sonami identifies, in this sense, the ideal composer-subject of computer music as a "brain in a jar."[54] While alluding to the underrepresentation of nonnormative bodies, including people of color, women, transgender people, queer people, and disabled subjects in prominent computer music centers since the 1950s, such a figure also brings into relief Sonami's project of highlighting reproductive and care labor in experimental music.[55] The "brain in a vat" is a thought experiment often used to illustrate Cartesian dualism and found in popular science fiction, including the Wachowskis' 1999 vision of fully automated human reproduction in which VR-connected babies are grown in amniotic tubs.[56] Other visions of the posthuman, Sonami and DeMarinis's performance suggests, can be traced through a history of mechanization that ranges from bathing and care labor to food industry work to the very physiological functioning of the hand. The hand is a touchstone for mechanization, while, as an anatomical facilitator of counting, it also gives way to calculation and even to computing. Digitality, understood as the formally computed discretization of an apparently continuous or analog reality, is a register that, whatever its philosophical or theoretical implications, ultimately springs from the intimate functions of the human hand. Together, this

hand and its human operator provide the digital's conditions of possibility and emerge not from a vat but through lifetimes of care.

Care and Counting: Digitality from the Hand to the Human

As much as the hand is a mechanism of movement and manipulation, it is also a device of measurement: we use our hands to quantify, to count. In the process we mark time, express magnitude, show dimension, and, perhaps most importantly, encode number. Rather than downloaded (as in the Wachowskis' dystopian vision), the latter capacity is cultivated through human developmental learning, which prior to its striation into subject areas like mathematics, economics, and music we acquire during childhood. Evidence suggests that even days-old infants can discriminate between numerical values of two and three.[57] Nevertheless, we learn to count on our fingers with the help of parents and caretakers before assimilating the system of marks and vocalizations that invariably refer to such digits. Musical pedagogy extends beyond nursery rhymes like "One, Two, Buckle My Shoe"—whose particular lyrics are filled, programmatically, with myriad manual operations—yet retains similar links to counting and chirality. The Guidonian hand was a medieval pedagogical device, as noted, in which singers point with one hand to physical locations on the palm, thumb, and fingers of the other in order to recall members of the hexachord; as a way to enforce musical taboo, dissonances and chromatics were considered "off the hand." Counting patterns are taught in basic musicianship classes and in learning vocal and instrumental technique; prior to the autonomous conductor of the nineteenth century, ensemble leaders in the Western tradition were also expected to conduct. Audible counting with the hands, while found throughout non-Western and improvised musics, has been historically denigrated as with foot-stamping in art music, notwithstanding recent exceptions like Steve Reich's 1972 *Clapping Music* or, indeed, Yasunao Tone's lesser-known precedent, *Clapping Piece* (1962). Beginning in antiquity, the monochord taught us fractions and precise numerical ratios as the basis for Western harmony and tuning systems, at least prior to the prevailing adoption of temperament. And we deploy the hand in calculations both musical and mathematical using the modern keyboard, an observation that led the seventeenth-century scholars Athanasius Kircher and Marin Mersenne to use "abacus" interchangeably to refer to the keys of harpsichords and the pedagogical calculating device.[58] Acquired through teaching and care, such forms of manual music computation point to a continuity between number and body that extends through the notion of digitality.

Sonami's Lady's Glove not only refers to housework and cleaning, but also underscores the dimension of care labor common to both child-rearing and such forms of digital music pedagogy. In addition to presenting her work at conferences and guest lecturing in university settings, throughout her career Sonami has used her instrument to teach digital audio, electronics, and computing to primary- and secondary-school students including young women and populations underrepresented in both STEM fields and new and experimental music. "It's called a PC board," Sonami explains to a student as she points to circuits attached to the underside of her gloved arm while demonstrating her instrument to a class of forty-five at San Francisco's June Jordan School for Equity.[59] Sonami's daughter, Chinzalée Sonami, recounts bringing her gloved mom to "show and tell" for her physics and music classes throughout childhood.[60] And more recently Sonami has tutored young artists and composers at various levels of experience, including college and graduate students. Such activities may be understood as supportive of her musical practice, comparable perhaps to her auxiliary yet integral body of installation work, especially given Sonami's overall focus on proscenium performances such as *Why __ dreams* and *Mechanization*.

Yet it is perhaps indicative that few of the scholarly or critical accounts of Sonami acknowledge such teaching activities as relevant to her artistic work. One explanation can be found in the restricted work-concept that new music institutions inherit from aesthetic modernism: for composers, that is, musical output is judged by the aesthetic merit of individual works, usually referred to as "pieces," rather than by an understanding of the artist's work as a *practice* that may include, yet fundamentally exceeds, the sum of such works. Emerging from a genealogy of the historical avant-garde and its transformations into contemporary art, the umbrella of "social practice" art—which has come to describe more of a constitutive than an outlying aspect of contemporary art—departs from aesthetic modernism in its shift away from autonomous works and toward work conceived as both labor and practice. Specifically, cleaning and care labor can be found in Mierle Laderman Ukeles's feminist interventions with sanitation workers and child-rearing since the 1960s. And using an approach derived from the radical pedagogy movement, Tania Bruguera in her *Cátedra Arte de Conducta* (2002–2009) founded an art school in Cuba and presented it as art.[61] Such a lineage, furthermore, should not be considered as outside Sonami's purview since, in addition to her graduate training at Mills College, she studied for a period at the School of the Museum of Fine Arts, Boston and has since taught at a number of fine art schools.

Another reason for the underappreciation of Sonami's musical practice, particularly as it relates to teaching and care work, may relate to the fact that

such historically raced and feminized forms of reproductive labor themselves are undervalued. We acquire the skills of counting and arithmetic from caretakers and teachers—skills that form the basis of modern computation—yet such work itself goes undercompensated or indeed uncounted. In *Making Care Count*, the sociologist Mignon Duffy includes teachers alongside nurses, child-care workers, physicians, and social workers—in addition to housekeepers, hospital laundry operatives, nursing home cafeteria operators, and, in the context of health care, even secretaries and clerical workers—in the category of care labor.[62] Although focused on paid care work, the study builds from a critique of political economy that stretches back to Marx and Engels's original conception of reproductive labor to refer to activities that reproduce the workforce. Similar critiques draw from the autonomist Marxist feminist tradition and address unpaid work. Unpaid work may take the form of internships or other formal or professional activities found in music and artworld institutions—and are perpetuated, ironically, by the otherwise often progressive activities of social practice—which Leigh Claire La Berge critically identifies as "decommodified labor."[63] Federici has argued that as with other forms of uncompensated labor, reproductive work should be remunerated; at the same time, she contends that wages should not simply reinforce the naturalization of such work as somehow belonging to women, as in sexist notions concerning a woman's "place." Rather, in arguing for "wages *against* housework," she seeks to counteract such heteropatriarchal associations while underlining other forms of uncompensated work that, only when taken together, allow capitalism to function.

An important symbol of work, the hand metonymizes the human. An anatomical marker of dexterity, it facilitates an ability to count that some identify as a key difference separating humans from other primates. Owing to our hands' versatility, their degrees of freedom, and the variety of grips of which we're capable, Tallis contends that the hands have led humans to become "animals that *choose*."[64] This gives way to our ability to discretize, to carve up reality into finite entities that we affix to symbolic representations. Altogether, this discretionary capacity extends from and contributes to our powers of abstraction of which quantity is paradigmatic. We are, consequently, able to determine the difference between amounts of, say, ten and seven, which are distinct from approximate magnitudes like "many" and "a bit fewer." As Tallis contends, "Our 'three' is different from a chimpanzee's 'three': the latter is a comparative magnitude and the former an abstract quantity."[65] Yet along with such "external" evolutionary differences, humans have insisted on a variety of "internal" distinctions based, especially in the case of workers, on the role assigned to the hands. Women have been defined historically by reproductive

labor executed, in part, by the hands, although unlike their male counterparts such work is often made both economically and symbolically invisible. Political economy (and its critique) is filled with iconic references to the hand, from manual labor to the fist of revolutionary class struggle to the recent discourse of digital labor to the "father" of political economy Adam Smith's figure of the invisible hand.[66] Through her musical and pedagogical practice, Sonami makes visible—and audible—the laboring hands of the mother, caretaker, and teacher that, however indispensable, are often ignored. Her Lady's Glove represents, in this way, a digital accounting for work uncounted.

Modern computing itself is based on related forms of historically feminized labor (specifically, accounting and clerical work), which following their automation were, in fact, no longer counted. Not unlike the way, as discussed in chapter 2, the term "typewriter" was used interchangeably to refer to both the device and its typically female human operator, "computer" once possessed a similar ambiguity. In an autobiographical note, the feminist theorist Anne Balsamo reports, "My mother was a computer," referring to the fact that throughout the 1940s her mother entered orders and performed hand calculations for Sears, Roebuck and Company; after some years, she was replaced by an electromechanical calculating machine.[67] Whether calculated by hand or executed by a machine, the digital is the medium of discretization through which such computation operates. While the hand provides a prototype for its machinic replacement (recall the Unimate arm from chapter 3), together with the fingers it serves as an anatomical reference point for the very *division into parts*—the quantization—that constitutes the digital: numerals composing the base-10, or decimal system represented by the fingers and thumbs, and the binary system of zeroes and ones that mirrors the two hands. The otherwise unbroken flesh of the body divides at our extremes, separating out into appendages, which further extend at the hands and feet into digits. The analog is to the smoothness of the flesh what the digital is to the appendage's striation.[68]

The body already gives us in this sense proto-number, an inchoate digitality nonetheless forged through reproduction. Even prior to its numerical systematization, digitality inheres in our discretionary capacity, our chiro-powered ability to distinguish. "The digital is the basic distinction that makes it possible to make any distinction at all," Alexander R. Galloway contends. "The digital is the capacity to divide things and make distinctions between them."[69] When we point things out, when we distinguish, a finger often leads the way. Such a distinction gives way to others. Soon enough, we have a number (of them). Distinction between two and three may already exist in newborns, yet its refinement, its humanization, emerges from reproductive pedagogy. We learn to count to ten. We learn the phrase "on the one hand . . .

on the other." Language, the structuralists teach us, is the ultimate differential system; a poststructuralist adds that writing is the "discretization of the flow of speech."[70] From the output of the mouth to its encoded traces in handwriting, the *mother tongue* pedagogically discretizes the body, makes us into digital animals that choose: actions, objects, words, numbers.[71] Fingers and hands; digits versus the logical pair: itself a binary, as Sadie Plant reminds us, homologous to the model of sexual difference upon which computation is built: "Man and woman, male and female, masculine and feminine: one and zero looked just right, made for each other: 1, the definite, upright line; and 0, the diagram of nothing at all: penis and vagina, thing and hole . . . hand in glove."[72] Transgender and queer subjectivities, and to a different extent, the superpositioning of zeroes and ones found in quantum computing, may complicate such a neat correlation.[73] Doubtless, modern computers use a variety of number systems, programming languages, and forms of symbolic representation. Indeterminacy and hardware failure complicate things further.

Nonetheless, it is perhaps not incidental that sexual and reproductive themes reverberate through the history of computing and technoculture. Recall, for instance, chapter 1's discussion of Moravec's fantasy of birthing digital *Mind Children*; this context accents its conflation of social and digital reproduction that, however seemingly novel, can already be found in computing's sociomorphic automation of gendered labor. Along similar lines, consider the notion of "babysitting" a computationally intensive process, or tending to a mainframe for instance in the early days of computer music. Recall from the 1990s the hand-held Tamagotchi devices that required users to feed and care for virtual pets. Or, think of the artist Sara Roberts's 1989 work *Early Programming*, in which a feminine LPC-robot voice repeatedly reminds users to eat their vegetables or, regarding the appendage of present concern, "keep your hand in the car unless you want to lose it."[74] In a related register, the parental commingles with the pedagogical in Sonami's characterization of her recent work with AI and machine learning. Referring to her use of the engineer Rebecca Fiebrink's machine learning software in her Spring Spyre instrument, Sonami explains that "with the artificial intelligence systems, with the software, you have to tell it, kind of like a child, 'when this happens, this is what you do.'"[75] Mirroring computing's historical automation of feminized calculation work, machine learning's own mechanization of pedagogical labor is concealed only by its nominal omission of a reference to the pedagogue herself. We don't call it machine teaching.

It was one of Sonami's own teachers, Radigue, who first suggested she use computers for composing music. Prior to her invention of the "perfect housewife's tool," which relies on real-time computer music software, Sonami

used analog synthesizers and cassette decks to create electronic music and tell stories during the 1970s in what she refers to as "live cooking shows."[76] Cooking shares with electronics and music a requirement to perform exacting measurements, follow detailed instructions, and count. (Computer scientists often use the metaphor of recipes to explain how algorithms work.)[77] Footage from one of these performances unites signifiers of the domestic, musical, and technological, depicting Sonami and a collaborator operating a series of mixers and keyboards while holding microphone stands embellished with Christmas-tree lights. She refers to her setup from this time as comprising "homemade electronics,"[78] a phrase that comes from a DIY lexicon in which Sonami would eventually find a home; here it also connotes actual domesticity. One of the instruments she used during this time was an Electronic Music Studios VCS 3 modular synthesizer, which Sonami found in the basement of the School of the Museum of Fine Arts. While not digital, the synth is certainly hands-on. In addition to a joystick, a notable feature of the VCS 3 is its three oscillators configured via a small on-board matrix router; by manually inserting a series of small colored pins into inputs on a signal flow graph one could, for example, direct a low-frequency sine wave to modulate the frequency of another audio-range waveform to produce a tone with vibrato. This is comparable to typical modular synthesizers in which users create customizable signal chains by plugging in a series of cables by hand.

Sonami's comments also remind us that computers, not unlike pianos, have only recently become domestic instruments. Early computer music, including Tenney's and Mathews's work at Bell Labs, was executed on large multimillion-dollar mainframes which, only after completing previously queued tasks, would take hours if not days to compute only a few minutes of digital audio. Around the time computing entered the household in the form of personal computers like the one Sonami and DeMarinis used for *Mechanization*, the engineer and computer musician Miller S. Puckette began work while at IRCAM on the real-time computer music language Max. Originally called The Patcher, Max is based on a digital simulation of the modular synthesis "patching" paradigm— whose connotations of weaving, patchwork, and other "women's work" already invoke the continuity between the nineteenth-century loom and early punch-card computing. Initially, Max handled only MIDI data and events; later it added digital signal processing, hence the name's addendum MSP, or Max Signal Processing (or the initials of its original programmer, Miller S. Puckette). Distinct from text-based languages like MUSIC or CSound, Max/MSP's graphical user interface allows programmers to configure any number of small boxes, or *objects*, each responsible for a computational function, by drawing virtual patch cables between their respective inputs and outputs. The language

has been pivotal for Sonami's stage performances, including those with the Lady's Glove, which have drawn upon a community of users who contribute original software in the form of "patches": programs assembled from functionally interacting sets of virtually connected objects. Such a design form—which incorporates elements from analog modular synthesis that become strictly speaking nonfunctional when ported to their digital counterpart—is referred to as a skeuomorph.[79] Like a note-taking app made to resemble a yellow legal pad, Max/MSP reversions an analog predecessor whose previous, manually operated functions—hand-patching compared to handwriting—it replaces with a digital update.

If, like Max/MSP, Sonami's Lady's Glove skeuomorphically returns the hand to music computation, then her instrument also refers to computing's longer history as a gynomorph. In 1821, the mathematician and inventor Charles Babbage complained to a colleague about the error rate of his women computers: "I wish to God these calculations had been executed by steam!"[80] Two centuries later, his wish takes command over much of our domestic, personal, and professional lives. Rather than steam, however, today's metaphor is the cloud: all that is solid, again Marx and Engels, melts into air.[81] Prior to this supposed evaporation, though, computation counted on the hands of its earliest women operators as much as today's postindustrial digital economy depends on the labor of caretakers, teachers, parents, and other "essential workers." Earlier, it depended on the mathematical, musical, and experimental genius of Ada Lovelace, who, beyond Babbage's Difference Engine, proposed the first programs: algorithmic instructions that would operate not only on numbers, but would one day, as she saw it, generate text and even music.[82] As computing continues to move "off the hand," Sonami's Lady's Glove adds another object, and returns the hand of the composer—but also of the teacher, caretaker, and mother—to this skeuomorphic signal chain. In the process, she draws our attention to the reciprocal political-economic movement between computing's care for counting and the counting of care. Digitality roots both registers, care and counting, in the intimate functions of the hand.

Gesture and Gestation in *What Happened II*

The hand may serve as an instrument of measurement and counting, but it also facilitates expression. We use our hands to wave, hail, summon, point, and pontificate. In the process, we employ a register at once perhaps prior to language while just beyond its discursive horizon: the paralinguistic. With the hands, that is, we gesticulate; we gesture. It is 1994, and Sonami takes the stage at the Festival International de Musique Électroacoustique in Bourges,

France to perform her work *What Happened II* for voice and the fourth version of her Lady's Glove, which she built in collaboration with the technologist Bert Bongers and STEIM.[83] Holding a microphone with her right hand, her eyes gazing across the audience, Sonami calmly recites a text by Carnahan: "When I had a baby / I lost my sex drive. / My husband came home from the war and found me sleeping with a woman. / He took her away. / They are now together. / My baby died." The compounding tragedy of the narrative meets an incongruous neutrality in Sonami's delivery that renders it almost rote. Each line's truncated semi-regularity, bolstered by her lack of emotional expression or dramatic punctuation, answers her title's paradoxical implications of an uncomplicated recounting—or indeed such a recounting's recurrence: the performance is in fact a restaging of Sonami's *What Happened* of 1980, a work based on the same text and composed for custom analog electronics and voice prior to her invention of the Lady's Glove. Life is a matter of repetition, *What Happened II* suggests, of placing one foot in front of the other despite adversity or oppression. Yet if life is reproduction, Sonami suggests, it is a refrain resounded inequitably, a labor shouldered unequally. Still holding the mic, her gloved hand held at her chest, Sonami continues: "I got my sex drive back and had another baby. / I married a man who brought with him two children of his own. / He loved them dearly. / He stayed home to care for them. / I went out each day to make money, but found / I hated my job." At that point, her left hand, which had previously been relatively relaxed, suddenly clenches and immediately releases to trigger a subtle, percussive click. "I quit."

Sonami's *What Happened II* begins with gestation and ends with gesture. She starts with her narrative exposition describing a series of failed familial and professional relationships and morphs into an electroacoustic texture consisting of vocal fragments and frequency-modulated synth squelches.[84] Sonami continues to recite the Carnahan text, which follows the narrator through further episodes of grief, tragedy, and misfortune. As she intones, Sonami mimics the text's rhythm with quasi-randomized movements of her individual fingers, generating a rapid succession of synchronously gated noise sounds along with analogous changes in her voice's amplification level. The samples and synth fragments begin to overpower Sonami's voice, eventually completing a long-form crossfade in which one audio source (here the electronic sounds) gradually overtakes another (Sonami's voice). Sonami describes the process cinematically, imagining "a camera pointing at the story, and as it slowly changes focus, the story gets blurred and other images revealed." Using a different figure, she continues: "someone's story disintegrates as the hand starts moving, a shift from the talking person to . . . a mute

ENGENDERING THE DIGITAL 121

person"—a description that invokes comparisons of Sonami's work to sign language (and even perhaps to Wiener's hearing glove).[85] At the same time, Sonami uses this large-scale temporal gradient, or dissolve in her idiom, as a way to comment on reproductive themes, transitioning from the narrator's postnatal life to its fragmentation.

Sonami's narration of familial reproduction elides with its representational undoing; gestation dissolves into gesture. Historically, the two terms are in fact linked: gesture originally referred to the manner of carrying the body, including but not limited to deportment and posture, and derives from the Latin *gerere*, or "to bear." Both gesture and gestation relate to the notion of carriage. Not only do we live in our bodies, but we also "carry" them, presenting ourselves as (quasi-)public objects.[86] Referred to as "kicking," fetuses engage in gestures that scientists describe as assisting in mind and body formation.[87] Gesture is not only felt but also seen, which is, indeed, an important aspect of social being qua embodiment. Like gesture, gestation contains related implications regarding sight and being seen. A significant body of feminist thought exists on the publicity of the pregnant body, highlighting a paradoxical "externality" of the uterus, its social visibility.[88] Gesture implies a related kind of visuality: our bodily movements not only carry us through space; they also exhibit that carriage, offer up our bodies as proto-signifiers that code and communicate. Sonami does not appear pregnant during the performance, yet her hands occupy a similar space of the public object.

Sonami's gestures are not only seen but form an integral part of her narration of natality, social reproduction, and its breakdown. Gesture's accent on visibility may nonetheless account for a disconnect found in critical accounts of Sonami's work that view gesture primarily in the service of generating sound. Writing of Sonami's Bourges performance of *What Happened II* in the *Computer Music Journal*, David Keane finds her "motions necessary to control the electronics obtrusive and limited by repetition. . . . Nevertheless, the sound material the controls acted upon varied sufficiently to keep the piece strong and interesting." Doubtless the motions and resulting electronic sounds obtrude into the narration and use compounding repetition to produce the disintegration effect that Sonami also describes. The reviewer further contends, however, that since electronic sounds can be produced with or without alternate controllers, their visual function should be considered secondary in the context of computer music, subservient to the sounds they control.[89] The reviewer thus relegates the signifying capacity of gesture, its ability to embody and carry meaning, musical or otherwise.

Yet rather than serving only as a tool for sound generation, Sonami's gestures, I think, play an important role in her generation of extra-musical

(and extra-artistic) meaning, particularly as it relates to social reproduction.[90] Read through her Lady's Glove, Sonami's use of gesture stands for a making visible of the hidden labor of care—from teaching to cleaning to parenting—in music and art cultures. Such a function relies on signification and, as the reviewer suggests, visuality: registers often demoted in new music contexts. Overall, gesture is elevated in new music owing to the European musical avant-garde's inheritance of expressivity from romanticism; consider, for instance, the emotive bird calls in Luciano Berio's 1966 *Gesti* (Gestures) for alto recorder. Conversely, experimental music has broadly attempted to undermine the composer's hand through indeterminacy, computer algorithms, or the process-oriented approaches found in La Monte Young's or Phil Niblock's drone music. Philosophically, Giorgio Agamben conceives of gesture in the context of film and early motion studies as at once "communication of communicability" and an indication of "not being able to figure something out in language."[91] Gesture in this sense is both metalinguistic, in that it conveys a potential for communication, and prelinguistic in its groping toward representation, as in the waving of one's hands to find the right word or phrase. Gesture is, in this sense, paralinguistic. Such a conception of gesture as beyond the purely legible is not incongruous with new music's general program of aesthetic modernism, which again inherits from absolute music an understanding of music as non-signifying sound. Computer music draws (unequally) from both traditions, embracing new music's "expressive" gesturality as seen in conferences like New Interfaces for Musical Expression, while making room, historically, for experimentalism's programmatic withdrawal of expression and artistic intentionality.

Sonami's use of gesture works both with and against its function in non-signifying sound. Locally, gesture functions in *What Happened II* as a paralinguistic eschewal of conceptual meaning as it gradually overtakes the previously legible Carnahan text. Yet on the level of the composition—and indeed in terms of Sonami's practice—gesture functions as artistic self-commentary. As much as it contains gesture, her practice is also *about* gesture: Sonami communicates the movement between communication and its disintegration. While her Lady's Glove movements and resulting sounds subsume *What Happened II*'s narrative themes of maternity and social reproduction, gesture and gestation contribute to the work's overall meaning: the gesturing hand also stands for the hand of the mother, caretaker, and worker. The meaning of gesture here is thus not the romantic expression of "man" in the face of his loss of agency or technological decentering, but concerns feminized work and maternal care, themes Sonami further explores through indeterminacy. Recall Sonami's description of the biomechanical codependence of finger

movements. In a technical description of *What Happened II*, she notes that "one finger controls the output of the voice and sounds associated with it, the others the density of events, the bending of the notes, or triggering of individual events."[92] Given the anatomical limitations of the hand Sonami later describes, such a setup can hardly support unfettered "dreams of control."[93] Her hand may guide, but like a responsible parent, it doesn't simply control.

As an alternate controller, Sonami's Lady's Glove uses the metaphor of the hand to comment reflexively on reproductive labor using the forms and technologies of experimental music. Sonami's use of indeterminacy in *What Happened II* shares with child-rearing, for instance, a concern for the impossibility of being in complete control of that for which one cares—whether the results of a musical performance or the life of another human. Other implications of her glove controller concern not only the problem of embodiment in computer music, but issues of computation more broadly. Her use of the Lady's Glove, both in performances such as *Why __ dreams* and *Mechanization* and as a pedagogical tool in her teaching, symbolically elevates the counting of care—in the work of teachers, caretakers, and parents—over computation's care for counting. Computation and digitality owe, in part, to the hand's facilitation of our capacity for distinction and discretization, while modern computation traces back to the automation of calculation work performed by the hands of women. Today's computers pervade much of our domestic, personal, and professional lives, yet when viewed historically figure as one form of automation among many. Relativizing such a technology among Giedion's encyclopedic history of mechanization and its effects on the human, Sonami's collaboration with DeMarinis exhibits the prehensile appendage as a kind of proto-technology whose augmentation is always a kind of doubling. Whether counting or caring, grasping or gesticulating, the hand roots us in the bodies we carry, Sonami demonstrates, while facilitating a digitality that gestures perhaps beyond our bodily finitude. Similar gestures suggest that our bodies may, in a sense, already be technological. Yet Sonami points not to fantasies of our posthuman descendants but to our actual children and the labors of care that sustain life in the present.

6

The Last Invention: Recursion, Recordings, and Yasunao Tone's *AI Deviation*

Introduction

Recursion refers to an object that includes itself; it describes a condition in which a thing or a process is defined in terms of itself. Visually, recursion conjures the image-within-an-image effect of *mise en abyme*. In computer science, recursion occurs when a process iteratively self-executes until meeting a certain condition, at which point it stops. Recursivity spans human and nonhuman sources: music, language, software, learning models, AI, even plant biology. At the same time, recursion destabilizes the human by rendering self-relation mathematical, translatable, and immanently machinic. Found across the natural world and throughout history, recursive structures notably pervade modern culture. Theorists have defined modernity, in fact, by its recursive search for the new. What happens to this sense of novelty, however, in a contemporary posthuman era in which newness, if it's even still possible, is no longer understood as the exclusive purview of the human? This chapter uses the concept of recursion to examine the Japanese American composer and artist Yasunao Tone's work with AI and recording technology in order to consider the problems of newness and invention as they relate to the contemporary posthuman. Is the production of the new possible in a moment when human agency has purportedly become decentered through technological, environmental, economic, and informational networks? Or have we already seen humanity's last invention?

It is June 9, 2016, and Tone appears at Brooklyn's Issue Project Room to premiere *AI Deviation*, a computer music work that uses algorithmic processes to simulate Tone's performances of a previous work, which itself refactors other, previously generated recordings. Filled to capacity, the large hall is silent save for the last of the audience settling into place for the forty-minute performance. Tone's setup is minimal. He sits at a small table that hosts a

THE LAST INVENTION 125

laptop along with an audio interface and a mixer routed to the venue's loud-speakers. Reflected in Tone's glasses is the computer's LCD display, a graphical user interface partially visible, which the careful yet disinterested artist uses to make some preparatory adjustments. Suddenly and without change in demeanor, Tone strikes a key, and sound engulfs the space. Unlike Tone's unwavering affect, the acoustic shift is absolute: negative aural space immediately gives way to a wall of relentless noise. The loudness and saturation are overwhelming; like stepping out of a darkened theater on a sunny afternoon, only intensity seems to register. Eventually, details emerge. A pulsating hiss interrupts sediments of spectrally disjointed crackle. A sequence of bit-crushed sawtooth tones zips downward then inverts under bands of inharmonic squelch. Innumerable such permutations materialize. Paradoxically both static and ever-changing, every few seconds a new constellation of sounds covers the audible spectrum. Recursion appears to produce the new by reproducing the same.[1]

Tone uses recursive structures to reflect on the possibilities of sound reproduction technology through its historical intersections with writing and digitality. The self-referential process running on Tone's laptop parallels techniques found throughout his oeuvre. For example, Tone was invited to publish a CD with Lovely Music in 1993; emerging from the traditions of experimentalism and Fluxus along with other (neo-)avant-garde collectives, however, the composer figured that of his extant works—which had variously used imagery, movement, and contrasts between live and recorded sounds—none was suitable for an audio recording. Tone therefore sought to create a work *for* CD, in that it would not merely reproduce the sounds of, say, an instrumental composition but would rather be "something that only the CD as a medium could produce."[2] For the resulting work, *Musica Iconologos,* Tone scanned images of the characters of two ancient Chinese poems—the 44-character *Liao Jiao Fruits* and the 262-character *Solar Eclipse in October*—from the *Shih Ching* anthology compiled by Confucius in the sixth century BCE. He then transformed these two-dimensional bitmap images into a series of digits that resemble a bar graph, or a histogram; converted that information to binary audio data; and, finally, burned it onto a CD.[3] Upon playback, as with ordinary audio CDs, segments of these binary digits produce higher-resolution amplitude values interpreted like the pulse code modulation (PCM) technique discussed in chapter 5. Yet, while in one sense precise digital translations of one another, the sounds and Chinese character images contain wholly different organizations of data, and the audio has no perceivable correlation to the poems. Instead, a listener experiences an unpredictable, though not entirely unpatterned, noise texture that Tone would recycle in subsequent projects.

Musica Iconologos was the first of Tone's works to extend his sonification process to the digital. Although the CD-based medium specificity he had originally sought can be questioned—*Musica Iconologos*'s audio files were of course playable on computers at the time—Tone's subsequent iteration does suggest a dependence on the disc medium. *Solo for Wounded CD* (1997) is a recorded "performance" of a copy of *Musica Iconologos* that Tone altered with pieces of Scotch tape poked with small pinholes. Beginning with his *Music for 2 CD Players* (1986), which used popular and classical music as source material, Tone discovered that such alterations produced unpredictable irregularities in playback. Cage sat in the front row during Tone's 1986 premiere of *Music for 2 CD Players* at the Experimental Intermedia Foundation in New York and was amused to the extent that he laughed audibly throughout much of the performance. According to Tone, Cage had approved.[4] In any case, Tone's CD alterations, or "wounds" in his later use, also functioned for the composer as *preparations* not unlike the bolts and screws Cage placed inside his prepared pianos starting in the 1940s. As a use of tools beyond their intended purpose, furthermore, they figured for Tone as forms of technological "deviation."[5]

If, like experimentalism, recursion is a process the result of which may be unknown, then Tone's deviations represent specifically technological variants of indeterminacy. Following *Solo for Wounded CD*, Tone sought to develop a similar indeterminate process for the MP3, a file format that has recently become the world's most common for the exchange of digital audio. The question arose for Tone of how to subject MP3 files to the kinds of preparations he had previously used on CDs—how to make them "deviate." *MP3 Deviation* (2011) resulted in a series of laptop performances in which Tone employed special software to produce errors and disruptions in MP3 playback. He devised a software system in collaboration with the computer music researcher Tony Myatt and the New Aesthetics in Computer Music (NACM) group at the University of York, UK, during a residency in 2009. The application, which included a graphical user interface developed in Max/MSP, produced a variety of corruptions that correspond to one or more of twenty-one error types reported by the MAD MP3 decoder library including "lost synchronization," "forbidden bitrate value," and "bad frame length."[6] Less common than CD errors, such anomalies nonetheless arise from incomplete downloads, damaged hard drives, and other processes leading to corrupt data. Yet, like a skipping CD, such failures trigger perhaps a listener's awareness of the technology itself—what Jonathan Sterne describes in his Heideggerian analysis as the MP3's readiness-to-hand, its technological "thingness."[7] Similarly, Tone's deviations bring recording technology's thingness to consciousness through

THE LAST INVENTION

disruption and failure. In this case produced artificially, the errors correspond to any number of MP3 *frames*: consistently sized fragments of audio, each containing synchronization, sampling rate, and bit rate data.[8] During playback, the results of these errors range between sharp bursts of noise and, in the case of bad frames, a skipping effect comparable to that of CDs yet distinct in its consistent frame-length jitter. Along with changes in playback speed, phase inversion, and stereo flipping effects, Tone subjected recordings of his previous works to processes that were to an extent unpredictable yet also included Tone's alterations during performance. For Tone, this equates to "indeterminacy, not randomness."[9] If the latter represents a static field with knowable bounds, indeterminacy shares with recursion a potential for the unknown.

Heavily theorized in cybernetics, recursion is found in AI, for instance, in the concept of recursive self-improvement—a notion in tension with Tone's concept of technological deviation. As with other experimentalists discussed throughout this book, Tone's use of indeterminacy departs from the control and communication program of first-order cybernetics—yet another term he coins for indeterminacy is "*de*control"—while it resonates with the potential of unpredictable processes theorized throughout the history of cybernetics.[10] The French philosopher Pierre Livet proposes an understanding of recursion in three stages that correspond roughly to N. Katherine Hayles's periodization of cybernetics. First-order cyberneticians understand recursion as a form of feedback, which influenced theirs and subsequent models of information and noise. Second-stage cyberneticians posit a self-reflexive model of recursion that incorporates, epistemologically, the presence of the observer, whereas the third stage is concerned with connectivist learning and neural networks.[11] An imaginative example of the latter was the "ultraintelligent machine" envisioned by the British mathematician Irving John Good in 1965 (nearly a decade before von Foerster's naming of second-order cybernetics in 1974).[12] In Good's scenario, once a neural network AI achieved intelligence beyond that of a human, the machine would itself become capable of creating machines of greater intelligence, since such an intellectual capacity would be, by definition, within the domain of human intelligence and hence within the machine's grasp. Machines making better machines could, potentially, lead to a runaway process of recursive self-improvement, an "intelligence explosion" comparable to the AI scenarios discussed in chapter 1.[13] Outstripping humanity's capacity for technological novelty, according to Good, this could be our "last invention."[14] Needless to say, we have yet to build such a machine, and some claim it's likely we never will.[15] I'll ultimately frame this modernist drive toward radical novelty and invention in relation to the contemporary, which no longer foregrounds the human production of the new.

To be sure, Tone has never sought to build such an ultraintelligent machine. As opposed to fantasies of technological omnipotence, moreover, he describes an interest in AI's "crudeness and imperfection," its proclivity toward error and failure.[16] Instances of the latter have appeared throughout the history of artificial intelligence, from the overambitious timeline McCarthy set in 1956 of "a summer" for the achievement of human-level AI to the infamous "AI winters" declared during the 1970s and 1980s, which some trace back to the failures of early neural network implementations.[17] Tone describes his original impetus for *AI Deviation*: "if I damage a neuron deliberately and continuously, I may be able to create new sounds without my intention."[18] Programmatically experimental, Tone's process the result of which is unknown also recalls his proclivity toward error in *MP3 Deviation* and damage in *Solo for Wounded CD*. His consequent clause's encapsulation of indeterminacy further reveals the composer's paradoxical intention to create novelty ("new sounds") in the absence of intentionality. Tone notes that he became interested in AI in 1966 while organizing a festival with Team Random, the first computer art group in Japan. At the time, he read about the Perceptron Mark I, the first neural network machine, which the psychologist Frank Rosenblatt designed with limited success for the purpose of image recognition.[19] It would be another fifty years before Tone would realize this interest in AI through his collaboration with NACM. But while neural networks were a generative source for the project—Myatt agrees that the coding was "neural network–inspired"—ultimately, *AI Deviation* did not end up using them.[20] Rather, the *AI Deviation* software employs an earlier model of artificial intelligence known as an expert system, which uses a series of hard-coded rules to model the cognitive processes of a human expert.

This chapter uses the concept of recursion to analyze Tone's work with AI and recording technology alongside the problems of novelty and newness. Premised on a form of self-inclusion, the *AI Deviation* software analyzes Tone's prior performances of *MP3 Deviation* to derive a series of new, simulated versions of his behavior which the artist instantiates in a performance. As part of the software engineering process, Myatt and NACM researchers Paul Modler and Mark Fell recorded Tone performing *MP3 Deviation* over the course of a five-day residency in a Surrey University lab in 2015. The composer's manipulations of a set of ten parameters included changes in playback speed, MP3 error type, and stereo inversion effects. The team then used this series of recorded performances to program an AI application that instantiates five virtual copies of Tone that artificially listen to the audio output and respond in real time in ways that approximate the artist's prior behavior. The resulting *AI Deviation* software encodes various unpredictable processes as

it simulates Tone's musical behavior. Tone controls the software in his live concerts, even though the artist expresses a feeling of being made redundant when he suggests, "this piece doesn't need me."[21] Alongside this kind of artistic decentering, the application also departs technologically from Tone's original neural network concept. In this sense, the engineering plays an important role in the artistic process and vice versa. Rather than an artist working in isolation, the project depended on collaborations within a network of human and nonhuman agents comparable to yet distinct from Tone's work since the 1960s with avant-garde collectives.

The chapter examines *AI Deviation* alongside Tone's work with networked artistic production and avant-garde groups to ask: is the production of the new still possible in a contemporary posthuman era? Artificial intelligence and recording technology are perhaps unusual sites for such a question since each is based on a form of *reproduction*—acoustic effects in the case of recording technology; their cognitive causes, in many cases, in AI and algorithmic music. *AI Deviation* links both paradigms through its use of an *artificial listener* that passes digital signal analysis results to a set of rules devised to simulate Tone's musical behavior. Deployed as a form of technological reproduction, according to Tone, "AI is only able to respond based on how it was trained and what it has already learned, which couldn't include what I didn't perform." Yet, paradoxically, such a process allows Tone to "perform something that I don't know . . . something unthinkable."[22] Discontented with pure reproduction, Tone has used recording technology and, more recently, AI to achieve such "unthinkable" results in indeterminacy. But are Tone's deviations instances of noise, or do they produce new information—a category some cyberneticians compare to "surprise"?[23] Do Tone's recursive processes produce sameness, or do they align with the avant-garde's paradigmatic investment in the new? In addition to *AI Deviation*, the chapter analyzes Tone's *Parasite/Noise*, an installation he presented at the 2001 Yokohama Triennale contemporary art festival, while tracing Tone's use of recording technology to his early improvised *musique concrète* experiments with the avant-garde collective he co-founded in Tokyo in 1958, known as the Music group.[24] In examining *AI Deviation*, the Music group, and *Parasite/Noise*, the chapter considers the problem of novelty and human invention as a key impasse of the contemporary posthuman.

Recursive Indeterminacy: Deviating *AI Deviation*

AI Deviation deviates in form and function through recursive layers of indeterminacy. Each of the software's "virtual Tones" attempts to answer the

question: for a given sound output of the system, what would Tone's corresponding behavior be in a typical live performance? How would he change the control knobs? The expert system solves this problem statistically, so that each of Tone's virtual copies produces a unique yet stochastically similar output. During a performance, Tone introduces one layer of indeterminacy by choosing which and how many virtual copies of himself to run at any given moment. At first blush, Tone's interventions at this level may seem unnecessary given the system's efforts to offload such musical decision-making processes to the AI software. If AI represents a form of automation, indeed we might expect a corresponding reduction in, or even elimination of, the artistic labor required to run such a system (even though, as we saw in chapter 3, automation doesn't necessarily trend in that direction). Already in his preparatory conversations with Myatt, as noted, Tone concluded, "this piece doesn't need me."[25] Despite the fact that Tone is physically present during his *AI Deviation* performances and remains personally involved in artistic decisions, he insists on his own redundancy. The piece no longer strictly depends on his embodied presence or even his cognitive input since the latter has been captured, recorded, and reused in the software's automated process of self-appropriation. Over fifty years earlier, Tone had experimented with related notions of distributed authorship in his event score titled *Music for Several Composers* (1964), which consists solely of the instruction, "Write a piece under my name."[26] Here I want to suggest not only that *AI Deviation* produces layers of musical indeterminacy, but that the production of its software further encodes a similar kind of artistic decentering through Tone's dispersion of agency among a network of human and nonhuman collaborators.

Each of *AI Deviation*'s virtual Tones contains a model of the artist that uses the input of the artificial listener to derive an output based on Tone's previously recorded behavior. The artificial listener approximates certain aspects of human auditory perception, yet due to its requisitely incomplete nature it contributes unpredictability to the system. Beyond the original raw audio signal, the artificial listener extracts perceptually relevant though partial data, or *features*, based on a mathematical model of human hearing. Here Myatt and his team used the Max Sound Box library, a set of analysis tools based on the Fast-Fourier Transform and developed at IRCAM, which provides multiple streams of frequency-domain information.[27] These analysis streams correlate, to an extent, with the perception of pitch, loudness, noisiness, spectral density, and so on. In one sense, the analysis data are far in excess of human cognition since they contain ten individual measurements for every ten milliseconds of sound, equivalent to one thousand observations per second. In another sense, however, such measurements account for only

a kind of skeleton of perception since they lack many higher-order cognitive functions of human hearing. Perceptual tasks we take for granted, like discriminating between two or more simultaneous sounds—what the cognitive scientist Albert Bregman attributes to "auditory stream segregation"[28]—are simply beyond the artificial listener's capacity. An increase in the number of simultaneous sounds may register as a rise in spectral density, to be sure, but that measurement provides no independent information regarding the perception of simultaneity. Such information may or may not influence Tone's musical decisions. But, recalling Tone's *AI Deviation* premiere, simultaneous sounds are indeed detectable—at least following the initial shock of the texture's intensity.

AI Deviation correlates the artificial listener's partial yet consistent analysis data to Tone's prior behavior using a form of pattern matching. Alongside audio and video recordings of Tone's *MP3 Deviation* performances in the Surrey University lab, Myatt and the NACM team captured changes the artist made to the parameters by their creation of *sequences* of the respective positions of the user interface control values. Imagine a set of ten horizontal lines stretched across a Cartesian plane, the vertical dimension representing the value of each control knob (playback speed, MP3 error type, stereo inversion, etc.), and the horizontal axis representing time. Each moment is then correlated to the artificial listener's perceptual analysis data. Together, these perceptual features, which are linked to parameter changes, represent a database of recorded behavior through which each virtual Tone iteratively searches to find a statistically similar match based on the artificial listener's analysis of the current audio output. For instance, if the artificial listener detects a high, dense noise burst in performance, each virtual Tone will seek a close fit to a similar, previously analyzed sound and adjust the controls accordingly. This pattern matching works stochastically, as noted, based on a range of acceptable fits, so the respective virtual Tones often find different matches in the data. In the exceedingly unlikely event that the analysis data were to match part of a previous performance exactly, one or more of the virtual Tones would simply replay that sequence of the artist's recorded output. But, as a result of multiple forms of indeterminacy, the software tends to deviate from such an outcome.

In a different sense, *AI Deviation* also deviates from the software's stated design. Several of the press releases for the *AI Deviation* performances, including Issue Project Room's announcement of the premiere, indicate that the software devised in collaboration with Myatt uses neural networks to simulate Tone's previous performances. These statements paraphrase Tone's own account of how the original version of the software used self-organizing maps, a type of artificial neural network based on the 1980s work of the

Finnish computer scientist Teuvo Kohonen. "At the lab in the University," Tone notes, "a series of my performances of my *MP3 Deviation* were captured and used to train Kohonen Neural Networks to develop artificial intelligences that simulate my performances."[29] Tone's description is accurate to the extent that the NACM researchers did initially train Kohonen neural networks on his *MP3 Deviation* performances. Yet, as noted, the engineering team did not end up using any form of neural networks in the final version of the software and instead employed an expert system. More than a mere technical detail, Tone explains, this departure altered his approach to the project and necessitated a shift away from his initial conceptual impetus.[30] Nonetheless, Tone says that the decision to use an expert system instead of neural networks was a change that he welcomed "wholeheartedly."[31] *AI Deviation* deviates from determinate musical results, while Tone and NACM depart, in this regard, from its original engineering model. The piece may not need Tone in performance, but its software depends on his collaboration with networks—just not of the artificial neural type.

Rather than eliminating intentionality, indeterminacy contributes here to a form of distributed agency. As opposed to the myth of the composer working in isolation, Tone figures as a node within a network of human and machine actors. Speaking to *AI Deviation*'s software design and the decision to use an expert system, Myatt describes the group's initial attempt to use neural networks and how the level of complexity, and corresponding computing power, increased significantly as the number of output parameters grew. A practical consideration was that the software had to run in real time on Tone's laptop, and so processing power was limited. Kohonen neural networks, which can decrease complexity through dimensionality reduction, offered a potential solution. Another intentional factor was that the virtual Tones were meant to be perceived as accurate musical simulations. Yet, in the course of their experiments, Tone and the other engineers found that the neural network implementation ultimately failed to produce a convincing simulation of Tone's prior *MP3 Deviation* performances. Myatt explains that, in practice, the neural networks "produce[d] a very simplistic version of what Yasunao was really hoping that they would do. There's no way that you could confuse the output of Yasunao performing the software against the computer performing the software. They're just radically different."[32] As though subjected to a kind of musical Turing test, the expert system implementation did convincingly confuse human and AI actors and therefore served as the functional basis of the *AI Deviation* software. Tone and his collaborators thus bring us full circle from Cage's 1965 words to Alvin Lucier, "It doesn't matter if it doesn't work."[33] Implementation secondary, here it *only* matters if it works.

But certain engineering details are significant to *AI Deviation* particularly as they relate to agency and intention. Tone notes that even though he did not see the final app until several months after his Surrey residency, the change from neural networks to the expert system "forced [the] performance [toward a] different aspect."[34] That aspect no longer involved his original vision of damaging one or more artificial neurons, but included his control of up to five AI versions of himself in performance. The disparity between the expert system and a neural network could, arguably, be conceived as a matter of implementation rather than functionality. Recalling our discussion of black boxes in chapter 4, without knowledge of its inner workings, one could argue that the system behaves in ways that could be mistaken for the neural network process described in the press releases. Yet, in this case, *AI Deviation*'s programming is not a mystery; its code is no black box. Expert systems like this one consist of a set of hard-coded rules, whereas neural networks learn such rules as a set of boundary conditions obtained over an iterative process of error correction known as machine learning. Both model human cognitive functions. In *AI Deviation*, the expert system models Tone's musical decisions, as noted, using a stochastic pattern-matching algorithm. Myatt explains, "in a way, it's not a million miles away from how a neural network would work, in terms of the details of how a neural network might find a solution to a certain parameter space."[35] Nonetheless, a key difference is that an expert system doesn't *learn* parameter space solutions the way a neural network does. Rather, such solutions result here from a series of trials and errors conducted between the artist, engineers, and machines. Suggesting a fluidity between these roles, Myatt contends that there is "an awful lot of knowledge from Yasunao engineered into the software."[36] In such a redistribution of agency, engineering decisions imply artistic significance, while the artist's own knowledge becomes a part of the code.

Tone also deviates from historical precedents of AI in algorithmic music and experimentalism. AI and algorithmic music typically automate music composition by generating sequences of symbolic representations of musical events, or acoustic *causes*—although a number of recent neural network experiments have successfully generated nonsymbolic audio-sample-level output.[37] Expert systems have a longer history in new and experimental music than neural networks. One reason is the above-noted practical consideration of the computational intensity required to run neural networks. Another was the restriction of neural networks since Rosenblatt's Perceptron to rudimentary, linear distinctions between data until the use of hidden neural layers beginning in the 1980s and their subsequent enhancement with pre-training techniques in the 2000s.[38] Yet another reason for the prevalence

of expert systems in algorithmic music is perhaps the morphological congruency between the respective rule-based structures of computational and compositional systems. Art music has been "algorithmic," in this sense, for centuries, its rule structures white-boxed through harmony and counterpoint textbooks and historical music theory treatises alike. Recall from this book's introduction Hiller's 1957 *Illiac Suite*, one of the first computer-generated compositions: "Experiment One" inherits the Renaissance polyphony rules famously codified by the Austrian music theorist Johann Joseph Fux, whereas "Experiment Two" deploys subroutines to avoid parallel octaves and fifths and other conventions of common practice–era tonal music.[39] Hiller's collaboration with Cage, *HPSCHD*, used a FORTRAN computer program to algorithmically recompose preexisting Hiller and Cage works in addition to harpsichord music by Beethoven, Mozart, and others. Mozart's inclusion may allude to the composer's proto-algorithmic *Musikalisches Würfelspiel*, the eighteenth-century musical dice games acknowledged in chapter 3.[40] The incorporation of other Cage and Hiller works anticipates perhaps the kind of recursive self-inclusion found in Tone's *AI Deviation*. When asked about the latter's relevance to Hiller and other American and European algorithmic composers, however, Tone indicated that he places his "autopoiesis work outside of music."[41] (This despite the fact that much of such work occurred in a group *called* Music.)

Nevertheless, Tone has worked extensively with automatic processes. And his self-*exclusion* from this Western canon of algorithmic music suggests perhaps more about his work with (and on) non-Western and nonmusical avant-garde movements since the late 1950s than it does any actual lack of relevance to said canon.[42] In 1957, Tone completed the literature program at Chiba University, located in a suburb of Tokyo, with a graduation thesis on the Japanese Surrealists. A year later, he founded the Music group with other university graduates. Shortly thereafter, he joined the transnational (and at least music-adjacent) Fluxus movement and collaborated with the short-lived interdisciplinary Japanese Hi-Red Center group (1963–1964). If these groups variously implicate forms of artistic collectivity, Tone's initial experiments with autopoiesis—as though presaging the kind of agential redistribution he later explored in *AI Deviation*—explicitly sought to de-individuate the human subject through the "universality of automatism."[43] Yet rather than computers, Tone and fellow Music group members used the tape machine to capture their version of Surrealism's "psychic automatism"[44] through collectively improvised *musique concrète* performances. "In May of 1960," Tone announces, "the members of our group chanced to encounter [sôgû shita] an experiment concerning an absolutely new music. It was an improvisational

work of *musique concrète* done collectively."[45] Here I want to shift to a consideration of Tone's work with recording technology, especially as it engages the problem of novelty—note Tone's concern with "an absolutely new music"—in a contemporary posthuman era. How can a recording produce the new while it reproduces the same?

Deviant Recursion: Automatic Recordings and the Music Group

As opposed to the algorithmic generation of acoustic causes, recording technology reproduces their effects. It is May 8, 1960, and a tape machine sits in a room in the home of Mizuno Shûko, a member of the newly formed Music group and a former classmate of Tone's at Chiba University. When one of them presses "record," the machine whirs as a spool unfurls, threading the tape past the head where it receives a magnetic charge analogous to the input signal, and is sent along, re-looped, and stored on the other spool. Immanently recursive, recording is a form of time-bounded temporal accumulation archived in time. Recordings, for Friedrich Kittler, store time.[46] Stored on this reel are the sounds of Shûko and Tone along with fellow Music group members Kosugi Takehisa, Shiomi Chieko, and Tanno Yumiko. For nearly twenty-six minutes, the group activate drum cans, washtubs, water jugs, forks, plates, hangers, metal and wood dolls, a vacuum, cups, radios, gardening reference books, a wall clock, a cello, a rubber ball, an alto saxophone, a prepared piano, and a set of the small black and white stones used in the game Go.[47] Each sound typically lasts according to its natural duration, often overlapping with one or more other sounds, a uniformity lacking any discernible pattern. Recalling James Tenney's formalization of Cage's indeterminacy as *ergodicity*—or the equal distribution of randomness across possibility space—one of the texture's defining features is, not unlike *AI Deviation*, stasis. There are no buildups or climaxes, only incidental density fluctuations due to changes in simultaneity. The Music group achieve this texture not with the aid of computers, but by recording their collective improvisations in a process they refer to, after the Surrealists, as automatism. They title this recording *Automatism No. 1*.[48]

In the context of computer music, recorded group improvisations may seem like an unlikely source of automatism when compared to the use of algorithms and AI. Yet the Music group take their cue from the Surrealists' conception of the mind, and particularly of the unconscious, as automatic, even machinic. In his *Manifesto of Surrealism* of 1924, André Breton defines the newly formed avant-garde movement as premised on "psychic automatism," further characterizing its members as "receptacles of so many echoes, modest

recording instruments who are not mesmerized by the drawings we are making. . . ."[49] Like a phonograph, the Surrealists operated as neutral receptacles for phenomenal inscription, palimpsestic machines for the writing of, in their case, the unconscious. The Music group concretize Breton's references to the aural and its technological reproduction while extending the Surrealists' media (writing, drawing, painting, sculpture) to sound recordings. Tone had, in fact, emblematized this shift in his naming of the Music group in reference to the journal that Breton, along with Philippe Soupault and Louis Aragon, founded in 1919, *Littérature.* Apparently, Tone added "group" to avoid the potential confusion of referring to themselves simply as "music" (ongaku) since Japanese does not allow capitalization.[50] The Music group's name nonetheless shares *Littérature*'s sense of mockery and irony, as William A. Marotti notes, while the category of music, and indeed the discourse of experimentalism, has remained a fixture for Tone despite the paradoxical self-exclusion of his automatic work from its canons.[51]

Like other avant-garde collectives, the Music group sought, programmatically, to produce the new—in their case, through reproduction and, more specifically, in the form of recordings. Tone and the Music group saw their recorded, collective *musique concrète* improvisations as a kind of musical extension of the automatic writing techniques Breton and Soupault introduced in their 1919 book *Les Champs magnétiques* (*The Magnetic Fields*). Its chapters alternate between each author's stream-of-consciousness writing, which began in the morning and ended in the evening before sleep. Archetypically avant-garde, Breton and Soupault sought novelty through a collaborative action that favored collective enunciation, even though their psychic automatism technique operated at the level of the individual. Tone and the Music group adopt a similar kind of collective authorship, while they pun Breton and Soupault's title through their practical reference to magnetic tape.[52] Yet the Music group understood their intervention not merely as an homage to the Surrealists but as an update to and even an improvement upon their practices; hence their recordings were to be understood as something new. Tone suggests, for instance, that their spontaneous collective performances provided an alternative to the critic Yoshiaki Tōno's characterization of an egoistic, nonspontaneous Joan Miró.[53] Even further in this direction was Tone's view of their work as a subversion of humanistic individualism. In his 1960 essay, "On Improvised Music as Automatism," Tone hails Breton and Soupault's work as archetypically collaborative yet argues that "since even the unconscious of the individual retains egotistic, individual features and conventions of thought, and thus risks retaining the dregs of humanism, the act of collaboration could be said to seek the universality of automatism."[54] Their

form of improvisation, as the Music group saw it, offered a collective automatism that exceeds the individual.

The Music group's characteristically avant-garde search for novelty through this kind of dialectical confrontation with the past was an attitude they applied not only to Surrealism but also to *musique concrète*. It had been over a decade since Pierre Schaeffer heard the 1948 Paris premiere of his *Cinq études de bruits* (Five Noise Studies), which included the notorious *Étude aux chemins de fer* (Railroad Study)—all based on his work with the tape machine and his then-burgeoning theory of *l'objet sonore*, Schaeffer's fundamental ontological unit of sound.[55] Not unlike their reworking of Surrealism, Tone and the Music group endeavored to create a more direct and authentic *musique concrète* that uncovered something essential, in this case favoring extremes. "It is our wish that, after hearing this music," proclaims Tone, "you will see the true form of *l'objet sonore* in which degrees of transparency and opacity, and wetness and hardness, resound within the tempest of directness (chokusetsusei no arashi), a force beside which the *concrète* works of Schaeffer and Henry will pale by comparison."[56] The Music group member Kosugi was even more direct in his criticism, concluding that by focusing on electronic manipulations of recorded sounds, *musique concrète* composers present only a facade of unpredictability. "[B]y transforming sounds (onkyō) through electronic control (tape recorders, etc.), [extant *musique concrète*] tries to present an aspect of the unpredictability and chance replete in existence. This does not have the sense of a proper improvisational 'act,' but rather of an attempt at *objeti*fication."[57] Rather than manipulate individual concrete sounds, the Music group recorded their range of instruments and everyday objects and presented them without alterations or edits. Using chance and automatism, the Music group pursued a new form of *musique concrète* purportedly more authentic and extreme than that of their precursors.

Through this kind of artistic negation—and even deviance—Tone and his colleagues sought to supersede their Surrealist and *musique concrète* predecessors while also subsuming their techniques into the Music group's artistic program. In 1962, Tone and Kosugi staged a kind of recursive inversion of the work of Schaeffer. Rather than compose with recorded sounds of trains, as Schaeffer had done just fourteen years earlier in *Étude aux chemins de fer*, they played train recordings on an actual train.[58] Mobile tape players in hand, the duo boarded Tokyo's main subway line, the Yamanote, and, amid the real-life sounds of the subway and its passengers, interposed their aural simulacra into the passengers' daily commute. This self-inclusive structure of train(s) on a train homologizes perhaps the historical and transnational train of associations that links the Music group's gesture to *musique concrète*, while it

also suggests the latter's negation. Tone, in fact, saw their intervention as a form of "agitation" with social and political consequences: later that year, the action informed Tone's defense of Hi-Red Center artist Genpei Akasegawa, who was tried and convicted for an art/non-art transgression that involved a form of circulation other than transportation in producing intentionally unconvincing counterfeit Japanese currency.[59] In a characteristically avant-garde move, the Music group action jumps tracks between art and life— what one of Tone's later collaborators, Allan Kaprow, would refer to as the "blurring of art and life"—by exhibiting their mutual inclusion.[60] Through the minimal difference of technological mediation, the Music group produce another, meaningful difference perceivable only through the reinsertion of art back into life. The resulting difference between recording and recorded, between signifier and signified, invokes Tone's Derridean critique of "representation as re-presentation": the difference between representation (life) and re-presentation (art) as meaningful difference deferred: *différance*.[61] Rendered as *information*, the Music group's action appears, as the cybernetician Gregory Bateson might have it, as a "difference which makes a difference."[62]

During this time, in addition to his work with the Music group, Tone produced other works with recording technology that used recursion to generate difference. In 1962, Tone displayed a tape machine covered in a cloth bag at the Yomiuri Indépendant exhibition in Tokyo. Tone submitted the work, which he titled *Têpu rekôdâ* (Tape Recorder), as a sculpture since the Yomiuri restricted submissions to such conventional categories. He had initially considered submitting only the tape machine, but then, losing his nerve, he painted it in hopes that it would be more readily accepted; considering it further, Tone hid the device in a bag, and it was accepted as such. The tape machine contained a roughly thirty-five-minute reel that Tone played and left to loop during each day of the exhibition. The exact contents of the tape, however, have been lost to history since the tape was stolen during the exhibition, at which point the sculpture fell silent.[63] Not unlike Tone's collaborative train action of the same year, *Têpu rekôdâ* suggests a recursive doubling of *musique concrète*, here focusing on one of its theoretical principles. Recalling chapter 2's discussion of Schaeffer's notion of *acousmatics*, in which recording technology removes or hides the source of a sound, *Têpu rekôdâ* hides the technological apparatus itself—a hiding that nonetheless makes its hiddenness visible through the presence of the cloth bag. Through the contingent, indeterminate circumstances of its exhibition, the sounds were further concealed from the historical record. As a hidden record hidden from the record, *Têpu rekôdâ* symmetrically inverts recording technology's ordinary recursive structure as temporal storage stored in time.

If *Têpu rekôdâ* creates difference through subtraction, Tone's *Number* (1961) uses addition and "digital" recursion to deviate between mediums.[64] Tone starts by recording himself counting aloud from one to one or two hundred at a consistently low volume. He then plays that recording at a very high volume, which adds an unusual amount of tape noise, background sound, and resonant frequencies: certain bands of spectral energy, or formants, particular to the architectural dimensions of a room. Over the course of ten iterations, the process produces such an extreme level of distortion and noise that the reel-to-reel tape machine, in Tone's account, "literally starts jumping around" on stage.[65] Transforming quantity into quality, Tone's recursive process ultimately turns the tape machine into a choreography machine. He composed the work, in fact, to accompany a dance production by Kawana Kaoru (1916–1965). Tone's under-discussed *Number* anticipates of course Lucier's notorious *I Am Sitting in a Room* of 1969. Both works use recording technology and the spoken voice to explore the potential of feedback processes to explode aurality into the kinesthetic and the architectural. *Number* highlights an iterative, accumulative aspect of feedback in which, through recursion, technological reproduction becomes production. Speaking to *Number* in a recent interview, Tone contends, "I [have] always felt that technologies of reproduction are not merely tools for playback. I see them as technologies for production or creation." For Tone, such technologies aid in his goal of novelty: "I want to find sounds that I've never heard before." On the one hand, Tone's interdisciplinary experimental music decenters sound; he insists, "Sound is merely a result." He also describes his work as *paramedia*, a term that suggests a status both beyond and adjacent to media, while extending Michel Serres's notion of *parasite*, a French pun that simultaneously refers to "leech," "guest," and "noise."[66] On the other hand, rather than noise, the object of Tone's post-sonic search for newness elides perhaps more with the cybernetic category of information.

In this sense, Tone's work points to a continuity between information and the new. Doubtless, these two concepts emerge from distinct historiographical lineages—cybernetics, in the case of information; art history, avant-garde theory, and modernity itself, regarding the new—yet they share some provocative common ground. As for cybernetics, Claude Shannon, Norbert Wiener, and Bateson were formative in the articulation of information. Shannon and Wiener understand it as a function of thermodynamic order or entropy. For Wiener, the two correlate directly: more information equals more order.[67] For Shannon, the opposite is true: information measures uncertainty, or lack of redundancy (i.e., sameness).[68] Many thus interpret Shannon's concept of information as a measure of "surprise." For instance, if one is trying to guess

an English word starting with S, words that begin with Sz would be more surprising, and hence would contain more information, because they appear less frequently in the English language than those beginning with Sa.[69] In this sense, information is contextual in that if one *expects* Tone's extreme noise textures, one might experience his *AI Deviation* as less surprising than would another listener. Surprise stands in here for the new. In avant-garde theory, surprise and shock reflect the newness of modernity, as seen in Walter Benjamin's treatment of Bertolt Brecht's *Verfremdungseffekt*, the alienation or distancing effect discussed in chapter 4; or, for instance, Renato Poggioli's "quasi-morbid shock of [the] fortuitous encounters" of Surrealism.[70] For Adorno, the new more broadly represents the avant-garde's "mimetic adaptation" of a capitalism that produces new commodities by reproducing sameness—a kind of homeopathic doubling-as-negation of the constitutive new of modernity.[71] Modernity is indeed the very *time of the new*, as Reinhart Koselleck contends, a temporality animated through capitalism's recursive search for novelty.[72] Here I want to shift to a consideration of the problem of novelty and invention in the move from modernity—which centers human agency in the production of the new—to the contemporary, which parallels the movement from humanism's human to the posthuman. What happens to the possibility of newness in a contemporary posthuman moment marked by a subsumption of human agency into the network?

The Last Invention: Impasses of the Contemporary Posthuman

Artistically, Tone straddles the modern and the contemporary, while his work speaks to the concomitant shift from the human to the posthuman. It is September 2, 2001, and the Yokohama Triennale contemporary art festival opens in the second largest metropolis in Japan. Tone's *Parasite/Noise* (2001) is part of a series of installations presented in the Yokohama Red Brick Warehouse (Akarenga Sōko), a historic building ordinarily used as a shopping mall and banquet hall. The work uses the Triennale's audio guide system to present visitors with an MP3 recording of *Pasagenwerk* (*The Arcades Project*), Benjamin's notorious unfinished account of the similarly structured arcades of Paris. As visitors move throughout the space, a series of infrared beams trigger an LPC-robot voice reading Benjamin's text[73]—altogether not unlike Sonami and DeMarinis's glove-controlled Giedion voice discussed in chapter 5. Recalling his notion of *paramedia*, Tone's title makes further reference to Serres's noise pun. Tone describes his understanding of noise in this context as a kind of "surplus" in excess of the other Red Brick Warehouse installations: works by over twenty contemporary artists from six continents

including Allan Sekula, Eduardo Kac, Stelarc, William Kentridge, Fiona Tan, and Keisuke Oki. At the same time, Tone parasitizes these heterogeneous artistic sites by reimagining them as fodder for a contemporary Benjaminian flâneur, collapsing the latter's scopophilic (and gendered masculine) opticality into the portable aurality of an MP3-encoded robot voice. Rather than the goal of new sounds, however, Tone seems to focus here on the spatial rearrangement of existing historical objects.

While Tone does not relinquish the new, his *Parasite/Noise* suggests a kind of recursive folding of time into space that is endemic to the contemporary understood as "the spatialization of historical temporality."[74] Emerging in art theory during the 1980s and 1990s, the contemporary, as noted in this book's introduction, describes the temporality of postwar deregulated global capitalism *and* a distinct art-historical condition—contemporary art—conceived in part as a response to this era. Like cybernetics, the contemporary begins after the second world war; it then expands geopolitically during the 1960s and with global deregulation after 1989 (although the concept is not to be understood in a "stagist" conception of history in which one period simply replaces another).[75] Contemporary art refers to art following the radical transformations of the postwar avant-garde that morphed formalist artistic modernism into postformalist (or postconceptual) art: an art that prioritizes discursive meaning and social process over aesthetic value and medium specificity. Artistic mediums are still used, to be sure, as in the photographs of Tone's Red Brick Warehouse co-exhibitor Sekula. But the focus has shifted to the broader production of extra-artistic meaning, as in the ways Sekula's shipping container photos speak to what he called the "imaginary and material geographies of the advanced capitalist world."[76]

Tone's *Parasite/Noise* relies on a network of dependencies not unlike the indeterminate human and nonhuman relationships seen in *AI Deviation*. Yet rather than "this piece doesn't need me," the appropriate phrase here might be "this piece needs much more than me": *Parasite/Noise* requires a heterogeneous assemblage of contemporary artworks whose contents Tone *détourns* via Benjamin into the shop displays of an interwar Parisian arcade. According to Tone, he obtained consent from the artists involved in his intervention, hence perhaps the connotation of *parasite* as "guest."[77] Obtaining permission for such a potentially disruptive gesture has of course a practical dimension. Yet it can also be read as an allegory of the diminished centrality of the contemporary posthuman subject: no longer the central agent of history, the human remains only as a guest. Recall Cary Wolfe's posthuman and how it combines metaphors of time—before and after humanism's human—and space—the human's decentering—to describe a historical condition.[78] Yet

142 CHAPTER SIX

rather than the postmodern, I've been arguing that the contemporary better captures this mutual implication of time and space in its "spatialization of historical temporality."[79] If the posthuman names the subject of this moment, then the contemporary refers to its articulation in time and space. Yet how do we account for the arrival of what appears to be a new subject in a moment no longer defined by modernity's production of the new?

While Tone remains interested in artistic newness, his engagements with AI speak perhaps to the perceived failure of modern technoscience to live up to its novel ambitions. In this sense, *AI Deviation* doesn't actually replace the human performer and operator of its software, despite Tone's suggestion to the contrary. And rather than a realistic simulation of the renowned German Jewish philosopher, the robot Benjamin voice of Tone's *Parasite/Noise* points to the failures of speech synthesis to meet even rudimentary expectations of authenticity. Rather than a time of the new, these works speak to a spatial rearrangement of the extant. The notion that we live in a time without invention or novelty may seem to conflict with our lived experience of the world, given the constant influx of new devices, apps, technologies, and so on. At the same time, many feel a profound underdelivery on the promises of cybernetics and postwar technoscience. "Where are the flying cars?" asks the late David Graeber. Where are the Mars colonies, teleportation devices, immortality drugs, and mind upload devices? What happened to the imminent intelligence explosion? Graeber characterizes this disappointment, paradigmatic of postmodernism, as one result of cybernetics' emphasis on simulation. Simulation heralded, for Graeber, a "new historical period in which we understood that there is nothing new; that grand historical narratives of progress and liberation were meaningless; that everything now was simulation, ironic repetition, fragmentation, and pastiche." He continues, "all this makes sense in a technological environment in which the only breakthroughs were those that made it easier to create, transfer, and rearrange virtual projections of things that either already existed, or, we came to realize, never would."[80] Graeber is referring to postmodernism, yet the dissolution of novelty, progress, and grand narratives in addition to the cybernetic virtuality he identifies can be extended to the contemporary as well. But rather than a postmodern imaginary based on capital's beyond—recall Jameson's *late* capitalism—the contemporary points beyond the human (suggesting instead perhaps a relevance of the phrase "late humanism") to its dwindling agency in the posthuman.

This may be a reason why figures like Good's "last invention" are so fascinating to us today: they invoke a time when radical change and novelty still felt like human-achievable ends. They appeal to a moment when history, as we understood it, was the result of human-directed, or what Hannah Arendt

called *anthropogenic*, action. Today, change and newness seem as likely to arise from an environmental disaster or a global pandemic as from an economic system we're told is beyond anyone's control.[81] In the face of this increasingly post-anthropocentric universe, then, a return to anthropocentric agency—expressed, paradoxically, in fantasies of creating technological systems beyond human control—appeals to a nostalgia for a human-directed, anthropogenic era. Tone's *AI Deviation* represents the obverse of these fantasies through his insistence on indeterminacy, decontrol, and deviation. Rather than an intelligence explosion, Tone's emphasis on technological failure and uncertainty points to an implosion of individual agency in the contemporary posthuman. The new may still be possible, but it is no longer strictly the product of anthropogenic action. If Tone remains a modernist in his commitment to "new sounds," his work is contemporary, not only in its postformalist (and postconceptual) production of extra-artistic meaning (which comments on the limits of contemporary technoscience), but also in its posthuman means for realizing such a project. No longer based on the solitary vision of the artist, works like *Parasite/Noise* and *AI Deviation* reflect the contemporary condition as an interconnected network of human and nonhuman agents.

Common to Tone's *AI Deviation*, his work with the Music group, and *Parasite/Noise* is the artist's insistence on the productive potential of music and audio reproduction technologies. Through a recursive reproduction of the same, Tone suggests, recording technology and AI might lead to instances of the new. In the case of *AI Deviation*, Tone and NACM deploy a process of automated self-appropriation to create seemingly authentic simulations of Tone's musical behavior. Yet during the course of this process, the system deviates: in design, through the replacement of neural networks with an expert system; in form, through the system's somewhat unpredictable behavior; and in function, through Tone's human manipulations of the nonhuman simulations. Chance and unpredictability were at the heart of Tone's collective improvisations with the Music group, which appropriated and to an extent reproduced the avant-garde techniques of Surrealism and *musique concrète*. *Parasite/Noise* recreates Benjamin's reflections on European modernity in the context of a global contemporary art festival yet also creates perhaps something else. What these projects share is their use of an indeterminacy that allows for the emergence of what Tone describes as an "unthinkable"—a form of information or novelty that cybernetics and the avant-garde render, from different perspectives, as an interruption of sameness. Nonetheless, one detects a slight shift from confidence to tentativeness in Tone's approach to newness, from his 1960 "experiment concerning an absolutely new music" to his

more recent wish "to find sounds that I've never heard before" to his recent impetus in *AI Deviation* concerning the *possibility* of creating "new sounds without my intention."[82] At the same time, Tone is consistent in his appeal to experimental processes that emphasize an openness to the unknown—to deviation and decontrol—over unwavering agential force.

If we understand the contemporary posthuman as the marginalization of human agency amid technological, environmental, and informational networks, Tone suggests that this condition does not completely foreclose the human capacity for novelty. It may, however, press upon our relationship to the thinkable, to the finitude of human agency to bring about forms of radical newness: to simply will the exceptional into being. So much of our understanding of the present era seems to turn on likelihoods and statistical probabilities rather than the more imaginal registers of speculation and pure possibility. The Google engineer François Chollet's recent critique of Good's scenario, for example, appeals to the latter's "implausibility" based on the purported externalized nature of intelligence and general limits of recursive intelligence augmentation.[83] While there may be good reason to give up on such fantasies of posthuman AI, the attachment to it many still feel, from scientists to philosophers to artists to laypeople, speaks to a very human desire to question the limits of the possible. Nonetheless, as an antidote perhaps to the teleological certainty of some visions of the future, Tone insists on the wonders of indeterminacy and technological failure—on the "surprise" potential of the familiar and mundane as much as the broken or malfunctioning. Anthropogenic novelty may be the product of a bygone modernity, but if we fully stop listening for the new, we may never escape the recursive repetition of the same that characterizes the contemporary. If we don't allow for deviation, Tone suggests, we may indeed have already seen the human's last invention.

CONCLUSION

Music after Extinction

This book has argued that experimental music since the second world war composes and reflects on the contemporary posthuman. Starting with *Music for Solo Performer*, we saw how Alvin Lucier's neurofeedback speaks to cognitive labor and the crisis of the posthuman brain. From the brain to the body, we heard Pamela Z's technologies of the embodied voice as she confronted the continued gendered and racializing effects of the posthuman's ideological preconditions in liberal humanism. Nam June Paik then expanded our engagement with the Enlightenment through *Robot K-456*'s references to eighteenth-century musical automata, while his robot's failed suicide affirmed labor's unique capacity for self-negation. From there we explored the distancing effects of extraplanetary life in Pauline Oliveros's Deep Listening and her work with moonbounce. From the extraplanetary to the close-at-hand, Laetitia Sonami's Lady's Glove and its references to reproductive labor pointed to a continuity between the body and number in the concept of digitality. Finally, Yasunao Tone's recursive experiments with AI and recording technology intervened in the historical impasses of the contemporary posthuman.

Such artistic practices, I've contended, amount to more than reproductions of musical modernism. Through an interdisciplinary postformalist approach to experimentalism, these artists address the contemporary posthuman and incorporate cybernetics and its decentering effects on the human as one set of themes among others in their respective practices. This is not to say that all composers and musicians associated with experimental music adopt a postformalist approach—John Cage's avoidance of the social in music has remained influential for many. Nor is it to suggest that cybernetics and posthumanism have even served as predominant themes given the diverse totality of postwar experimental music. Indeed, I hope that this book's case

studies have exhibited the relevance of experimentalism to race, ethnicity, labor, political economy, gender, sexuality, and disability—registers that turn, not incidentally, on the category of the human. But it is to suggest that beyond their respective uses of technology, these musicians produce heterogeneous forms of meaning that intervene in the social, cultural, and material reproduction of life. To conclude, I want to extend this analysis to a subject often said to elude meaning altogether.

Death and, by extension, extinction have pertained to experimental music, especially by way of cybernetics and its ties to the military. We've seen Paik's suicidal robot, while Sonami's glove-controller text settings include both human tragedy and animal death. Meanwhile, the deathly violence of antiblackness undergirds Z's interventions in the legacies of opera and the acousmatic voice. In another register, cybernetics' roots in military science did not prevent Lucier and Oliveros from appropriating its technologies, however self-consciously. To be sure, cyberneticians have felt varying degrees of comfort with military collaboration. Norbert Wiener's shift from developing anti-aircraft missiles to his later interest in "medical cybernetics" speaks to what some have identified as the mathematician's restorative turn, while John von Neumann evidently felt less inhibited than his colleague for his role in creating the atomic bomb.[1] Nonetheless, experimentalism's inheritances from, and involvements in, cybernetics—from PCM digital audio to speech synthesis to brain–computer interfaces to robotics to AI—are perhaps never fully separable from such military associations. Recall Herbert Brün's indictment of a desire felt during the 1960s to "make music with the weapons of death."[2] Or consider again Andreas Huyssen's Cold War homology between Cage's indeterminacy and the possibility of a nuclear "silence beyond art and life."[3]

More fundamentally, such a possibility of the intentional death of the human species inaugurates the very era of the contemporary posthuman. Edward Teller, a theoretical physicist who worked alongside von Neumann on the Manhattan Project during the 1940s, apparently listed the deployment target of one prototypical bomb as "backyard." The reasoning was that once the lethal effects of such a nuclear weapon reached a planetary scale, the consequences would be equivalent regardless of where it was detonated. "Since that particular design would probably kill everyone on Earth," one observer concluded, "there was no use carting it elsewhere."[4] Omnicide became operational. But how does our potential for self-extinction square with an understanding of the contemporary as post-anthropogenic, in which history is no longer strictly the product of human-led action? Certainly, extinction can be said to decenter the human. But, more importantly, our concept of the contemporary allows for both human and nonhuman forms of agency.

Anthropogenic action does not disappear; it becomes relativized. That is, we may have produced the threat of nuclear self-extinction, but, like the Anthropocene, such human origins do not ensure anthropogenic control of its effects—despite the reduction in nuclear warheads or efforts to reduce global warming. Recalling Cage's conflict between "people and things,"[5] the hydrogen bomb appears quasi-agential even without the guidance of AI or automation. The contemporary post-anthropogenic era arrives, in this way, through the prospect of self-annihilation.

Nonetheless, extinction was born much earlier. In his recent historiography of extinction, Thomas Moynihan traces the concept to the eighteenth century. During this time, most could not accept that a species could die off completely due to an assumption inherited from antiquity that nature was radically plentiful. This is why it was commonplace, as we saw in chapter 4, for everyone from Kant to laypeople to assume that extraterrestrials abundantly inhabited the cosmos. Even if humans could become extinct, all would not be lost, since innumerable human-like creatures thrive on other planets. Nonetheless, late eighteenth-century prognostications ranged from a geologist's warnings that Earth could one day become uninhabitable to an astronomer charting possible collision courses with comets.[6] Two centuries later, cybernetics not only facilitated the threat of nuclear extinction but also made possible the supposed "existential risk" of AI more recently popularized by Stephen Hawking, Elon Musk, and others. In another view, Wiener located the roots of our potential demise in our anatomy. The human brain may prove to be a maladaptation, a "destructive specialization" comparable to the nose horns of the extinct titanotheres, which could lead us to a similar fate.[7] Wiener's speculation is further provocative in light of chapter 1's discussion of Lucier and the posthuman brain. If this cognitive organ is so inherently flawed, why all the effort to duplicate it? Can indeterminacy interrupt the kind of neural automaticity Wiener sees as a potential cause of our ultimate death? If the possibility of self-extinction opens the contemporary posthuman era, what might bring about its closure?

If postwar experimentalism reflects on the contemporary posthuman, how does it compose death and extinction? In the remainder of this short conclusion, I want to consider two moments in which experimental music confronts, respectively, death and extinction. First, I'll turn to the work of the Texas-born experimentalist Jerry Hunt, an artist who ended his own life while living with terminal lung cancer and emphysema. Rather than simply an obstacle to futurity, Hunt rendered death as a meaningful theme in his art and life alike. Hunt furthermore composed a kind of ethics of death: shortly before his suicide, the artist created a video intended to assist others living

148 CONCLUSION

with late-stage terminal illness. Second, I want to consider a posthumous performance of Cage's *Organ²/ASLSP (As SLow aS Possible)* (1985), which its originators intend to last for more than six centuries—a timeline that could, with current predictions, meet the possibility of human extinction. During his lifetime, Cage expressed a related fantasy concerning music that outlasts his own death. Following his anechoic chamber experience, the composer assures listeners that, although the sounds of his nervous system will cease upon his death, others will continue, and this should abate any concerns about the future of music. He assures us that music, conceived as the ultimate reflection of nature, will continue because humanity and nature are "in this world together."[8] But what happens when humans are no longer in this world? Does extinction escape meaning, or does death compose its radical essence?

Death is, in some ways, paradigmatically posthuman. In it we confront a beyond not only of the human but of life itself. Yet death is also a limit to even the most far-reaching visions of the posthuman since, according to the second law of thermodynamics invoked by Shannon and Wiener, all biological and technological systems invariably break down over time and, eventually, come to an end due to entropy.[9] If technologies like brain emulation and AI are based in part on a fantasy of escaping or postponing death, they are also haunted by its inevitability.[10] If such inventions don't end up saving us from extinction—due to climate change, nuclear annihilation, or otherwise—one fantasy suggests that something like us can live on in them. Emblematized by Moravec's *Mind Children*, such figures point to a biotechnological valence of what the queer theorist Lee Edelman describes as "reproductive futurism."[11] Yet rather than surviving through progeny, human or machine, Cage imagines himself in musical continuity with a radically inhuman nature. Death, for Cage, proffers an extreme form of indeterminacy, a resolute withdrawal of intentionality in which sounds are no longer carriers of human meaning but can finally be "themselves."[12] But as Cage's 1992 encounter with an AIDS activist suggests, death weaves meaning into sound as much as silence. This book's final counterpoint to Cage's inhuman musicality finds a defiant if at times disturbing approach to death in the life and work of Hunt.

Experimenting Death

In 1993, Hunt executed a series of artistic works before taking his own life in what one commentator described as "perhaps the most meticulously thought-out suicide in history."[13] Hunt produced a twenty-minute video performance, *Talk (slice): duplex*, as one of four posthumously released "video translations" of works he had previously composed for performance. The video depicts

Hunt against a black background from the neck up, face to face with and just inches away from his fellow performer, Rod Stasick. Hunt begins to speak plainly. "I don't think that there's any sense in trying to make more out of a situation than there is, but I, just personally, can't take death seriously." Hunt continues, his gaze fixed on his interlocutor. "I take suffering seriously, you know, pain, and the projection of pain—." Interrupting Hunt, Stasick strikes a pair of wooden claves and speaks on a seemingly unrelated subject. Hunt then similarly interrupts Stasick. Back and forth, this process continues as the two meander through topics ranging from the everyday to the scientific, religious, artistic, musical, sexual, and technological. "When I was a young boy," the openly gay composer recalls, "I had the idea that I might pursue some kind of futuristic environment, which involved a mysterious combination of electronics and ill-defined sexuality."[14] Hunt then suggests that his long-time partner, Stephen Housewright, lacked a sense for religious experience. "I can't imagine anything I've felt that strongly about except perhaps pain," Hunt explains. To which Stasick inquires, "Don't you feel the pain when you see another animal that's hurting or dead?" "That's it," affirms Hunt. "You've hit right on the ultimate issue here."

Death and pain were indeed principal concerns for Hunt because at the time he had been planning his suicide in response to the overwhelming physical effects of his terminal illness. The same year Hunt recorded *Talk*, he created another video titled "How to Kill Yourself Using the Inhalation of Carbon Monoxide Gas." Contrary to his opening statement in *Talk*, in this video Hunt appears to take death very seriously. Hunt faces the camera while sitting next to a large brown gas cylinder. His affect is plain and unflinching as he describes his preference for this suicide method as a difficult yet rational choice due to its high (but not absolute) rate of success. Addressing the viewer, he explains, "The reason I'm making this tape is because the difficulty that I've experienced in coming to some decision about this was so great that I decided that it might be useful to other people to have some information about decisions that I've made." Already apparent is his concern for the other.

Hunt's suicide takes on an ethical, even social dimension. He goes on to describe how he purchased the $102 carbon monoxide cylinder as well as the steps he had taken to exonerate the gas supplier and manufacturer. He also explains how to prevent accidental harm, due to gas inhalation, of any human or animal that might later find his deceased body. The solution he describes involves ventilating the space and using a tube that passes the gas into a dust mask, which he demonstrates by briefly wearing the mask. Further describing this approach, Hunt alludes to mounting concerns expressed in the media around euthanasia at the time. "Because of some of the attention that

has been placed around carbon monoxide in the last year (this tape is being made in 1993) it's very clear that it's very effective."[15] It is likely that Hunt is referring to the controversy surrounding Dr. Jack Kevorkian, whose highly publicized assisted suicides starting in the early 1990s involved the physician's self-assembled Thanatron—a lethal injection–administering "death machine"—and his carbon monoxide–based Mercitron, a "mercy machine" he operated in the back of a Volkswagen van.[16] According to Housewright, Hunt had fantasized about Kevorkian becoming his "personal physician."[17]

Hunt's "How to Kill Yourself" differs from *Talk* in terms of form, content, and mode of address; and, to be sure, nowhere does Hunt suggest the video is to be considered part of his artistic output. It may be tempting nevertheless to compare Hunt's statement to the 1960s videos of Vito Acconci and John Baldessari, artists whose de-aestheticized performances often include signifiers of white masculinity and use a similar deadpan, direct-to-camera address. Or one may think of Joseph Beuys's macabre 1965 performance *How to Explain Pictures to a Dead Hare*, which shares Hunt's paradoxical invocation of the self-help genre. But, importantly, nowhere does Hunt specify that his tape is to be viewed as anything more than a document of pragmatic communication.[18] "How to Kill Yourself" emphasizes the reflexive second person pronoun, yet the target of its communication seems to be a broader community of those living with terminal illness. He is reluctant, in any case, to unequivocally promote his solution to—and even *of*—suicide. Hunt concludes the tape by saying, "I wish you good success in whatever endeavor you feel that you might find necessary."

Another of his four video translations, *Bitom [fixture]: topogram*, choreographs an aural homoerotics of the posthuman body, a medicalized queer body, to recall Jack Halberstam and Ira Livingston, under the sign of AIDS and subject to fears of contamination.[19] The video depicts Hunt and another performer, the late Texan artist Michael Galbreth, in roles Hunt labels, respectively, as *agent* and *patient*. The patient is seated while Hunt crouches. Donning a pair of Latex gloves, Hunt listens to various parts of Galbreth's body using both a stethoscope and a device that measures the skin's electrical conductance. Using a form of biofeedback not unlike Lucier's EEG, the measurements of Galbreth's electrodermal activity control the pitch of an intense, high-frequency, noisy drone that subtly changes as Hunt intimately caresses the patient's body. Amid a multitasking Hunt—who, in addition to wielding medical instruments, intermittently blows into a tin whistle—Galbreth sits calmly with a blank expression that at times resembles the look of boredom that might arise during a routine examination. Throughout this process, Hunt's affect ranges from intrigue to ecstatic anguish. Both performers

are clothed, yet the scenario may invoke the notion of "playing doctor"—a euphemism for the reciprocal genital examination behavior found in early childhood development—or perhaps its later manifestation in adult medical fetishism.

Moreover, Hunt's gesture alludes to his own encounter with chronic illness, which, at the height of the AIDS pandemic, points if only catachrestically to the deathly homophobic responses to HIV/AIDS found in medical communities and the public alike. To be sure, Hunt did not have HIV/AIDS, yet he was nevertheless subjected to anti-gay sentiment and stigma. Housewright recounts one of his partner's final trips to the emergency room, in which "Jerry agreed to undergo an HIV test; the hospital records reflected the negative results, and at the same time these results allayed the staff's fear of AIDS, they announced our identity as a gay couple."[20] Around the time Hunt tested negative, yet before his death, Cage had his own encounter with the subjects of death and HIV/AIDS. Speaking at the same symposium that saw his worldline cross with the author of *How We Became Posthuman*, Cage was reproached by an attendee who, repeating the slogan of the AIDS Coalition To Unleash Power (ACT UP), exclaimed, "silence equals death."[21] To the attendee's reframing of Cage's silence through AIDS activism, the composer responded, "in Zen life equals death," adding, "Everything you open yourself to is your silence."[22] Cage's response appears enigmatic if we understand indeterminacy, as discussed in this book's introduction, as a historically specific form of queer resistance deployed during McCarthyism and the Cold War.[23] At the same time, his comments recall perhaps the composer's fantasy of sounds continuing after his death. To conclude, let us turn to the intersecting worldlines of another deadly pandemic and a Cage performance currently in progress that can be said to experiment with extinction.

Experimenting Extinction

If experimentalism experiments the human, it has also imagined music that could outlast our extinction. Cage's music should last for more than another six centuries if a posthumous realization of his 1987 composition for organ continues to go as planned. Cage adapted *Organ²/ASLSP (As SLow aS Possible)* from a piano work he had written in 1985 that includes the tempo indication "as slow as possible." Following a 1998 organ symposium in Trossingen, Germany, a group of musicians and musicologists decided that in order to authentically realize Cage's tempo marking, they would have to calibrate a performance according to the "lifespan" of the organ whose origins they located in the fourteenth century.[24] As such, the performance began sounding

in 2001 on an organ in St. Burchardi church in Halberstadt, Germany and is scheduled to last until 2640, for a total of 639 years. Even with conservative estimates of the global impact of climate change, it is possible that humans may never hear the performance's final notes.

Nevertheless, the sounds of Cage's organ composition—or at least some of them—could, potentially, survive an extinction event. As a solution to the problem of the extremely long duration of each note, the organ pedals that activate its pipes are held down by sandbags, which performers change periodically in concert events that have occasionally garnered media attention. A recent instance of such events provided another intersection between experimental music, death, and global pandemic. We end just days after this book's beginning. Roughly a week after Musk unveiled Neuralink, the Coronavirus death toll topped one million worldwide amid financial crisis and global protests following the police murder of George Floyd. A crowd of onlookers, many of whom can be seen wearing masks, gathered in Halberstadt. Photos depict gloved musicians carefully adding the notes G#3 and E4 to the organ's already sounding pitches C4, D♭4, D#4, and E5. The *New York Times* described the event as part of "A 639-Year Concert, With No Intermission for Coronavirus."[25]

How, finally, does experimental music compose extinction? Cage's imperative to open oneself to silence invites us perhaps to contemplate the impossible possibility of a performance that would last not hundreds of years but closer to cosmic time scales. The knowledge of our own extinction extends here to the inexorable death of the planet, the solar system, and even the universe. Writing in 1958, one year after Cage fantasized about sounds continuing after his death, the French philosopher Gilbert Simondon described "the machine" as that which "fights against the death of the universe; it slows down the degradation of energy, as life does, and becomes a stabilizer of the world."[26] Substituting "organ" for "machine," we might imagine *As SLow aS Possible* performing a similar life-affirming function—an instrument that dramatically slows things down.[27] At the same time, even the most fantastical inventions may never escape what science refers to as the inevitable heat death of the universe: a radical slowing down of all matter until nothing interesting will ever happen again. Absolute silence.

Meanwhile, indeterminacy. As with both individual death and extinction, the exact timing of the heat death of the universe remains indeterminate, but the fact that it will occur does not. The universe and everything in it, scientists conclude, will come to an end. Concluding his discussion of Freud's death drive and extinction, the philosopher Ray Brassier insists that to acknowledge this fate is to understand, paradoxically, that one is "already dead,

and that philosophy is neither a medium of affirmation nor a source of justi-fication, but rather the organon of extinction."[28] An organon is an instrument for acquiring knowledge based on a set of philosophical or scientific prin-ciples. Music, Cage suggests, may play a similar role.[29] Yet if Cage's organ be-comes an instrument for imagining the possibility of music after extinction, Hunt and the other artists in this book do not seek a musical universe beyond human meaning. Rather, they compose the contemporary posthuman by ex-perimenting the messy, complicated—social and political—universe that *is* the human.

Acknowledgments

I want to thank Elizabeth Branch Dyson and Mollie McFee at the University of Chicago Press for their extraordinary work on this project. Thanks also to the two anonymous peer reviewers for their insightful feedback. A big thank you to Benjamin Piekut and Christian Grüny for reading earlier drafts of this book and offering invaluable suggestions. Thanks to Leigh Claire La Berge, Georgina Born, Christopher Haworth, Eric Drott, Daniel Fox, and Justin Adams Burton for reviewing and commenting on various parts of this text as it developed.

Thank you to Pamela Z, Yasunao Tone, Tony Myatt, Daniela de Paulis, and Andres Bosshard for volunteering to be interviewed and for sharing materials related to their work. Thank you to Laetitia Sonami and Paul DeMarinis for providing archival materials and details on their collaboration. For intellectual exchange and/or inspiration, thanks to George E. Lewis, Georgina Born, Peter Osborne, Andrew Pickering, Seb Franklin, Jonathan Impett, Paulo de Assis, William Brooks, Nicholas Brown, Mara Mills, Clara Latham, Thomas Patteson, Teresa Heffernan, Alexander R. Galloway, Branden W. Joseph, David Joselit, Douglas Kahn, Iain Campbell, Miki Kaneda, Andrew Cappetta, Philip Thomas, Tao G. Vrhovec Sambolec, Xenia Benivolski, Terry Blum, David Grubbs, Chia-ling Lai, Ryan Nolan, and Mark Harris.

Thanks for sharing research, commentary, and/or feedback go to Suhail Malik, Ted Gordon, Daniel K. L. Chua, Alexander Rehding, Flora Lysen, Douglas Cohen, Paul Murphy, Robin Hanson, Gualtiero Piccinini, Renetta Sitoy, Charissa Noble, Robb Hernández, Matteo Pasquinelli, You Nakai, Ione, Anne Bourne, Sam Ridout, Stephen Docherty, and Alex Kitnick. And thanks to fellow travelers Peter Ablinger, Ari Benjamin Meyers, Theresa Beyer, Brandon Farnsworth, Colin Tucker, David Schafer, Samson Young, Erik DeLuca,

Manfred Werder, Casey Anderson, James R. Currie, Naomi Waltham-Smith, Paul Carr, Seamus Carter, Koen Nutters, Kristina Warren, Gabriel Paiuk, Travis Just, Kara Feely, William Dougherty, Esther Marié Pauw, Emma Dusong, Giorgio Magnanensi, Kathryn Cai, John Lely, Monty Adkins, Jau-lan Guo, Emily Payne, Ada Kai-Ting Yang, Natilee Harren, Nick Roth, Anna Katsman, Christopher Botta, Lin Chi-Wei, Jennifer Walshe, Jeremy Woodruff, and Danilo Correale. The composer and poet Chris Mann provided valuable insights into my treatment of cybernetics before he passed away in 2018. In memoriam, Chris.

Thank you to Katy Dammers at The Kitchen, Gaylord Robb at Salisbury University, Karl McCool at Electronic Arts Intermix, and Michael Beiser and Tara Hart at the Whitney Museum of American Art for their archival assistance. Thanks to Donald Swearingen and Penny Yeung for image permissions. Thanks to Justin Murphy for hosting writing and work sessions. Thank you to Elizabeth Ellingboe and Evan Young for their attentive copyediting, and to June Sawyers for indexing this book. Thanks to Timothy Holland, Erin Nunoda, Alejandro L. Madrid, and Annie Moore for their editorial suggestions on various parts of this book. Many thanks to Maarten Pereboom and Donna Knopf for facilitating various grants, conference funding, a teaching release, and other support from the Fulton School of Liberal Arts at Salisbury University. Thanks to Clifton Griffin and Teri Herberger for funding from the university, and to the Salisbury University Foundation for additional support. Thanks to James Burton, Andrew Sharma, Aaron Gurlly, Michelle Hirsch, and others in the Communication Department at Salisbury University. Thanks also to Marcin Ramocki and my colleagues in the Media Arts Department at New Jersey City University, along with Tamara Jhashi, João Sedycias, and Jason Martinek.

For their enduring friendship and support, thank you to Benjamin Piekut, Marina Rosenfeld, Leigh Claire La Berge, Caroline Woolard, Lindsey Lodhie, Francesco Gagliardi, Imogen Dickie, Sari Carel, Justin Sullivan, Bob Sullivan, Karen Sullivan, Jordan Carel, Sarah M. Schmidt, Shruti Patel, Christian Grüny, Elisa Band, Petros Touloudis, Cássio Diniz Santiago, James Orsher, Kerstin Fuchs, Ryan Conrath, Stephanie Bernhard, Eric Shuster, Ryan Sporer, Ellen Kang, David Gladden, Tara Gladden, Shannon O'Sullivan, and Matthew Michaud. Thanks to my family for their encouragement and to Maria Huffman for her patience and good humor. Thank you to my wonderful partner, Alethea Rockwell, for her love and support and for being the most rigorous and thoughtful interlocutor at every stage of writing this book.

This project is also indebted to the many teachers and mentors I've had over the years. Composition lessons and classes on American "mavericks" with the

late James Tenney were foundational to my thinking on indeterminacy and algorithmic music. At an early stage, Jim encouraged my writing on music and, along with other faculty and fellow students at CalArts, planted seeds that would grow into this book. Christian Wolff, Sara Roberts, Michael Pisaro-Liu, Tom Leeser, Mark Trayle, James R. Currie, Peter Ablinger, Richard Boulanger, and Cort Lippe similarly shaped my thoughts on experimental music, contemporary art, media theory, and music technology. I would be remiss here not to mention Alvin Lucier, a composer and pedagogue whose wry sense of humor was nearly as poignant as his music. I had the pleasure of studying with Alvin at an art residency and at multiple music festivals. As it happened, at one such festival a group of eager students—many of whom had already possessed advanced degrees in music—rushed over to congratulate him after the European premiere of his monumental new work for orchestra. "Alvin, that was amazing! What an incredible piece." After a brief pause in the excitement, he deadpanned, "Well, I do have a master's degree in music composition." Sadly, he passed away just as I finished writing this book. This book is for Alvin.

Notes

Introduction

1. Neuralink, "Neuralink Progress Update, Summer 2020," YouTube video, 1:13:30, August 28, 2020, https://www.youtube.com/watch?v=DVvmgjBL74w. Prior to that event, Elon Musk tweeted that he anticipated music streaming to be a feature of Neuralink. See Anthony Cuthbertson, "Elon Musk Claims His Neuralink Chip Will Allow You to Stream Music Directly to Your Brain," *Independent*, July 21, 2020, https://www.independent.co.uk/life-style/gadgets-and-tech/news/elon-musk-neuralink-brain-computer-chip-music-stream-a9627686.html. See the white paper: Elon Musk and Neuralink, "An Integrated Brain-Machine Interface Platform with Thousands of Channels," *Journal of Medical Internet Research* 21, no. 10 (October 31, 2019). For a recent analysis and survey of electroencephalography (EEG) in art (and music), see Flora Christine Lysen, "Brainmedia: One Hundred Years of Performing Live Brains, 1920–2020" (PhD diss., University of Amsterdam, 2020).

2. Alvin Lucier to Joel Chadabe, no date (ca. 1966), "Correspondence 1963–1976," Alvin Lucier Papers 1939–2015, Box 3, New York Public Library.

3. Pauline Oliveros, "Tripping on Wires: The Wireless Body—Who Is Improvising?," in *Sounding the Margins: Collected Writings 1992–2009* (Kingston, NY: Deep Listening Publications, 2010), 123; Ray Kurzweil, "The Law of Accelerating Returns," *Kurzweil: Tracking the Acceleration of Intelligence*, March 7, 2001, https://www.kurzweilai.net/the-law-of-accelerating-returns.

4. Pauline Oliveros, "Quantum Listening: From Practice to Theory (to Practice Practice)," in *Sounding the Margins*, 84.

5. Alvin Lucier, "Ostrava Days 2001—Transcript of Alvin Lucier Seminar," seminar organized by Petr Kotik, cited in Douglas Kahn, *Earth Sound Earth Signal: Energies and Earth Magnitude in the Arts* (Berkeley: University of California Press, 2013), 99.

6. Donna Haraway locates three "boundary breakdowns" in the cyborg—namely, between human and animal, organism and machine, and the physical and the nonphysical. Donna Haraway, "Manifesto for Cyborgs: Science, Technology, and Socialist Feminism in the 1980s," *Socialist Review* 80 (1985): 68. Note, however, that Haraway has never fully embraced the term "posthuman" or "posthumanism." Donna Haraway, "Companions in Conversation [with Cary Wolfe]," in *Manifestly Haraway* (Minneapolis: University of Minnesota Press, 2016), 261.

7. Neuralink, "Neuralink Progress Update, Summer 2020." Chapter 1 touches on sonification via Volker Straebel and Wilm Thoben's analysis of Lucier. Volker Straebel and Wilm Thoben,

"Alvin Lucier's *Music for Solo Performer*: Experimental Music Beyond Sonification," *Organised Sound* 19, Special Issue 1 (April 2014): 17–29. See also chapter 6 for an analysis of Yasunao Tone's use of sonification.

8. Neuralink, "Neuralink Progress Update, Summer 2020."

9. Warren McCulloch, "Recollections of the Many Sources of Cybernetics," *ASC Forum* 6, no. 2 (1974): 5–16. Cited in Gualtiero Piccinini, "The First Computational Theory of Mind and Brain: A Close Look at McCulloch and Pitts's 'A Logical Calculus of Ideas Immanent in Nervous Activity,'" *Synthese* 141 (August 2004): 179. Their original paper is Warren S. McCulloch and Walter Pitts, "A Logical Calculus of the Ideas Immanent in Nervous Activity," *Bulletin of Mathematical Biology* 5 (1943): 115–33. Chapter 6 considers neural networks in the context of artificial intelligence.

10. Norbert Wiener, *Cybernetics; or, Control and Communication in the Animal and the Machine*, reissue of the 1961 second edition (Cambridge, MA: MIT Press, 2019). See also Norbert Wiener, *The Human Use of Human Beings* (1950; London: Free Association Books, 1989).

11. Bruce Clarke, *Posthuman Metamorphosis: Narrative and Systems* (New York: Fordham University Press, 2008), 4. Note that Clarke's use of "contemporary" here does not necessarily equate to the periodizing concept explained below.

12. John Locke, *Second Treatise of Government*, ed. C. B. Macpherson (Indianapolis, IN: Hackett Publishing Co., 1980), 18.

13. N. Katherine Hayles, *How We Became Posthuman: Virtual Bodies in Cybernetics, Literature, and Informatics* (Chicago: University of Chicago Press, 1999), 4.

14. Julien Offray de La Mettrie, *Machine Man and Other Writings*, trans. and ed. Ann Thomson (Cambridge, UK: Cambridge University Press, 1996), 7. See chapter 3.

15. I am thinking here of Sylvia Wynter (see chapter 2). There are various other examples of antiracist critics of humanism who do not pursue its abolishment. Considering the clashes between liberal humanism and biological racism in the antebellum US, for instance, Christin Ellis argues that the antislavery materialism of Frederick Douglass, Henry David Thoreau, and Walt Whitman rebutted biological racism on its own terms while departing, to an extent, from the liberal humanism for which those thinkers are often remembered. Christin Ellis, *Antebellum Posthuman: Race and Materiality in the Mid-Nineteenth Century* (New York: Fordham University Press, 2018), 5.

16. On the relationships between humanism, antihumanism, and posthumanism, see Rosi Braidotti, "Posthuman Humanities," *European Educational Research Journal* 12, no. 1 (2013): 1–19.

17. Alexander G. Weheliye, *Habeas Viscus: Racializing Assemblages, Biopolitics, and Black Feminist Theories of the Human* (Durham, NC: Duke University Press, 2014), 135.

18. Zakiyyah Iman Jackson, "Outer Worlds: Persistence of Race in Movement 'Beyond the Human,'" *GLQ: A Journal of Lesbian and Gay Studies* 21, no. 2–3 (June 2015), Dossier: Theorizing Queer Inhumanisms, ed. José Esteban Muñoz, 216. See also Zakiyyah Iman Jackson, *Becoming Human: Matter and Meaning in an Antiblack World* (New York: NYU Press, 2020).

19. Weheliye, *Habeas Viscus*, 25. See also David Scott and Sylvia Wynter, "The Reenchantment of Humanism: An Interview with Sylvia Wynter," *Small Axe* 8 (September 2000): 119–207.

20. Immanuel Kant, *Anthropology from a Pragmatic Point of View*, trans. Robert B. Louden (1798; Cambridge, UK: Cambridge University Press, 2006), 238, 236. See chapter 4.

21. Oliveros, "Quantum Listening," 84.

22. Slavoj Žižek, *Hegel in a Wired Brain* (New York: Bloomsbury, 2020), 20.

NOTES TO PAGES 6–7

23. While popularized by Ray Kurzweil, Vernor Vinge is credited with coining the technological singularity in 1993. Vernor Vinge, "Technological Singularity," *VISION-21 Symposium*, NASA Lewis Research Center and Ohio Aerospace Institute, March 30-31, 1993, https://frc.ri.cmu.edu/~hpm/book98/com.ch1/vinge.singularity.html.

24. In his fascinating philosophical inquiry into neurotechnologies, Michael Haworth refers to this as the "interior-exterior structure of finite experience." Michael Haworth, *Neurotechnology and the End of Finitude* (Minneapolis: University of Minnesota Press, 2018), 2. I thank Christopher Haworth for this reference.

25. In the June 2000 performance at Stavanger Konserthus, Norway, Gilchrist invited four community members (a bricklayer, a jeweler, a yogi, and a painter) to participate. Each participant was asked to recall their last creative act while connected to an EEG monitoring device on stage. Bruce Gilchrist, "Thought Conductor #2," artEmergent, accessed September 28, 2021, http://www.artemergent.org.uk/tc/tc2.html. Gilchrist's occupational identification of the "members of the community" further suggests relevance to chapter 1's political-economic interpretation of Lucier's *Music for Solo Performer* as staging the brain at work.

26. Georgina Born, "Social Forms and Relational Ontologies in Digital Music," in *Bodily Expression in Electronic Music: Perspectives on Reclaiming Performativity*, ed. Deniz Peters, Gerhard Eckel, and Andreas Dorschel (New York: Routledge, 2012), 171, italics in original.

27. Georgina Born, "Social Forms," 172–73. On *Thought Conductor #2*, see also Miriam Fraser, "Making Music Matter," *Theory, Culture & Society* 22, no. 1 (2005): 173–89. Fraser compares *Thought Conductor #2* to John Cage's *4'33"*.

28. Georgina Born and Andrew Barry, "Introduction," *Contemporary Music Review* 37, nos. 5–6: Music, Mediation Theories and Actor-Network Theory (2018): 447; they cite (and see also) Georgina Born, "On Nonhuman Sound—Sound as Relation," in *Sound Objects*, ed. Rey Chow and James A. Steintrager (Durham, NC: Duke University Press), 185–207.

29. The symposium, "John Cage at Stanford: Here Comes Everybody," occurred January 27–31, 1992, and was hosted by the Stanford University Humanities Center in Palo Alto, California. N. Katherine Hayles spoke on the Poethics panel held January 29, along with Gerald Burns, Daniel Herwitz, and Joan Retallack. Hayles's contribution was later published in the volume that resulted from the symposium. N. Katherine Hayles, "Chance Operations: Cagean Paradox and Contemporary Science," in *John Cage: Composed in America*, ed. Marjorie Perloff and Charles Junkerman (Chicago: University of Chicago Press, 1994), 226–41. N. Katherine Hayles, *How We Became Posthuman: Virtual Bodies in Cybernetics, Literature, and Informatics* (Chicago: University of Chicago Press, 1999).

30. On Cage's and Lejaren Hiller's *HPSCHD*, see Brander W. Joseph, "*HPSCHD*—Ghost or Monster?," in *Mainframe Experimentalism: Early Computing and the Foundations of the Digital Arts*, ed. Hannah B. Higgins and Douglas Kahn (Berkeley: University of California Press, 2012), 147–69.

31. James Pritchett, James Tenney, Andrew Culver, and Frances White, "Cage and the Computer: A Panel Discussion," in *Writings Through John Cage's Music, Poetry, and Art*, ed. David W. Bernstein and Christopher Hatch (Chicago: University of Chicago Press, 2001), 190–209; see Culver's chart of Cage's computer programs on 194–95.

32. Hayles, "Chance Operations," 227.

33. While the term "posthumanism" did not circulate widely until the 1990s, the literary theorist Ihab Hassan used it as early as 1977. Ihab Hassan, "Prometheus as Performer: Toward a Posthumanist Culture?," *Georgia Review* 31, no. 4 (1977): 830–50. Notably, Hassan associates

posthumanism with postmodernism (831, 835), cybernetics (834, 841), and the work of Cage (840–42). Hayles cites Hassan in *How We Became Posthuman*, 247.

34. Hayles, "Chance Operations," 229.

35. John Cage, "Experimental Music: Doctrine" (1955), in *Silence: Lectures and Writings* (Middletown, CT: Wesleyan University Press, 1961), 13; the article was originally titled "Experimental Music" and appeared in *The Score and I. M. A. Magazine* (June 1955). Cage delivered a statement, also titled "Experimental Music," in 1957, which is included in *Silence*, 7–12.

36. Cardew's inclusion as an experimentalist is complicated by the fact that at the time he served as Stockhausen's assistant and later went on to distance himself from both the European avant-garde and experimentalism.

37. See Martin Iddon, *New Music at Darmstadt: Nono, Stockhausen, Cage, and Boulez* (Cambridge, UK: Cambridge University Press, 2013); and Jennifer Iverson, *Electronic Inspirations: Technologies of the Cold War Musical-Avant-Garde* (New York: Oxford University Press, 2019), Kindle location 139–145. Andreas Huyssen argues, paradoxically, that serialism planted the seeds for Cage's indeterminacy: "Excessive determination itself had already opened the door to chance in the works of Stockhausen and Boulez, and Cage, it can be said, simply drew the conclusions of what was latent in serialism itself." Andreas Huyssen, *Twilight Memories: Marking Time in a Culture of Amnesia* (New York: Routledge, 1995), 204.

38. John Cage, "Composition as Process: II. Indeterminacy," in *Silence*, 35–40.

39. Georgina Born, *Rationalizing Culture: IRCAM, Boulez, and the Institutionalization of the Musical Avant-garde* (Berkeley: University of California Press, 1995), 56.

40. James Tenney, "Computer Music Experiences, 1961–1964," *Electronic Music Reports #1* (Utrecht: Institute of Sonology, 1969), 38; published in James Tenney, *From Scratch: Writings in Music Theory*, ed. Larry Polansky, Lauren Pratt, Robert Alexander Wannamaker, and Michael Winter (Champaign: University of Illinois Press, 2015), 97–127. See also Douglas Kahn, "James Tenney at Bell Labs," in *Mainframe Experimentalism*, 131–46.

41. Cage, "Composition as Process: II. Indeterminacy," 36.

42. Liz Kotz notes that another version of Cage's score indicates the durations 30″, 2′23″, and 1′40″. Liz Kotz, *Words to Be Looked At: Language in 1960s Art* (Cambridge, MA: MIT Press, 2007), 5.

43. Kotz, *Words to Be Looked At*, 5.

44. Cage, "Experimental Music" (1957), *Silence*, 8.

45. Cage, "Experimental Music" (1957), *Silence*, 10.

46. Douglas Kahn, "John Cage: Silence and Silencing," *The Musical Quarterly* 81, no. 4 (Winter 1997): 559. Relatedly, Benjamin Piekut argues that Cage adhered to a modernist ontology that separated "social affairs from natural ones." Benjamin Piekut, "Chance and Certainty: John Cage's Politics of Nature," *Cultural Critique* 84, no. 1 (2013): 135. See also Benjamin Piekut, "Sound's Modest Witness: Notes on Cage and Modernism," *Contemporary Music Review* 31, no. 1, "Cage at 100," ed. Benjamin Piekut and David Nicholls (February 2012): 3–18.

47. See G Douglas Barrett, "The Limits of Performing Cage: Ultra-red's *SILENT|LISTEN*," *Postmodern Culture* 23, no. 2 (2014).

48. John Cage in Allan Miller, dir., *American Masters*, "John Cage: I Have Nothing to Say and I am Saying It," season 5, episode 8, aired September 17, 1990, on PBS. See also John Cage and Daniel Charles, *For the Birds* (London: Boyars, 2000), 116; and Cage, "Composition as Process III: Communication" (1958), in *Silence*, 41–56, in which he said "Don't you agree with Kafka when he wrote, 'Psychology—never again?'" (47); cited in Branden W. Joseph, *Experimentations: John*

Cage in Music, Art, and Architecture (New York: Bloomsbury, 2016), 33n; Joseph notes that by "psychology" Cage meant orthodox psychoanalysis (26).

49. Jonathan Katz, "John Cage's Queer Silence; or, How to Avoid Making Matters Worse," *GLQ: A Journal of Lesbian and Gay Studies* 5, no. 2 (1999): 231–52. Conversely, Moira Roth argues that Cage's silence was part of an "aesthetics of indifference" that characterized 1950s art in the US. Moira Roth, in Moira Roth and Jonathan Katz, *Difference/Indifference: Musings on Postmodernism, Marcel Duchamp and John Cage* (Amsterdam: G+B Arts International, 1998), 35.

50. Caroline A. Jones, "Finishing School: John Cage and the Abstract Expressionist Ego," *Critical Inquiry* 19, no. 4 (Summer 1993): 628–65; Philip M. Gentry, "The Cultural Politics of 4'33"": Identity and Sexuality," *Tacet Experimental Music Review* no. 1, Who Is John Cage? (2011): 19–39. See also Barrett, "The Limits of Performing Cage."

51. John Cage, "Diary: How to Improve the World (You Will Only Make Matters Worse) (1965)," in *A Year from Monday: New Lectures and Writings* (Middletown, CT: Wesleyan University Press, 1967), 11; Joseph, "*HPSCHD*—Ghost or Monster?," 160.

52. See John Borrie, "Cold War Lessons for Automation in Nuclear Weapon Systems," in *The Impact of Artificial Intelligence on Strategic Stability and Nuclear Risk: Volume I Euro-Atlantic Perspectives* (Report), May 1, 2019, ed. Vincent Boulanin (Stockholm: Stockholm International Peace Research Institute, 2019), 41–52.

53. Referring to cybernetician John von Neumann's coterminous work on the atomic bomb and modern computing architecture, the French collective Tiqqun note, "[T]he computer and the atomic bomb are born together." Tiqqun, *The Cybernetic Hypothesis*, trans. Robert Hurley (2001; Los Angeles, CA: Semiotext[e], 2020), 44.

54. Huyssen, *Twilight Memories*, 204–5.

55. Philip Mirowski, *Machine Dreams: Economics Becomes a Cyborg Science* (Cambridge, UK: Cambridge University Press, 2001), 136.

56. Lejaren Hiller, Leonard M. Isaacson, *Experimental Music: Composition with an Electronic Computer* (New York: McGraw-Hill, 1959), 82, 83, 93.

57. Cage, "Experimental Music: Doctrine," 13. William Brooks distinguishes between Cage's conception of the musical experiment as *observation* and Hiller's notion of it as a *test*. William Brooks, "In re: 'Experimental Music,'" *Contemporary Music Review* 31, no. 1, "Cage at 100," ed. Benjamin Piekut and David Nicholls (February 2012): 38–39. Lydia Goehr makes a related distinction regarding Cage and the scientific method of Francis Bacon—namely, between the *experiment* and *the experimental*. Lydia Goehr, "Explosive Experiments and the Fragility of the Experimental," in *Experimental Affinities in Music*, ed. Paulo de Assis (Leuven, Belgium: Leuven University Press, 2015), 15–41.

58. Joseph suggests, however, that despite aesthetic divergences they shared an aversion to "pure white noise." Joseph, "*HPSCHD*—Ghost or Monster?," 150.

59. Laetitia Sonami in Tara Rodgers, *Pink Noises: Women on Electronic Music and Sound* (Durham, NC: Duke University Press, 2010), 229.

60. Laetitia Sonami in an interview with Phoebe Legere following Sonami's April 26, 2000 performance at Roulette, New York. Video available at https://vimeo.com/11316136.

61. Herbert Brün, "Wayfaring Sounds," in *When Music Resists Meaning: The Major Writings of Herbert Brün*, ed. Arun Chandra (Middletown, CT: Wesleyan University Press, 2004), 126. Cited in Rodgers, *Pink Noises*, 7. Notably, Brün was involved in algorithmic composition and second-order cybernetics research. He co-taught courses with Heinz von Foerster that culminated in a book written collectively by members of the class, *The Cybernetics of Cybernetics*

(1974). Herbert Brün and Stephen Sloan, *The Cybernetics of Cybernetics*, second edition (Urbana-Champaign, IL: Future Systems Inc., 1995). See Chandra, *When Music Resists Meaning*, 285.

62. Laetitia Sonami, "Instruments—Lady's Glove—LAETITIA SONAMI," accessed April 4, 2020, http://sonami.net/ladys-glove.

63. Sonami, interview with Legere.

64. Cary Wolfe, *What Is Posthumanism?* (Minneapolis: University of Minnesota Press, 2010), xv.

65. Wolfe, *What Is Posthumanism?*, xv.

66. La Mettrie, *Machine Man*. See also Paul-Henri Thiry, Baron d'Holbach, *The System of Nature*, vol. 1 (1770; New York: Routledge, 2019). The Scottish Enlightenment philosopher David Hume simultaneously promoted free will and determinism in what became known as the "compatibilist" position. David Hume, *An Enquiry concerning Human Understanding* (1748; Indianapolis, IN: Hackett Publishing, 1993).

67. Peter Osborne, *The Postconceptual Condition: Critical Essays* (New York: Verso, 2018), EPUB location 28. See also Peter Osborne, *Anywhere or Not at All: Philosophy of Contemporary Art* (London: Verso, 2013).

68. Gilles Deleuze, "Control and Becoming" and "Postscript on Control Societies," in *Negotiations*, trans. Martin Joughin (New York: Columbia University Press, 1995), 175, 177–82. See Reinhold Martin, "The Organizational Complex: Cybernetics, Space, Discourse," *Assemblage* 37 (December 1998): 104. See also "Control" in Seb Franklin, *Control: Digitality as Cultural Logic* (Cambridge, MA: MIT Press, 2015), 3–38.

69. Martin, "The Organizational Complex," 104.

70. "Conjunctively disjunctive" is from Osborne, *The Postconceptual Condition*, 27. Terry Smith's version of the contemporary begins somewhat more decisively in 1989 with the triumph of neoliberalism, the integration of electronic and digital culture, and globalization's production of post- and decolonial subjectivities. Terry Smith, *What Is Contemporary Art?* (Chicago: University of Chicago Press, 2009). See also Alexander Alberro, Response to "Questionnaire on 'The Contemporary,'" *October* 130 (Fall 2009): 55.

71. Jean-François Lyotard, *The Postmodern Condition: A Report on Knowledge*, trans. Geoff Bennington and Brian Massumi (Minneapolis: University of Minnesota Press, 1984), 81.

72. Wolfe, *What Is Posthumanism?*, 121.

73. Fredric Jameson, *Postmodernism; or, The Cultural Logic of Late Capitalism* (Durham, NC: Duke University Press, 1990). See Osborne, *The Postconceptual Condition*, 15.

74. For a history of the Soviet response to and development of cybernetics, see Slava Gerovitch, *From Newspeak to Cyberspeak: A History of Soviet Cybernetics* (Cambridge, MA: MIT Press, 2002). On Chile's Project Cybersyn, see Eden Medina, *Cybernetic Revolutionaries: Technology and Politics in Allende's Chile* (Cambridge, MA: MIT Press, 2011).

75. Philip Mirowski, *Machine Dreams: Economics Becomes a Cyborg Science* (Cambridge: Cambridge University Press, 2001), 523; John von Neumann and Oskar Morgenstern, *Theory of Games and Economic Behavior* (Princeton, NJ: Princeton University Press, 1944); John von Neumann, *The Theory of Self-Reproducing Automata*, ed. Arthur Burks (Urbana: University of Illinois Press, 1966).

76. Mirowski, *Machine Dreams*, 99. Relatedly, Franklin locates cybernetics as "a moment in the history of political economy [and] as the epistemic grounding for a worldview that posits all material objects and their interactions as digital and thus predisposed to exchange and valorization" (*Control*, 33).

77. Suhail Malik, "Contra-Contemporary," in *The Future of the New*, ed. Thijs Lijster (Amsterdam: Veliz Press, 2018), 259–62. Malik's term is actually "posthistory," which characterizes the contemporary's shift from the anthropogenic time of modernity. Hannah Arendt, *The Human Condition*, second edition (1958; Chicago: University of Chicago Press, 1998), 177–78.

78. Cage, "Diary," 160.

79. The modern can be conceived as the historical production of the temporality of the new, exhibited perhaps most transparently in German with the lexico-historiographical shift from *neue Zeit* [new time] to *Neuzeit* [modernity] that occurred in the late eighteenth century. Writ large, *Neuzeit* refers to the period of time following the Middle Ages, but used more specifically it marks the onset of industrialism in the late eighteenth century. Reinhart Koselleck, *Futures Past: On the Semantics of Historical Time*, trans. Keith Tribe (New York: Columbia University Press, 2004), 224–25. See chapter 6.

80. Born, *Rationalizing Culture*, 62–63. For a more recent treatment of new music as aesthetic modernism, see Seth Brodsky, *From 1989; or, European Music and the Modernist Unconscious* (Berkeley: University of California Press, 2017), 108–28.

81. Born, *Rationalizing Culture*, 62–63.

82. Born, *Rationalizing Culture*, 64. Born notes Cage's IRCAM residency on p. 304. On Tudor's electronic music, see the exceptional You Nakai, *Reminded by the Instruments: David Tudor's Music* (New York: Oxford University Press, 2021).

83. See chapter 6.

84. Born, *Rationalizing Culture*, 62.

85. Sonami in Rodgers, *Pink Noises*, 229.

86. Born, *Rationalizing Culture*, 58.

87. Osborne, *Anywhere or Not at All*, 18.

88. Osborne (in the context of philosophy and art theory) has proposed the phrases "postconceptual music" and "music *qua* art" to refer to interdisciplinary postformalist music practices (*The Postconceptual Condition*, 221, 215). I have proposed "critical music" and "musical contemporary art" to similar ends. G Douglas Barrett, *After Sound: Toward a Critical Music* (New York: Bloomsbury, 2016); G Douglas Barrett, "Contemporary Art and the Problem of Music: Towards a Musical Contemporary Art," *Twentieth-Century Music* 18, no. 2 (2021).

"Contemporary music" has more in common with "new music" and "modern music" than with "contemporary art." "Contemporary music" is not equivalent to postformalist music, nor does it refer to a musical version of contemporary art understood as postformalist or postconceptual art. Neither does the "contemporary" in "contemporary music" make reference to the historical and philosophical concept of "the contemporary" found in contemporary art theory. Rather, "contemporary music" either (1) qualifies recently composed new/modern music as being contemporaneous with its critical reception; (2) periodizes art music composed during the twentieth century, since 1945, the 1960s, or 1989; or (3) simply renames new/modern music. See Barrett, "Contemporary Art and the Problem of Music."

89. Edgard Varèse, "The Electronic Medium (1962)," *Perspectives of New Music* 5, no. 1, "The Liberation of Sound," ed. and ann. Chou Wen-chung (Autumn–Winter 1966): 18.

90. See Barrett, *After Sound* and "Contemporary Art and the Problem of Music."

91. Julia Robinson, "From Abstraction to Model: George Brecht's Events and the Conceptual Turn in Art of the 1960s," *October* 127 (Winter 2009): 77. See also Natilee Harren, "George Brecht and the Notational Object," in *Fluxus Forms: Scores, Multiples, and the Eternal Network* (Chicago: University of Chicago Press, 2020), 101–32.

92. Kotz, *Words to Be Looked At.*

93. Cage, *Silence*, 13.

94. Cage, *Silence*, 13. Cage goes on to characterize the inseparability of the senses as "theatre" (14).

95. See Rosalind Krauss, *A Voyage on the North Sea: Art in the Age of the Post-Medium Condition* (New York: Thames & Hudson, 2000).

96. See Dick Higgins and Hannah Higgins, "Intermedia," *Leonardo* 34, no. 1 (February 2001): 49–54.

97. Haraway's extensive contributions to animal studies date back to her 1985 "Manifesto for Cyborgs." See also Donna Haraway, *Primate Visions: Gender, Race, and Nature in the World of Modern Science* (New York: Routledge, 1989); Donna Haraway, *When Species Meet* (Minneapolis: University of Minnesota Press, 2007). See Cary Wolfe, *Animal Rites: American Culture, the Discourse of Species, and Posthumanist Theory* (Chicago: University of Chicago Press, 2003); and Wolfe, *What Is Posthumanism?*

98. Rachel Mundy, *Animal Musicalities: Birds, Beasts, and Evolutionary Listening* (Middletown, CT: Wesleyan University Press, 2018); Bernie Krause, *Voices of the Wild: Animal Songs, Human Din, and the Call to Save Natural Soundscapes* (New Haven, CT: Yale University Press, 2015); David Rothenberg, *Nightingales in Berlin: Searching for the Perfect Sound* (Chicago: University of Chicago Press, 2019). For a recent edited volume, see Tobias Fischer and Lara Cory, eds., *Animal Music: Sound and Song in the Natural* (Cambridge, MA: MIT Press, 2015). Regarding experimentalism in particular, see the extensive contributions of composer and naturalist David Dunn.

99. David Cecchetto, *Humanesis: Sound and Technological Posthumanism* (Minneapolis: University of Minnesota Press, 2013).

100. Justin Adams Burton, *Posthuman Rap* (New York: Oxford University Press, 2017).

101. I draw significantly on Kahn's wonderful *Earth Sound Earth Signal* in chapters 1 and 4. Higgins and Kahn, eds., *Mainframe Experimentalism*; Nakai, *Reminded by the Instruments.* While focusing on postwar German electronic music, Iverson's *Electronic Inspirations* deserves praise for its astute account of cybernetics' influence on both experimentalism and the European avant-garde. Ted Gordon promises an exceptional contribution to cybernetics and experimental music studies with his work-in-progress, "The Composer's Black Box: Cybernetics and Instrumentality in Postwar American Music." See also Ted Gordon, "Bay Area Experimentalism: Music and Technology in the Long 1960s," PhD diss., University of Chicago, 2018. For a recent collection of articles on experimental music and cybernetics, see "Music and Cybernetics in Historical Perspective," special issue, ed. Christopher Haworth and Eric Drott, *Resonance* 2, no. 4 (Winter 2021). This area also overlaps with histories of audio and communication technologies, which Mara Mills critically extends through disability studies. See her watershed study, Mara Mills, *On the Phone: Hearing Loss and Communication Engineering* (Durham, NC: Duke University Press, forthcoming).

This book has also benefited from the work of Orit Halpern, Reinhold Martin, Christopher Hight, and others working at the intersection of visual studies, architectural history, and media studies. See Halpern's expansive history of cybernetics, visualization, and data. Orit Halpern, *Beautiful Data: A History of Vision and Reason Since 1945* (Durham, NC: Duke University Press, 2015); Reinhold Martin, *The Organizational Complex: Architecture, Media, and Corporate Space* (Cambridge, MA: MIT Press, 2003); Christopher Hight, *Architectural Principles in the Age of Cybernetics* (New York: Routledge, 2008).

102. Concerning contemporary art theory, in addition to Osborne and Malik I am also thinking of John Roberts. See John Roberts, *Revolutionary Time and the Avant-Garde* (New York: Verso, 2015).

Media theory interfaces with the art-historical work of Alex Kitnick, David Joselit, and Pamela Lee; in music studies, it undergirds recent scholarship by Deirdre Loughridge, Roger Moseley, Holly Rogers, George E. Lewis, Daniel K. L. Chua, and Alexander Rehding; media theorists working on and around music include Kahn, Mills, and Jonathan Sterne; and media theorists who analyze contemporary art include Wolfe, Mark B. N. Hansen, and Joanna Zylinska.

Chapter One

1. Joan Retallack and John Cage, *Musicage: Cage Muses on Words, Art, Music: John Cage in Conversation with Joan Retallack* (Middletown, CT: Wesleyan University Press, 1996), 86. Cage in William Duckworth, *Talking Music: Conversations with John Cage, Philip Glass, Laurie Anderson, and Five Generations of American Experimental Composers* (Boston: Da Capo Press, 1999), 27, 112.

2. Lucier quoted in Douglas Kahn, *Earth Sound Earth Signal: Energies and Earth Magnitude in the Arts* (Berkeley: University of California Press, 2013), 101; Gordon Mumma, "Alvin Lucier's 'Music for Solo Performer,'" *Source: Music of the Avant-Garde*, vol. 2 (1967): 68–69; reprinted in Larry Austin, Douglas Kahn, and Nilendra Gurusinghe, eds., *Source: Music of the Avant-Garde, 1966–1973* (Berkeley: University of California Press, 2011), 79–81.

3. I derive this phrase from Sven Stollfuß, "The Rise of the Posthuman Brain: Computational Neuroscience, Digital Networks and the 'In Silico Cerebral Subject,'" *Trans-Humanities* 7, no. 4 (2014): 82–90.

4. Lucier quoted in Kahn, *Earth*, 99.

5. Alvin Lucier, "Music for Solo Performer (1965)," in *Electronic Music: Systems, Techniques, and Controls*, ed. Allen Strange (Dubuque, IA: W. C. Brown, 1972), 59.

6. Alvin Lucier, "'. . . to let alpha be itself,' Music for Solo Performer (1965)," in *Reflections: Interviews, Scores, Writings 1965–1994 / Reflexionen: Interviews, Notationen, Texte 1965–1994*, second edition (Cologne, Germany: MusikTexte, 1995), 50.

7. See, for instance, Richie Cyngler, "*Music for Various Groups of Performers* (After Lucier): An Improvised Electroencephalographic Group Performance," *Proceedings of the 2017 ACM SIGCHI Conference on Creativity and Cognition* (New York: Association for Computing Machinery, 2017), 462–65.

8. As evidence for a "neuromusical turn" in 1960s experimentalism, numerous composers incorporated brainwaves: Cage in *Variations VII* (1966); Tenney in *Metabolic Music* (1965); David Rosenboom in his extensive biofeedback work; and Petr Kotik, in *There Is Singularly Nothing* (1971–1973), mapped brainwave data from fruit flies. Kotik also derived the instrumental parts of his six-hour operatic setting of Gertrude Stein's *Many Many Women* (1976–1968) from EEG graphs that the scientist Jan Kučera created in order to study the effects of alcohol on the nervous system. Paik's 1966 proposal for a "DIRECT-CONTACT-ART" (Kahn, *Earth*, 278n) shares many features with both Lucier's *Music for Solo Performer* and Manford L. Eaton's work. For a detailed study of the latter, see Branden W. Joseph, "Biomusic," in "On Brainwashing: Mind Control, Media, and Warfare," ed. Andreas Killen and Stefan Andriopoulos, special issue, *Grey Room* 45 (Fall 2011): 128–50.

9. On automation, see Ramin Ramtin, *Capitalism and Automation: Revolution in Technology and Capitalist Breakdown* (London: Pluto Press, 1991), 60–73. See also Aaron Benanav,

Automation and the Future of Work (New York: Verso, 2020). A discussion of automation continues in chapter 3.

10. Nick Dyer-Witheford, *Cyber-Proletariat: Global Labour in the Digital Vortex* (London: Pluto Press, 2015), 45.

11. Dyer-Witheford, *Cyber-Proletariat*, 45; Ramtin, *Capitalism and Automation*, 45. See also Ramtin, *Capitalism and Automation*, 68–69.

12. N. Katherine Hayles, *How We Became Posthuman: Virtual Bodies in Cybernetics, Literature, and Informatics* (Chicago: University of Chicago Press, 1999), 2.

13. Chapter 3 discusses La Mettrie's mechanistic materialism. Recall, however, that for "compatibilist" thinkers like Hume, determinism and free will were not mutually exclusive. See Hume, *An Enquiry concerning Human Understanding*. Chapter 3 also explores the Marxian distinction between formal and concrete freedom in the context of the posthuman.

14. Hayles, *How We Became Posthuman*, 1; Hans Moravec, *Mind Children: The Future of Robot and Human Intelligence* (Cambridge, MA: Harvard University Press, 1988).

15. Locke, *Second Treatise of Government*, 18.

16. C. B. Macpherson, *The Political Theory of Possessive Individualism: Hobbes to Locke*, introduction by Frank Cunningham (1962; New York: Oxford University Press, 2011).

17. Hayles, *How We Became Posthuman*, 3. Franklin takes Hayles as a point of departure in locating cybernetics in the development of contemporary political economic control systems. Seb Franklin, *Control: Digitality as Cultural Logic* (Cambridge, MA: MIT Press, 2015), 33.

18. See also Alexander G. Weheliye, *Habeas Viscus: Racializing Assemblages, Biopolitics, and Black Feminist Theories of the Human* (Durham, NC: Duke University Press, 2014) and the next chapter.

19. Hayles, *How We Became Posthuman*, 2, 5.

20. Philip Mirowski, *Machine Dreams: Economics Becomes a Cyborg Science* (Cambridge: Cambridge University Press, 2001), 18.

21. Norbert Wiener, *Cybernetics; or, Control and Communication in the Animal and the Machine*, reissue of the 1961 second edition (Cambridge, MA: MIT Press, 2019), 35–36.

22. Mirowski, *Machine Dreams*, 99; John von Neumann and Oskar Morgenstern, *Theory of Games and Economic Behavior* (Princeton, NJ: Princeton University Press, 1944).

23. Quoted in Matteo Pasquinelli, "To Anticipate and Accelerate: Italian Operaismo and Reading Marx's Notion of the Organic Composition of Capital," *Rethinking Marxism* 26, no. 2 (2014): 183.

24. Moishe Postone, *Time, Labor, and Social Domination: A Reinterpretation of Marx's Critical Theory* (Cambridge, UK: Cambridge University Press, 1993), 25.

25. Pasquinelli, "To Anticipate and Accelerate," 183.

26. Pramod K. Nayar, *Posthumanism* (Cambridge, UK: Polity, 2014), 2. For Nayar, "Critical posthumanism . . . is the radical decentering of the traditional sovereign, coherent and autonomous human in order to demonstrate how the human is always already evolving with, constituted by and constitutive of multiple forms of life and machines" (2, emphasis removed).

27. Nick Land, "The Teleological Identity of Capitalism and Artificial Intelligence," transcribed by Jason Adams, Incredible Machines Conference, March 10, 2014. For critiques of Land, see Park MacDougald, "The Darkness Before the Right," *The Awl*, September 28, 2015, http://www.theawl .com/2015/09/good-luck-to-human-kind; and Shuja Haider, "The Darkness at the End of the Tunnel: Artificial Intelligence and Neoreaction," *Viewpoint Magazine*, March 28, 2017, https://www .viewpointmag.com/2017/03/28/the-darkness-at-the-end-of-the-tunnel-artificial-intelligence -and-neoreaction/.

NOTES TO PAGES 26–27

28. Nick Land, "Machinic Desire," *Textual Practice* 7, no. 3 (1993): 479.

29. Rory Cellan-Jones, "Stephen Hawking Warns Artificial Intelligence Could End Mankind," *BBC News*, December 2, 2014. See also Nick Bostrom's "paperclip maximizer" scenario. Nick Bostrom, *Superintelligence: Paths, Dangers, Strategies* (New York: Oxford University Press, 2014), 123.

30. See, for instance, Robin Hanson and Eliezer Yudkowsky, *The Hanson-Yudkowsky AI-Foom Debate* (Berkeley, CA: Machine Intelligence Research Institute, 2013). On the distinction between expert systems and artificial neural networks, see chapter 6.

31. These tendencies are particularly pronounced in the transhumanist movement, of which Bostrom and Moravec have been leading proponents. Moravec is also a frequent spokesperson for the transhumanist Extropy Institute, which promotes a form of libertarian techno-determinism. See Joshua Raulerson, *Singularities: Technoculture, Transhumanism, and Science Fiction in the 21st Century* (New York: Oxford University Press, 2013), 51.

32. Robin Hanson, *The Age of Em: Work, Love and Life When Robots Rule the Earth* (New York: Oxford University Press, 2016), 47. Hanson uses the terms "simulation" and "emulation" interchangeably to refer to the digital replication of a distinct human mind. The Dutch neuroscientist and neuroengineer Randal A. Koene, however, distinguishes between the two terms: "We call the stochastically generated models simulations and the faithful copies [i.e., Hanson's topic] emulations." Randal A. Koene, "Uploading to Substrate-Independent Minds," in *The Transhumanist Reader: Classical and Contemporary Essays on the Science, Technology, and Philosophy of the Human Future*, ed. Max More and Natasha Vita-More (Hoboken, NJ: Wiley-Blackwell, 2013), 148. See Stollfuß, "The Rise of the Posthuman Brain," 93. For a technical report on the 2008 state of the art of brain emulation technologies, see Anders Sandberg and Nick Bostrom, *Whole Brain Emulation: A Roadmap*, Technical Report #2008-3, Future of Humanity Institute, Oxford University, www.fhi.ox.ac.uk/brain-emulation-roadmap-report.pdf.

33. Robin Hanson, "What Will It Be Like to Be an Emulation?," in *Intelligence Unbound: The Future of Uploaded and Machine Minds*, ed. Russell Blackford and Damien Broderick (Hoboken, NJ: Wiley Blackwell, 2014), 298, emphasis added.

34. Emily Underwood, "A $4.5 Billion Price Tag for the BRAIN Initiative?," *Science*, June 5, 2014; Elbert Chu, "European Researchers Win $1.3 Billion to Simulate the Human Brain," *Popular Science*, February 18, 2018.

35. Hans Moravec, *Mind Children*.

36. Stollfuß, "The Rise of the Posthuman Brain," 81.

37. See Russell Blackford and Damien Broderick, eds., *Intelligence Unbound: The Future of Uploaded and Machine Minds* (Hoboken, NJ: Wiley Blackwell, 2014).

38. Capital "operationaliz[es] science fiction scenarios as integral components of production systems." Nick Land, "Teleoplexy: Notes on Acceleration (2014)," in *#Accelerate: The Accelerationist Reader* (Windsor Quarry, UK: Urbanomic, 2014), 515. If, in this sense, "the boundary between science fiction and social reality is an optical illusion," as it is for Haraway, then perhaps we can also think of it as a sonic or musical illusion. Donna Haraway, "Manifesto for Cyborgs: Science, Technology, and Socialist Feminism in the 1980s," *Socialist Review* 80 (1985): 66.

39. Cage quoted in Volker Straebel and Wilm Thoben, "Alvin Lucier's *Music for Solo Performer*: Experimental Music Beyond Sonification," *Organised Sound* 19, Special Issue 1 (April 2014): 17.

40. Prior to the score's 1980 publication in *Chambers*, Lucier referred to the work in various letters as *Music for Solo Performer 1965* (year included). Alvin Lucier, "Correspondence

1963–1976," *Alvin Lucier Papers 1939–2015*, New York Public Library, Box 3. Alvin Lucier, *Music for Solo Performer for Enormously Amplified Brain Waves and Percussion* (1965), score, in *Chambers: Scores by Alvin Lucier. Interviews with the Composer by Douglas Simon* (Middletown, CT: Wesleyan University Press, 1980), 67.

41. There are multiple versions of Lucier's score in addition to the commonly referenced version published in *Chambers*. Distinct from the latter, one of the unpublished score manuscripts contains a nine-point list describing in technical detail the 1965 premiere performance at Brandeis University's Rose Art Museum. A similar score manuscript by Lucier includes a dedication to Cage in place of the extended title ("for enormously amplified brain waves and percussion"). Finally, yet another version of the score closely resembles the *Chambers* version but contains both a 1965 and a 1977 copyright. Alvin Lucier, "Scores," *Alvin Lucier Papers 1939–2015*, New York Public Library, Box 34, Folder 4. My quotations are taken exclusively from the *Chambers* version.

Before he used written scores, Lucier apparently relied on firsthand verbal instruction: "There is not much in the way of a score [for *Music for Solo Performer*], so I rely on an oral tradition, i.e., I tell-teach it to those who want to do it." Alvin Lucier to Howard Hersh, September 11, 1969, "Correspondence 1963–1976."

42. Kahn, *Earth*, 86.

43. Lucier quoted in Kahn, *Earth*, 101.

44. Mumma, "Alvin Lucier's 'Music for Solo Performer,'" 79–81.

45. Lucier also seems to invoke performance anxiety, a problem shared between musical performance and the workplace. "A few colleagues advised me to record my alpha [brainwaves] and compose a tape piece, but I decided to perform it live. That was a dangerous decision because in a live performance you have to be able to generate alpha in front of an audience. You can't be sure you're going to get it. The harder you try, the less likely you are to succeed; so the task of performing by not intending to, gave the work an irony it would not have had on tape." Alvin Lucier, "Discovery Is Part of the Experience," in *Reflections*, 32.

46. Alvin Lucier, "Music for Solo Performer," in *Music 109: Notes on Experimental Music* (Middletown, CT: Wesleyan University Press, 2012), 53; Kahn, *Earth*, 90.

47. Robert Ashley, *Music with Roots in the Aether* (1976), DVD7701-7, 7 DVDs (Lovely Music Ltd.), 2005.

48. Kahn, *Earth*, 101. Kahn's comparison of *Music for Solo Performer* to Cage's *4'33"* as an instance of "withheld performance" can be considered in light of Pickering's thesis that the cybernetic brain is itself already performative. Pickering draws on Ashby to conceive of "the brain as an immediately embodied organ, intrinsically tied into bodily performances." Andrew Pickering, *The Cybernetic Brain: Sketches of Another Future* (Chicago: University of Chicago Press, 2010), 6. Kahn does, however, locate a sense of "concentrated interiority" inherent to *Music for Solo Performer* (*Earth*, 100), and discusses Pickering's conception of cybernetics as a "nonmodern ontology" (*Earth*, 86).

49. Lucier, ". . . to let alpha," 50.

50. Alvin Lucier to Joel Chadabe, no date (ca. 1966), "Correspondence 1963–1976."

51. Fernando Vidal, "Brainhood: Anthropological Figure of Modernity," *History of the Human Sciences* 22, no. 1 (2009): 6, 22. From "*you* are your brain," Malabou shifts to the first person plural and draws upon neuroscientist Antonio Damasio's notion of the "proto-self" (and Marx) to contend, "'We end up coinciding completely with 'our brain'—because our brain is us, the intimate form of a 'proto-self,' a sort of organic personality—and we do not know it." Catherine Malabou, *What Should We Do with Our Brain?* trans. Sebastian Rand (2004; New York:

NOTES TO PAGES 31–33

Fordham University Press, 2008), 8. See also George Makari, *Soul Machine: The Invention of the Modern Mind* (New York: W. W. Norton, 2014).

52. Jodi Dean, *Democracy and Other Neoliberal Fantasies: Communicative Capitalism and Left Politics* (Durham, NC: Duke University Press, 2009), 19–48. See also Michael Hardt and Antonio Negri, *Empire* (Cambridge, MA: Harvard University Press, 2000). On digital labor, see the work of Christian Fuchs, including Fuchs, *Digital Labor and Marx* (New York: Routledge, 2014).

53. Alquati quoted in Pasquinelli, "To Anticipate and Accelerate," 183, emphasis removed.

54. Pasquinelli, "To Anticipate and Accelerate," 183.

55. Alvin Lucier, "Notes on Verbal Notation," in *Word Events: Perspectives on Verbal Notation*, ed. John Lely and James Saunders (New York: Bloomsbury, 2012), 254.

56. Dyer-Witheford, *Cyber-Proletariat*, 45; Ricardo Antunes, *The Meanings of Work: Essay on the Affirmation and Negation of Work* (Leiden, Netherlands: Brill, 2013), 39. For an art-historical account of the turn to language beginning with Cage's *4'33"* and the text/event score compositions of the 1960s, see Liz Kotz, *Words to Be Looked At: Language in 1960s Art* (Cambridge, MA: MIT Press, 2007).

57. Lucier quoted in Kahn, *Earth*, 101.

58. Lucier, "Ostrava Days 2001," cited in Kahn, *Earth*, 99.

59. See Haraway, "Manifesto for Cyborgs."

60. Dyer-Witheford, *Cyber-Proletariat*, 51.

61. Lucy R. Lippard, "Escape Attempts," in *Six Years: The Dematerialization of the Art Object from 1966 to 1972; A Cross-Reference Book of Information on Some Esthetic Boundaries . . .* (Berkeley: University of California Press, 1973), vii–xxii. See Peter Osborne, Introduction, "Dossier: Art and Immaterial Labour," with Antonio Negri, Maurizio Lazzarato, Judith Revel, and Franco Berardi, *Radical Philosophy* 149 (2008).

62. Straebel and Thoben, "Alvin Lucier's *Music for Solo Performer*," 27; cf. Kahn, *Earth*, 100–101. Note, however, that Lucier composed *Music for Solo Performer* the same year as Joseph Kosuth's notorious *One and Three Chairs*.

63. Straebel and Thoben, "Alvin Lucier's *Music for Solo Performer*," 27. See also G Douglas Barrett, *After Sound: Toward a Critical Music* (New York: Bloomsbury, 2016).

64. Lucier, ". . . to let alpha," 48.

65. Straebel and Thoben, "Alvin Lucier's *Music for Solo Performer*," 19.

66. Compare Cage's quintessential 1955 statement on experimental music to the 1957 words of the German scientist Wernher von Braun: "Basic research is what I am doing when I don't know what I am doing." Von Braun in Yves Reni Marie Simon, "Work, Society, and Culture," *New York Times*, December 16, 1957, 32. It becomes clear why Hannah Arendt, who quoted von Braun's famous statement, contended that the natural sciences had become fundamentally processual and, moreover, capable of triggering "processes of no return." Hannah Arendt, *The Human Condition*, second edition (Chicago: University of Chicago Press, 2013), 231. For a critique of cognitive science that, among other things, compares this tendency of cybernetics to the sorcerer's apprentice myth, see Jean-Pierre Dupuy, *On the Origins of Cognitive Science: The Mechanization of the Mind*, trans. M. B. DeBevoise (Cambridge, MA: MIT Press, 2009), xii–xiii. Cf. Wiener's invocation of the same myth in *Cybernetics*, 243.

67. John Cage, *Silence: Lectures and Writings* (Middletown, CT: Wesleyan University Press, 1961), 13.

68. Claude Shannon, "A Mathematical Theory of Communication," *Bell System Technical Journal* 27 (1948): 379–423. Compare Shannon's thesis to Lucier's description of his experiments

in preparation for *Music for Solo Performer*: "At first I couldn't distinguish what was noise and what was alpha. . . . Alpha waves pulse from 8 to 12 cycles per second fairly regularly but in uneven bursts. They slow down and speed up a little, get louder and softer. Electrical noise is more complex and constant." Lucier, "Music for Solo Performer," *Music 109*, 52. Cage understood the outcome of his collaboration with Hiller, in part, as a variation on Shannon's notion of entropy. Branden W. Joseph, "*HPSCHD*—Ghost or Monster?," in *Mainframe Experimentalism: Early Computing and the Foundations of the Digital Arts*, ed. Hannah B. Higgins and Douglas Kahn (Berkeley: University of California Press, 2012), 150.

69. Cage, *Silence*, 35.

70. John Cage in Allan Miller, dir., *American Masters*, "John Cage: I Have Nothing to Say and I am Saying It," season 5, episode 8, aired September 17, 1990, on PBS. On the role of Cage's sexuality in his rejection of psychoanalysis, see Jonathan Katz, "John Cage's Queer Silence; or, How to Avoid Making Matters Worse," *GLQ: A Journal of Lesbian and Gay Studies* 5, no. 2 (1999): 233–34. See also Caroline A. Jones, "Finishing School: John Cage and the Abstract Expressionist Ego," *Critical Inquiry* 19, no. 4 (Summer 1993); Philip M. Gentry, "The Cultural Politics of 4'33": Identity and Sexuality," *Tacet Experimental Music Review* no. 1, Who Is John Cage? (2011).

71. Lynn Fedler, *Michel Foucault* (New York: Bloomsbury, 2010), 78; Catherine Malabou, *Morphing Intelligence: From IQ Measurements to Artificial Brains* (New York: Columbia University Press, 2019).

72. Kahn, *Earth*, 93–105.

73. Kahn, *Earth*, 86.

74. Edmond Dewan, "'Other Minds': An Application of Recent Epistemological Ideas to the Definition of Consciousness," *Philosophy of Science* 24, no. 1 (January 1957): 70–76. Dewan's statement, which privileges "consciousness" as a prerequisite for the creation of a thinking machine, warrants a comparison to the work of Ashby. Nearly a decade before Dewan, Ashby's similar statement emphasizes not consciousness but the brain's performative dimension: "To some, the critical test of whether a machine is or is not a 'brain' would be whether it can or cannot 'think.' But to the biologist the brain is not a thinking machine, it is an *acting* machine; it gets information and then it does something about it." W. Ross Ashby, "Design for a Brain," *Electronic Engineering* 20 (December 1948): 379.

75. Catherine Malabou, "Metamorphoses of Intelligence: 'Like a Pollock Painting,'" YouTube video, University of California, Irvine, May 22, 2015, https://www.youtube.com/watch?v=4LFyQRcSc2w.

76. Catherine Malabou, *Plasticity at the Dusk of Writing: Dialectic, Destruction, Deconstruction*, trans. Carolyn Shread (New York: Columbia University Press, 2009), 59, emphasis in original.

77. Malabou, *What Should We Do with Our Brain?*, 8.

78. Slavoj Žižek, *The Parallax View* (Cambridge, MA: MIT Press, 2006), 209. Žižek cites Malabou's original French text. Catherine Malabou, *Que faire de notre cerveau?* (Paris: Bayard, 2004), 88.

79. Malabou, *What Should We Do with Our Brain?*, 35.

80. Malabou, "Metamorphoses of Intelligence."

81. Malabou, "Metamorphoses of Intelligence."

82. Hanson, *The Age of Em*, 62.

83. More specifically, Golumbia provides a critical historiography of functionalism—the philosophical view that the mind itself must be a computer—along with a related genealogy of

NOTES TO PAGES 37–39

cybernetics, cognitive science, computational linguistics, and artificial intelligence, to support his broader challenge to the cultural hegemony of "computationalism," a program he defines as a "commitment to the view that a great deal, perhaps all, of human and social experience can be explained via computational processes." David Golumbia, *The Cultural Logic of Computation* (Cambridge, MA: Harvard University Press, 2009), 8. See also Gualtiero Piccinini, "The First Computational Theory of Mind and Brain: A Close Look at McCulloch and Pitts's 'A Logical Calculus of Ideas Immanent in Nervous Activity,'" *Synthese* 141 (August 2004). For a recent view doubtful of the prospects of brain emulation, see Gualtiero Piccinini, "The Myth of Mind Uploading," in *The Mind-Technology Problem: Investigating Minds, Selves and 21st Century Artefacts*, ed. Robert W. Clowes, Klaus Gärtner, and Inês Hipólito (Berlin: Springer, 2021).

84. Lucier, "Ostrava Days 2001," cited in Kahn, *Earth*, 99.

Chapter Two

1. Pamela Z, "Pamela Z's Voci," accessed May 28, 2018, http://www.pamelaz.com/voci.html. This chapter's title cites a section title in Alexander G. Weheliye, "'Feenin': Posthuman Voices in Contemporary Black Popular Music," *Social Text* 20, no. 2 (2002): 21–47.

2. The literature on acousmatics is extensive. For a philosophical and historical overview, see Brian Kane, *Sound Unseen: Acousmatic Sound in Theory and Practice* (New York: Oxford University Press, 2014). For its early theorization in *musique concrète*, see Pierre Schaeffer, *Treatise on Musical Objects: An Essay Across Disciplines* (Berkeley: University of California Press, 2017). For *acousmêtre* (off-*screen* sound), see Michel Chion, *Audio-Vision: Sound of Screen*, trans. Claudia Gorbman (New York: Columbia University Press, 1994); for opera (off-*stage* sound), see Carolyn Abbate, *In Search of Opera* (Princeton, NJ: Princeton University Press, 2001). From the perspective of continental philosophy and psychoanalysis, see Mladen Dolar, *A Voice and Nothing More* (Cambridge, MA: MIT Press, 2006); Kaja Silverman focuses on gender and film in *The Acoustic Mirror: The Female Voice in Psychoanalysis and Cinema* (Bloomington: Indiana University Press, 1988). On acousmatics as a transdisciplinary problematic, see Rey Chow, "Listening After 'Acousmaticity': Notes on a Transdisciplinary Problematic," in *Sound Objects*, ed. Rey Chow and James A. Steintrager (Durham, NC: Duke University Press, 2019), 113–29. On acousmatics and race, see Jennifer Lynn Stoever, "Fine-Tuning the Sonic Color-line: Radio and the Acousmatic Du Bois," *Modernist Cultures* 10, no. 1 (2015): 99–118; and Nina Sun Eidsheim, "Marian Anderson and 'Sonic Blackness' in American Opera," *American Quarterly* 63, no. 3, Sound Clash: Listening to American Studies (September 2011): 641–67. Eidsheim draws on the work of Mendi Obadike in developing "acousmatic blackness"; see Mendi Obadike, "Low Fidelity: Stereotyped Blackness in the Field of Sound" (PhD dissertation, Duke University, 2005).

3. Weheliye, "'Feenin,'" 26. Kodwo Eshun writes, "Sonically speaking, the posthuman era is not one of disembodiment but the exact reverse: it's a *hyperembodiment*, via the Technics SL 1200 [record player]"—Kodwo Eshun, *More Brilliant than the Sun: Adventures in Sonic Fiction* (London: Quartet Books, 1998), -002.

4. Hayles borrows the phrase "embodied virtuality" from Mark Weiser, "The Computer for the 21st Century," *Scientific American* 265 (September 1991): 94–104. N. Katherine Hayles, *How We Became Posthuman: Virtual Bodies in Cybernetics, Literature, and Informatics* (Chicago: University of Chicago Press, 1999), 300n46.

5. "The BodySynth | History," accessed May 28, 2018, https://www.thebodysynth.com/history.

6. "bsynth [The BodySynth Specifications Summary]," accessed May 28, 2018, https://web.archive.org/web/20160303052323/http://www.synthzone.com/bsynth.html. My discussion of alternate controllers continues in chapter 5.

7. During the question-and-answer portion of the October 28, 2004 performance of *Voci* at The Kitchen, Z addresses the challenge of singing while using the BodySynth and other music technologies: "The really hard part of course is dealing with the fact that sometimes technology, especially when computers are involved, can be finicky, and things can go wrong." She then describes purchasing a secondary backup computer system for use in such cases, of which she provides examples. See also Kim Cascone, "The Aesthetics of Failure: 'Post-Digital' Tendencies in Contemporary Computer Music," *Computer Music Journal* 24, no. 4 (Winter 2000): 12–18; for a recent study of latency that foregrounds Pamela Z's work, see Lucie Vágnerová, "Composed Instruments, Failing Circuits: Out-of-Control Controllers and the Theatricality of Latency," After Experimental Music conference, Cornell University, February 9, 2018.

8. Jack Halberstam and Ira Livingston, eds., "Introduction," in *Posthuman Bodies* (Bloomington: Indiana University Press, 1995), 3.

9. See, for instance, Lev Manovich, *The Language of New Media* (Cambridge, MA: MIT Press, 2001); and Don Ihde, *Bodies in Technology* (Minneapolis: University of Minnesota Press, 2001).

10. Already in the 1980s, Haraway had attributed the construction of the cyborg, in part, to technological miniaturization processes. Donna Haraway, "Manifesto for Cyborgs: Science, Technology, and Socialist Feminism in the 1980s," *Socialist Review* 80 (1985): 70.

11. Anne Midgette, "An Encyclopedia of Voices, Human and Otherwise," *New York Times*, October 30, 2004.

12. Lucie Vágnerová describes Z's work in both cyborgian and posthumanist terms ("Sirens/Cyborgs: Sound Technologies and the Musical Body" [PhD thesis, Columbia University, 2016], 144, 192); a related posthuman valence is also found in Charissa Noble's characterization of Z's work as complicating an "ontological divide between vocal sound that is 'human' and 'technological'" ("Recoding the Voice: Experimental Singing After 'Extended Vocal Techniques' in the Electroacoustic Performance of Pamela Z," After Experimental Music conference, Cornell University, February 9, 2018). Vágnerová ("Sirens/Cyborgs," 13) attributes a reading of "Pamela Z's use of digital delay as Afrofuturist" to George E. Lewis, "The Virtual Discourses of Pamela Z," *Journal of the Society for American Music* 1, no. 01 (February 2007): 57–77. *Afrofuturism* was coined by Mark Dery in "Black to the Future: Interviews with Samuel R. Delany, Greg Tate, and Tricia Rose," in "Flame Wars: The Discourse of Cyberculture," ed. Mark Dery, special issue of *South Atlantic Quarterly* 94, no. 4 (1993): 735–78. See also Eshun, *More Brilliant than the Sun*; the list of Afrofuturist resources compiled by Kalí Tal at www.afrofuturism.net; and the work of Alondra Nelson, including the special issue she edited of *Social Text*: "Afrofuturism," ed. Alondra Nelson, *Social Text* no. 71 (June 2002).

13. According to Lewis, in "Voice Studies," "the multiplicity of accents that mark U.S. English serves as material for a pointedly political exploration of the relationship between vocal production and cultural expression" ("The Virtual Discourses of Pamela Z," 74). Links to the original recordings can be found here: https://www.academia.edu/15969458/John_Baughs_matched_guise_recordings_for_linguistic_profiling. My discussion of the subject continues below.

14. Jennifer Lynn Stoever, *The Sonic Color Line: Race and the Cultural Politics of Listening* (New York: New York University Press, 2016).

NOTES TO PAGES 41–43

15. Z's musical citations of both rock and jingles can be found in "La Voce nella Doccia," which starts with "Singing Fragments of Rossini" followed by "Riffing on Chicken of the Sea commercial à la Zappa" and, finally, "Improvising on Elvis Costello" ("Pamela Z, *Voci*, Libretto and Stage Directions," Last Letter Music—ASCAP, 2003/2004 [Kitchen 2004 Version], emphasis removed, 4). Z speaks to her heterogeneous musical training/background in an interview: "[A]s a composer I require more than just a single voice." She continues, "I think most of the interesting music is being done by people who've been trained in [a variety] of schools or traditions— who did more than one thing" (Z in Kathy Kennedy, "A Few Facets of Pamela Z," *MusicWorks* 76 [Spring 2000], http://www.pamelaz.com/musicworks.html).

16. Zakiyyah Iman Jackson, "Outer Worlds: Persistence of Race in Movement 'Beyond the Human,'" *GLQ: A Journal of Lesbian and Gay Studies* 21, no. 2–3, Dossier: Theorizing Queer Inhumanisms, ed. José Esteban Muñoz (June 2015): 215, 216, 217. Regarding Jackson's "queering of perspective" toward the human, see the other contributions to this dossier, especially Muñoz's.

17. Weheliye, "'Feenin,'" 24.

18. Alexander G. Weheliye, *Habeas Viscus: Racializing Assemblages, Biopolitics, and Black Feminist Theories of the Human* (Durham, NC: Duke University Press, 2014), 40.

19. John Locke, *Second Treatise of Government*, ed. C. B. Macpherson (Indianapolis, IN: Hackett Publishing Co., 1980), 18; Weheliye, *Habeas Viscus*, 135.

20. See Christin Ellis, *Antebellum Posthuman: Race and Materiality in the Mid-Nineteenth Century* (New York: Fordham University Press, 2018).

21. Hortense J. Spillers, "Mama's Baby, Papa's Maybe: An American Grammar Book," *Diacritics* 17, no. 2, Culture and Countermemory: The "American" Connection (Summer 1987): 67, emphasis removed.

22. Sylvia Wynter, "The Ceremony Found: Towards the Autopoetic Turn/Overturn, Its Autonomy of Human Agency and Extraterritoriality of (Self-)Cognition," in *Black Knowledges/ Black Struggles: Essays in Critical Epistemology*, ed. Jason R. Ambroise and Sabine Broeck (Liverpool University Press, 2015), 202.

23. Katherine McKittrick, "Yours in the Intellectual Struggle," in *On Being Human as Praxis*, ed. Katherine McKittrick (Durham, NC: Duke University Press, 2015), 7.

24. Weheliye, *Habeas Viscus*, 25. See also David Scott and Sylvia Wynter, "The Reenchantment of Humanism: An Interview with Sylvia Wynter," *Small Axe* 8 (September 2000).

25. Pamela Z in Tara Rodgers, "Pamela Z," in *Pink Noises: Women on Electronic Music and Sound* (Durham, NC: Duke University Press, 2010), 217. See Pamela Z in Jennifer Kelly, "Pamela Z," in *In Her Own Words: Conversations with Composers in the United States* (Urbana: University of Illinois Press, 2013), 213; and Pamela Z in Tom Sellar, "Parts of Speech: Interview with Pamela Z," *Theater Magazine* 30, no. 2 (2000).

26. Z notes that she has since recreated hardware delays, like the Ibanez DM1000 Digital Delay, with software via Max/MSP: "delays have remained the mainstay of my gear, though now I'm doing it with Max/MSP" (Z in Rodgers, "Pamela Z," 217). This continues to be reflected in her current Max/MSP patch, the result of years of evolution, which is named "PZ Delay System." The core of the system consists of five delay lines labeled "Lexi" (referring to emulated Lexicon hardware delay), "Digi 1," "Digi 2" (Digitech hardware), "Iban," and "Iban 2" (Ibanez DM1000). It also includes two general VST (Steinberg's Virtual Studio Technology) plugins and one VST dedicated to reverb. These effects, along with the delay and some other parameters, are modified via a bank of presets with names corresponding to the different scenes of *Voci* (unpublished Max/MSP patch screenshot).

27. Atau Tanaka, "Embodied Musical Interaction: Body Physiology, Cross Modality, and Sonic Experience," in *New Directions in Music and Human-Computer Interaction*, ed. Simon Holland, Tom Mudd, Katie Wilkie-McKenna, Andrew McPherson, and Marcelo M. Wanderley (Cham, Switzerland: Springer, 2019), 137, 140.

28. Z gave the keynote address and performed at the 2018 New Interfaces for Musical Expression conference held June 6, 2018, in Blacksburg, Virginia.

29. See Lewis, "The Virtual Discourses of Pamela Z," 65. In another article, Lewis describes his watershed interactive music software, Voyager, as a form of "technology-mediated animism," and alludes to Francis Bebey's discussion of certain African musical traditions in which instruments are, at times, regarded as human beings. He further cites an instance in which one musician compared selling his drum to delivering a slave into bondage. George E. Lewis, "Too Many Notes: Complexity and Culture in Voyager," *Leonardo Music Journal* 10 (2000): 37; Francis Bebey, *African Music: A People's Art* (Westport, CT: Lawrence Hill, 1975), 119–20.

30. Norbert Wiener, *Cybernetics; or, Control and Communication in the Animal and the Machine*, reissue of the 1961 second edition (Cambridge, MA: MIT Press, 2019), 40. See also chapter 3.

31. Note that despite the clarity of Z's references to political topics, she also expresses an ambivalence regarding such gestures in her artistic practice: "There's a tension in my work between not having any particular desire to be political and wanting to play with language and human interaction and tendencies in ways that are bound to *become* political. I sort of slip on the banana peel of politics by just playing with language." Eric Lyon and Pamela Z, "Interview with Pamela Z," *Seamus* 332, July 28, 2016, www.seamusonline.org/interview-with-pamela-z/.

32. However, as Burton notes, Weheliye seems to have found "posthumanism" inadequate since at least the publication of *Habeas Viscus* in 2014; see Justin Adams Burton, *Posthuman Rap* (New York: Oxford University Press, 2017), 37.

33. Lindon Barrett, *Blackness and Value: Seeing Double* (Cambridge, UK: Cambridge University Press, 1999), 55–93, esp. 72, 58; Alexander G. Weheliye, *Phonographies: Grooves in Sonic Afro-Modernity* (Durham, NC: Duke University Press, 2005), 37. See also Sidonie Smith and Julia Watson, "Introduction," in *De/Colonizing the Subject: The Politics of Gender in Women's Autobiography* (Minneapolis: University of Minnesota Press, 1992).

34. Weheliye, *Phonographies*, 37, emphasis added; a similar passage appears in Weheliye, "'Feenin,'" 27.

35. Weheliye, *Phonographies*, 38. This phrase can be compared to Jason Stanyek and Benjamin Piekut's notion of "corpaurality" from their highly influential article "Deadness: Technologies of the Intermundane," *TDR: The Drama Review* 54, no. 1 (T205) (Spring 2010): 19. However, Z's engagements with the voice and, as Kane and others suggest, the acousmatic as such, are broader than the aural.

36. Lewis, "The Virtual Discourses of Pamela Z," 65–66.

37. This is my transcription of this section from Z's ODC performance. It appears in the libretto as "Oqwei fjioen sinovhne woihe pv wo[aj neih faweiohb8 ao9ih3 alks hvge," followed by "Kkcqxkc! Kk . . . kh. . . ." The consistent use of the repeated "K" sounds indicates another potential reading of "Qwerty Voice," namely, its relation to so-called stammering songs such as "K-K-K-Katy" by Geoffrey O'Hara, composed in 1917, which was later used in a parody that ridiculed the Ku Klux Klan.

38. Both The Kitchen and ODC fit this description.

39. Friedrich Kittler, *Gramophone, Film, Typewriter*, trans. Geoffrey Winthrop-Young and Michael Wutz (Stanford, CA: Stanford University Press, 1999), 183–84. In fact, Kittler is both

NOTES TO PAGES 45–48

posthuman and cybernetic according to Bruce Clarke: "the media theory of Friedrich Kittler's *Gramophone, Film, Typewriter* is cybernetic tout court." He continues, "For Kittler, media determine our posthumanity, and they have been doing so in technological earnest at least since the phonograph broke the storage monopoly of writing." Bruce Clarke, *Narrative and Neocybernetics* (Minneapolis: University of Minnesota Press, 2014), 17.

40. See Barrett, *Blackness and Value*, 61–62. See also Fred Moten, *In the Break: The Aesthetics of the Black Radical Tradition* (Minneapolis: University of Minnesota Press, 2003), 4–7.

41. John Baugh, "Linguistic Profiling," in *Black Linguistics: Language, Society and Politics in Africa and the Americas* (New York: Routledge, 2003), 155, 158–60, 165.

42. Jennifer Stoever, "Fine-Tuning the Sonic Color-line: Radio and the Acousmatic Du Bois," *Modernist Cultures* 10, no. 1 (2015): 100.

43. W. E. B. Du Bois, *The Souls of Black Folk* (New Haven, CT: Yale University Press, 2015), 1, 32.

44. Du Bois, *The Souls of Black Folk*, 5.

45. Stoever, "Fine-Tuning the Sonic Color-line," 104.

46. "Hidden from their eyes, only the voice of their master reached the disciples." Acousmatics, for Schaeffer, "marks the perceptive reality of a sound as such, as distinguished from the modes of its production and transmission" (Schaeffer, *Treatise on Musical Objects*, 61).

47. Patrick Valiquet, "Hearing the Music of Others: Pierre Schaeffer's Humanist Interdiscipline," *Music and Letters* 98, no. 2 (May 2017): 276; Brian Kane, *Sound Unseen: Acousmatic Sound in Theory and Practice* (New York: Oxford University Press, 2014), 5, 24, 49.

48. Note the translators' decision to replace various racial epithets Schaeffer used in his *In Search of a Concrete Music*—"Translators' Note," in Pierre Schaeffer, *In Search of a Concrete Music*, trans. Christine North and John Dack (Berkeley: University of California Press, 2012), xii. It wasn't until Du Bois became involved in radio production, as he drafted *Dusk of Dawn: An Essay toward an Autobiography of a Race Concept* (1940), that his mature thinking on race and communications technologies began to congeal. Initially enamored of radio's potential, Du Bois became frustrated and eventually disillusioned with the medium, as he struggled against censorship, propaganda, and aurally raced stereotypes. The maturation of radio occurred, as Stoever notes, alongside the predominance of liberal ideologies of color blindness in the postwar United States. A new form of racism emerged, a *color-blind racism*, that, according to Eduardo Bonilla-Silva, reframed elements of traditional liberalism, such as work ethic and equal opportunity, for "racially illiberal goals" (Eduardo Bonilla-Silva, *Racism without Racists: Color-Blind Racism and the Persistence of Racial Inequality in the United States* [Lanham, MD: Rowman & Littlefield, 2006]).

49. Noé Cornago, "Schaeffer, Boulez, and the Everyday Diplomacies of French Decolonization," in *International Relations, Music and Diplomacy: Sounds and Voices on the International Stage*, ed. Frédéric Ramel and Cécile Prévost-Thomas (New York: Palgrave Macmillan, 2018), 154, Schaffer cited and translated on 150.

50. Schaeffer in Cornago, "Schaeffer, Boulez," 154, translation in original.

51. It is also interesting to consider Schaeffer's work in light of posthumanism. Valiquet suggests that one reason for the reluctant French reception of Schaeffer's *Treatise* in 1966 was that, by then, phenomenology had fallen out of favor in a context dominated by the antihumanism of Foucault and Derrida (Valiquet, "Hearing the Music of Others," 268). Schaeffer's phenomenology, inspired by the ardent humanism of Husserl, appeared simply as old hat. Frances Dyson describes a Schaeffer who imparts "a certain amount of agency to technology and import[s]

the idea of a benign, evolutionary force operating through technics" as heralding "the posthuman" (Frances Dyson, *Sounding New Media: Immersion and Embodiment in the Arts and Culture* (Berkeley: University of California Press, 2009), 12).

52. Personal communication, May 28, 2018.

53. Z, "Pamela Z, *Voci*, Libretto and Stage Directions."

54. Along these lines, Marc Leman, Micheline Lesaffre, and Pieter-Jan Maes describe the listener in a "closed interacting loop" with their environment. "This loop is constrained by the human body, hence 'embodied.'" Marc Leman, Micheline Lesaffre, and Pieter-Jan Maes, "Introduction: What Is Embodied Music Interaction?," in *The Routledge Companion to Embodied Music Interaction*, ed. Marc Leman, Micheline Lesaffre, and Pieter-Jan Maes (New York: Routledge, 2017), 1.

55. Goehr also discusses a recent digital incarnation as www.dialadiva.net. Lydia Goehr, "The Domestic Diva: Toward an Operatic History of the Telephone," in *Technology and the Diva: Sopranos, Opera, and Media from Romanticism to the Digital Age* (Cambridge, UK: Cambridge University Press, 2017), 114.

56. See Stoever, *The Sonic Color Line*; Eidsheim, "Marian Anderson"; and Rosalyn Story, *And So I Sing: African-American Divas in Opera and Concert* (New York: Grand Central Publishing, 1990). Regarding typecasting, Story cites the "maid/slave-girl/gypsy syndrome" (*And So I Sing*, 184; cited in Eidsheim, "Marian Anderson," 661).

57. Naomi André, *Black Opera: History, Power, Engagement* (Urbana: University of Illinois Press, 2018), 2–4.

58. Hannah Clancy, David Gutkin, and Lucie Vágnerová, "A Chronology," in *Technology and the Diva: Sopranos, Opera, and Media from Romanticism to the Digital Age* (Cambridge, UK: Cambridge University Press, 2017), 1.

59. André, *Black Opera*, 9–10.

60. Mladen Dolar, "The Birth of Opera from the Spirit of Absolutism," in *Opera's Second Death* (New York: Routledge, 2002), 5–8.

61. Richard A. Carlton, "Florentine Humanism and the Birth of Opera: The Roots of Operatic 'Conventions,'" *International Review of the Aesthetics and Sociology of Music* 31, no. 1 (June 2000): 67–78.

62. Cary Wolfe, *What Is Posthumanism?* (Minneapolis: University of Minnesota Press, 2010), 121.

63. Midgette, "An Encyclopedia of Voices"; Stephen Brookes, "Pamela Z at the Tivoli," *Washington Post*, May 15, 2007, Performing Arts Section (C), 2.

64. Clarke, *Narrative and Neocybernetics*, 22, emphasis removed.

65. Z, "Pamela Z, *Voci*, Libretto and Stage Directions."

66. This version of the scene list is taken from the libretto. The list printed in The Kitchen program contains various differences: regarding scene titles, "It Is the Voice" appears as "Your Voice Is"; "Bone Music" is replaced with "Gradual Quartet"; and "Metal/Vox/Water" appears as "Metal Voice." And rather than appearing as two separate scenes, "Voice Studies" and "Voices" are concatenated as "Voice Studies/Voices." The ODC program contains other similar discrepancies: the first half of the program appears as "The Larnyx [*sic*] / Melody w/ Minor 9ths & Octaves / Voice Activated / That Tone / Badagada / Meta/Vox/Water / Singing in the Shower / Under the Seat Disturbance / Voices in Your Head / Divas." In the ODC program, "Keitai (Cell Phone Voice)" appears as "Keitai II (Cell Phone Voice)."

67. The scene continues with a "waltz-like sound bed" containing various vocal loops, over which Z sings an ariatic lament. Together with Z's mimicry of the bird samples, this section is

listed as "Birdvoice" in both the ODC and The Kitchen programs. However, the libretto names the whole scene "Syrinx/Birdvoice"—but only on page 10, not in the full list of scenes that appears prior to page 1 ("Pamela Z, *Voci*, Libretto and Stage Directions"). This extra scene is reflected with a preset labeled "Syrinx" in Z's Max/MSP patch (unpublished Max/MSP screenshot).

68. E.g., Handel, Glinka, Beethoven, Mendelssohn, Liszt, Balakirev, Grieg, Granados, Ravel, Milhaud, Prokofiev, Respighi, and Messiaen. See also David Rothenberg, *Why Birds Sing: A Journey Into the Mystery of Bird Song* (New York: Basic Books, 2005).

69. Dolar, *A Voice and Nothing More*, 30.

70. David Golumbia, *The Cultural Logic of Computation* (Cambridge, MA: Harvard University Press, 2009), 92.

71. See Joseph Weizenbaum, *Computer Power and Human Reason: From Judgement to Calculation* (New York: W. H. Freeman and Company, 1976); for commentary, see Lydia H. Liu, "The Neurotic Machine," in *The Freudian Robot: Digital Media and the Future of the Unconscious* (Chicago: University of Chicago Press, 2010), 230–38; and Elizabeth Wilson, "Artificial Psychotherapy," in *Affect and Artificial Intelligence* (Seattle: University of Washington Press, 2010), 83–108.

72. Z, "Pamela Z, *Voci*, Libretto and Stage Directions." On HAL 9000 and *acousmêtre*, see Chion, *Audio-Vision*. On HAL 9000 and AI, see Luciana Parisi, "AI (Artificial Intelligence)," in *Posthuman Glossary*, ed. Maria Hlavajova and Rosi Braidotti (New York: Bloomsbury, 2018), 21–22. On HAL 9000, posthumanism, and popular music, see Joseph Auner, "'Sing It for Me': Posthuman Ventriloquism in Recent Popular Music," *Journal of the Royal Musical Association* 128, no. 1 (2003): 98–122.

73. For a cultural politics and history of the automation of feminized office work, see Helen Hester, "Technically Female: Women, Machines, and Hyperemployment," *Salvage*, August 8, 2016, http://salvage.zone/in-print/technically-female-women-machines-and-hyperemployment/. See also Jennifer Rhee, "Caring: Care Labor, Conversational Artificial Intelligence, and Disembodied Women," in *The Robotic Imaginary: The Human and the Price of Dehumanized Labor* (Minneapolis: University of Minnesota Press, 2018), 31–66.

74. Halberstam and Livingston, "Introduction," in *Posthuman Bodies*, 10, emphasis added. The phrase is a play on Benedict Anderson, *Imagined Communities: Reflections on the Origin and Spread of Nationalism* (New York: Verso, 1991).

75. My discussion of reproductive labor and posthumanism continues in chapter 5.

76. On the cybernetic origins of telephony, see Mara Mills, *On the Phone: Hearing Loss and Communication Engineering* (Durham, NC: Duke University Press, forthcoming).

77. Z, "Pamela Z, *Voci*, Libretto and Stage Directions."

78. Personal communication, May 28, 2018.

79. Z, "Pamela Z, *Voci*, Libretto and Stage Directions." As an indication of the shifting status of cell phones (and beepers) as "disruptive," in 2003 the program for *Voci*'s premiere at ODC contains the request, "Phones and Beepers in silent mode, please!" ("*Voci* Program [ODC]," unpaginated). The 2004 program at The Kitchen contained no such request ("*Voci* Program [Kitchen]").

80. Weheliye, "'Feenin,'" 31.

81. Z in Kennedy, "A Few Facets of Pamela Z." "For my listening pleasure, the audience will now perform 'Keitai,' a work in two movements for voices and cellular telephones" ("Pamela Z, *Voci*, Libretto and Stage Directions," 10). Z's title refers to "keitai denwa" (or 携帯電話), Japanese for mobile phone; this also figures in keitai culture, a term that marks Japan's early adoption of mobile phones and hence their prevalence in Japan in 1999.

180 NOTES TO PAGES 56–61

82. Karen Henson, "Introduction: Of Modern Operatic Mythologies and Technologies," *Technology and the Diva: Sopranos, Opera, and Media from Romanticism to the Digital Age* (Cambridge, UK: Cambridge University Press, 2017), 12.

83. Lewis, "The Virtual Discourses of Pamela Z," 69.

84. Although note that her voice is amplified and given a reverb effect.

85. André, *Black Opera*, 9–10.

86. Lewis also notes, in the context of post-1950s improvised music, the important Afrological trope of "telling your own story." George E. Lewis, "Improvised Music after 1950: Afrological and Eurological Perspectives," *Black Music Research Journal* 16, no. 1 (Spring 1996): 117.

Chapter Three

1. British television news report, "There's a Message in there Somewhere," June 24, 1965, http://www.movietone.com/N_search.cfm?ActionFlag=back2ResultsView&start=1&pageStart=1&totalRecords=1&V_DateType=1&V_DECADE=1929&V_FromYear=19, accessed June 11, 2019. The performance the news report documents was part of the *24 Stunden* event held at Galerie Parnass, Wuppertal, Germany, June 5–6, 1965.

2. Joan Rothfuss, *The Topless Cellist: The Improbable Life of Charlotte Moorman* (Cambridge, MA: MIT Press, 2014), 92.

3. Several accounts of the event indicate that both breasts twirled, whereas Ben Piekut interprets *New York Times* music critic Raymon Ericson's comment, which was written after the festival's opening night, as suggesting that only the left breast rotated (Ben Piekut, *Experimentalism Otherwise: The New York Avant-Garde and Its Limits* [Berkeley: University of California Press, 2011], 159; Raymon Ericson, "Avant-Garde Music. Festival Opens," August 31, 1964, *New York Times*, 20).

If this was, in fact, a variation, it's possible that it was either intentional or produced as a result of one of *K-456*'s frequent malfunctions. During the same festival *K-456* was supposed to perform alongside Moorman in Stockhausen's *Plus-Minus* (1963), but broke down due to a "nervous short circuit" (Leighton Kerner, "Buzz, Buzz," *Village Voice*, September 3, 1964, 15). Another reviewer called it "stage fright." Faubion Bowers, "A Feast of Astonishment," *The Nation*, September 28, 1964, 173.

4. Kerner, "Buzz, Buzz," 15.

5. Sophie Landres analyzes *Robot Opera* in the context of *opera buffa*. Sophie Landres, "The First Non-Human Action Artist: Charlotte Moorman and Nam June Paik in *Robot Opera*," *Performing Arts Journal* 118 (2018): 11–25.

6. Undated flyer for *Robot Opera*, punctuation added, capitalization removed. Smithsonian American Art Museum, Nam June Paik Archive, Box 19, F. 11. Reprinted in Melissa Chiu and Michelle Yun, eds., *Nam June Paik: Becoming Robot* (New York: Asia Society Museum, 2014), 63.

7. Although the robot's ad hoc appearance implied for some that the artist had "made it for next to nothing" (*Electronic Design* 14, no. 1 [1966]), it was valuable enough that Paik considered selling it for parts in order to pay for several months of living expenses in New York. In an undated letter to John Cage (ca. 1970), Paik listed the total cost to make *K-456* as $2,400 (US), which would be equal to roughly $16,000 today. Letter available in Reuben Hoggett, "1964—Robot K-456—Nam June Paik (Korean) & Shuya Abe (Japanese)—cyberneticzoo.com," September 1, 2010, accessed June 17, 2019, http://cyberneticzoo.com/robots-in-art/1964-robot-k-456-nam-june-paik-korean-shuya-abe-japanese/.

NOTES TO PAGES 61–63

8. W. Grey Walter, "An Imitation of Life," *Scientific American* (May 1950): 42–45.

9. Although the robotics enthusiast Reuben Hoggett does not detect any sensors or limit switches in photographic documentation of the 1964 version of *K-456*, Jack Burnham lists unspecified "sensory devices" in his account of Paik's robot. Hoggett, "1964—Robot K-456"; Jack Burnham, *Beyond Modern Sculpture: The Effects of Science and Technology on the Sculpture of the Century* (1968; New York: George Braziller, 1975), 351.

10. Ericson, "Avant-Garde Music." Hoggett includes an image with a caption that refers to *K-456* as a "radio-controlled belly dancer" (Hoggett, "1964—Robot K-456").

11. Fred Stern, "Charlotte Moorman and the New York Avant Garde," 1980, YouTube video, posted December 14, 2006, by Fred Stern, https://www.youtube.com/watch?v=wiEJdOlgcDE. See also Piekut, *Experimentalism Otherwise*, 160–62.

12. Margaret Rhee, "Racial Recalibration: Nam June Paik's *K-456*," *Asian Diasporic Visual Cultures and the Americas* 1 (2015): 295.

13. Paik quoted in Piekut, *Experimentalism Otherwise*, 161.

14. Burnham, *Beyond Modern Sculpture*, 351.

15. On the question of Moorman's agency in performing Cage, see Piekut, "Murder by Cello," in *Experimentalism Otherwise*, 140–76.

16. See Landres, "The First Non-Human Action Artist," 18. See also Paik's *Listening to Music through the Mouth* (1963), cited in Rothfuss, *The Topless Cellist*, 84–5.

17. Rhee, "Racial Recalibration," 295. Paik created *K-456* prior to his arrival in the US, yet its references to eighteenth-century automata can nonetheless be interpreted as pointing to a biological, gendered, and ethnic "otherness" of these devices that resonates with the treatment he experienced while in America. Specifically, Vaucanson's duck was one of several automata that resemble animals; other automata like the harpsichord player by the French clock maker Jaquet-Droz possessed exaggerated feminine features and behavior; and one of the most notorious automata of this era was Wolfgang von Kempelen's chess player of 1770, widely known as the Turk. On Vaucanson's duck and the Turk, see Jessica Riskin, "The Defecating Duck; or, The Ambiguous Origins of Artificial Life," *Critical Inquiry* 29, no. 4 (Summer 2003): 599–633. On the Jaquet-Droz automaton, see Adelheid Voskuhl, *Androids in the Enlightenment: Mechanics, Artisans, and Cultures of the Self* (Chicago: University of Chicago Press, 2013).

18. Incidentally, the play also involves robots refusing to work, which some of its characters attribute to illness. See Jennifer Rhee's instructive analysis of Čapek's *R.U.R.* in "Robot Origins," in *The Robotic Imaginary: The Human and the Price of Dehumanized Labor* (Minneapolis: University of Minnesota Press, 2018), 17–24.

19. From Paik's poem, "Pensée" (1965), in *Treffpunkt Parnass: Wuppertal 1949–1965* (Cologne: Rheinland-Verlag, 1980), 286–89 (unpaginated semi-transparent inserts). See also Wulf Herzogenrath, *Nam June Paik Video Works 1963–88* (London: Hayward Gallery, 1988), 21.

20. N. Katherine Hayles, *How We Became Posthuman: Virtual Bodies in Cybernetics, Literature, and Informatics* (Chicago: University of Chicago Press, 1999), 234.

21. Riskin is careful to note that her use of "simulation" is based on its twentieth-century meaning as an "experimental model from which one can discover properties of the natural subject" (Riskin, "The Defecating Duck," 605n4).

22. Nam June Paik, "Norbert Wiener and Marshall McLuhan," *ICA Bulletin* (Bulletin of the Institute of Contemporary Art, London) no. 172/3 (1967): 7.

23. Paik, "Norbert Wiener and Marshall McLuhan," 7–8; Norbert Wiener, *Cybernetics; or, Control and Communication in the Animal and the Machine* (1948; Cambridge, MA: MIT Press,

2019). Paik cites Marshall McLuhan, *Understanding Media: The Extensions of Man* (1964; Cambridge, MA: MIT Press, 1994), 43. See Alex Kitnick, "The Age of Mechanical Production," in *Distant Early Warning: Marshall McLuhan and the Transformation of the Avant-Garde* (Chicago: University of Chicago Press, 2021), 11–33.

24. Paik cited in Wulf Herzogenrath, *Nam June Paik Video Works 1963–88*; Nam June Paik, "Cybernated Art," in *Manifestos, Great Bear Pamphlets* (New York: Something Else Press, 1966), 24.

25. Paik cited in John Hanhardt, "Chance in a Lifetime," *ArtForum*, April 2006, https://www.artforum.com/print/200604/nam-june-paik-10623.

26. Paik in Gene Youngblood, *Expanded Cinema* (New York: E. P. Dutton, 1970): "the real issue implied in 'Art and Technology' is not to make another scientific toy, but how to humanize the technology and the electronic medium" (306). Paik in "Nam June Paik: Edited for Television," interview with Calvin Tompkins, hosted by Russell Connor (1975; New York: WNET/Thirteen).

27. Nam June Paik in Willoughby Sharp, "Artificial Metabolism: An Interview with Nam June Paik," *Video 80*, no. 4 (Spring/Summer 1982): 14.

28. Karl Marx, "Machinery and Modern Industry," in *Capital: Volume I* (New York: Dover Publications, 2019), 405–556; Karl Marx, "The Fragment on Machines," in *Grundrisse: Foundations of the Critique of Political Economy* (New York: Penguin, 2005), 670–712.

29. Rodney Brooks's genealogy links Walter's tortoises with the Roomba, a product of iRobot, the company Brooks co-founded in 1990 with two other members of the MIT Artificial Intelligence Lab. Rodney Brooks, *Flesh and Machines: How Robots Will Change Us* (New York: Vintage Books, 2003).

30. Some robots appear more biomorphic than others, so my use of the term is to be understood as expansive. Many industrial robots such as the Unimate arm simulate only a single body part. For others, bodily resemblance is latent, vestigial, or, as with the Stanford Cart, relates to their sensing and/or navigational abilities. Software "bots" lack physical embodiment altogether, yet they may be understood as biomorphic with respect to the mind. Other machines appear to straddle distinctions between non-biomorphic automation and robotics. Vaucanson's loom, while not a robot, used the same mechanical design the inventor later used in his proto-robotic musical automata. Relatedly, Jean-Claude Beaune locates an incipient biomorphism already at play in automation, claiming that "before thinking of automating manual labor, one must conceive of mechanically representing the limbs of man." Jean-Claude Beaune, *L'Automate et ses mobiles* (Paris: Flammarion, 1980), 257; translated and cited in Riskin, "The Defecating Duck," 623fn54.

31. Matteo Pasquinelli, "Abnormal Encephalization in the Age of Machine Learning," *e-flux 75* (September 2016), https://www.e-flux.com/journal/75/67133/abnormal-encephalization-in-the-age-of-machine-learning/.

32. Jennifer Rhee analyzes *K-456* in terms of care labor. Jennifer Rhee, *The Robotic Imaginary: The Human and the Price of Dehumanized Labor* (Minneapolis: University of Minnesota Press, 2018), 58–60.

33. Catherine Malabou, *Morphing Intelligence: From IQ Measurements to Artificial Brains* (New York: Columbia University Press, 2019).

34. Alexander G. Weheliye, *Habeas Viscus: Racializing Assemblages, Biopolitics, and Black Feminist Theories of the Human* (Durham, NC: Duke University Press, 2014), 135.

35. David Bates, "Cartesian Robotics," *Representations* 124, no. 1 (Fall 2013): 63. René Descartes, *Traité de l'homme*, in *Oeuvres de Descartes*, ed. Charles Adam and Paul Tannery, 11 vols. (Paris: Léopold Cerf, 1983), 11:185.

NOTES TO PAGES 66–69

36. George Caffentzis, "Why Machines Cannot Create Value: Marx's Theory of Machines," in *In Letters of Blood and Fire: Work, Machines, and the Crisis of Capitalism* (Oakland, CA: PM Press, 2013), 162, emphasis removed.

37. Paik in "Nam June Paik: Edited for Television."

38. Kerner, "Buzz, Buzz," 15; Bowers, "A Feast of Astonishment," 173.

39. See Lydia H. Liu, *The Freudian Robot: Digital Media and the Future of the Unconscious* (Chicago: University of Chicago Press, 2010), 139–42.

40. For one such interpretation, see Liu, *The Freudian Robot*; Masahiro Mori, "The Uncanny Valley," trans. Karl F. MacDorman and Norri Kageki, *IEEE Robotics and Automation Magazine* 19, no. 2 (2012): 98–100. Note, however, that Mori's text does not explicitly engage with Freud's notion of the uncanny. For a reading that relates Mori to the establishing of boundary conditions of the human, see Rhee, *The Robotic Imaginary*, 13–17.

41. Philip Mirowski, *Machine Dreams: Economics Becomes a Cyborg Science* (Cambridge, UK: Cambridge University Press, 2001), 373. Mirowski cites evidence that Shannon encouraged the scientist John Larry Kelly Jr. in his application of information theory to economics.

42. Nick Dyer-Witheford, *Cyber-Proletariat: Global Labour in the Digital Vortex* (London: Pluto Press, 2015), 50; Willoughby Sharp and Nam June Paik, "Artificial Metabolism," 14. Wulf Herzogenrath claims that four were necessary to operate *K-456*. Wulf Herzogenrath, *Nam June Paik Video Works 1963–88* (London: Hayward Gallery, 1988), 21.

43. Dyer-Witheford, *Cyber-Proletariat*, 50.

44. See Harry Braverman, *Labor and Monopoly Capital: The Degradation of Work in the Twentieth Century* (1974; New York: Monthly Review Press, 1998). On deskilling in an art-historical context, see John Roberts, *The Intangibilities of Form: Skill and Deskilling in Art After the Readymade* (New York: Verso, 2007).

45. Rhee, *The Robotic Imaginary*.

46. See Hanna Hölling, *Paik's Virtual Archive: Time, Change, and Materiality in Media Art* (Berkeley: University of California Press, 2017), 39–40. Relatedly, Hölling suggests that later in his career Paik's role in his artistic process had become increasingly that of a "manager and designer" (37).

47. Brooks, *Flesh and Machines*, 114.

48. Dyer-Witheford, *Cyber-Proletariat*, 51.

49. See, e.g., Burnham, *Beyond Modern Sculpture*, 351; or Rhee, *The Robotic Imaginary*, 58.

50. Christopher Null and Brian Caulfield, "Fade to Black: The 1980s Vision of 'Lights-Out' Manufacturing, Where Robots Do All the Work, Is a Dream No More," *Fortune*, June 1, 2003, http://archive.fortune.com/magazines/business2/business2_archive/2003/06/01/343371/index.htm. Cited in Dyer-Witheford, *Cyber-Proletariat*, 56.

51. Gary Zywiol quoted in Null and Caulfield, "Fade to Black."

52. Wiener, *Cybernetics*, 40.

53. Paik, "Pensée." Kalindi Vora and Neda Atanasoski locate a related symmetry between slavery and roboticization as a form of "surrogacy" inherent to liberal humanism that includes "the body of the enslaved standing in for the master, the vanishing of native bodies necessary for colonial expansion, as well as invisibilized labor including indenture, immigration, and outsourcing." Kalindi Vora and Neda Atanasoski, *Surrogate Humanity: Race, Robots, and the Politics of Technological Futures* (Durham, NC: Duke University Press, 2019), 6.

54. See "Art and the Future: Extract of Douglas Davis interview with Nam June Paik"; and Wulf Herzogenrath, *Nam June Paik Video Works 1963–88*, 19.

184 NOTES TO PAGES 69–74

55. Brooks, *Flesh and Machines*, 25.

56. See Lester Earnest's genealogy linking the Cart to self-driving cars. Lester Earnest, "Stanford Cart: How a Moon Rover Project was Blocked by a Politician but got Kicked by Football into a Self-Driving Vehicle," March 11, 2018, https://web.stanford.edu/~learnest/sail/cart.html.

57. Cited in Hoggett, "1964—Robot K-456."

58. Brooks, *Flesh and Machines*, 51–52.

59. Brooks, *Flesh and Machines*, 50, 52.

60. Riskin, "The Defecating Duck," 602. An analysis of these automata as living dolls and machines appears in Gaby Wood, *Living Dolls: A Magical History of the Quest for Mechanical Life* (London: Faber and Faber, 2002); published in the US as *Edison's Eve: A Magical History of the Quest for Mechanical Life* (New York: Alfred A. Knopf, 2002).

61. Riskin, "The Defecating Duck," 612.

62. There is some disagreement about whether or not Mozart wrote K. 456 for Maria Theresa von Paradis. Hermann Ullrich, "Maria Theresa Paradis and Mozart," *Music & Letters* 27, no. 4 (October 1946): 224–33. Richard Maunder, "J. C. Bach and the Early Piano in London," *Journal of the Royal Musical Association* 116, no. 2 (1991): 201–10. On the flute solo, see Martha Kingdon Ward, "Mozart and the Flute," *Music & Letters* 35, no. 4 (October 1954): 303.

63. Annette Richards, "Automatic Genius: Mozart and the Mechanical Sublime," *Music & Letters* 80, no. 3 (August 1999): 383.

64. Paik in application for Rockefeller Grant, 1967. See William Kaizen, "Computer Participator: Situating Nam June Paik's Work in Computing," in *Mainframe Experimentalism*, ed. Hannah Higgins and Douglas Kahn (Berkeley: University of California Press, 2012), 231.

65. Paik in Jud Yalkut, "Art and Technology of Nam June Paik," *Arts Magazine*, April 1968, 50, emphasis in original. Paik's computer-generated haiku emerges from the same place, and around the same time, as Alison Knowles's *House of Dust* (1967), a similarly composed permutation poem that was engineered by fellow Bell Labs resident and computer music composer James Tenney. See Hannah B. Higgins, "An Introduction to Alison Knowles's *The House of Dust*," in *Mainframe Experimentalism*, 195–99; and Benjamin H. D. Buchloh, "The Book of the Future: Alison Knowles's *The House of Dust*," in *Mainframe Experimentalism*, 200–208.

66. Riskin, "The Defecating Duck," 628.

67. La Mettrie, *Machine Man*, 7.

68. Ann Thomson, "Introduction," in La Mettrie, *Machine Man and Other Writings*, xvi.

69. A brief description of Paik's *Descartes in Easter Island* (1993) appears in Kenneth Silver, "Nam June Paik: Video's Body," *Art in America* (November 1993).

70. Bates, "Cartesian Robotics," 46.

71. Bates, "Cartesian Robotics," 46, emphasis removed.

72. Bowers, "A Feast of Astonishment," 173.

73. A scrap of Whitney Museum letterhead labeled "file: ROBOT" contains the performance's time and date ("6/22/82 11:00 AM") and the four-fold order of events (capitalization removed):

1. Robot stops & eats hot dog

2. Robot waits for light, crosses 75th Street. Cars honk.

3. Robot turns to cross Madison

4. Robot struck by car from rear.

Corresponding numbers appear next to locations on a map sketched to show the order of events. The document was likely authored earlier in the month of June, 1982. Box 0109-111,

NOTES TO PAGES 74–78

Folder 35, Nam June Paik 1982 April 30—October 24 81.0, Whitney Museum of American Art, Frances Mulhall Achilles Library and Archives, New York.

74. Nam June Paik with Betsy Connors and Paul Garrin, *Living with the Living Theatre* (1989), video, co-production of WGBH New Television Workshop, Electronic Arts Intermix.

75. Herzogenrath, *Nam June Paik Video Works 1963–88*, 24; Jennifer Rhee, *The Robotic Imaginary*, 60.

76. Paik cited in John Hanhardt, "Chance in a Lifetime," *ArtForum*, April 2006, https://www.artforum.com/print/200604/nam-june-paik-10623.

77. Paik in Youngblood, *Expanded Cinema*, 306.

78. Rhee, *The Robotic Imaginary*, 60. For an extended treatment of technological surrogacy, see Vora and Atanasoski, *Surrogate Humanity*.

79. Paik in Nam June Paik with Betsy Connors and Paul Garrin, *Living with the Living Theatre*.

80. Paik with Connors and Garrin, *Living with the Living Theatre*.

81. Paik, "Pensée" (1965).

82. Paik cited in Wulf Herzogenrath, *Nam June Paik Video Works 1963–88*, 21.

83. Herzogenrath, *Nam June Paik Video Works 1963–88*, 19.

84. Paik quoted in Laurie Werner, "Nam June Paik—Laureates," *Northwest Orient* (June 1986): 40.

85. Undated letter to John Cage, likely written around 1967, John Cage Collection, Series II: Notations Project, Subseries 2: Correspondence, Box 10, Folder 6: Nam June Paik (n.d.), Northwestern Archival and Manuscript Collections.

86. This was during the time Paik worked on *Electronic Opera #1*, which is available on *The Medium Is the Medium* (1969), a compilation produced by Boston's WGBH-TV that contains video works by Aldo Tambellini, Allan Kaprow, Otto Piene, and Paik. On the Pulsa commune, see Yates McKee, "The Public Sensoriums of Pulsa: Cybernetic Abstraction and the Biopolitics of Urban Survival," *Art Journal* 67, no. 3 (Fall 2008): 46–67.

87. Eduardo Kac, "The Origin and Development of Robotic Art," *Convergence: The International Journal of Research into New Media Technologies* 7, no. 1 (March 2001): 78. See also Eduardo Kac, "Foundation and Development of Robotic Art," *Art Journal* 56, no. 3, Digital Reflections: The Dialogue of Art and Technology (Autumn 1997): 61–62.

Chapter Four

1. H. Paul Shuch, "2001: A Moonbounce Odyssey," *QST* (November 2001): 1.

2. Julia DeMarines, "Observing the Earth as a Communicating Exoplanet," *Astro2020 Decadal Review* (2019), whitepaper; Woodruff T. Sullivan III, "Eavesdropping on Galactic Civilizations," *Science* 202, no. 4366 (October 27, 1978): 376–77.

3. Oliveros explains that the Doppler shift ascends in pitch as the moon is setting and descends when rising. Oliveros in Scot Gresham-Lancaster, "Pauline Oliveros—Some Thoughts on Sonification," Sound & Data podcast, March 8, 2015, http://arteca.mit.edu/podcast/thoughts-on-sonification, accessed December 28, 2019.

4. Pauline Oliveros, "Echoes from the Moon," in *Sounding the Margins: Collected Writings 1992–2009* (Kingston, NY: Deep Listening Publications, 2010), 58–59. Oliveros describes her vision of an "installation where [participants] could send the sound of their voices to the moon and hear the echo come back to earth [*sic*]. They would be vocal astronauts."

186 NOTES TO PAGES 78–81

5. J. L. Austin, *How to Do Things with Words* (1955/1962; London: Oxford University Press, 2011).

6. Friedrich Kittler, *Gramophone, Film, Typewriter* (Stanford, CA: Stanford University Press, 1999), 21. Edison, along with Arthur E. Kennelly, had even proposed a system of detecting radio waves from the sun; see Woodruff T. Sullivan III, *Cosmic Noise: A History of Early Radio Astronomy* (Cambridge, UK: Cambridge University Press, 2009), 19.

7. Pauline Oliveros, "The Expanded Instrument System: An Introduction and Brief History," in *Sounding the Margins*, 218.

8. Oliveros discusses biofeedback in Pauline Oliveros, "Meditation Project: A Report," in *Software for People: Collected Writings 1963–80* (Baltimore, MD: Smith Publications, 1984), 160. On Lucier's use of brainwaves and biofeedback, see chapter 1.

9. Ted Gordon, "Composing, Performing, Listening: Pauline Oliveros's *Mnemonics*," unpublished manuscript, February 15, 2019.

10. Pauline Oliveros, "Sounding the Borders," in *Sounding the Margins*, 176. Oliveros's talk contains an epigraph from Ray Kurzweil's self-published essay, "The Law of Accelerating Returns."

11. John McCarthy, "Possible Forms of Intelligence: Natural and Artificial," in *Interstellar Communication: Scientific Perspectives*, ed. Cyril Ponnamperuma, Alastair Graham, and Walter Cameron (1963; New York: Houghton Mifflin, 1975), 79–87; Marvin Minsky, "Communication with Alien Intelligence," *Byte Magazine* 10, no. 4 (1985): 126–42, available online at https://web.media.mit.edu/~minsky/papers/AlienIntelligence.html. See also Daniel Oberhaus, *Extraterrestrial Languages* (Cambridge, MA: MIT Press, 2019), 33.

12. Pauline Oliveros, "Quantum Listening: From Practice to Theory (to Practice Practice)," in *Sounding the Margins*, 80.

13. Pauline Oliveros, "The Accordion (& the Outsider)," in *Sounding the Margins*, 159.

14. Pauline Oliveros in Martha Mockus, *Sounding Out: Pauline Oliveros and Lesbian Musicality* (New York: Routledge, 2007), 168; Pauline Oliveros, "Statement: January 10, 1997," in *Sounding the Margins*, 14–15.

15. Pauline Oliveros, "And Don't Call Them 'Lady' Composers," *New York Times*, September 13, 1970, sec. 2, p. 2.

16. Oliveros in Mockus, *Sounding Out*, 155.

17. Breanne Fahs, "The Radical Possibilities of Valerie Solanas," *Feminist Studies* 34, no. 3, The 1970s Issue (Fall 2008): 597.

18. Oliveros, "Quantum Listening," 77–78.

19. Oliveros, "Quantum Listening," 76; Oliveros, "Tripping on Wires: The Wireless Body—Who Is Improvising?," in *Sounding the Margins*, 123.

20. Oliveros in Beth Anderson, "Interview with Pauline Oliveros," *Ear Magazine East* 2, no. 6 (February/March 1981): 13, quoted in Mockus, *Sounding Out*, 40.

21. According to a June 11, 2002 patent application by The Pauline Oliveros Foundation, Inc., though, Oliveros had used the term Deep Listening one year earlier, in 1988. The US Patent and Trademark Office record describes Deep Listening as:

Educational services, namely, conducting workshops, seminars, conferences, retreats and training programs to enhance musical and artistic creativity through an understanding of sound and its effects on the human mind and body, and distributing printed course materials in connection therewith; entertainment services in the nature of live performances, music publishing services, and multi-media production and recording

NOTES TO PAGES 81–85

services, namely, providing production and recording services for the fixation in a tangible medium, musical and artistic work on phono record, audio and video cassette tape, CD, DVD and digital media capable of transmission over the Internet.

The record indicates, however, that this application was cancelled February 20, 2010. The Pauline Oliveros Foundation, Inc., Deep Listening, filed June 11, 2002, and canceled February 20, 2010.

22. Oliveros cited in Douglas Kahn, *Earth Sound Earth Signal: Energies and Earth Magnitude in the Arts* (Berkeley: University of California Press, 2013), 181.

23. Although the pictograph appears to lack gender-related features, the accompanying numerical figures, in fact, include the average height of men at the time—1.76 meters (5 feet, 9 inches)—while omitting any such detail for women. For a numerical analysis of the Arecibo message, see Daniel Oberhaus, "Appendix A: The Arecibo Message," in *Extraterrestrial Languages*, 171–77.

24. Enrico Fermi quoted in Eric M. Jones, "'Where Is Everybody?' An Account of Fermi's Question," Technical Report LA-10311-MS, Los Alamos National Laboratory, Los Alamos, New Mexico, March 1985.

25. Michael H. Hart, "An Explanation for the Absence of Extraterrestrials on Earth," *Royal Astronomical Society* 2, vol. 16 (1975): 128.

26. See Jones, "'Where Is Everybody?'"

27. Duncan H. Forgan, *Solving Fermi's Paradox* (Cambridge, UK: Cambridge University Press, 2019), 6.

28. See Doug Vokach and Matthew Dowd, eds., *The Drake Equation: Estimating the Prevalence of Extraterrestrial Life through the Ages* (Cambridge, UK: Cambridge University Press, 2015).

29. Milan M. Ćirković refers to the "Great Silence" as "nothing more than a generalized form of Fermi's question." Milan M. Ćirković, *The Great Silence: Science and Philosophy of Fermi's Paradox* (New York: Oxford University Press, 2018), 4. Referring to a sense of interdisciplinarity, Shklovsky describes himself as a "strange mixture of artist and conquistador." See Iosif Shklovsky, *Five Billion Vodka Bottles to the Moon: Tales of a Soviet Scientist* (New York: W. W. Norton, 1991), 90. Cited in Sullivan, *Cosmic Noise*, 215.

30. Pauline Oliveros, "Software for People," in *Software for People*, 179.

31. Oliveros describes an ESP experiment in which she attempted to transmit sounds and images mentally as part of a performance of her 1972 work *Phantom Fathom*. Oliveros, *Software for People*, 162; see Oliveros's remarks on Lucier's *Music for Solo Performer* (93).

32. Milan Ćirković, "Against the Empire," *Journal of the British Interplanetary Society* 61, no. 7 (July 2008): 4, https://arxiv.org/pdf/0805.1821.pdf.

33. Ćirković, "Against the Empire," 7.

34. Robin Hanson, "The Great Filter—Are We Almost Past It?," September 15, 1998, accessed June 4, 2020, http://mason.gmu.edu/~rhanson/greatfilter.html.

35. Stephen Webb, *If the Universe Is Teeming with Aliens . . . WHERE IS EVERYBODY? Seventy-Five Solutions to the Fermi Paradox and the Problem of Extraterrestrial Life*, second edition (New York: Springer, 2015).

36. Ćirković, "Against the Empire," 11.

37. Carl Schmitt, *Land und Meer*, 65–66, translated in Peter Szendy, *Kant in the Land of the Extraterrestrials: Cosmopolitical Philosofictions* (New York: Fordham University Press, 2013), 29.

38. Szendy, *Kant in the Land of the Extraterrestrials*, 29.

39. Oliveros directly engaged themes of colonialism in her musical work. In 2007 she co-directed *Tele-Colonization*, a distance performance that connected the Tintinnabulate and Sound-Wire ensembles in order to "highlight and create awareness of dislocatedness." Jonas Braasch, Chris Chafe, Pauline Oliveros, and Bart Woodstrup, "Tintinnabulate and SoundWire: Tele-Colonization," liner notes (Kingston, NY: Deep Listening Publications, 2009), n.p. Recently, Ione led a series of posthumous performances of *The Nubian Word for Flowers: A Phantom Opera*, for which she is the librettist and which Oliveros had nearly completed before her death in 2016. The work tells the story of Horatio Herbert Kitchener, a senior officer in the British Army and the colonial administrator known for winning British control of Sudan and the Boer Republics.

40. This is from Sullivan's quotation of the seventeenth-century natural philosopher Robert Hooke. Sullivan, *Cosmic Noise*, 1.

41. Sullivan, *Cosmic Noise*, 3, emphasis in original.

42. Although it was likely only radio emissions caused by storms on Jupiter, Tesla was convinced it was "a message from another world, unknown and remote" (Nikola Tesla to the American Red Cross, New York City, 1900, cited in Oberhaus, *Extraterrestrial Languages*, 9).

43. Philip Ball, "What the War of the Worlds Means Now," *NewStatesman*, July 18, 2018, https://www.newstatesman.com/2018/07/war-of-the-worlds-2018-bbc-hg-wells.

44. Badmington is referring to Byron Haskin's 1953 film adaptation of *War of the Worlds*, but the description holds for the novel as well. Neil Badmington, *Alien Chic: Posthumanism and the Other Within* (New York: Routledge, 2004), 17.

45. Badmington, *Alien Chic*, 15–16.

46. Sullivan, *Cosmic Noise*, 29.

47. Sullivan, *Cosmic Noise*, 265–66.

48. DeWitt quoted in Kahn, *Earth Sound Earth Signal*, 182; see Sullivan, *Cosmic Noise*, 264–71.

49. Kahn, *Earth Sound Earth Signal*, 182.

50. "Diana," *Time*, February 4, 1946. Cited in Sullivan, *Cosmic Noise*, 269.

51. Sullivan, *Cosmic Noise*, 270–71. Although their existence was suspected as early as 1917, exoplanets were only confirmed to exist in 1992.

52. Oliveros, "Quantum Listening," 81.

53. For an analysis of the Golden Record in the context of music theory, see Daniel K. L. Chua and Alexander Rehding, *Alien Listening: Voyager's Golden Record and Music from Earth* (Brooklyn, NY: Zone Books, 2021). For a more journalistic account, see Jonathan Scott, *The Vinyl Frontier: The Story of the Voyager Golden Record* (New York: Bloomsbury, 2019). See also Oberhaus, *Extraterrestrial Languages*, 15.

54. Chua and Rehding, *Alien Listening*, 161.

55. Joe Davis, "Monsters, Maps, Signals and Codes," *bioMediale*, archived February 13, 2009, https://web.archive.org/web/20090213181823/http://biomediale.ncca-kaliningrad.ru:80/?blang=eng&author=davis.

56. Tony Phillips, "Voyager, the Love Story," *NASA Science: Share the Science*, April 28, 2011, https://science.nasa.gov/science-news/science-at-nasa/2011/28apr_voyager2, accessed December 28, 2019.

57. Frank White, *The Overview Effect: Space Exploration and Human Evolution*, third edition (1987; Reston, VA: American Institute of Aeronautics and Astronautics, 2014).

58. Oliveros, *Software for People*, 116, capitalization replaced with emphasis.

NOTES TO PAGES 89–91

59. Kelly Oliver, *Earth and World: Philosophy after the Apollo Missions* (New York: Columbia University Press, 2015), 2. See also Kahn's treatment of Armstrong's and Aldrin's call to Nixon, in Kahn, *Earth Sound Earth Signal*, 182.

60. For a phonolinguistic-acoustic analysis of Armstrong's recorded speech, see Laura Dilley et al., "One Small Step for (a) Man: Function Word Reduction and Acoustic Ambiguity," *Proceedings of Meetings on Acoustics* 19 (2013): 1–6, https://asa.scitation.org/doi/pdf/10.1121/1.4 800664?class=pdf. As for technical contributors to the ambiguity, Armstrong notes, "Perhaps it was a suppressed sound that didn't get picked up by the voice mic," cited in Olivia B. Waxman, "Lots of People Have Theories about Neil Armstrong's 'One Small Step for Man' Quote. Here's What We Really Know," *Time*, July 15, 2019, https://time.com/5621999/neil-armstrong-quote/.

61. Pauline Oliveros, "Welcoming Address: 1977 International Computer Music Conference," in *Software for People*, 176.

62. Kant's "On the Volcanoes on the Moon" appeared in the March 1785 issue of *Berlinische Monatsschrift*. See *Kant: Natural Science*, ed. Eric Watkins (Cambridge, UK: Cambridge University Press, 2012), 418–25. The Kant Plateau is 25.8 miles (41.5 km) from Mare Tranquillitatis, the Apollo 11 landing site.

63. Immanuel Kant, *Anthropology from a Pragmatic Point of View*, trans. Robert B. Louden (1798; Cambridge, UK: Cambridge University Press, 2006), 238, 236, emphasis removed. See Szendy, "Kant in the Land of Extraterrestrials," in *Kant in the Land of Extraterrestrials*, 45–80.

64. Kant, *Anthropology*, 225.

65. Kant, *Anthropology*, 237, emphasis removed. This theme has resurfaced in contemporary science fiction, including Liu Cixin's *The Three-body Problem* trilogy. See Liu Cixin, *The Dark Forest*, trans. Joel Martinsen (New York: Tor Books, 2008).

66. Ione in de Paulis's 2018 realization.

67. Improvisation is rooted in traditions of storytelling and fabulation, however, which places it at odds with Kant's extraterrestrials. See Benjamin Piekut, "Another Version of Ourselves: The Enigmas of Improvised Subjectivity," *Liminalities: A Journal of Performance Studies* 14, no. 1 (2018): 88.

68. Mark Swed, "A Study in Comparisons, Contrasts," *Los Angeles Times*, August 18, 1997.

69. See the extensive and important work of both Piekut and Lewis on improvisation and experimentalism: Ben Piekut, *Experimentalism Otherwise: The New York Avant-Garde and Its Limits* (Berkeley: University of California Press, 2011); Benjamin Piekut, ed., *Tomorrow Is the Question: New Directions in Experimental Music* (Ann Arbor: University of Michigan Press, 2014); George E. Lewis and Benjamin Piekut, *The Oxford Handbook of Critical Improvisation Studies*, vols. 1 & 2 (New York: Oxford University Press, 2013); George Lewis, *A Power Stronger than Itself: The A.A.C.M. and American Experimental Music* (Chicago: University of Chicago Press, 2007). On Oliveros and improvisation, see Stephanie Jensen-Moulton, "Sounds of the Sweatshop: Pauline Oliveros and *Maquilapolis*," in Piekut, ed., *Tomorrow Is the Question*, 211–28. On interdisciplinary artistic forms of improvisation (including music), see Georgina Born, Will Straw, and Eric Lewis, *Improvisation and Social Aesthetics* (Durham, NC: Duke University Press, 2017). I return to the subject of improvisation in the context of Tone's work with the Music group in chapter 6.

70. Pauline Oliveros, "Quantum Improvisation: The Cybernetic Presence," in *Sounding the Margins*, 47.

71. Pauline Oliveros, "Echoes from the Moon," description of performance, accessed December 20, 2019, http://www.kunstradio.at/VR_TON/texte/4.html.

72. Oliveros, "Tripping on Wires," 123.

73. Oliveros, "Tripping on Wires," 123.

74. Immanuel Kant, *An Answer to the Question: "What is Enlightenment?"* (New York: Penguin, 2013).

75. "The human being can only become human through education." Immanuel Kant, *Lectures on Pedagogy* (1803), trans. Robert Louden, in *Anthropology, History, Education* (Cambridge, UK: Cambridge University Press, 2007), 439. See also Lindon Barrett, *Blackness and Value: Seeing Double* (Cambridge, UK: Cambridge University Press, 1999), 72.

76. Immanuel Kant, *Universal Natural History and Theory of the Heavens*, trans. Olaf Reinhardt, in Immanuel Kant, *Natural Science*, ed. Eric Watkins (Cambridge: Cambridge University Press, 2012), 301. See Szendy, *Kant in the Land of Extraterrestrials*, 53. Note that Kant's views regarding race changed during the 1790s, and some argue that his later work supports a genuinely egalitarian view of race. See, for instance, Pauline Kleingeld, "Kant's Second Thoughts on Race," *Philosophical Quarterly* 57, no. 229 (October 2007): 573–92.

77. Minsky, "Communication with Alien Intelligence"; McCarthy, "Possible Forms of Intelligence."

78. Ray Kurzweil, "The Law of Accelerating Returns," *Kurzweil: Tracking the Acceleration of Intelligence*, March 7, 2001, https://www.kurzweilai.net/the-law-of-accelerating-returns.

79. Oliveros, "Quantum Listening," 84.

80. Kurzweil, "The Law of Accelerating Returns"; Oliveros, "Quantum Improvisation," 51, 57.

81. Oliveros, "Tripping on Wires," 121–22.

82. John Cage, "Experimental Music: Doctrine" (1955), in *Silence: Lectures and Writings* (Middletown, CT: Wesleyan University Press, 1961), 8. Discussed in this book's Introduction, Cage and Hiller's *HPSCHD* (1967–1969) included projected images of NASA's moon landings. During the 1960s and 1970s, Cage also composed a series of works based on the star charts of Czech astronomer Antonín Bečvář: *Atlas Eclipticalis* (1961), *Etudes Australes* (1974–1975), and the *Freeman Etudes* (1977–1980).

83. Pauline Oliveros, *Sonic Meditations* (Baltimore, MD: Smith Publications, 1974). She later realized this meditation with the aid of a light environment used to induce concentration known as a "Moonpool"; see Oliveros, *Software for People*, 160–61.

84. Oliveros, "Echoes from the Moon," 59.

85. Oliveros, "Quantum Improvisation," 51.

86. Oliveros, "Quantum Listening," 74.

87. Oliveros, "Tripping on Wires," 127.

88. The Apollo explorations had the effect of moving us, as the philosopher Kelly Oliver contends, "from thinking about a world at war to thinking about the unification of the entire globe" (Oliver, *Earth and World*, 3).

89. Gresham-Lancaster quoted in Kahn, *Earth Sound Earth Signal*, 181.

90. Pauline Oliveros, "From Telephone to High-Speed Internet: A Brief History of My Tele-Musical Performances," in *Sounding the Margins*, 191.

91. This is according to Andres Bosshard, personal communication, January 14, 2020.

92. Ione, Facebook post to The Center for Deep Listening @ Rensselaer, March 22, 2018. "In St. Polten [*sic*], I sent my poem (created for that moment) to the Moon, listening as the echoes returned. I wore a white gown and moved through the audience beforehand, assisting those in the audience to send their voices as well. In Salzburg the amp[h]itheater was filled with the gorgeous sounds of Pauline's accordion playing with the returning sounds from the moon."

NOTES TO PAGES 95–99

93. Ione, "Moon, Mond, Luna, Lune," in *Nile Night* (Kingston, NY: Deep Listening Publications, 2008), 33.

94. Bosshard, personal communication, January 14, 2020.

95. "Mondecho" website, https://web.archive.org/web/20010405000341/http://www.mondecho.at/htmlpage.htm, my translation.

96. W. Ross Ashby, *An Introduction to Cybernetics*, second edition (London: John Wiley and Sons, 1957), 88.

97. Andrew Pickering, *The Cybernetic Brain: Sketches of Another Future* (Chicago: University of Chicago Press, 2010), 20.

98. Ashby, *An Introduction to Cybernetics*, 110.

99. Scot Gresham-Lancaster emphasizes this point in personal communication, January 8, 2020.

100. Pickering, *The Cybernetic Brain*, 21. See also Ted Gordon's treatment of the Buchla Box modular synthesizer in Ted Gordon, "Bay Area Experimentalism: Music and Technology in the Long 1960s," PhD diss., University of Chicago, 2018, 18–79.

101. "The returning sounds are not only delayed in time, but also changed in tonal quality: fine, iridescent crackling reveals that the radar signals have passed through magnetic fields close to the Earth." "Mondecho" website, my translation.

102. Oliveros, "Echoes from the Moon," 59.

103. D. Michilli et al., "An Extreme Magneto-ionic Environment Associated with the Fast Radio Burst Source FRB 121102," *Nature* 553 (2018): 182–85.

104. Cary Wolfe, *What Is Posthumanism?* (Minneapolis: University of Minnesota Press, 2010), xv.

105. Fredric Jameson, *Postmodernism; or, The Cultural Logic of Late Capitalism* (Durham, NC: Duke University Press, 1991), 51. A more recent elaboration of the "spatial dialectic" appears in Fredric Jameson, *Valences of the Dialectic* (New York: Verso, 2010). See also Alberto Toscano and Jeff Kinkle, *Cartographies of the Absolute* (New York: Zero Books, 2015).

106. Peter Osborne, *The Postconceptual Condition: Critical Essays* (New York: Verso, 2018), 24.

107. Pauline Oliveros interview with Hanna Bächer. "Pauline Oliveros on the Power of Listening," Red Bull Music Academy, November 22, 2016, https://www.redbullmusicacademy.com/lectures/pauline-oliveros-lecture.

108. Oliveros, "Quantum Improvisation," 51.

109. Chapter 6 addresses this implicit reference to Gregory Bateson's recursive definition of information as a "difference which makes a difference." Gregory Bateson, *Steps to an Ecology of Mind: Collected Essays in Anthropology, Psychiatry, Evolution, and Epistemology* (1972; Chicago: University of Chicago Press, 2000), 462.

Chapter Five

1. Laetitia Sonami, "Laetitia Sonami," DCTV (2000), perf. Sonami (April 26, 2000), prod. Jim Staley, dir. Matt Mehlan, video available at https://vimeo.com/11316136.

2. The box, known as SensorLab, is a portable mini-computer developed by Amsterdam's Studio for Electro Instrumental Music (STEIM) that translates analog input signals into MIDI output.

3. Elizabeth Hinkle-Turner describes *Why __ dreams*: "Sonami expressively choreographs her hand movements to not only trigger interesting sonic commentaries on the spoken text but also to express its meaning, much as a singer interprets the drama in an operatic work."

Elizabeth Hinkle-Turner, *Women Composers and Music Technology in the United States: Crossing the Line* (Farnham, UK: Ashgate, 2006), 91.

4. Georg Essl describes the text, and Sonami's performance, as containing gendered themes and stereotypes. Georg Essl, "On Gender in New Music Interface Technology," *Organised Sound* 8, no. 1 (April 2003): 24–25. On the concept of gestational labor, see Sophie Lewis, *Full Surrogacy Now: Feminism Against Family* (New York: Verso Books, 2019). The Scottish philosopher Mary O'Brien offers an early Marxist-Hegelian feminist account of gestational labor. Mary O'Brien, *The Politics of Reproduction* (New York: Routledge, 1981). See also Lewis's critical remarks in *Full Surrogacy Now*, 9, 61.

5. Sonami quoted in "CalArts Alpert Award in the Arts," accessed May 31, 2020, http://previous.alpertawards.org/archive/winner02/sonami.html.

6. The composer Tod Machover lists toys, video games, and fighter planes as sources of inspiration for alternate controller designs of the time. Tod Machover in "Round Table: Electronic Controllers in Music Performance and Composition," in *Trends in Gestural Control of Music*, ed. Marc Battier and Marcelo M. Wanderley (Paris: IRCAM/Centre Georges Pompidou, 2000). In addition to Sonami and Machover, the other roundtable participants included in the contribution were William Buxton, Don Buchla, Chris Chafe, Max Mathews, Bob Moog, Jean-Claude Risset, and Michel Waisvisz.

7. Sonami in interview with Phoebe Legere following Sonami's 2000 Roulette performance.

8. Laetitia Sonami, "Instruments—Lady's Glove."

9. Sonami in Tara Rodgers, *Pink Noises: Women on Electronic Music and Sound* (Durham, NC: Duke University Press, 2010), 229; Rodgers, "Introduction," in *Pink Noises*, 9.

10. Steve J. Heims, *John von Neumann and Norbert Wiener: From Mathematics to the Technologies of Life and Death* (Cambridge, MA: MIT Press, 1980), 214; cited in Mara Mills's excellent study of the "hearing glove." Mara Mills, "On Disability and Cybernetics: Helen Keller, Norbert Wiener, and the Hearing Glove," *differences* 22, no. 2/3 (2011): 84. For analysis of Sonami's work in relation to sign language, see Lucie Vágnerová, "Video Games and Sign Language in the Work of Laetitia Sonami," in "Sirens/Cyborgs: Sound Technologies and the Musical Body," PhD diss., Columbia University, 2016, 172–187. Sonami discusses sign language as a source of her interest in glove controllers and gesture in *the ear goes to the sound: the work of Laetitia Sonami*, dir. Renetta Sitoy (Kicked Your Height Productions, 2014), DVD video, runtime 68 minutes.

11. Herbert Brün, "Wayfaring Sounds," in *When Music Resists Meaning: The Major Writings of Herbert Brün*, ed. Arun Chandra (Middletown, CT: Wesleyan University Press, 2004), 126.

12. The engineer Bert Bongers collaborated with Sonami on the fourth and fifth versions of the Lady's Glove. He describes some of the technical processes, including the Hall effect, in Burt Bongers, "Physical Interfaces in the Electronic Arts: Interaction Theory and Interfacing Techniques for Real-time Performance," in *Trends in Gestural Control of Music*.

13. Sonami, "Instruments—Lady's Glove."

14. Sonami in Rodgers, *Pink Noises*, 229.

15. Sonami in interview with Legere.

16. Specifically, a mainstay of these hardware samplers was the Peavey DPM SP Sample Playback Synthesizer, which the company introduced in 1989.

17. Note that the use of "sample" here, which represents a single instantaneous amplitude value, is distinct from its use in "sampler" above, which refers to a typically short audio recording that an electronic instrument or device can trigger. For a technical explanation of digital

NOTES TO PAGES 103–107

audio, see Curtis Roads, "Digital Audio Concepts," in *The Computer Music Tutorial* (Cambridge, MA: MIT Press, 1996), 5–48.

18. James Tenney, "Computer Music Experiences, 1961–1964," *Electronic Music Reports #1* (Utrecht: Institute of Sonology, 1969), 38.

19. Laetitia Sonami, "Writings—Goldsmith [*sic*]—LAETITIA SONAMI," accessed April 4, 2020, http://www.sonami.net/writing-goldsmith. The quoted text was part of Sonami's keynote lecture-performance, which as noted included her use of the Lady's Glove, at the New Interfaces for Musical Expression conference held at Goldsmiths College, London, June 30–July 4, 2014.

20. Sonami, "Writings—Goldsmith." While not unique to humans, the ability to move the fingers quasi-independently is remarkable. According to Raymond Tallis, "Opposability, combined with the ability (which is not unique to humans but is seen in some other primates) to move the fingers independently, made it possible for the hand to become a stunningly versatile organ for interacting with the world. There is no other organ like it in the animal kingdom." Raymond Tallis, *The Hand: A Philosophical Inquiry into Human Being* (Edinburgh, UK: Edinburgh University Press, 2003), 142.

21. Craig Anderton, "The Fall Fashions in MIDI Apparel," *Keyboard Magazine*, July 1994, available at http://www.sonami.net/LS-reviews/rev_keyboard.htm.

22. Alvin Lucier, " '. . . to let alpha be itself,' *Music for Solo Performer* (1965)," in *Reflections: Interviews, Scores, Writings 1965–1994 / Reflexionen: Interviews, Notationen, Texte 1965–1994*, second edition (Cologne, Germany: MusikTexte, 1995), 50.

23. Sigfried Giedion, *Mechanization Takes Command: A Contribution to Anonymous History* (1948; New York: Oxford University Press, 1970).

24. "The human hand is a prehensile tool, a grasping mechanism"—Giedion, *Mechanization Takes Command*, 46.

25. Sonami, "Instruments—Lady's Glove."

26. Laetitia Sonami, "Lady's Glove—Laetitia Sonami," accessed April 25, 2020, http://www.sonami.net/sonami/?page_id=6.

27. On the use of "abacus" to refer to the keyboard, see Nicolas Meeùs, "The Chekker," *Organ Yearbook* 16 (1985): 5–25, cited in (and see also) Roger Moseley, *Keys to Play* (Berkeley: University of California Press, 2016), 100.

28. Tallis, *The Hand*, 196–97.

29. Leigh Claire La Berge, *Wages Against Artwork: Decommodified Labor and the Claims of Socially Engaged Art* (Durham, NC: Duke University Press, 2019), 3. See the section below on "Care and Counting."

30. Paul DeMarinis and Laetitia Sonami, "Ars Electronica Archive—Giedion Text," accessed May 1, 2020, available at http://90.146.8.18/en/archives/festival_archive/festival_documentations/1991/demar.html.

31. On speech synthesis, gender, and race, see Patricia Fancher, "Composing Artificial Intelligence: Performing Whiteness and Masculinity," *Present Tense* 6, no. 1 (2016): 1–8.

32. The conference where Giedion met Wiener was the 1950 meeting of the Inter-science Committee at the Massachusetts Institute of Technology. In Giedion's follow-up letter, he writes, "I felt reconforted [*sic*], because thoughts & ideas, which I had to work out lonely for many years are growing in your circle by the force of similar circumstances." Sigfried Giedion to Norbert Wiener, February 22, 1950, box 3, folder 112, Norbert Wiener Papers, Massachusetts Institute of Technology, Institute Archives and Special Collections. Cited in Reinhold Martin, *The*

Organizational Complex: Architecture, Media, and Corporate Space (Cambridge, MA: MIT Press, 2003), 20, 235n13.

33. Specifically, Christopher Hight, *Architectural Principles in the Age of Cybernetics* (New York: Routledge, 2008), 116. Hight also notes that the architect and theorist Mark Wigley has made this claim in a lecture for the Architectural Association in 1999.

34. Giedion, *Mechanization Takes Command*, 720, 721.

35. Giedion, *Mechanization Takes Command*.

36. Martin Heidegger, *Being and Time*, trans. J. Macquarrie and E. Robinson. (1927; Oxford, UK: Basil Blackwell, 1962), 154.

37. Tallis, *The Hand*, 40.

38. Giedion, *Mechanization Takes Command*, 46.

39. Sonami in Anderton, "The Fall Fashions in MIDI Apparel"; Sonami, "Writings—Goldsmith."

40. Silvia Federici, *Wages Against Housework* (Bristol, UK: Power of Women Collective and Falling Wall Press, 1975). See also her more recent work on the subject in Silvia Federici, *Revolution at Point Zero: Housework, Reproduction, and Feminist Struggle* (Oakland, CA: PM Press, 2012).

41. Giedion, *Mechanization Takes Command*, 46.

42. Hight, *Architectural Principles in the Age of Cybernetics*, 115. Giedion writes: "We shall inquire in the first line into the tools that have molded our present-day living" (*Mechanization Takes Command*, 2).

43. Giedion, *Mechanization Takes Command*, 2, 4.

44. Giedion, *Mechanization Takes Command*, 218; Frederick Law Olmsted, *A Journey Through Texas; or, A Saddle-trip on the Southwestern Frontier* (New York: Dix, Edwards & Co., 1857), 9. Note that Giedion's quotation contains inconsistencies related to both spelling and typography. For instance, Olmsted's "chop, chop, sounds again" becomes "chop, chop sound again" in Giedion's text. Giedion italicizes "No iron-cog wheel could work with more regular motion" without documentation. Sonami and DeMarinis use Giedion's phrase "chop, chop sound again," but do not retain his italics in their written transcription of the text. See DeMarinis and Sonami, "Ars Electronica Archive—Giedion Text." For audio recordings, which are labeled "Chop" and "Cincinnati 1850," see Paul DeMarinis, "Mechanization Takes Command: Verses from Giedion's Bible (1991) Paul DeMarinis and Laetitia Sonami," accessed May 1, 2020, http://pauldemarinis.org/Mechanization.html.

45. DeMarinis and Sonami, "Ars Electronica Archive—Giedion Text."

46. DeMarinis refers to Sonami's first Lady's Glove as used in their performance of *Mechanization* as "the early butcher's glove [*sic*] with sensors." Paul DeMarinis in personal communication, May 1, 2020.

47. Giedion, *Mechanization Takes Command*, 243.

48. "We begin with the concept of Movement, which underlies all mechanization. There follows the Hand, which is to be supplanted; and Mechanization as a phenomenon" (Geidion, *Mechanization Takes Command*, 5).

49. Giedion, 629.

50. Giedion, 711.

51. Giedion, 629.

52. Giedion, 685.

53. Giedion, 512, 519. For a more recent account of domestic work, see "Domestic Work: Many Hands, Heavy Work," in Mignon Duffy, *Making Care Count: A Century of Gender, Race, and Paid Care Work* (New Brunswick, NJ: Rutgers University Press, 2011), 20–41.

NOTES TO PAGES 112–116

54. Sonami in interview with Legere.

55. See Marie Thompson's recent work on reproductive labor in new/contemporary and experimental music. Marie Thompson, "Sounding the Arcane: Contemporary Music, Gender and Reproduction," *Contemporary Music* 39, no. 2 (September 2020): 273–92. See also Eric Drott's analysis of music streaming technologies in the context of social reproduction. Eric Drott, "Music in the Work of Social Reproduction," *Cultural Politics* 15, no. 2 (2019): 162–83.

56. *The Matrix*, Lana Wachowski and Lilly Wachowski, dirs. (Warner Bros., 1999), runtime 136 minutes. Two years later, the philosopher Nick Bostrom published the first version of his widely cited 2003 "simulation hypothesis." Nick Bostrom, "Are You Living in a Computer Simulation?," *Philosophical Quarterly* 53, no. 211 (2003): 243–55 (first version, 2001). For an earlier filmic reference, see *The Brain That Wouldn't Die*, Joseph Green, dir. (Sterling Productions, 1962), runtime 90 minutes.

57. Stanislas Dehaene, *The Number Sense: How the Mind Creates Mathematics* (New York: Oxford University Press, 1997), 50.

58. Meeùs, "The Chekker"; Moseley, *Keys to Play*, 100.

59. Nexmap, "Inside Out—Laetitia Sonami at June Jordan School for Equity," December 1, 2020, documented online and available at https://vimeo.com/27067119.

60. Chinzalée Sonami in *the ear goes to the sound*, 2014.

61. On Bruguera and social practice, see Claire Bishop, *Artificial Hells: Participatory Art and the Politics of Spectatorship* (New York: Verso, 2012), 246–50. Compare the artistic practices of Laderman and Bruguera, in which reproductive labor *is* in an important sense the work, to the representational logic of Áine O'Dwyer's 2012 *Music for Church Cleaners*. As Thompson contends, "It is important to note that O'Dwyer's pieces are *for* or *about* the cleaners but not *by* them. The sounds of cleaning (and childcare) are an extra-musical backdrop that is played with or over." Thompson, "Sounding the Arcane," 283, emphasis in original. Note Thompson's reference to the paradigmatic new/modern music category of the *piece* rather than practice. Somewhere between the reification of the piece and the open-endedness of practice is perhaps the event. Another artistic precedent can be found in Yasunao Tone and Allan Kaprow's collaborative realization of the Hi-Red Center collective's *Cleaning Event* at CalArts in 1972, which consisted of the instruction, "Participants have to clean their circumstances." See Dasha Dekleva, "In Parallel," in *Yasunao Tone—Noise, Media, Language* (Berlin: Errant Bodies Press, 2017), 50. On Tone, see chapter 6.

62. Duffy, *Making Care Count*, 6, 132. She also distinguishes between "nurturant" and "nonnurturant" care: "Nurturant care includes labor that is inherently relational, that is, the core of nurturant care workers—nurses, child-care workers, physicians, teachers, social workers—involves intimate and face-to-face relationship[s] with the people they are caring for. Nonnurturant care is the labor that undergirds nurturant care but may not be relational at all—the work of housekeepers, hospital laundry operatives, nursing home cafeteria workers, and health-care orderlies" (6).

63. La Berge, *Wages Against Artwork*, 3.

64. Tallis, *The Hand*, 195, emphasis in original.

65. Tallis, *The Hand*, 202.

66. See Katrine Marçal, *Who Cooked Adam Smith's Dinner? A Story About Women and Economics* (New York: Pegasus Books, 2017). On digital labor, Christian Fuchs has published an extensive body of work. See, for instance, Christian Fuchs, *Digital Labour and Karl Marx* (New York: Routledge, 2014).

67. Anne Balsamo, *Technologies of the Gendered Body: Reading Cyborg Women* (Durham, NC: Duke University Press, 1995), 133. Hayles uses Balsamo's statement as the title of one of her follow-up texts to *How We Became Posthuman*. N. Katherine Hayles, *My Mother Was a Computer: Digital Subjects and Literary Texts* (Chicago: University of Chicago Press, 2005), 1, explanation of title.

68. David Golumbia uses a related Deleuzian distinction between smooth and striated space to refer to the process of submitting phenomena to computation. Golumbia, *The Cultural Logic of Computation* (Cambridge, MA: Harvard University Press, 2009), 11; Gilles Deleuze, "Postscript on the Societies of Control," *October* 59 (Winter 1992): 3–7. See also Gilles Deleuze and Félix Guattari, *A Thousand Plateaus: Capitalism and Schizophrenia*, trans. Brian Massumi (Minneapolis: University of Minnesota Press, 1987).

69. Alexander R. Galloway, *Laruelle: Against the Digital* (Minneapolis: University of Minnesota Press, 2014), xxix.

70. Bernard Stiegler, *For a New Critique of Political Economy*, trans. Daniel Ross (Cambridge: Polity Press, 2010), 31–32. Cited in Galloway, *Laruelle*, 52.

71. See Friedrich Kittler, "The Mother's Mouth," in *Discourse Networks, 1800/1900*, trans. Michael Metteer and Chris Cullens (1985; Redwood City, CA: Stanford University Press, 1990), 25–69.

72. Sadie Plant, *Zeroes and Ones: Digital Women and the New Technoculture* (New York: Doubleday, 1997), 35.

73. On quantum physics and feminism, see Karen Barad, *Meeting the Universe Halfway: Quantum Physics and the Entanglement of Matter and Meaning* (Durham, NC: Duke University Press, 2007). See also Vicki Kirby, *Quantum Anthropologies: Life at Large* (Durham, NC: Duke University Press, 2011).

74. Sara Roberts, "Sara > Early Programming (1989)," accessed May 21, 2020, http://www.sroberts.earbee.com/installations-1/early-programming-1.html. See Sara Roberts, "Early Programming: An Interactive Installation," *Leonardo* 24, no. 1 (February 1991): 90.

75. The Big Conversation Space, "Instrument, Controller, Interface: Inside the Artist's Studio with Laetitia Sonami and the Spring Spyre," video recording, July 15, 2019, accessed May 21, 2020, available at https://vimeo.com/348233269.

76. Sonami, in *the ear goes to the sound*. Compare this description to artist Martha Rosler's 1975 video *Semiotics of the Kitchen*, which also parodies the live cooking show.

77. Yuk Hui, *Recursivity and Contingency* (New York: Rowman and Littlefield, 2019).

78. Sonami, in *the ear goes to the sound*.

79. Hayles borrows this term from archaeological anthropology and uses it as one of her "constellations" of features to describe her phases of cybernetics. N. Katherine Hayles, *How We Became Posthuman: Virtual Bodies in Cybernetics, Literature, and Informatics* (Chicago: University of Chicago Press, 1999), 13–18.

80. Charles Babbage quoted in H. W. Buxton, *Memoir of the Life and Labours of the Late Charles Babbage, Esq., F.R.S.*, ed. Anthony Hyman (1988; Cambridge, MA: MIT Press, 2007), 46. Cited in Simon Schaffer, "Babbage's Intelligence: Calculating Engines and the Factory System," *Critical Inquiry* 21, no. 1 (Autumn 1994): 204.

81. Karl Marx and Friedrich Engels, *The Communist Manifesto* (New York: Verso, 1998), 35. For a further consideration of this "elemental" technological metaphor, see John Durham Peters, *The Marvelous Clouds: Toward a Philosophy of Elemental Media* (Chicago: University of Chicago Press, 2015).

NOTES TO PAGES 119–125

82. Plant refers to Lovelace as a "mathematical, musical, and experimental genius" (*Zeroes and Ones*, 32).

83. In addition to the fourth, as noted, Bongers also collaborated with Sonami on the fifth version of her Lady's Glove. See Bongers, "Physical Interfaces in the Electronic Arts."

84. The samples are triggered from her Peavey DPM SP Sample Playback Synthesizer, and the synthesizer she uses is the Yamaha TG77, known for frequency modulation (FM) synthesis.

85. On the hearing glove, see Mills, "On Disability and Cybernetics." On Sonami and sign language, see Vágnerová, "Video Games and Sign Language in the Work of Laetitia Sonami."

86. I borrow this linguistic connection from Tallis, *The Hand*, 75.

87. Colwyn Trevarthen, Jonathan Delafield-Butt, and Benjamin Schögler, "Psychobiology of Musical Gesture: Innate Rhythm, Harmony and Melody in Movements of Narration," in *New Perspectives on Music and Gesture*, ed. Anthony Gritten and Elaine King (Farnham, UK: Ashgate Publishing, 2011), 17.

88. On pregnancy and publicness, see Rebecca Kukla, "Pregnant Bodies as Public Spaces," in *Motherhood and Space: Configurations of the Maternal through Politics, Home, and the Body* (New York: Palgrave Macmillan, 2005), 283–306. On visibility, see Rosalind Pollack Petchesky, "Fetal Images," *Feminist Studies* 13 (1987). See also Barbara Duden, *Disembodying Women: Perspectives on Pregnancy and the Unborn*, trans. Lee Hoinacki (Cambridge, MA: Harvard University Press, 1993), 81; and Janelle Taylor, "The Public Fetus and the Family Car: From Abortion Politics to a Volvo Advertisement," *Public Culture* 4 (1992).

89. David Keane, "Synthèse 1994: The 1994 Bourges Festival International de Musique Électroacoustique," *Computer Music Journal* 19, no. 1 (Spring 1995): 99. Keane writes, "electronic sounds can be excited with *any* gesture—or no gesture at all. Live controllers exist so that audiences can *see* the sounds being initiated."

90. Rodgers considers how "sounds themselves are reproductive. Reproductive sounds are variously *produced* by bodies, technologies, environments, and their accompanying histories; *reproduced* in multiple reflections off reverberant surfaces or in recording media; *reproducible* within spaces of memory and storage that hold sounds for future playbacks; and *productive*, by generating multiple meanings in various contexts" (Rodgers, "Introduction," in *Pink Noises*, 15, emphasis in original).

91. Giorgio Agamben, "Notes on Gesture," in *Means without End: Notes on Politics*, trans. Vincenzo Binetti and Cesare Casarino (1992; Minneapolis: University of Minnesota Press, 2000), 59.

92. Laetitia Sonami in unpublished document, " 'Scores': Achim Wollscheid, Dietmar Wiesner / Nicolas Collins / Laetitia Sonami."

93. Sonami, "Writings—Goldsmith."

Chapter Six

1. In his reading of Gregory Bateson on the work of Alfred Korzybski, Yuk Hui suggests that "the same pattern in its repetition can produce difference and *sameness as difference*." Yuk Hui, *Recursivity and Contingency* (New York: Rowman & Littlefield International, 2019), 237, emphasis in original.

2. Yasunao Tone, "John Cage and Recording," *Leonardo Music Journal* 13, Groove, Pit, and Wave: Recording, Transmission and Music (2003): 12.

3. See Federico Marulanda's treatment of Tone's work. Federico Marulanda, "From Logogram to Noise," in *Yasunao Tone: Noise Media Language* (Berlin: Errant Bodies, 2017), 79–95.

NOTES TO PAGES 126–127

4. Tone, "John Cage and Recording," 12.

5. Yasunao Tone, "Record, CD, Analog, Digital," in *Audio Culture: Readings in Modern Music* (New York: Bloomsbury, 2004), 344.

6. Tony Myatt's group report a total of twenty-two possible errors returned by the MAD MP3 library, which they used to create a dedicated custom Max/MSP object generally referred to as an *external*. Thom Blake, Mark Fell, Tony Myatt, and Peter Worth, "Yasunao Tone and MP3 Deviation," *International Computer Music Conference Proceedings* (Ann Arbor: University of Michigan Publishing, 2010), 236.

Tone reports twenty-one errors in the liner notes of the 2011 Editions Mego recordings of *MP3 Deviations #6+7* and *MP3 Deviations #8*. The discrepancy may be the result of counting one of the source code's errors listed as "no error" (line 132, "stream.c").

The other error messages capable of being returned by the MAD MP3 library are: input buffer too small (or EOF), invalid (null) buffer pointer, not enough memory, lost synchronization, reserved header layer value, forbidden bitrate value, reserved sample frequency value, reserved emphasis value, CRC check failed, forbidden bit allocation value, bad scalefactor index, bad bitrate/mode combination, bad frame length, bad big_values count, reserved block_type, bad scalefactor selection info, bad main_data_begin pointer, bad audio data length, bad Huffman table select, Huffman data overrun, and incompatible block_type for JS. "stream.c" C code (lines 133–57), in libmad-0.15.1b.tar.gz, *MAD: MPEG Audio Decoder*, available at https://sourceforge.net/projects/mad/files/libmad/0.15.1b/libmad-0.15.1b.tar.gz/download, accessed July 14, 2020.

7. Jonathan Sterne, *MP3: The Meaning of a Format* (Durham, NC: Duke University Press, 2012), 195–96.

8. MP3 frames contain other "nonsonic" information including a copyright protection bit that most decoders, including the MAD library, do not use. Accordingly, Sterne describes MP3 frames as "one of the key nonsonic aspects of the MP3's thingness" (Sterne, *MP3*, 196).

9. Tone quoted in Blake et al., "Yasunao and MP3 Deviation," 236, emphasis removed. Note that Tone distinguishes his use of indeterminacy from Cage's, suggesting a further distance from intentionality: "I am not interested in chance as in the way John Cage thought of it. My attitude to chance is that I don't exclude chance and I don't use chance as a method to achieve something I intend." He adds, "I am not in favour of using the term 'indeterminacy' in the sweeping way that people use it. Cage also distinguished it from 'chance operation.'" ("Yasunao Tone Interviewed by Jared Davis," *Un. Magazine* 2, no. 2 [November 2008]: 13, 14).

10. On Tone's notion of decontrol, see Roc Jiménez de Cisneros, "Blackout Representation, Transformation and De-control in the Sound Work of Yasunao Tone," *Quaderns d'àudio, Radio Web MACBA (RWM)*, Museu d'Art Contemporani de Barcelona, March 29, 2009, emphasis added.

11. Pierre Livet, "La notion de récursivité, de la première cybernétique au connexionnisme," *Intellectica* 39 (2004/2): 125–37. Cited in Hui, *Recursivity and Contingency*, 229. Note that Livet (and Hui) also group Ashby together with second-order cybernetics. Even though Ashby never directly addressed the inclusion of the observer's own position within the domain of science, which was central for von Foerster's notion of second-order cybernetics, his work is not incompatible with it. See Stuart A. Umpleby, "Ross Ashby's General Theory of Adaptive Systems," *International Journal of General Systems* 38, no. 2, The Intellectual Legacy of W. Ross Ashby (2009): 231–38.

12. Umpleby, "Ross Ashby's General Theory of Adaptive Systems," 234.

13. Mikel Olazaran describes neural networks as "computational architectures bearing some resemblance to the brain's nets of neurons." Mikel Olazaran, "A Sociological Study of the Official History of the Perceptrons Controversy," *Social Studies of Science* 26, no. 3 (August 1996): 617.

NOTES TO PAGES 127-129

14. Irving John Good, "Speculations Concerning the First Ultraintelligent Machines," in *Advances in Computers Volume 6*, ed. Franz L. Alt and Morris Rubinoff (Cambridge, UK: Academic Press, 1965), 33.

15. See, for instance, the 2017 essay by Google engineer François Chollet, "The Implausibility of Intelligence Explosion," *Medium*, November 27, 2017, https://medium.com/@francois.chol let/the-impossibility-of-intelligence-explosion-5be4a9eda6ec. Hanson suggests that, apart from brain emulations, human-level AI is possible but may take two to four centuries to realize. Robin Hanson, *The Age of Em: Work, Love and Life When Robots Rule the Earth* (New York: Oxford University Press, 2016), 127.

16. Tone in Alexander Iadarola, "This Piece Doesn't Need Me: Yasunao Tone in Conversation with Alexander Iadarola," *Mousse Magazine* 60 (October–November 2017): 273.

17. The Dartmouth Summer Project's 1956 grant proposal to the Rockefeller Foundation concluded, "We think that a significant advance can be made in one or more of these problems if a carefully selected group of scientists work on it together for a summer." Quoted in Nick Bostrom, *Superintelligence: Paths, Dangers, Strategies* (New York: Oxford University Press, 2014), 5. Two so-called AI winters occurred between 1974 and 1980, due to major DARPA funding cuts, and between 1987 and 1993. Jim Howe, "Artificial Intelligence at Edinburgh University: A Perspective," June 2007, accessed September 23, 2020, http://www.inf.ed.ac.uk/about/AIhistory .html. Stuart J. Russell and Peter Norvig, *Artificial Intelligence: A Modern Approach* (Upper Saddle River, NJ: Prentice Hall, 2003), 24.

18. Tone, personal communication, August 31, 2020.

19. "It was very intriguing to me because between two layers of neurons, when one neuron dies the one next to it substitutes itself for it." Tone in Iadarola, "This Piece Doesn't Need Me," 273.

20. Tony Myatt, personal communication, August 5, 2020; Tone, personal communication, August 31, 2020 and September 16, 2020.

21. Tone in Iadarola, "This Piece Doesn't Need Me," 273.

22. Tone in Iadarola, "This Piece Doesn't Need Me," 273.

23. Hui, *Recursivity and Contingency*, 234. The bibliography of noise and noise music is extensive. Recent contributions include Paul Hegarty, *Annihilating Noise* (New York: Bloomsbury, 2020); Paul Hegarty, *Noise/Music* (New York: Bloomsbury, 2007); Greg Hainge, *Noise Matters: Towards an Ontology of Noise* (New York: Bloomsbury, 2013); John Melillo, *The Poetics of Noise from Dada to Punk* (New York: Bloomsbury, 2020); Stephen Kennedy, *Future Sounds: The Temporality of Noise* (New York: Bloomsbury, 2020). An interesting recent study that focuses on noise in the context of Shannon and Weaver's information theory is Cecile Malaspina, *An Epistemology of Noise* (New York: Bloomsbury, 2019). For a recent study of the Japanese noise music scene, see the work of the ethnomusicologist David Novak. David Novak, *Japanoise: Music at the Edge of Circulation* (Durham, NC: Duke University Press, 2013). Jacques Attali's notorious study connects political economy to music and information theory. Jacques Attali, *Noise: The Political Economy of Music* (Minneapolis: University of Minnesota Press, 1985), information theory on 33.

24. William Marotti makes the case for referring to the collective as "the Music group" over their common rendering as "Group Ongaku," suggesting that the latter exoticizes Japanness through its partial and inconsistent translation. Marotti, "Challenge to Music," in Benjamin Piekut, ed., *Tomorrow Is the Question: New Directions in Experimental Music* (Ann Arbor: University of Michigan Press, 2014), 109. See also William Marotti, "Sounding the Everyday: The Music Group and Yasunao Tone's Early Work," in *Yasunao Tone: Noise Media Language*, 13–33.

25. Tone in Iadarola, "This Piece Doesn't Need Me," 273.

26. Capitalization removed. One year earlier, Tone had composed *Solo for Several Composers* (1963): "Perform simultaneously several composers' works."

27. See "Max Sound Box | Ircam Forum," accessed September 23, 2020, https://forum.ircam.fr/projects/detail/max-sound-box/.

28. Albert Bregman, *Auditory Scene Analysis: The Perceptual Organization of Sound* (1990; Cambridge, MA: MIT Press, 1994), 47–50. For computational applications, see DeLiang Wang, Guy J. Brown, and Guy Story Brown, eds., *Computational Auditory Scene Analysis* (New York: Wiley-IEEE Press, 2006).

29. From the liner notes to the Editions Mego CD and MP3 release of the recorded 2016 Issue Project Room premiere of *AI Deviation*. Yasunao Tone, *AI Deviation #1, #2*, Editions Mego, 2016. Compare Tone's statement to the Issue Project Room press release, which states, "A series of performances using Tone's MP3 Deviation software were captured in a laboratory then used to train Kohonen Neural Networks to develop artificial intelligences that can simulate several of his performance approaches." "Yasunao Tone: *AI Deviation*," *Issue Project Room*, accessed August 30, 2020, https://issueprojectroom.org/video/yasunao-tone-ai-deviation. A similar statement can be found in the announcement for Tone's December 19, 2017 performance of *AI Deviation* at Experimental Intermedia; see "Experimental Intermedia," *Phil Niblock*, November 27, 2017, accessed September 22, 2020, https://phillniblock.com/2017/11/27/experimental-intermedia-december-2017/. Another press release that suggests that Tone and NACM used neural networks is for the artist's October 14, 2017 performance at Chicago's Graham Foundation; see "Yasunao Tone—October 14, 2017 | Lampo," accessed September 22, 2020.

Notably, for Tone's August 3, 2017 performance at Gavin Brown's enterprise in New York, organized by Lawrence Kumpf (who had previously organized the Issue Project Room premiere) and Robert Snowden for Blank Forms, the press release does not contain any mention of neural networks. "Yasunao Tone—Blank Forms," accessed September 22, 2020, https://blankforms.org/events/yasunao-tone/.

30. Tone, personal communication, August 31, 2020.

31. Tone, personal communication, August 31, 2020.

32. Myatt, personal communication, August 5, 2020.

33. Cage in Volker Straebel and Wilm Thoben, "Alvin Lucier's *Music for Solo Performer*: Experimental Music Beyond Sonification," *Organised Sound* 19, Special Issue 1 (April 2014): 17.

34. Tone in Iadarola, "This Piece Doesn't Need Me," 273; Tone, personal communication, August 31, 2020.

35. Myatt, personal communication, August 5, 2020.

36. Myatt, personal communication, August 5, 2020.

37. See, for instance, OpenAI's *Jukebox*, a recent use of neural networks trained on digital audio recordings of popular music. Rather than generating symbolic musical output, these neural networks produce "new" recordings in the style of Elvis Presley, Katy Perry, and Frank Sinatra. "Jukebox," *OpenAI*, April 30, 2020, accessed September 22, 2020, https://openai.com/blog/jukebox/. For a discussion of symbolic versus audio-level algorithmic composition, see Jean-Pierre Briot, Gaëtan Hadjeres, and François-David Pachet, "Representation," in *Deep Learning Techniques for Music Generation* (Cham, Switzerland: Springer, 2020), 19–48.

38. Briot, Hajeres, and Pachet, *Deep Learning Techniques for Music Generation*, 51–52.

39. Lejaren Hiller, Leonard M. Isaacson, *Experimental Music: Composition with an Electronic Computer* (New York: McGraw-Hill, 1959), 82, 83, 93.

NOTES TO PAGES 134–138

40. See also the work of David Cope, a composer whose extensive catalog of algorithmic compositions contains simulations of the music of Mozart, Bach, Brahms, Prokofiev, Bartók, and others. David Cope, *Experiments in Musical Intelligence* (Middleton, WI: A-R Editions, 1996).

41. Tone in Iadarola, "This Piece Doesn't Need Me," 273.

42. Tone published a chronology of Japanese avant-garde art from 1916–1968 in the Japanese art magazine *Bijutsu Techo* 24 (1972).

43. Tone, "Ôtomatizumu to shite," 16, translated in Marotti, "Challenge to Music," 124.

44. This is André Breton's definition of Surrealism, which he expressed in his 1924 *Manifesto of Surrealism*. André Breton, *Manifestoes*, trans. Richard Seaver and Helen R. Lane (1969; Ann Arbor: University of Michigan Press, 1972), 26.

45. Yasunao Tone, "Ôtomatizumu to shite no sokkyôongaku nit suite," *Nijû seiki buyô* 5 (August 20, 1960): 15, translated in Marotti, "Sounding the Everyday," 23.

46. "What phonographs and cinematographs, whose names not coincidentally derive from writing, were able to store was time: time as a mixture of audio frequencies in the acoustic realm and as the movement of single-image sequences in the optical." Friedrich Kittler, *Gramophone, Film, Typewriter* (Stanford, CA: Stanford University Press, 1999), 3.

47. Tone, "Ôtomatizumu to shite," 15, translated in Marotti, "Sounding the Everyday," 24.

48. The recording was published on CD in 1996. Group ONGAKU, *Automatism (ôtomatizumu)*, music of group ONGAKU, Hear Sound Art Library 002, 1996.

49. Breton, *Manifestoes*, 24, emphasis in original.

50. Marotti, "Sounding the Everyday," 27n40.

51. Marotti, "Sounding the Everyday," 27.

52. Marotti, "Challenge to Music," 117.

53. Marotti, "Challenge to Music," 125.

54. Tone, "Ôtomatizumu to shite," 16, translated in Marotti, "Challenge to Music," 124.

55. See Kane, "Pierre Schaeffer, the Sound Object, and the Acousmatic Reduction," in Brian Kane, *Sound Unseen: Acousmatic Sound in Theory and Practice* (New York: Oxford University Press, 2014), 15–41. See also chapter 2.

56. Tone, "Ôtomatizumu to shite," 16, translated in Marotti, "Challenge to Music," 125. Translation slightly modified.

57. Kosugi Takehisa, "Sokkyôteki ongaku sôzô no tame no nôto," 14, translated in Marotti, "Challenge to Music," 122. According to Tone, by this time, Music group members had known of Cage anecdotally, but wouldn't meet him until two years later, in 1962, when Cage visited Japan. Hence the use of "unpredictability" and not "indeterminacy."

58. Details of the event remain unclear, notes Marotti, but Tone vaguely recalls playing recordings of trains. Radio may have also been involved. Marotti, "Sounding the Everyday," 32n56.

59. Marotti, "Sounding the Everyday," 33. Note that Tone has expressed an ambivalence concerning political themes in his work. He even claims in a 2001 interview with Hans Ulrich Obrist, conducted at the Yokohama Triennale, that "Ongaku as a group was never interested in politics per se" (Tone in Hans Ulrich Obrist, "Interview with Yasunao Tone," in *Yasunao Tone—Noise, Media, Language*, 67). On Genpei Akasegawa's *Model 1,000-Yen Note Incident*, see Reiko Tomii, "State v. (Anti-)Art: *Model 1,000-Yen Note Incident* by Akasegawa Genpei and Company," *positions: east asia cultures critique* 10, no. 1 (Spring 2002): 141–72.

60. See Allan Kaprow, *Essays on the Blurring of Art and Life*, ed. Jeff Kelley (Berkeley: University of California Press, 1993). Tone collaborated with Kaprow in a performance of *Cleaning Event* by Hi-Red Center at CalArts in 1972.

61. Tone in "Yasunao Tone Interviewed by Jared Davis," *Un. Magazine* 2, no. 2 (November 2008): 14. Wolfe has considered extensive linkages, and disparities, between Derrida and second-order cybernetics and systems theory. For instance, "Derrida and Luhmann approach many of the same questions and articulate many of the same formal dynamics of meaning (as self-reference, iterability, recursivity, and so on), but they do so from diametrically opposed directions." He continues, "the starting point for systems theory is the question of what makes order possible and how highly organized complexity, which is highly improbable, comes into being at all. Deconstruction, on the other hand, begins with the taken-for-granted intransigent structures of logocentrism and the metaphysics of presence that are already ensconced in textual and institutional form, and then asks how the subversion of those structures by their own elements can be revealed." Cary Wolfe, *What Is Posthumanism?* (Minneapolis: University of Minnesota Press, 2010), 13–14; see also xxvi.

62. Gregory Bateson, *Steps to an Ecology of Mind: Collected Essays in Anthropology, Psychiatry, Evolution, and Epistemology* (1972; Chicago: University of Chicago Press, 2000), 462.

63. Marotti, "Sounding the Everyday," 29–30. Recently, Tone has suggested that the tape may have contained a recording of his 1961 *Anagram for Strings*. Tone, personal communication, October 4, 2020. One could compare Tone's *Têpu rekôdâ* to Man Ray's Surrealist-inspired *L'énigme d'Isidore Ducasse* (The Enigma of Isidore Ducasse) (1920), which consists of a sewing machine wrapped in an army blanket tied up with a string. Not unlike Tone's tape, Ray's original object was lost, as were similar sculptural objects of his that he photographed, yet he recreated this work in 1972.

64. See de Cisneros, "Blackout Representation," 7. Tone has also referred to this work as *Days*. Yasunao Tone in Miki Kaneda and Yasunao Tone, "Sound Is Merely a Result: Interview with Tone Yasunao, 2," *MoMA Post*, accessed June 15, 2020, https://post.at.moma.org/content _items/476-sound-is-merely-a-result-interview-with-tone-yasunao-2.

65. Tone in Kaneda and Tone, "Sound Is Merely a Result."

66. Tone in Kaneda and Tone, "Sound Is Merely a Result." Michel Serres, *Parasite*, trans. Lawrence R. Schehr (Baltimore, MD: Johns Hopkins University Press, 1982).

67. Wiener states, "Messages are themselves a form of pattern and organization. Indeed, it is possible to treat sets of messages as having an entropy like sets of states of the external world. Just as entropy is a measure of disorganization, the information carried by a set of messages is a measure of organization. In fact, it is possible to interpret the information carried by a message as essentially the negative of its entropy, and the negative I logarithm of its probability. That is, the more probable the message, the less information it gives. Cliches, for example, are less illuminating than great poems." Norbert Wiener, *The Human Use of Human Beings* (1950; London: Free Association Books, 1989), 21.

68. Claude Shannon, "A Mathematical Theory of Communication," *Bell System Technical Journal* 27 (1948).

69. Hui, *Recursivity and Contingency*, 234.

70. Renato Poggioli, *The Theory of the Avant-garde*, trans. Gerald Fitzgerald (Cambridge, MA: Belknap Press of Harvard University Press, 1981), 160. On shock in Benjamin and Brecht, see Mara Polgovsky Ezcurra, "On 'Shock': The Artistic Imagination of Benjamin and Brecht," *Contemporary Aesthetics* 10 (2012), https://contempaesthetics.org/newvolume/pages/article.php ?articleID=659.

71. This is Michael Shaw's translation of Peter Bürger's citation of a passage from Adorno's *Ästhetische Theorie* (39): Peter Bürger, *Theory of the Avant-garde*, trans. Michael Shaw

NOTES TO PAGES 140–146

(Minneapolis: University of Minnesota Press, 1984), 61. Robert Hullot-Kentor translates the passage differently—"Art is modern art through mimesis of the hardened and alienated"—versus Shaw's "Modernism is art through mimetic adaptation to what is hardened and alienated. . . ." Theodor W. Adorno, *Aesthetic Theory*, trans. Robert Hullot-Kentor (New York: Continuum, 1997), 21.

Note that, for Bürger, Adorno doesn't go far enough in capturing the avant-garde's radical break with tradition, which includes, paradigmatically, a break with and critique of institutions up to and including art itself (*Theory of the Avant-garde*, 61).

72. Reinhart Koselleck, *Futures Past: On the Semantics of Historical Time*, trans. Keith Tribe (New York: Columbia University Press, 2004), 224–25.

73. See Obrist, "Interview with Yasunao Tone."

74. Peter Osborne, *The Postconceptual Condition: Critical Essays* (New York: Verso, 2018), 24.

75. Osborne, *The Postconceptual Condition*, 28.

76. Allan Sekula, "Notes for an Exhibition Project" (for Witte de With, Rotterdam), 1992, unpublished manuscript (Xerox), 1, cited in "Allan Sekula / Matrix 162," *University of California, Berkeley Art Museum • Pacific Film Archive*, accessed September 18, 2020, http://archive.bampfa .berkeley.edu/exhibition/162.

77. According to Tone, he received verbal permission from the other artists included in the exhibition space except for the Dutch artist duo Jeroen de Rijke and Willem de Rooij. As a result, *Parasite/Noise* did not involve their section of the venue.

78. Wolfe, *What Is Posthumanism?*, xv.

79. Osborne, *The Postconceptual Condition*, 24.

80. David Graeber, "Of Flying Cars and the Declining Rate of Profit," *The Baffler*, no. 19 (March 2012), https://thebaffler.com/salvos/of-flying-cars-and-the-declining-rate-of-profit. From a political perspective that ostensibly departs from Graeber's left-anarchism, the libertarian entrepreneur Peter Thiel contended around the same time, "We wanted flying cars, instead we got 140 characters," referring to Twitter's tweet length limitation at the time. Graeber and Thiel discussed flying cars and more during a 2014 debate held in a New York City library. See Jennifer Schuessler, "Still No Flying Cars? Debating Technology's Future," *New York Times*, September 22, 2014, C3.

81. Cf. Thomas Moynihan's contention about the relationship between pandemics and global population flows: "pandemics—even if naturally occurring—are in some ways always anthropogenic." Thomas Moynihan, *X-risk: How Humanity Discovered Its Own Extinction* (Windsor Quarry, UK: Urbanomic Media, 2020), 295, EPUB.

82. Tone, "Ôtomatizumu to shite"; Tone in "Sound is Merely a Result"; Tone, personal communication, August 31, 2020.

83. Chollet, "The Implausibility of Intelligence Explosion."

Conclusion

1. See Steve J. Heims, *John von Neumann and Norbert Wiener: From Mathematics to the Technologies of Life and Death* (Cambridge, MA: MIT Press, 1980), 208–15.

2. Herbert Brün, "Wayfaring Sounds," in *When Music Resists Meaning: The Major Writings of Herbert Brün*, ed. Arun Chandra (Middletown, CT: Wesleyan University Press, 2004), 126.

3. Andreas Huyssen, *Twilight Memories: Marking Time in a Culture of Amnesia* (New York: Routledge, 1995), 204–5.

4. Robert Serber, *The Los Alamos Primer: The First Lectures on How to Build an Atomic Bomb* (Berkeley: University of California Press, 1992), 439n20, EPUB; cited in Moynihan, *X-risk*, 320.

5. John Cage, "Diary: How to Improve the World (You Will Only Make Matters Worse) (1965)," in *A Year from Monday: New Lectures and Writings* (Middletown, CT: Wesleyan University Press, 1967), 160.

6. Moynihan, *X-risk*, 316, 43–44, 38, 5.

7. Norbert Wiener, *Cybernetics; or, Control and Communication in the Animal and the Machine* (1948; Cambridge, MA: MIT Press, 2019), 214. Cited in Moynihan, *X-risk*, 352.

8. John Cage, "Experimental Music" (1957), in *Silence: Lectures and Writings* (Middletown, CT: Wesleyan University Press, 1961), 8.

9. That the two cyberneticians disagreed as to whether such post-entropic remains contain more or less information is beside the point. See N. Katherine Hayles, *How We Became Posthuman: Virtual Bodies in Cybernetics, Literature, and Informatics* (Chicago: University of Chicago Press, 1999), 102–3.

10. Other technologies, like cryogenic preservation, while offering potential use cases such as long-duration space travel, similarly appeal to a base interest in suspending or overcoming death. See the French composer François J. Bonnet's essay on this topic. François J. Bonnet, *After Death*, trans. Amy Ireland (Windsor Quarry, UK: Urbanomic, 2020).

11. Lee Edelman, *No Future: Queer Theory and the Death Drive* (Durham, NC: Duke University Press, 2004). See, especially, Edelman's critique of Jean Baudrillard's "biotechnological" modes of reproduction (64).

12. Cage, "Experimental Music" (1957), 10. See also Douglas Kahn, "John Cage: Silence and Silencing," *The Musical Quarterly* 81, no. 4 (Winter 1997): 582.

13. Michael Schell, "Unlikely Persona: Jerry Hunt (1943–1993)," *MusicWorks* 65 (Summer 1996), available at http://www.jerryhunt.org/huntmus.htm.

14. According to Hunt's partner, Stephen Housewright, "he never really needed to 'come out.' He was cast as an eccentric early on, and it was a role enjoyed and cultivated throughout his life." Stephen Housewright, "Part One: Lovers," in *Partners*, n.d., 2, available at http://www.jerry hunt.org/partners.htm. Republished as Stephen Housewright, *Partners: A Biography of Jerry Hunt* (Brooklyn, NY: Blank Forms, 2022).

15. A transcript of the video can be found at http://www.jerryhunt.org/kill.htm. The web page contains the following disclaimer: "This file is provided only for informational purposes. The Webmaster and other individuals affiliated with Jerry's estate and archives do not necessarily endorse the views Jerry expresses herein, and will not accept responsibility whatsoever for anyone who acts on this information, nor will they provide any assistance in response to inquiries. If you find this subject matter offensive, please close this page now. By proceeding, you agree not to bring complaints or objections to any person, company or organization affiliated with this Web site or its Internet host." It should go without saying that this book does not promote or endorse suicide in any way whatsoever.

16. Nicholas Jackson, "Jack Kevorkian's Death Van and the Tech of Assisted Suicide," *The Atlantic*, June 3, 2011, https://www.theatlantic.com/technology/archive/2011/06/jack-kevorkians -death-van-and-the-tech-of-assisted-suicide/239897/.

17. Hunt quoted in Stephen Housewright, "Part Three: Partners," in *Partners*, n.d.,19, available at http://www.jerryhunt.org/partners.htm.

18. Art history has produced studies of the non- or para-artistic activities of artists, which have yet to receive an exact correlate in music studies. See, for instance, Elena Filipovic, *The Apparently Marginal Activities of Marcel Duchamp* (Cambridge, MA: MIT Press, 2016).

NOTES TO PAGES 150–153

19. "The posthuman body is a technology, a screen, a projected image; it is a body under the sign of AIDS, a contaminated body, a deadly body, a techno-body; it is, as we shall see, a queer body." Jack Halberstam and Ira Livingston, eds., "Introduction," in *Posthuman Bodies* (Bloomington: Indiana University Press, 1995), 3.

20. Housewright, "Partners," 19.

21. Cage quoted in Caroline A. Jones, "Finishing School: John Cage and the Abstract Expressionist Ego," *Critical Inquiry* 19, no. 4 (Summer 1993): 665.

22. Cage quoted in Jones, "Finishing School," 665.

23. Jones, "Finishing School"; Philip M. Gentry, "The Cultural Politics of 4′33″: Identity and Sexuality," *Tacet Experimental Music Review* no. 1, Who Is John Cage? (2011); Jonathan Katz, "John Cage's Queer Silence; or, How to Avoid Making Matters Worse," *GLQ: A Journal of Lesbian and Gay Studies* 5, no. 2 (1999). See also G Douglas Barrett, "The Limits of Performing Cage: Ultra-red's SILENT|LISTEN," *Postmodern Culture* 23, no. 2 (2014).

24. See the project website at https://www.aslsp.org/de/.

25. Catherine Hickley, "A 639-Year Concert, With No Intermission for Coronavirus," *New York Times*, September 7, 2020, https://www.nytimes.com/2020/09/07/arts/music/john-cage-as -slow-as-possible-germany.html.

26. Gilbert Simondon, *On the Mode of Existence of Technical Objects*, trans. Cecile Malaspina and John Rogove (Minneapolis, MN: Univocal, 2017), 21.

27. Wolfgang Ernst suggests that Cage's *Organ²/ASLSP (As SLow aS Possible)* addresses the "machinic non-sense of time." Wolfgang Ernst, "As Slow as Possible? On the Machinic (Non-) Sense of the Sonic Present and Digital Indifference toward Time," *ASAP Journal* 4, no. 4, Special Issue: "As Slowly as Possible" (September 2019): 676.

28. Ray Brassier, *Nihil Unbound: Enlightenment and Extinction* (New York: Palgrave Macmillan, 2007), 239.

29. Ernst offers a similar wordplay in his analysis of the Halberstadt realization of Cage's *Organ²/ASLSP (As SLow aS Possible)*. "The lifespan of a single organist, by extending the rehearsal to 639 years, by necessity is replaced by the expected lifespan of an organ as technical *organon*." Wolfgang Ernst, "As Slow as Possible?," 676, emphasis in original.

Index

Abe, Shuya, 58, 69
absolute music, 15
abstract expressionism, 10
Acconci, Vito, 150
acousmatics, 38, 44, 46–49, 54, 56, 138, 146, 173n2, 176n35, 177n46
Active SETI, 78
ACT UP (AIDS Coalition To Unleash Power), 151
Adorno, Theodor, 9, 140, 202–3n71
aesthetic modernism, 15–17, 114, 122, 141, 165n80
affective labor, 30–31
Afrofuturism, 40, 43, 174n12
Agamben, Giorgio, 122
agency, 10, 13–14, 62, 89, 96, 122, 134; contemporary posthuman, 143–44, 146–47; and cybernetics, 107; human and nonhuman forms of, 146; and indeterminacy, 8; and intention, 133; negation of, 12
AI. *See* artificial intelligence (AI)
AI Deviation (Tone), 124, 135, 140–44; artificial listener, 129–31; artistic decentering, 130; expert system, use of, 128, 132–33; indeterminacy, as distributed agency, 132; neural networks, use of, 131–32; as recursive, 134; virtual Tones, 129–31
AIDS Coalition To Unleash Power (ACT UP), 151
Akasegawa, Genpei, 138
algorithm (computer science), 118–19
algorithmic music, 7–8, 11, 14, 102–3, 119, 122, 129, 133–35, 200n37, 201n40
Alien Bog (Oliveros), 79
Allende, Salvador, 13
Alquati, Romano, 25, 31
Althusser, Louis, 5
American Federation of Musicians, 80
American Psychological Association (APA), 9

Amsterdam, 103
Anagram for Strings (Tone), 202n63
Anderson, Laurie, 48
Anderson, Marian, 49
André, Naomi, 49–50
animal musicality, 19, 52
animal studies, 19, 166n97
Anthropocene, 147
anthropogenic action, 147
Anthropology from a Pragmatic Point of View (Kant), 88–89
antihumanism, 5, 12, 39, 160n16, 177–78n51
APA (American Psychological Association), 9
Apollo 11, 78, 83; "great man" treatment, 89
Apollo missions, 89, 94
Apple, Siri, 54
Aragon, Louis, 136
Arecibo Observatory, 77, 81, 88
Arendt, Hannah, 13–14, 171n66; anthropogenic action, 142–43
Armstrong, Neil, "giant leap" statement, 89, 189n60
Ars Electronica festival, 101, 104
artificial intelligence (AI), 1, 5–6, 10, 13–14, 23, 34, 37, 54, 56, 65, 70–71, 92, 117, 124, 142, 145–46, 148; AI winters, 128, 199n17; algorithmic music, 129, 133–34; and algorithms, 135; automation, form of, 130; brain-wave analysis, 22; and capitalism, 25–26, 36; error and failure, proclivity to, 128; extraterrestrial life, 79; recording technology, 129; and recursion in, 20, 127–28
artistic modernism, 15; formalism, 141; medium-specificity, 75, 141
artistic postmodernism, 16
Ashby, Ross, 95–96, 170n48, 172n74, 198n11
Ashley, Robert, 103

208 INDEX

Astronomers Without Borders, 81, 88
Atanasoski, Neda, 183n53
atom bomb, 146; and computers, 10, 163n53
Austin, J. L., 78
automata, 13, 71, 73, 181n17, 182n30
automaticity, 21, 33, 36–37
automation, 23, 64, 68, 104–5, 123; AI, 130; bio-
 morphism in, 182n30; and cybernetics, 67; and
 robotics, 69, 75–76; slavery, comparison to, 43
automatism, 135–36
Automatism No. 1 (Music group), 135. *See also*
 Tone, Yasunao
autonomy, central to liberal humanism, 23
autopoiesis, 23, 42, 134
avant-garde (artistic), 10, 18, 114, 125, 129, 134–40;
 collectives, 125, 129, 136–38, 143; European, 7,
 14–15, 162n36, 166n101; historical, 114; Japanese,
 201n42; neo-avant-garde movement, 18; non-
 Western and nonmusical, 134; postwar, 141
avant-garde (musical). *See* modern music
avant-garde theory, 139–40

Babbage, Charles, Difference Engine, 119
Bach, Johann Sebastian, 61–62
Bacon, Francis, 163n57
Badmington, Neil, 86, 88, 188n44
Baldessari, John, 150
Balsamo, Anne, 116
Barrett, Lindon, 43, 45, 92; distinction between
 signing voice and singing voice, 44
Bates, David, 73
Bateson, Gregory, 138–39, 197n1
Baugh, John, 40, 46, 48
Beaune, Jean-Claude, 182n30
Bebey, Francis, 176n29
Bečvář, Antonín, 190n82
Bedingfield, Stephen, 88–89
Beethoven, Ludwig van, 103, 134, 179n68
Behrman, David, 103
Bell Laboratories, 72; computer music, 102, 118
Benjamin, Walter, 142–43; *Pasagenwerk* (*The
 Arcades Project*), 140
Bergson, Henri, 35
Berio, Luciano, *Gesti* (Gestures), 122
Beuys, Joseph, *How to Explain Pictures to a Dead
 Hare*, 150
Bhardwaj, Saurabh, 90
Biennale of Contemporary African Art (Dak'Art),
 43
biofeedback, 18, 23–24, 27–28, 39, 42, 83, 150,
 167n8, 186n8
Bitom [fixture]: topogram (Hunt), 150
blackface, 49
Black feminist thought, 42–43; and posthuman-
 ism, 19, 41
Black opera, shadow culture, 49–50

Black popular music, cell phone references, 55
Black posthumanism, 43–45, 55
Black studies, 40–41
Black subjectivity, 44
Black voice, 39, 41; African American culture, as
 unique form of value within, 43; as "distur-
 bance," 45; double bind, 46; and housing
 discrimination, 45; in opera, 56; as overdeter-
 mined and undervalued, 46; signing voice and
 singing voice, distinction between, 44
Blue Brain Project, 34
Blue Marble, The (photograph), 94
bodily materiality, 24
body art, 39
Bongers, Bert, 119–20, 192n12, 197n83
Bonilla-Silva, Eduardo, 177n48
Born, Georgina, 6–9, 14–16; "supraformalist," use
 of, 15
Bosshard, Andres, 81, 91, 94; spatialization
 process, 95
Bostrom, Nick, 169n31, 195n56
Boulez, Pierre, 7, 162n37
brain emulation technology, 26–27, 36, 65, 148
BRAIN Initiative, 26
Brandeis University, 33; Rose Art Museum, 29
Brassier, Ray, 152–53
Breakthrough Listen, 97
Brecht, Bertolt, distancing effect, 90–91
Brecht, George: *Entrance Music/Exit Music*, 60;
 Piano Piece No. 1, 17–18
Bregman, Albert, 131
Breton, André, 201n44; *Manifesto of Surrealism*,
 135–36
*Bride Stripped Bare by Her Bachelors, Even (The
 Large Glass), The* (Duchamp), 62
Brooks, Rodney, 70, 76, 182n29
Brooks, William, 163n57
Brown, Earle, 7
Bruguera, Tania, 114, 195n61
Brün, Herbert, 11, 101, 146, 163–64n61
Buchla, Don, 192n6
Bürger, Peter, 202–3n71
burlesque, 61
Burnham, Jack, 62, 181n9
Burton, Justin Adams, 19, 176n32
Buxton, William, 192n6

C (programming language), 7, 106–7
Caffentzis, George, 66
Cage, John, 11, 15–16, 20, 27–28, 34, 76, 96, 102–3,
 126, 132, 163n57, 171n66, 180n7, 201n57; AIDS,
 silent response to, 148, 151; anarchism, align-
 ment with, 9; as apolitical, 9; avoidance of
 social, 145; chance operations, 7, 10, 21, 198n9;
 death, as extreme form of indeterminacy, 148,
 162n37; "Diary: How to Improve the World

INDEX

(You Will Only Make Matters Worse)," 10; experimentalism of, 7, 17, 96–97; *4'33"*, 8–10, 17–18, 103; Harvard anechoic chamber, 9, 93, 148; indeterminacy of, 7–10, 21–22, 33, 36, 93, 135, 146, 151, 198n9; libidinal, 33; *Music of Changes*, 8; *Organ2/ASLSP (As SLow aS Possible)*, 148, 151–53, 205n27, 205n29; "people and things," conflict between, 10, 14, 147; psychoanalysis, dissatisfaction with, 9, 33; queer resistance, 9, 33; on serialism, 17; silence of, 152, 163n49; *Sixty-Two Mesostics Re Merce Cunningham*, 45; *Song Books*, 9; *Variations VII*, 167n8; *Williams Mix*, 8; *0'00" (4'33" No. 2)*, 9, 17–18, 29

Cambridge Centre for the Study of Existential Risk, 26

Camerata, 50

Čapek, Karel, 63, 69; *Rossum's Universal Robots (R.U.R.)*, 62, 75

capitalism, 31, 66, 115; AI, 25–26, 36; capitalist subjectivity, 37; cognitive labor, 29–30; experimental music, 27; experimental nature of, 27; future, forecasting of, 27; global, 12–13, 22; knowledge production, 32–33; labor relations of, 24; recursive search for novelty, 140; and time, 25. *See also* market capitalism

Cardew, Cornelius, 7, 16, 162n36

Carnahan, Melody Sumner, 99, 120, 122

Cassiopeia, 87

Catalani, Alfredo, *La Wally*, 52–53

Cátedra Arte de Conducta (Bruguera), 114

Cecchetto, David, 19

Chadabé, Joel, 103

Chafe, Chris, 192n6

chatbots, 25, 87, 182n30

Chiba University, 134–35

Chieko, Shiomi, 18, 135

Chollet, François, 144

Chua, Daniel K. L., 167n102

Cinq études de bruits (Five Noise Studies; Schaeffer), 137

Ćirković, Milan M., 83–84

civil rights, 39

Clapping Music (Reich), 113

Clarke, Bruce, 3, 51, 176–77n39

climate change, 148, 152

cognitive labor, 2, 23, 25, 28, 32, 36–37, 67; capitalism, 29–30; conceptual groundwork for, 30–31; and cybernetics, 31; and neurofeedback, 19; post-Fordist notions of, 22

Cold War, 9–10, 13, 28, 60, 89, 101, 146, 151

colonialism, 84–85, 188n39

color line, 46; veil, as analog to, 47

communicative capital, 31

computational economics, 13

computational neuroscience, 27

computer art, 128

computer music, 101, 112, 117, 135; and digitality, 102; embodiment in, 123; expressive gesturality, 122; Pulse Code Modulation (PCM), 102. *See also* Max (Max/MSP, programming language); MUSIC (programming language)

computers, 10–13, 24, 27, 39–40, 53, 72, 79, 83, 92, 99, 117–18, 123, 125–26, 132, 134; as women, 105, 116, 119

computer science, 27; recursion, 124

conceptual art, 17–18, 32

conceptual music, 32, 165n88

Confucius, 125

Confused Rain (Paik), 72

conspiracy theories, 82

contemporary art, 14, 17, 32, 129, 140, 143; contemporary art theory, 19, 165n88, 167n102; musical contemporary art, 165n88; as postconceptual, 141, 165n88; as postformalist, 16, 141, 165n88; social practice art, 114

contemporary posthuman, 2, 4, 12, 20, 22, 37, 42, 50–51, 56, 71, 89, 106, 124, 141–42, 145, 147, 153; agency, 143–44, 146; experimentalism, 18; experimental music, 19; extinction, of human species, 146; extraterrestrial intelligence, 77; newness, possibility of, 140; nonhuman death, 109–10; novelty and human invention, 129; production of the new, 129; temporality and sequence, function of, 13–14

Copernican revolution, 85

Copernicus, 85

Cornago, Noé, 48

"corpaurality," notion of, 176n38

cryogenic preservation, 204n10

Culver, Andrew, 7

cybernetics, 2–3, 5, 10–12, 25, 34–35, 37, 52, 61, 64, 66, 68, 79, 92, 101, 127, 139, 141, 164n76, 168n17; and agency, 107; and automation, 67; cognitive labor, 31; control and communication, 107, 127; and digitality, 102; experimental music, shaped by, 4, 14, 18; financial system, 13; first order, 127; homeostasis, 23; indeterminacy, 103; information theory, 33; liberal humanism, 23; medical, 146; military, ties to, 146; phases of, 23, 32–33; post-Fordism, 32; posthuman brain, 21, 24, 27; posthuman imaginary, 100; and posthumanism, 14, 19, 145; and psychoanalysis, 67; receptive sense modeling, 70; reflexivity, 23; and robotics, 76; second stage, 127, 198n11, 202n61; as term, 109; third stage, 127; underdelivery of, 142; virtuality, 23, 63

Cybernetics (Wiener), 107–8

cyberspace, 111

cyborg, 2, 40, 159n6, 174n10

Dada, 10

Dak'Art (Biennale of Contemporary African Art), 43

210 INDEX

Damasio, Antonio, notion of proto-self, 170–71n51

Davis, Joe, 87

Dean, Jodi, 31

decolonization, 48

deconstruction, 202n61

Deep Listening Pieces (Oliveros), 81

Deleuze, Gilles: control societies, 13; smooth and striated space, 3, 116, 196n68

DeMarinis, Paul, 107–10, 140, 194n46; *Mechanization Takes Command: Verses from Giedion's Bible* (with Sonami), 104–6, 112, 114, 118, 123, 194n46; Power Glove, 106, 111

Dempster, Stuart, 81

de Paulis, Daniela, 81, 87–90

Derrida, Jacques, 177–78n51; second-order cybernetics and systems theory, 202n61

Descartes, René, 4, 41, 76; automata, as early theorist of, 73; automaton, human body as, 73; Cartesian dualism, 112; human body, as mechanical, 73; human soul, 66; mind-body split, 73

Descartes in Easter Island (Paik), 73

deskilling, 67, 72, 183n44

Dewan, Edmond M., 22, 33–34, 172n74

DeWitt, John, Project Diana, 86

Deym, Franz, 72

"Diary: How to Improve the World (You Will Only Make Matters Worse)" (Cage), 10

digital audio, 4, 17–18, 102, 118, 126, 146, 192–93n17, 200n37. *See also* Pulse Code Modulation (PCM)

Digital Experiment at Bell Labs (Paik), 72

digitality, 20, 105, 112–13, 117; ability to distinguish, 116; carving up, 111; and cybernetics, 102; and hand, 119, 123; and posthuman, 12; posthuman hand, 104

"DIRECT-CONTACT-ART" (Paik), 167n8

Dolar, Mladen, 53

Douglass, Frederick, 41–42, 160n15

Drake, Frank, 81–83, 88

drone music, 122

Druyan, Ann, 87

Du Bois, W. E. B., 49, 177n48; Black music, championing of, 47; color line, 46–47; double consciousness, 46–47; *The Souls of Black Folk*, 46–47; spirituals, transcriptions of, 47; veil, 46–47

Duchamp, Marcel, 111, 204n18; *Bride Stripped Bare by Her Bachelors, Even (The Large Glass)*, 62

Duffy, Mignon, 115, 195n62

Dwingeloo Radio Observatory, 81, 87–89

Dyer-Witheford, Nick, 32

Dyson, Frances, 177–78n51

Earth-Moon-Earth (EME) communications, 77–78, 86, 90, 95–96. *See also* moonbounce

Earthrise (photograph), 94

Eastman, Julius, 9

Eaton, Manford L., 28, 167n8

Echoes from the Moon (Oliveros), 20, 77, 79, 85–87, 97; Apollo 11 moon landing, inspiration for, 78, 89; black box theory, 96, 98; collaborative realization of, 94–95; Deep Listening, 80–83, 94, 97, 146, 186–87n21; distance performance, 93; EME system, 95–96; improvisation, use of, 91; indeterminacy, use of, 96; moonbounce speech, 88–90, 96; networked performance of, 88; speech acts, 90

Edelman, Lee, reproductive futurism, 148

Edison, Thomas, 78, 186n6

EDVAC (computer), 10–11

Eidsheim, Nina Sun, 49

Electronic Opera #1 (Paik), 185n86

Electronic Superhighway (Paik), 75

Ellis, Christin, 160n15

Engels, Friedrich, 115, 119

ENIAC (computer), 10–11

Enlightenment, 4, 5, 12, 20, 44–45, 50, 70, 73, 76, 82, 89, 92, 145; musical automaton, 63

Entrance Music/Exit Music (G. Brecht), 60

entropy, 139, 148, 202n67

Epsilon Eridani, 87

Ergodos I (for John Cage) (Tenney), 8, 102

Ericson, Raymon, 180n3

Ernst, Wolfgang, 205n27, 205n29

Eshun, Kodwo, 43, 173n3

Essl, Georg, 192n4

Étude aux chemins de fer (Railroad Study; Schaeffer), 137

Etude 1 (Paik), 72

Europe, 50, 69–71

European Union (EU): Blue Brain Project, 26–27; Human Brain Project, 26–27

euthanasia, 149

exoplanets, 77, 82

Experimental Intermedia Foundation, 126

experimental music, 1, 41, 58, 61, 103, 112, 123, 125–26, 133, 147, 151; automaticity, 37; and capitalism, 27; Cold War technoscience, incorporation of, 28; computer music, 102, 122; contemporary posthuman, 18–19; and cybernetics, 4, 14, 18, 32; death and extinction, 146; decentering of sound, 18; EEG, turn to, 28; and extinction, 152; and indeterminacy, 7–8, 22, 32–33, 37, 122; as interdisciplinary, 6, 14, 17–18, 32, 139; musical postmodernism, exemplifying of, 15; neuromusical turn, 167n8; new music, distinction between, 15; noncontrol, 8; and opera, 54; as postformalist, 16–18, 32, 145; and posthuman, 3, 7, 12, 14; posthuman automata, link to, 76; posthumanism, 6; postwar art, 17–18; and social, 11, 16; as transdisciplinary, 2–4; virtuality and digital, 104

INDEX

"Experimental Music" (Cage), 17
Experimental Music (Hiller and Isaacson), 11
extinction, 147–48, 151, 153; and experimental music, 146, 152
extra-artistic, 16, 18, 122, 141, 143
extra-musical, 16, 56, 98, 121–22, 195n61
extrasolar planets. *See* exoplanets
extraterrestrial intelligence, 89, 147; alien, figure of, 81–82; city-state model, 83–84; colonization, 83–84; contemporary posthuman, 77; extraplanetary radio transmissions, 87; "Great Silence," 83; human, historical category of, 81; overview effect, 88, 90–91; spatial distance, 92; "where is everybody?," 88; "who is everybody?," 88, 94, 98
Extropy Institute, 169n31

Family of Robot series (Paik), 65
Fanuc, 69; as automated factory, 68
Fast-Fourier Transform, 130
Federici, Silvia, 31, 109
feedback, 28, 32, 49, 63, 65, 68, 79, 85, 91, 95, 97, 127, 139; loops, 6, 23, 42; and post-Fordism, 23
Fell, Mark, 128
feminism, 39, 80, 121; Marxist, 109, 115
feminized labor, 116
Fermi, Enrico, 90; "Great Filter," Hanson's response to, 84; "where is everybody?," as Fermi's paradox, 82–84
Fiebrink, Rebecca, 117
Finnell, Carrie, 61
First Accident of the Twenty-first Century (Paik), 66, 73, 75
Floyd, George, 3, 152
Fluxus, 18, 61, 125, 134
fMRI scanning, 30
food studies, 39–40
Fordism, 108
Fortunati, Leopoldina, 30–31, 109
Foucault, Michel, 5, 33, 36, 177–78n51; power regimes, 13
4'33" (Cage), 9, 17–18, 29
Franklin, Seb, 164n76, 168n17
free will, 12, 23, 164n66, 168n13
Freud, Sigmund, 8; death drive, 67, 152–53; uncanny, notion of, 67, 183n40
Fuller, Buckminster, 10
functionalism (philosophy), 172–73n83
Fux, Johann Joseph, 11, 134

Galbreth, Michael, 150–51
Galileo, 85
Galloway, Alexander R., 116
gay and lesbian movements, 39
Gentry, Philip, 10
Gesamtkunstwerk, 49

gestation, 120, 123; carriage, notion of, 121; and gesture, 105, 121
gesture, 119–20, 123, 197n89; avant-garde, and expressivity, 122; carriage, notion of, 121; labor of care, 122; as metalinguistic, 122; as paralinguistic, 122; visibility, accent on, 121
Giedion, Sigfried, 108–9, 111, 123, 140, 193–94n32, 194n44; meat, as motif, 110; *Mechanization Takes Command: A Contribution to Anonymous History*, 19, 104–6; servantless household, 112
Gilchrist, Bruce, *Thought Conductor #2*, 6, 161n25
global capitalism. *See* capitalism
globalization, 164n70
Godwin, Frances, *Man in the Moon*, 86–87
Goehr, Lydia, 49, 163n57
Golumbia, David, 36, 53, 172–73n83, 196n68
Good, Irving John: critique of, 144; last invention, 127, 142; ultraintelligent machine, as last invention, 127
Gordon, Ted, 79, 166n101
Graeber, David, 142, 203n80
Greenfield, Elizabeth Taylor, 49
Gresham-Lancaster, Scot, 81, 88, 94
Guem, 81, 94–95

Halberstam, Jack, 39, 150, 179n74, 205n19
Halpern, Orit, 166n101
ham radio, 77
hand, 99, 103, 105, 108–11, 117; abstraction and physicality, 100; dexterity, 115; as digital instrument of care, 101; and digitality, 102, 112–13, 119, 123; expression, facilitating of, 119; gesturing, 119; invisible hand, 116; as mechanism, 106; mechanization, touchstone for, 112; numericity and corporeality, ties to, 100; political economy, 116; as symbol of work, 115; as tactile, 101; virtuality and embodiment, interface between, 100
Hanhardt, John G., 73
Hansen, Mark B. N., 167n102
Hanson, Robin, 27, 35, 169n32, 199n15; brain emulations (ems), 26, 36; "Great Filter," 84
Haraway, Donna, 2, 52, 159n6, 166n97, 169n38, 174n10
Harren, Natilee, 19
Haskin, Byron, 188n44
Hawking, Stephen, 26, 147
Haworth, Michael, 161n24
Hayles, N. Katherine, 7, 13, 23–25, 27, 41, 43, 168n17, 196n79; embodied virtuality, 39, 173n4; Macy Cybernetics conferences, 71; periodization of cybernetics, 63, 127
Heidegger, Martin, 108, 126
Herzogenrath, Wulf, 75

Higgins, Dick: as Fluxus member, 18; intermedia, notion of, 18, 63
Higgins, Hannah, 19
Hight, Christopher, 109, 166n101
Hiller, Lejaren, 7, 11, 134, 163n57
Hinkle-Turner, Elizabeth, 191–92n3
Hi-Red Center group, 134, 138; *Cleaning Event* (Kaprow and Tone), 195n61, 201n60
historicity, and plasticity, 35
Hitler, Adolf, 78
HIV/AIDS, 39, 148, 150–51
Hobbes, Thomas, 24, 44
Hoggett, Reuben, 181n9
Holiday, Billie, 44
Hölling, Hanna, 183n46
homeostasis, 23–24
homophobia, 80
Housewright, Stephen, 149–51, 204n14
"How to Kill Yourself Using the Inhalation of Carbon Monoxide Gas" (Hunt), 149–50
HPSCHD (Cage and Hiller), 7, 11, 134, 190n82
Hui, Yuk, 197n1, 198n11
Hullot-Kentor, Robert, 202–3n71
humanism, 56, 91; Florentine, 50; human of, 5, 12, 50, 57, 60, 63, 71, 82, 91, 97, 140; and opera, 50; voice, and sociality, 5. *See also* liberal humanism
human labor: and leisure, 62; refusal of, 65–66; robotic simulation, difference between, 58; self-negating capacity of, 66, 69, 73–74, 76; technological replacement of, 64; uniqueness of, 20, 65
Hume, David, compatibilist position, 164n66, 168n13
Hunt, Jerry, 20, 153, 204n14, 204n15; anti-gay sentiment toward, 151; *Bitom [fixture]: topogram*, 150; ethics of death, 147–48; "How to Kill Yourself Using the Inhalation of Carbon Monoxide Gas," 149–50; suicide of, 147–49; *Talk (slice): duplex*, 148–50
Husserl, Edmund, 47, 177–78n51
Huyssen, Andreas, 10, 146, 162n37

I Am Sitting in a Room (Lucier), 139
IBM: neurosynaptic CPU chip, 34–35; Personal Computer AT (Advanced Technology), 106
I Ching, 7–8
Ihnatowicz, Edward, *The Senster*, 70
ILLIAC (computer), 11
Illiac Suite (Hiller), 11, 134
immaterial labor, 30–31
indeterminacy, 10, 15, 32, 36, 93, 96, 117, 123, 126–30, 135, 143–44, 147, 151–52, 162n37, 198n9; and capitalism, 22; cybernetics, 103; and death, 148; experimental music, 22, 37, 122; human agency, 8; libidinal, link to, 33; psychoanalysis, as alter-

native to, 33; as queer resistance strategy, 9; unknown, potential for, 127
industrialism, 165n79
informatics, 27
information theory, 4, 55, 183n41; and cybernetics, 33
Institut de Recherche et Coordination Acoustique/Musique (IRCAM), 14–16, 103, 118, 130
Ione, 81, 88, 90, 94; *The Nubian Word for Flowers* (librettist), 188n39
IRCAM. *See* Institut de Recherche et Coordination Acoustique/Musique (IRCAM)
iRobot (company), 182n29
Isaacson, Leonard, 11
Issue Project Room (performing arts venue), 124, 131
Iverson, Jennifer, 19, 166n101

Jackson, Zakiyyah Iman, 5, 41, 43
Jacquard, Joseph Marie, 105
Jameson, Fredric: cognitive mapping, 97; late capitalism, and postmodernism, 13, 142
Jansky, Karl, 86
Jaquet-Droz (clock maker), 181n17
Jones, Caroline A., 10
Joselit, David, 167n102
Joseph, Branden W., 10, 19, 163n58
Jukebox (OpenAI), 200n37

Kac, Eduardo, 76, 140–41
Kahn, Douglas, 9, 19, 28, 33–34, 86–88, 166n101, 167n102, 170n48
Kane, Brian, 47, 176n35
Kant, Immanuel, 44; *Anthropology from a Pragmatic Point of View*, 88–89; and extraterrestrials, 5, 82, 89–92, 147, 189n67; human species, cosmopolitan character of, 89–90; Kant Plateau (moon), 189n62; race, writings on, 92, 190n76
Kaoru, Kawana, 139
Kaprow, Allan, 138, 185n86, 195n61; *Cleaning Event* (with Tone), 201n60
Katz, Jonathan, 9, 33
Keane, David, 121, 197n89
Keller, Helen, 101
Kelly, John Larry, Jr., 183n41
Kennedy, John F., 60–61
Kennelly, Arthur E., 186n6
Kentridge, William, 140–41
Kepler, Johannes, 85; *Harmonices Mundi*, 87
Kevorkian, Jack: Mercitron machine, 150; Thanatron machine, 150
Keynes, John Maynard, 76
KGNU radio, 48
Kircher, Athanasius, 113
Kitchen, The (performing arts venue), 40, 55, 178n66, 178–79n67

INDEX

Kitchener, Horatio Herbert, 188n39
Kitnick, Alex, 167n102
Kittler, Friedrich, 45, 135, 176–77n39
knowledge production, and capitalism, 32–33
Knowles, Alison, 18, 184n65
Koene, Randal A., 169n32
Kohonen, Teuvo, 131–32
Kohonen neural networks, 132
Korzybski, Alfred, 197n1
Koselleck, Reinhart, 140
Kotik, Petr, 28; *There Is Singularly Nothing*, 167n8
Kotz, Liz, 8, 17, 19
Kucera, Jan, 167n8
Kurzweil, Ray, 2; singularity, vision of, 5–6, 92, 93, 161n23

La Berge, Leigh Claire, decommodified labor, 115
La bohème (Puccini), 55–56
labor, 21, 26, 76, 106, 146; affective, 30–31; artistic, 29–30, 62, 130; automation, 68; and capitalism, 24; care, 74, 112, 114–15, 122; changes in structure of, 75; cognitive, 2, 18–19, 22–23, 25, 28–32, 145; "dead," 65; decommodified, 105, 115; deskilled, 67; digital, 45, 84, 116; digital labor studies, 31; domestic, 109, 110; essential workers, 119; factory, 22, 25; feminized, 116; forced, 62; free labor market, 66; as gendered, 12, 117; historical shifts in concept of, 22; human, 4–5, 20, 58, 62, 64–66, 69; as invisibilized, 183n53; labor-saving devices, 112; and machines, shifting relationship between, 67, 69; manual, 116, 182n30; maternal, 56; means of production, 25; musical, 32; musical divisions of, 31; musical performance, as form of, 29; as negation, 67; pedagogical, 117; in performance, divisions of, 6; political economy, 5, 33, 64; post-Fordism, association with, 28, 67; posthuman brain, 18–19, 22, 145; productive, 31; raced and gendered divisions of, 112; refusal of, 64–65; as relational, 195n62; replacement for, 58, 60–61, 64–65; reproductive, 11–12, 18, 20, 29, 65, 100, 105, 112, 115, 123, 145, 195n61; robots, as embodying, 65; robots, as replacement for, 58, 60–61, 64; service, 101; sexualized, 62; as shouldered unequally, 120; slave, 69; as social, 65; transformation of, and robots, 65; uncompensated and unwaged, 109, 115; value-producing, 64; and women, 112; worker's time, 25. *See also* cognitive labor; computers
Laderman, Mierle, 195n61
Lady's Glove (Sonami), 18, 20, 118–20; "bypass the brain," attempt to, 103; care labor, 114; digitality, 105; feminized labor, 105; gesture, use of, 122; Hall effect, 101; hand, metaphor of, 123; "kitchen wear" version of, 104; Power Glove, 105; raced and gendered division of labor, 112;

reproductive work, 105, 112; women, hypersexualization of, 101; work uncounted, digital accounting for, 116
La Mettrie, Julien Offray de, 12, 23, 70, 76; human body, as automaton, 4; *Machine Man*, 73
Land, Nick, 25–26, 168n27
language, 15–16, 42, 46, 49, 95, 119–20, 122, 124; conscious thought, 91–92; as differential system, 117; materiality of, 45; musical, 86–87; natural language processing, 52–54, 56, 107; programming of, 43, 79, 102; as technology, 45
Lavender Scare, 9
La Wally (Catalani), 52–54
Lazzarato, Maurizio, 31
Lee, Pamela, 167n102
Leman, Marc, 178n54
L'énigme d'Isidore Ducasse (The Enigma of Isidore Ducasse; Man Ray), 202n63
Lesaffre, Micheline, 178n54
Lewis, George E., 44, 167n102, 174n13, 180n86; Voyager software, 176n29
LeWitt, Sol, 32
Liao Jiao Fruits (poem), 125
liberal humanism, 4–5, 12, 20, 25, 40, 44, 56, 65–66, 105, 145, 160n15, 183n53; autonomy, 23; legacy of, 42–43; market liberalism, 24; possessive individualism, 24; and racism, 41–42
Ligeti, György, 7
Linear Predictive Coding (LPC), 107–8, 110, 117
linguistic profiling, housing discrimination, 40, 46
Littérature (journal), 136
Liu, Lydia H., 67
Liu Cixin, *Three-body Problem* trilogy, 189n65
Livet, Pierre, 127, 198n11
Livingston, Ira, 39, 150
Locke, John, 4–5, 24, 41, 44
logocentrism, 202n61
Los Alamos National Laboratory, 82
Loughridge, Deirdre, 167n102
Lovelace, Ada, 119, 197n82
Lovely Music, 125
LPC. *See* Linear Predictive Coding (LPC)
Lucier, Alvin, 14, 20, 79, 83, 103–4, 132, 146–47, 170n41; cognitive labor, 2, 19, 36–37; contemporary posthuman, 37; contents of brain, as music, 36; and cybernetics, 27, 37; EEG electrodes, 18, 21, 37, 150; *I Am Sitting in a Room*, 139; indeterminacy, 21, 27, 36–37, 93; *Music for Solo Performer*, 2, 6, 21–24, 27–34, 36–37, 39, 83, 87, 145, 167n8, 169–70n40, 170n48; neural transduction, 3; neurofeedback, use of, 19, 39, 79; neuromusic, 36–37; performance anxiety, 170n45; posthuman brain, 147
Lyotard, Jean-François, 12; future anterior, figure of, 13; postmodernism of, 50, 97

machine man, 73
Machine Man (La Mettrie), 70, 73
Machover, Tod, 192n6
Maciunas, George, 18, 61
Macpherson, C. B., 24, 41
Maes, Pieter-Jan, 178n54
Malabou, Catherine, 65, 170–71n51; automaticity, 33; brain, plasticity of, 34–35; neurohumanities, 36; neuronal politics, 35; strategy of opposition, 35
Malik, Suhail: post-anthropogenic, 13–14; posthistory, 165n77
Manhattan Project, 10, 146
Man in the Moon (Godwin), 86–87
Many Many Women (Stein), 167n8
Maoism, 9
Marazzi, Christian, 31
Marconi, Guglielmo, 85–86
Marinetti, Filippo Tommaso, 45
market capitalism, 4; posthumanist amplification of, 25; posthumanist critique of, 25
Marotti, William A., 136, 199n24
Mars, 80, 85–86
Martin, Reinhold, 166n101
Marx, Karl, 25, 35, 64, 76, 115, 119, 170–71n51
Marxism, 24; and Alquati, 25; autonomist feminist, 109, 115; cybernetics, 31; Marxist-feminism, 30–31; Marxist-Hegelian feminism, 192n4
Massachusetts Institute of Technology (MIT), 101, 107; Artificial Intelligence Lab, 182n29; Inter-science Committee, 193–94n32; Millstone Hill Radar, 87
Mathews, Max, 72, 102, 118, 192n6
Matrix, The (film), 193n56
Mattel Toy Company, Power Glove, 104–5
Maturana, Humberto, 42
Max (Max/MSP, programming language), 118; Max Sound Box library, 130
McCarthy, John, 73, 79, 92, 128; Stanford Artificial Intelligence Laboratory (SAIL), 69, 76; Stanford Cart, 69–70
McCarthyism, 9, 151
McCulloch, Warren, 3
McKittrick, Katherine, 42
McLuhan, Marshall, 10, 63
mechanization, 104, 106–7, 109–11, 123; and hand, 112
Mechanization Takes Command: A Contribution to Anonymous History (Giedion), 19, 104–5, 107, 112; "The Hand," 106, 108; "Mechanization and Death," 106, 110; "The Mechanization of the Bath," 106, 111
Mechanization Takes Command: Verses from Giedion's Bible (Sonami and DeMarinis), 105–6, 112, 114, 118; Lady's Glove, 104, 123, 194n46; Power Glove, 104

media theory, 19, 167n102, 176–77n39
Mersenne, Marin, 113
mesostics, 7
Messaging Extraterrestrial Intelligence (METI), 78
Metabolic Music (Tenney), 167n8
Metropolitan Opera, 49
military-industrial complex, 22
Mill, James, 24, 167n102
Mills College, 79, 103
minority discourse, 39
Minsky, Marvin, 66, 79, 92
Miró, Joan, 136
Mirowski, Philip, 13, 24, 183n41
MIT. *See* Massachusetts Institute of Technology (MIT)
Mnemonics (Oliveros), 79
modernism, 2, 202–3n71. *See also* aesthetic modernism; modern music
modernity, 14, 111, 139, 142, 144, 165n79; newness of, 140; recursive search for new, 124
modern music, 2, 7–8, 10, 14–16, 31, 101–3, 114, 122, 134–35, 143–45, 165n88
Modler, Paul, 128
Moog, Bob, 192n6
moonbounce, 78; radio astronomy, 77. *See also* Earth–Moon–Earth (EME) communications
Moorman, Charlotte, 60, 62, 76, 180n3
Moravec, Hans, 24, 26–27, 169n31; *Mind Children*, 117, 148
Morgenstern, Oskar, 24
Mori, Masahiro, 183n40; uncanny valley, 67
Moseley, Roger, 167n102
Moynihan, Thomas, 147, 203n81
Mozart, Wolfgang Amadeus, 71, 76, 184n62; *Cosi fan tutte*, 55–56; F Minor Fantasie, K. 608, 72; "K system" of naming, 60; mechanical instruments, works for, 72; *Musikalisches Würfelspiel*, 72, 134
MP3, 102, 126–28, 131, 140–41, 198n6, 198n8
MP3 Deviation (Tone), 126, 131–32; technological "thingness," 126
MP3 Deviations #6+7 (Tone), 198n6
MP3 Deviations #8 (Tone), 198n6
Mumma, Gordon, 29, 62
Murtza, Hafez, 90
MUSIC (programming language), 102, 118
musical automata: causes and effects, 71; musical automaton, 63
musical modernism. *See* modern music
Music for Several Composers (Tone), 130
Music for Solo Performer for Enormously Amplified Brain Waves and Percussion (Lucier), 2, 6, 83, 87, 145, 167n8, 169–70n40, 170n48; alpha waves, attempt to produce, 28–29, 31; biofeedback, use of, 23–24, 36–37, 39; brain-computer interfaces,

INDEX

22; cognitive labor, as response to, 22–23, 28–30, 32, 36–37; and cybernetics, 33–34; EEG electrodes, 21, 27–28; feedback loop, 28; homeostasis, 23–24; "hotfoot," 29; and indeterminacy, 32–33; neurofeedback, 27, 34; post-Fordism, resonating with, 28, 31–32; posthuman brain, response to crisis of, 27, 36–37

Music for 2 CD Players (Tone), 15

Music group, 129, 134, 136, 199n24, 201n57; automatism, 135; chance and unpredictability, 143; *musique concrète*, 137–38; novelty, search for, 137. *See also* Tone, Yasunao

Musikalisches Würfelspiel (Musical Dice Games), K. 516f (Mozart), 72

musique concrète, 47–48, 129, 134–38, 143

Musk, Elon, 1, 3, 5–6, 26, 147, 152

mutually assured destruction (MAD), 10

Muybridge, Eadweard, 111

Myatt, Tony, 126, 130–31, 133, 198n6

NACM. *See* New Aesthetics in Computer Music (NACM) group

Nakai, You, 19, 165n82

National Aeronautics and Space Administration (NASA), 80, 87, 190n82

National Fair Housing Alliance, 46

Nayar, Pramod K., 168n26

Negri, Antonio, 31

neoliberalism, 35, 164n70

Netherlands, 81

Neuburg, Amy X, 55–56

neural implants, 1–3, 92–93

Neuralink, 2, 4–5, 30, 152; chip implant, 1, 3

neurofeedback, 19, 27–28, 33–34, 39, 79, 145

neuromusic, 36–37

neuroplasticity, 34

neuroscience, 27, 30, 37

New Aesthetics in Computer Music (NACM) group, 126, 128, 131–32, 143

New Interfaces for Musical Expression, 122

new music. *See* modern music

Newton, Isaac, 92

New World, 42

Niblock, Phil, 122

Nintendo Entertainment System, 106

Noll, A. Michael, 72

nomos (Schmitt), 85

noncontrol, 8; and death, 9

Nubian Word for Flowers, The (Oliveros), 188n39

Number (Tone), 139

O'Brien, Mary, 192n4

Obrist, Hans Ulrich, 201n59

ODC Theatre, 38

O'Dwyer, Áine, *Music for Church Cleaners*, 195n61

Oki, Keisuke, 140–41

Olazaran, Mikel, 198n13

Olean, Dave, 77–78

olfactory studies, 39–40

Oliver, Barney, 102

Oliveros, Pauline, 2, 5, 14, 146; *Alien Bog*, 79; biofeedback, and telepathy, 83; colonialism, 188n39; cybernetic system, 79; *Deep Listening Pieces*, 81; Deep Listening practice, 80–83, 94, 97, 145, 186–87n21; distance performance, notion of, 90–91, 93, 97; Doppler shift, 185n3; *Echoes from the Moon*, 20, 77–82, 85–89, 91, 93–98; electronics and tape delay, use of, 91; embodiment, as question of distance, 94; Expanded Instrument System (EIS), 39, 78–79, 90, 97; feminist themes, use of, 80; humans and machines, concern over potential merger of, 92; improvisation, 93, 98; indeterminacy, integral to, 93; liberal democracy, threat to, 92; *Mnemonics*, 79; *The Nubian Word for Flowers*, 188n39; *Phantom Fathom*, 187n31; posthumanism, embrace of, 80, 83, 94; site-specific performance, 80–81; *Sonic Meditations*, 80–81, 83, 93–94; space, hearing and listening to, 97; *Tele-Colonization*, 188n39; *To Valerie Solanas and Marilyn Monroe in Recognition of Their Desperation——*, 80; as vocal astronaut, 78, 185n4

Olivetti factory, 31

Olmsted, Frederick Law, 110, 194n44

omnicide, 146

Ono, Yoko, 18

OpenAI, *Jukebox*, 200n37

opera, 40–41, 52; blackface in, 49; Black voices, 56; and experimental music, 54; and humanism, 50; technology, use of, 49

opera buffa, 61

Organ2/ASLSP (As SLow aS Possible) (Cage), 148, 151–53, 205n27, 205n29

Originale (Stockhausen), 60

Osborne, Peter, 12–13, 97, 164n70; postconceptual music, 165n88

Otello (Verdi), 49

Oxford University, Future of Humanity Institute, 26

Paik, Nam June, 18–19, 28, 145, 180n7, 184n65; at Bell Labs, 72; cars, interest in, 75; computer music, 72; *Confused Rain*, 72; cybernated art, and cybernated life, 63; and cybernetics, 63; cybernetics, and robotics, 76; *Descartes in Easter Island*, 73; *Digital Experiment at Bell Labs*, 72; "DIRECT-CONTACT-ART," 167n8; *Electronic Opera #1*, 185n86; *Electronic Superhighway*, 75; Enlightenment philosophy, references to, 73; eroticism, interest in, 61–62; *Etude 1*, 72; *Family of Robot* series, 65; *First Accident of the*

Paik, Nam June (*cont.*)
 Twenty-first Century, 66, 73, 75; as manager and designer, 183n46; "Pensée," 69, 75; proto-robotics, 20; robotics, and slavery, 75; robotics discourse, 62–63; *Robot K-456*, 4–5, 14, 20, 58, 60–64, 66–71, 73–76, 145, 180n3, 181n9, 181n17; *Robot Opera*, 60–61, 66; *Simple*, 62; *Sonata for Adults Only*, 61–62; technology, catastrophe of, 74–76; technology, utopian potential in, 76; *32 Cars for the 20th Century Play Mozart's Requiem Quietly*, 75
PAL (programming language), 7
Palo Alto, CA, 46
pandemics, 151; as anthropogenic, 203n81; coronavirus, 3, 152
Parasite/Noise (Tone), 129, 140–43
Pasagenwerk (*The Arcades Project*; Benjamin), 140
Pasquinelli, Matteo, 25, 31, 65
Patterson, Ben, 18
PCM. *See* Pulse Code Modulation (PCM)
pedagogy movement, 114
"Pensée" (Paik), 69, 75
performance art, 39
Perry, Katy, 200n37
Phantom Fathom (Oliveros), 187n31
Piano Concerto No. 18 (Mozart), 60, 61
Piano Piece No. 1 (Brecht), 17–18
Pickering, Andrew, 170n48; black box ontology, 96; dance of agency, 96
Piekut, Benjamin, 162n46, 180n5; notion of "corpaurality," 176n38
Piene, Otto, 185n86
Pierce, John R., 4, 102
Pioneer space probe, 87
Pitts, Walter, 3
Plant, Sadie, 117, 197n82
plasticity, 34, 65; historicity, 35
Plato, "music of the spheres," 87
Plus-Minus (Stockhausen), 66
Poggioli, Renato, 140
political economy, 2, 5, 33, 146, 199n23; critique of, 23–24, 41, 64, 115–16; cybernetics, 164n76; and hand, 116; and labor, 64; and posthuman, 41
possessive individualism, 24, 41
postconceptual art, 16, 141, 143, 165n88. *See also* contemporary art
post-Fordism, 22, 28, 67, 75; cybernetic transformations of, 32; feedback, 23; redefinition of the worker, 31
postformalist art, 16, 141, 143, 165n88. *See also* contemporary art
postformalist music/postformalist experimental music, 14–16, 18, 32, 98, 145, 165n88; reference to musical materials, 17

posthuman, 1–2, 6, 20, 24, 40–41, 49–50, 54, 57, 64, 66, 70–71, 80, 92–94, 96, 98, 109–10, 123, 135, 140, 142; Black feminist thought, 19; and cybernetics, 100; and death, 148; decentering, 141; as diagnostic concept, 12; digitality of, 12, 99; experimental music, interface with, 3, 7, 12; ideological roots of, 3–4; interiority, 5; libidinal pull toward, 36; robotics discourse, 63; robots, as emblems of, 58; and time, 141; time and space, as function of, 97
posthuman AI, 144, 150
posthuman automata, 71, 73; experimental music, link to, 76; philosophical conceptions of human, influence on, 72
posthuman brain, 22–23, 25, 33–34, 36, 145, 147; and cybernetics, 21, 24, 27
posthuman hand, and digitality, 104–6
posthumanism, 2, 5, 7, 18, 39–40, 79, 83, 176n32; agency, negation of, 12; and animals, 19; challenges to, 41–42; critical, 168n26; and cybernetics, 14, 19, 145; decentering effect, 12; experimental music, 6; indeterminacy, 9; market capitalism, 25
postmodernism, 8, 12–13, 15–16, 50, 97, 142
Postone, Moishe, 25
post-serialism, 8, 15, 17, 31, 102–3
poststructuralism, 39, 45, 117
Pousseur, Henri, 7
Presley, Elvis, 15, 200n37
psychoanalysis: and acousmatics, 173n2; and Cage, 9, 33, 162–63n48, 172n70; and cybernetics, 67
Puckette, Miller S., 118
Pulsa (commune), 76
Pulse Code Modulation (PCM), 4, 125, 146; bit depth, 102; sampling rate, 102
Pygmalionism, 61

Queen, Julie, 55–56
queer theory, 39–40

race, 38, 40–47, 49, 54, 57, 64, 66, 75, 92, 99, 109, 112, 115, 146
racism, 80, 160n15; color blind, 177n48
Radigue, Éliane, 103, 117–18
radio, 86; color blindness, 177n48; and race, 47–48; and science fiction, 85
radio astronomy, 77, 79, 86; "audible" sky, 85; optical sky, 85
Radio-Baton, 102
Ramones, 48
Ray, Man, *L'énigme d'Isidore Ducasse* (The Enigma of Isidore Ducasse), 202n63
recursion, 20, 124–26, 129, 134, 138–39; and AI, 127–28; novelty and newness, 128, 140; unknown, potential for, 127

INDEX

Red Scare, 9
Rehding, Alexander, 167n102
Reich, Steve, 113
Renaissance, 11, 50, 87, 134
reproductive labor, 29–31, 100, 195n61; as not counted, 105; as undervalued, 114–15; and women, 115–16
Residents (band), 48
Rhee, Jennifer, 67, 74
Richards, Annette, 72
Riskin, Jessica, 63, 71, 181n21
Risset, Jean-Claude, 192n6
Roberts, John, 167n102
Roberts, Sara, *Early Programming*, 117
Robinson, Julia, 17, 19
robotics, 72; and automation, 69, 75–76; and puppetry, 107; slavery, comparison to, 75
robotics discourse, 64; as posthuman, 63; robot strike, 66, 74
robotics studies, 67
Robot K-456 (Paik), 4–5, 14, 20, 58, 64, 69–70, 76, 145, 181n9; automata, resemblance to, 61, 181n17; automobile, staged collision of, 73–75; burlesque, comparison to, 61; data recorder, 68; defecation, of dried beans, 60, 62, 71; experimental music, and deflationary humor, 61; Kennedy's "ask not" speech, 60; malfunctions of, 66, 73, 180n3; musical automata, 63; opera buffa, 61; "otherness," 181n17; Piano Concerto No. 18 (Mozart), reference to, 60–61; robotic imaginary, 67; speech recordings, 60, 71; title of, 60, 68, 71–72
Robot Opera (Paik), 60–61, 66
robots, 4–5; biomorphic body, 64–65, 69–71, 182n30; dystopian discourse, 62–63; and experience, 70; functionality, 69; human labor, technological replacements for, 60–61, 64; human labor and robotic simulation, difference between, 58; musical, 63; posthuman, as emblems of, 58, 65; robotic simulation, as sex robots; "senses," equipped with, 70; and slavery, 62; sociomorphic, 65, 74
Rockmore, Clara, and Theremin, 101
Rodgers, Tara, 197n90
Rogers, Holly, 167n102
Roomba, 182n29
Rosenberg, Jim, 7
Rosenblatt, Frank, 133; Perceptron Mark I, 128
Rosenboom, David, 28, 167n8
Roth, Moira, 163n49
Roulette (performing arts venue), 99
Rzewski, Frederic, 16

Sagan, Carl, Golden Record, 87
Schaeffer, Pierre, 40, 103, 137, 177n48; acousmatics, notion of, 47–49, 138, 177n46; *Cinq études de*

bruits (Five Noise Studies), 137; *Étude aux chemins de fer* (Railroad Study), 137; phenomenological reduction, 56; and radio, 47–48; reduced listening, 47; *Treatise*, 177–78n51
Schmitt, Carl, 85
Schoenberg, Arnold, 61
Schwitters, Kurt, 45
science fiction, 25, 82, 112, 169n38; and radio, 85
Search for Extraterrestrial Intelligence (SETI), 77–78, 80, 82–83
Sears, Roebuck and Company, 116
Second Annual New York Avant Garde Festival, 58, 66
second world war. *See* World War II
Sekula, Allan, 140–41
self-driving cars, 75–76
Senster, The (Ihnatowicz), 70
serialism, 10, 17, 102–3, 162n37
Serres, Michel, 140; parasite, notion of, 139
SETI. *See* Search for Extraterrestrial Intelligence (SETI)
Severinghaus, Ed, 39
sexism, 80
Shannon, Claude, 33, 73, 102, 148; information theory, 4, 139, 183n41; *Ultimate Machine*, 66–67, 74
Shaw, Michael, 202–3n71
Shklovsky, Iosif, 83, 187n29
Shûko, Mizuno, 135
Silicon Valley, 54
Simondon, Gilbert, 152
Simple (Paik), 62
singularity, 5–6, 92–93, 161n23
Siri, Apple, 54
slavery: automation, comparison to, 43, 69; and colorialism, 43; cybernetic control, 43; roboticization, as form of surrogacy, 183n53; robotics, comparison to, 75
Smith, Adam, 116, 195n66
sociality (the social), 5–6, 9–10, 12, 16–17, 40, 47, 49, 55, 90, 141, 145–46, 153; and bathing, 111; and labor, 25, 65; and suicide, 149; systems, 42; and technology, 11, 15, 101
social media, 88, 93
social practice art, 114–15, 195n61
social reproduction, 18, 56, 100, 109, 117, 121–22
Société de radiodiffusion de la France d'outre-mer (SORAFOM), 47; poetic neo-colonialism of, 48
Solanas, Valerie, *SCUM Manifesto*, 80
Solar Eclipse in October (poem), 125
Sonami, Chinzalée, 114
Sonami, Laetitia, 15, 19, 107–8, 110–11, 140, 192n4, 192n6; AI systems, 117; computer music, 101–2, 105, 112, 117–18; digitality, 20, 105; finger movements, 122–23; gesture, use of, 121–23;

Sonami, Laetitia (*cont.*)

 indeterminacy, embrace of, 103, 122–23; instrument building, DIY approach to, 103; Lady's Glove, 11–12, 14, 18, 20, 99–105, 106, 109, 112, 114, 116, 118–20, 122–23, 145, 192n12, 194n46, 197n83; "live cooking shows," 117–18; *Mechanization Takes Command: Verses from Giedion's Bible* (with DeMarinis), 104–6, 112, 114, 118, 123, 194n46; musical practice, underappreciation of, 114–15; music technology and cybernetics, 100; performance novels, 100; posthuman hand, 104–6; sign language, 192n10; Spring Spyre, 103, 117; *What Happened II*, 105, 120–23; *Why __ dreams like a Loose Engine (autoportrait)*, 99–102, 114, 191–92n3; as "wired storyteller," 100

Sonata for Adults Only (Paik), 61–62

Song Books (Cage), 9

sonic color line, 40, 47

Sonic Meditations (Oliveros), 80–81, 93–94; and telepathy, 83

SORAFOM. *See* Société de radiodiffusion de la France d'outre-mer (SORAFOM)

Souls of Black Folk, The (Du Bois), 46–47

sound studies, 39–40

Soupault, Philippe, 136

spatial revolution, 85

speech acts, 90

Spiegel, Laurie, 87

Spillers, Hortense J., 42

Stanford Cart, 70, 182n30; self-driving cars, precursor to, 69

Stanyek, Jason, notion of "corpaurality," 176n38

Stasick, Rod, 148–49

STEIM. *See* Studio for Electro-Instrumental Music (STEIM)

Stein, Gertrude, *Many Many Women*, 167n8

Stelarc, 140–41

Sterne, Jonathan, 126, 167n102

Stiegler, Bernard, 45

Stockhausen, Karlheinz, 7, 62, 162n36, 162n37; *Klavierstuck XI*, 8; *Originale*, 62; *Plus-Minus*, 66, 71, 180n3

Stoever, Jennifer Lynn, 49, 177n48; sonic color line, 40, 46–47

Story, Rosalyn, 49

Straebel, Volker, 32

Studio for Electro-Instrumental Music (STEIM), 103, 119–20, 191n2

subaltern subjects, 13, 45

Sullivan, Woodruff T., 85

Surrealism, 10, 134, 137, 140, 143, 201n44; as psychic automatism, 135–36; unconscious, 135

Surrey University, 128, 133

Swed, Mark, 91

Szendy, Peter, 85

Takehisa, Kosugi, 135, 137

Talk (slice): duplex (Hunt), 148–50

Tallis, Raymond, 108, 115, 193n20, 197n86

Tambellini, Aldo, 185n86

Tan, Fiona, 140–41

Tanaka, Atau, embodied musical interaction, 43

Tau Ceti, 87

Taylor, Elizabeth, 100–101

Taylorism, 108

Team Random (collective), 128

technology, 3–4, 8, 11, 54, 71, 86, 89, 146, 176n29; acousmatics, 40–41, 55; agency, 177–78n51; architectural, 50; Black voice, 41; and bodies, convergence between, 40; brain emulation, 26; catastrophe of, 64, 74–76; changes in, 25; and cybernetics, 102; dance, 39; degradation, upon human bodies, 110; as finicky, 174n7; as force that commands us, 109; "future human values," 2; humanizing, 64, 74, 182n26; humans and environment, upsetting equilibrium between, 108; interstellar communication, 83; and language, 45; music, 18–19, 39, 42–43, 100–101; musical notation, 50; nuclear, 82; opera, use of, 49; posthuman body, 205n19; proto-technology, 123; Pulsa technological commune, 76; recorded speech, 61; recording, 20–21, 38–39, 43–44, 47, 49, 71, 78, 92–93, 124, 128–29, 135, 138–39, 143, 145; as "ridiculous," 66; as social commentary, 15, 101; social effects of, 5; sound reproduction, 125; telematics, 94; thingness of, 126–27; utopian potential in, 76; voice, 49

Tele-Colonization (Oliveros), 188n39

Teller, Edward, 146

Tenney, James, 28, 60, 102, 118, 184n65; *Collage #1 ("Blue Suede")*, 15; ergodicity, use of, 103, 135; *Ergodos I (for John Cage)*, 8, 102; *Metabolic Music*, 167n8

Têpu rekôdâ (Tape Recorder; Tone), 138–39, 202n63

Tesla, Nikola, 85–86, 188n42

There Is Singularly Nothing (Kotik), 167n8

Thiel, Peter, 203n80

32 Cars for the 20th Century Play Mozart's Requiem Quietly (Paik), 75

Thoben, Wilm, 32

Thompson, Marie, 195n61

Thoreau, Henry David, 41–42, 160n15

Thought Conductor #2 (Gilchrist), 6

Tiqqun (collective), 163n53

Tokyo (Japan), 129, 138

Tomlinson, Gary, 45

Tone, Yasunao, 14, 18–19, 195n61, 201n57, 201n59; AI, interest in, 128, 142, 145; *AI Deviation*, 124, 128–35, 140–44; AI versions of himself, 133; *Anagram for Strings*, 202n63; autopoiesis, experiments

INDEX

with, 134; *Clapping Piece*, 113; *Cleaning Event* (with Kaprow), 201n60; indeterminacy, 126–28, 130–31, 143–44, 198n9; information and the new, continuity between, 139; *MP3 Deviation*, 126, 128, 131–32; *MP3 Deviations #6+7*, 198n6; *MP3 Deviations #8*, 198n6; *Musica Iconologos*, 126; *Music for Several Composers*, 130; *Music for 2 CD Players*, 15, 126; *musique concrète* experiments, 129, 134–38; neural network concept, 129, 131–32; newness, approach to, 143–44; *Number*, 139; parasite, as guest, 141; *Parasite/Noise*, 129, 140–43; pattern matching, 131; preparations, 126; recording technology, and problem of novelty, 135; recursion, 20, 125, 138–39, 145; *Solo for Wounded CD*, 126, 128; *Tēpu rekôdâ* (Tape Recorder), 138–39, 202n63; unthinkable form of information, 143; work of, as paramedia, 139–40. *See also* Music group
Tosca (Puccini), 55–56
touch studies, 39–40
To Valerie Solanas and Marilyn Monroe in Recognition of Their Desperation—(Oliveros), 80
Toyota, 67
transhumanist movement, 169n31
Treatise (Schaeffer), 177–78n51
Tronti, Mario, 31
Tudor, David, 8, 15, 103
"Tuesday Afternoon Sound Alternative, The" (radio program), 48
Turing, Alan, 65
typewriter, 52, 105; gendered status of, 45, 116

Ukeles, Mierle Laderman, 114
Ultimate Machine (Shannon), 66–67, 74
Unimate arm, 68, 75, 116, 182n30
Unimation, 68
University of California, San Diego, 80

Vágnerová, Lucie, 174n12
Valiquet, Patrick, 47, 177–78n51
van Muijlwijk, Jan, 88
van Raalte, Chris, 39
Varela, Francisco, 42
Varèse, Edgard, 48; music, as organized sound, 17
Variations VII (Cage), 167n8
Vaucanson, Jacques de, 63, 72, 76; automatic loom, 105; defecating duck, 60, 70–71, 181n17; loom, 182n30; pipe and tabor player, 71
veil, 46; color line, analog to, 47; Pythagorean, 47
Verfremdungseffekt (B. Brecht), 90–91, 140
Vidal, Fernando, 30
Vienna Philharmonic, 80
Vinge, Vernor, 161n23
Virno, Paolo, 31

virtuality, 23–24, 63
virtual reality (VR), 111
visual studies, 39–40
Voci (Z), 17, 178n66, 179n79; AI and acousmatic voice, link to, 54, 56; BabelFish, use of, 52–53; birdsong samples, 52; "Birdvoice," 52; "Bone Music," 51; "Cellovoice," 51; contemporary posthuman, 50–51, 56; cybernetics and opera, meeting between, 52–53; disembodied voice, 45; "Divas," 55–56; dramatic structure, lack of, 50; HAL 9000, re-gendering and re-racing of, 54; "imagined *comm*-unity," 54; "Keitai (Cell Phone Voice)," 55; at Kitchen, 174n7; "The Larynx," 51; "La Voce nella Doccia," 38, 45; "Lost Voice," 55; "Metal/Vox/Water," 51; nonhuman voices, 40; opera technologies, use of, 50, 55–56; as polyphonic mono-opera, 38; polyvocal narration of, 41; as posthuman, 41, 49; "Qwerty Voice," 44–45; scenes of, 51–52; "That Tone," 54; voice, signifier of, 51; "Voice Activated," 54; "Voice Lesson," 51; "Voices," 51; "Voices in Your Head," 51; "Voice Studies," 40, 45–46, 48
von Braun, Wernher, 171n66
von Foerster, Heinz, 127, 163–64n61, 198n11
von Kempelen, Wolfgang, 72; Turk chess player, 181n17
von Neumann, John, 10–11, 65, 83; atomic bomb, 146, 163n53; automata, theory of, 13; economics, important figure in, 24
von Paradis, Maria Theresa, 72
Vora, Kalindi, 183n53
Voyager missions, 87
VR (virtual reality), 111

Wachowskis, 112–13
Wagner, Richard, 61
Waisvisz, Michel, 192n6
Walter, W. Grey, 182n29; tortoises of, 61, 64–65, 70
War of the Worlds, The (film), 188n44
War of the Worlds, The (Wells), 85–86, 188n44
Webb, Stephen, 84
Weheliye, Alexander G., 5, 39–41, 49, 66, 92, 176n32; Black posthumanism, 43–45, 55
Weiser, Mark, 173n4
Weizenbaum, Joseph, ELIZA program, 53–54, 67, 87
Wells, H. G., *The War of the Worlds*, 85–86
What Happened II (Sonami), 105; gestation and gesture, 120–22; indeterminacy, use of, 123; Lady's Glove, 122; maternity and social reproduction, themes of, 122
Whitman, Walt, 41–42, 160n15
Whitney Museum, 63–64, 73–75
Way __ dreams like a Loose Engine (autoportrait) (Sonami), 99–102, 114, 191–92n3; Lady's Glove, 123

INDEX

Wiener, Norbert, 4, 22–24, 34, 43, 52, 63, 65, 73, 75, 95, 107–8, 139, 146–48, 193–94n32, 202n67; automatic factory, 68–69; "hearing glove," 101, 120–21
Wolfe, Cary, 12–13, 50, 52, 97, 141, 167n102, 202n61
Wolff, Christian, 7, 16
World War I, 112
World War II, 9, 13–14, 112, 141
Wynter, Sylvia, 160n15; feedback loop, 5, 42; genres of the human, 42

Yokohama Red Brick Warehouse, 140–41
Yokohama Triennale, 129, 140
Yomiuri Indépendant exhibition, 138
Young, La Monte, 122
Yumiko, Tanno, 135

Z, Pamela, 47, 78, 93, 145, 174n12, 175n15, 175n26, 176n31, 179n81; acousmatics, 38, 44, 46, 48–49, 146, 176n35; animality, 19; biofeedback loops, 42; birdsong, use of, 19, 178–79n67; Black

voices, as disembodied, 39; BodySynth, 14, 38–39, 43, 51–52, 57; color line, 46; contemporary posthuman, 42; digital delay loops, 38, 42–44, 48; embodied voice, 5, 19–20, 40, 42–43, 46, 52; embodiment, acousmatic techniques of, 44; feedback loop, 49; liberal humanism, legacy of, 43; linguistic profiling, 40; MIDI (Musical Instrument Digital Interface), use of, 39; polyvocal circuit, 49; posthuman opera of, 18; "Qwerty Voice," 176n37; race and gender, engagement with, 42, 46, 57; "The Tuesday Afternoon Sound Alternative" (radio program), 48; typewriter, use of, 45; vocal embodiment, 46; *Voci*, 17, 38, 40–41, 48–56, 174n7, 179n79; voice, as acous(ma)tic technology of embodiment, 40–41
0'00" (4'33" No. 2) (Cage), 9, 29
ZIM (programming language), 7
Žižek, Slavoj, 5, 35
Zylinska, Joanna, 167n102
Zywiol, Gary, 68

Lightning Source UK Ltd.
Milton Keynes UK
UKHW010737170123
415455UK00003B/98